What Is Contemporary Art?

TERRY SMITH

The University of Chicago Press Chicago and London

Terry Smith is the Andrew W. Mellon Professor
of Contemporary Art History and Theory in the
Department of the History of Art and Architec-
ture at the University of Pittsburgh, and a visit-
ing professor in the Faculty of Architecture,
University of Sydney. From 1994 to 2001, he was
the Power Professor of Contemporary Art and
Director of the Power Institute, Foundation for
Art and Visual Culture, University of Sydney.
He is the author of several books, including
Transformations in Australian Art, volume 1,
*The Nineteenth Century: Landscape, Colony,
and Nation;* volume 2, *The Twentieth Century:
Modernism and Aboriginality; Making the Modern:
Industry, Art, and Design in America;* and *The
Architecture of Aftermath.*

The University of Chicago Press, Chicago 60637
The University of Chicago Press, Ltd., London
© 2009 by The University of Chicago
All rights reserved. Published 2009
Printed in the United States of America

18 17 16 15 14 13 12 11 10 2 3 4 5

ISBN-13: 978-0-226-76430-6 (cloth)
ISBN-13: 978-0-226-76431-3 (paper)
ISBN-10: 0-226-76430-3 (cloth)
ISBN-10: 0-226-76431-1 (paper)

Library of Congress
Cataloging-In-Publication Data

Smith, Terry (Terry E.)
 What is contemporary art? / Terry Smith.
 p. cm.
 Includes bibliographical references and
index.
 ISBN-13: 978-0-226-76430-6 (cloth : alk. paper)
 ISBN-13: 978-0-226-76431-3 (pbk. : alk. paper)
 ISBN-10: 0-226-76430-3 (cloth : alk. paper)
 ISBN-10: 0-226-76431-1 (pbk. : alk. paper)
 1. Art, Modern—21st century—History
and criticism. 2. Aesthetics, Modern—
21st century. I. Title.
 N6497.S65 2009
 709.05—dc22
 2009013809

⊗ The paper used in this publication meets
the minimum requirements of the American
National Standard for Information Sciences—
Permanence of Paper for Printed Library
Materials, ANSI z39.48–1992.

List of Illustrations *xiii*
Preface and Acknowledgments *xi*

Introduction: Contemporary Art Inside Out 1

Illustrations

Preface and Acknowledgments

Despite, or more likely because of, their focus on the present, the ideas that constitute the basis of this book have been brewing for a long time. They first came together in a lecture titled "What Is Contemporary Art? Tate Modern, Sydney Style, and Art to Come," delivered at the University of Sydney on May 1, 2001. In that lecture I sought to respond to the responsibilities implied in the title of the chair that I, as director of the Power Institute, had held for some years—Power Professor of Contemporary Art—and to those of the position I was soon to take up at the University of Pittsburgh—Andrew W. Mellon Professor of Contemporary Art History and Theory. To profess contemporary art—that is, to offer its gifts to those who would receive or spurn them—does not mean accepting the definitions of the day or promoting them mindlessly. On the contrary, to speak from within a university obliges one to explore the art and ideas of the day, and of the past, with passion and care and with the aim of offering constructive descriptions and independent judgments. Professing the contemporary, then, begins from questioning it for its questions, from recognizing that these questions, among others that may be brought forward, are worth close consideration, and that they cannot be shelved for later historical sorting. It means, then, a searching—from within this double interrogation, with a spirit of doubled openness—for further questions. Such perspectives are not confined to those who work in universities. Artist, critic, curator, educator, merchant, collector, student, art lover—whatever one's engagement with art, it will always be, at root, an entanglement within art's questioning. Contemporary art begins (and, I will show, goes on, ends, and returns) from there—from the immediacy of asking, from the question just posed, anew or freshly formulated.

Asking the question "What is contemporary art?" has taken me on a long journey. On the way I have been challenged and assisted by many. In my

2001 lecture I wished to honor both the Power Institute's founding benefactor, artist, and philanthropist, John Joseph Wardell Power, and the ideal of artistic practice to which he was committed, as am I. I am grateful, too, to faculty and graduate students of the Power Institute on whom I tested these ideas over many years, to Heather Johnson for early research assistance, to Helena Poropat for invaluable assistance during my term as director, and to the Power Foundation Council, led by Peter Burrows, for their unstinting support. John Spencer and Peter Wright of the Schaeffer Library have been a great help to my work for decades.

I was privileged to spend 2001–2 as a Getty Scholar at the Getty Research Institute, Los Angeles. My fellow Scholars provided usefully skeptical and supportive responses to my evolving thinking on these matters: I thank especially Mieke Bal, Benjamin H. D. Buchloh, Thomas Crow, Andrew Perchuk and Ernst van Alpen. I am grateful to Charles Salas and the GRI staff who assisted the Scholars, my research assistant Christina Wegel, and the staff of the GRI Library.

Since August 2002 I have been working on these ideas at the University of Pittsburgh. In February 2003 I outlined my thoughts in progress in an inaugural lecture, "Contemporary Art, World Values: The View From Here." I thank Chancellor Mark Nordenberg, Provost James Maher, Dean N. John Cooper, and my colleagues in the Department of the History of Art and Architecture, led by David Wilkins and Kirk Savage, for providing such a welcoming environment; Ray Anne Lockard and the staff of the Frick Fine Arts Library; my invaluable research assistants, Cristina Albu, Carolina Carrasco, Gerald Hartnett, Jenny Liu, Rocio Nogales, Natalia Rents, and Miguel Rojas-Sotelo; and my teaching assistants and the students in my courses, especially in my graduate seminars on these topics. Colleagues at the Warhol Museum, the Carnegie Museum of Art, the Mattress Factory, and Carnegie Mellon University have also been very helpful.

The final revisions were made during my residency as GlaxoSmithKlein Senior Fellow at the National Humanities Center, Research Triangle Park, North Carolina, during the 2007–8 academic year. I thank Geoffrey Harpham, Kent Mullikin, Lois Whittington, the library, and other staff for their warm welcome and their assistance, and my fellow Fellows for their fellowship.

In shaping these essays I have benefited greatly from conversations with many, above all, Alexander Alberro, Andrew Benjamin, Tony Bond, John Clark, Nancy Condee, Jacques Derrida, Okwui Enwezor, Charles Green, Craig Johnston, Neil de Marchi, Barbara McCloskey, Gao Minglu, W. J. T. Mitchell, Richard J. Powell, Shelley Rice, Jeffrey Shaw, and Bernard Smith.

For their invaluable assistance on my journeys of discovery, I thank, among many others, Sergio Duarte, Gaudencio Fidelis, Paulo Venancio Filho, Richard Leeman, Hector Olea, Mari Carmen Ramirez, Jay Reeg, Sônia Salzstein, Gene Sherman, and James Thomas.

For sterling assistance with securing images and permissions, I thank Miguel Rojas-Sotelo; and for the index, Jan Williams.

At the University of Chicago Press, I thank again Susan Bielstein for her precision as a reader, as well as Anthony Burton, Megan Marz, Lisa Leverett, Mary Gehl, and the anonymous readers.

As always, my deepest gratitude goes to my family, Tina, Keir, and Blake, and to my mother, Gwen Smith.

I dedicate this book to my father, Allan George Eldridge Smith (1918–2005).

Sydney, Pittsburgh, Paris, Durham 2006-8

The following articles and lectures helped shape the book before you. I extend my thanks to the editors, contributors, and conveners who have worked with me in the past. *What is Contemporary Art? Contemporary Art, Contemporaneity and Art to Come* (Sydney: Artspace Critical Issues Series, 2001), Nick Tsoutas, series editor; *Konsthistorisk Tidskrift*, 71, no. 1–2 (2002): 3–15, Margaretha Rossholm Lagerlöf, editor; "Public Art Between Cultures: The Aboriginal Memorial and Nation in Australia," *Critical Inquiry* vol. 27, no. 4 (Summer 2001): 629–61, W. J. T. Mitchell, editor; "Biennales in the Conditions of Contemporaneity," in *Criticism+Engagement+Thought, On Reason and Emotion 2004 Biennale of Sydney*, edited by Blair French, Adam Geczy, and Nicholas Tsoutas (Sydney: Artspace, 2004), 53–59; *Art and Australia* 42:3 (March 2005): 406–15, Claire Armstrong, editor; "Thinking Wishfully; The 8th Havana Biennale Cuba," *Nka Journal of Contemporary African Art*, 19 (Summer 2004): 64–69, Okwui Enwezor, editor; "Making Manhattan Modern, But Not Contemporary, Again," *CAAReviews*, Essay online posted February 2005, http://www .caareviews.org/reviews/moma.html, Christopher Howard, editor; "Primacy, Convergence, Currency: Marketing Contemporary Art in the Conditions of Contemporaneity," *Art Papers*, 29:3 (May/June 2005): 22–27 and 29:4 (July/ August 2005), www.artpapers.org, Sylvie Fortin, editor; from the session "The Auction House and Art History," College Art Association Annual Meeting, Atlanta, February 2005, Cristin Tierney and Véronique Chagnon-Burke, conveners; "Creating Value Between Cultures: Contemporary Aboriginal

Art," in *Beyond Price: Values and Valuing in Art and Culture*, edited by Michael Hütter and David Throsby (Cambridge: Cambridge University Press, 2008); "Contemporary Art and Contemporaneity," *Critical Inquiry*, vol. 32, no. 4 (Summer 2006): 681–707, W. J. T. Mitchell, editor; "World Picturing in Contemporary Art; Iconogeographic Turning," *Australian and New Zealand Journal of Art*, 7, no. 1 (2006), Anthony White, Helen McDonald, Caroline Jordan, and Charles Green, editors; "Eye-Site: Situating Practice and Theory in the Visual Arts," developed from the keynote lecture at the annual conference of the Art Association of Australia and New Zealand, University of Sydney 2005, Roger Benjamin and Eril Bailey, conveners; "Creating Dangerously: Then and Now," in *The Unhomely: Phantom Scenes in Global Society*, edited by Okwui Enwezor (Seville: Bienal Internacional de Arte Contemporáneo de Sevilla, 2006); "Writing Contemporary Art History Now: Some Problems, Some Solutions," Art Historians Association Annual Conference, April 2006, Leeds, UK, in the session Writing Histories of Contemporary Art, Jon Kear and Sophie Berrebi, conveners; "Times Taken, Given by Contemporary Art," in *(Im)permanence: Cultures in/out of Time*, edited by Judith Schachter and Stephen Brockmann (Pittsburgh: Center for the Arts in Society, Carnegie Mellon University, 2008); "The Immediacy of Contemporary Art and the History of Contemporaniety," colloque given at the Institut national d'histoire de l'art, Paris, May 2007, at the invitation of Richard Leeman.

Introduction:
Contemporary Art
Inside Out

No idea about contemporary art is more pervasive than the idea that one can—even *should*—have no idea about it. Statements such as this are typical: "How do you take in the global art world today? Even finding the terms of reference is impossible today."[1] Generalization about contemporary art has evaded articulation for more than two decades: first because of fears of essentialism; followed by the sheer relief of having shaken off exclusivist theories, imposed historicisms, and grand narratives; and then, recently, delight in the simple-seeming pleasures of an open field. More prosaically, the answer has seemed obvious to the point of banality. Look around you: contemporary art is most—why not all?—of the art that is being made now. It cannot be subject to generalization and has overwhelmed art history: it is simply, totally contemporaneous. To me, however, this attitude amounts to a pluralist happy mix that seeks to pull a bland, idiot mask over the most irreducible fact about art today.

In the aftermath of modernity, art has indeed only one option: to be contemporary. But "being contemporary" these days means much more than a mindless embrace of the present. Of course all newly forged art is of its moment, and of its time, but perhaps never before has art been made within such a widespread sense that currency and contingency is all that there is in the world, all that there may ever be. Contemporaneity—which these days is multiplicitous in character but singular in its demands—requires responses that are in significant ways quite different from those that inspired the many and various modernisms of the nineteenth and twentieth centuries. This book aims to describe these responses and to show that they constitute new answers to the question: what is contemporary art?

These issues arise, in part, from a pervasive sense that the great, sustaining narratives supplied by modernity, including roles for art as mir-

ror, leisure, or licensed dissent, have had their day. The counters posed by postmodernity have become consumed in self-fulfilling prophecy. The most recent universalisms, such as globalization or the fundamentalisms, are falling conspicuously short or are overreaching, disastrously. An immediate consequence is that contemporary art has become—in its forms and its contents, its meanings and its usages—thoroughly questioning in nature, extremely wide-ranging in its modes of asking and in the scope of its inquiries. At the same time, in the absence of historical guarantees and the half-light of the deadly competition for global control, art, like every other human activity, can be no more than provisional as to its expectations about answers. Provocative testers, doubt-filled gestures, equivocal objects, tentative projections, diffident propositions, or hopeful anticipations: these are the most common forms of art today. What makes these concerns distinct from the contemporary preoccupations of previous art is that they are addressed—explicitly, although more often implicitly—not only by each work of art to itself and to its contemporaries but also, and definitively, as an interrogation into the ontology of the present, one that asks: What it is to exist in the conditions of contemporaneity?

The terms in use here will require some explaining. Each of them, although familiar, indeed ancient, has recently acquired additional connotations and, in some cases, new meaning. Many of the relationships among them are now quite different from what they have been during the past two hundred years. I will argue that these changes amount to a situation that has come to identify itself as contemporary, not only in fresh ways, but also as predominantly so. How this change has infused art practice, and vice versa, is the subject of this book.

The arguments offered in this book have been shaped by direct encounters with contemporary art: in discussions with artists as they planned upcoming projects; with works of art standing fresh in studios and at their first presentation; while involved in the planning of new museums and while visiting exhibitions at established ones; while doing the rounds of the galleries in many cities, visiting biennales across the globe, viewing private collections, and attending auctions and art fairs; participating in workshops, public fora, conference panels, or listening to lectures; and while checking out Web sites. I try to convey the sense of this art as it happened, to evoke the sites and spaces of its occurrence, the aura of its arrival, the qualities of its incipience, its present tension. This is, after all, the first and most immediate way in which art is, was, and in certain senses remains—as I write, as you read—contemporary.

I have been fortunate enough to be able to experience contemporary art as it first appeared to its publics in many parts of the world, on most continents, and to do so, in recent years especially, at a constant rate. This opened me to the second fundamental quality of the contemporary: its contemporaneousness, its coming into being at the same time as other beings, including other art. The question of what is shared and what is distinct between self and other, between one thing and another, arises immediately. These questions inform every detail of the incessant negotiation between contemporaries, be they persons, animals, or things. Contemporary artists know this: indeed, it may be more present to them than ever before. In 1997, at the age of thirty-two, Damien Hirst, undisputed leader of the "young British artists" (known as yBas), issued an elaborate autobiography entitled *I Want to Spend the Rest of My Life Everywhere, with Everyone, One to One, Always, Forever, Now.*[2] A cunning self-promoter in a style made famous by Andy Warhol, Hirst chose a title that acknowledges the profound superficiality that drives the urge to celebrity while at the same time embracing it unreservedly. Speaking directly to the potential reader, it expresses what every book might want. Is this, too, what every work of art might want?[3] Probably not, but its knowing naïveté, its wild hopefulness within cynicism, captures much about what artists of Hirst's generation feel impels their lives and their art. Taken at face value, it is an appeal to move from extreme isolation to total proximity, from individual alienation to complete togetherness, from spatial uniqueness to planetary oneness, from a personal particularity to total generality, from singularity to universality—and to do so instantly, constantly, for eternity. To be, in a word, contemporary with oneself, with others, with everything in the world, and with all time. To wish for this, even though you know it is impossible, and is becoming more so every day! How cool is that?

There is another, stronger sense of contemporaneity at work here. We all come into worlds that are already formed by others who are contemporaries in various stages of negotiation, and who are themselves continually striving to grasp the arrangements in play between the noncontemporaries before and, now, after them. History is born out of this disjunction. So, too, is art. The planet itself is advanced in its unfolding, the creatures on it in their evolutionary pathways: all of these processes move, at their pace, inexorably—yet suddenly, it seems due to our impatience, precipitously. Humans have always needed to conjure narratives of cotemporality. Now, we do so with a degree of urgency that, it seems, dare not pause to check whether it has precedents. The coexistence of distinct temporalities, of different ways of *being* in relation to time, experienced in the midst of a growing sense that

many kinds of time are running out, is the third, deepest sense of the contemporary: what it is to be *with* time, to be contemporary.

Works of art, before they are anything else, are testimony to each of these cotemporalities—from the simple fact of their coming into being in and of themselves, through their existence in a world replete with others, to their persistence through worlds shaped by repetition and difference. These are plain facts about art. They are, I would contend, also the source and structure of valuing when it comes to art. Valuing, like everything else, plays out in quite specific ways in the contemporary situation.[4]

This book is organized around these three core meanings of the term "contemporary": the immediate, the contemporaneous, and the cotemporal. We will return to them (and a fourth, the relation between the modern and the contemporary) often. In themselves, these meanings are not coterminal, nor are they flat sections of the same substance. They pick out distinctive kinds of particularity and generality, highlighting volatile relationships between these philosophical staples, as well as complex shifts between personal experience and world picturing. In the following chapters, I will suggest how they are, in turn, at the core of what I will show to be the major tendencies in the world's contemporary art. We will see them, too, in the general movement of contemporary art through the world's history as it has unfolded since the 1950s, its own process of becoming contemporary.

In the final chapter, I will set out some of the implications of my argument for art criticism and art history that addresses contemporary art. There, I will comment on the approaches that many of my colleagues are taking to these questions, and I will set out my argument as a proposal for writing the history of contemporary art. Right now, however, the priority is to get you to the essays about museums, exhibitions, artists, and actions as quickly as possible. So I will add just one further section to this introduction: my argument about contemporary art in the conditions of contemporaneity, spelled out in the most summary form.

Let me begin from within the concept of the contemporary, from a pivotal distinction. There are worlds of difference (but also an always necessary implication) between the ordinary usage of the word "contemporary"—with its hip, go-with-the-flow connotations, its default recognition of whatever is happening, up-to-date, simultaneous, or contemporaneous—and the depths of meaning contained within the concept itself: *con tempus* came into use, and remains in use, because it points to *a multiplicity of relationships between being and time*. The concept originates in precisely this multiplicity and has served human thought about this multiplicity ever since. It also

originated and persists in contention against other, often more powerful, terms—notably, in recent centuries, those associated with the concept of the modern—that have sought to account for similar, often overlapping phenomena with greater precision and according to dominant values. There is no question that, for most of the twentieth century, the contemporary played second fiddle to the modern. This began to change in the final decades. In the visual arts, the big story, now so blindingly obvious, is the shift—nascent during the 1950s, emergent in the 1960s, contested during the 1970s, but unmistakable since the 1980s—from modern to contemporary art.

My elaboration of the hypothesis about art in the conditions of contemporaneity begins from the questions being asked by contemporaneity itself. What is the current world picture? How has it changed since the postwar period in Europe, since decolonization opened up Africa and Asia, and since the era of revolution versus dictatorship in South America seems to be morphing into new phases? As the world order built on first, second, third, and fourth world divisions implodes, what arrangements of power are emerging? The evident inability of governments everywhere to move from failing modern modes and frantic overreactions indicates that the new disorder is much subtler than the theses about a "clash of civilizations" and other kinds of flat theory that still underlie the world picturing of the leaders of some powerful nations and, in a deadly dialogue, inspire all kinds of fundamentalism.[5] Is there a more nuanced, accurate way of describing these changing conditions and the kinds of art that are being made in response to them? I will attempt this in the following pages. For starters, I offer two contentions, expressed in extremely schematic form.

Contemporaneity is the most evident attribute of the current world picture, encompassing its most distinctive qualities, from the interactions between humans and the geosphere, through the multeity of cultures and the ideoscape of global politics to the interiority of individual being. This picture can no longer be adequately characterized by terms such as "modernity" and "postmodernity," not least because it is shaped by friction between antinomies so intense that it resists universal generalization, resists even generalization about that resistance. It is, nonetheless, far from shapeless. Within contemporaneity, it seems to me, at least three sets of forces contend, turning each other incessantly. The first is globalization itself, above all, its thirsts for hegemony in the face of increasing cultural differentiation (the multeity that was released by decolonization), for control of time in the face of the proliferation of asynchronous temporalities, and for continuing exploitation of

natural and (to a degree not yet seen) virtual resources against the increasing evidence of the inability of those resources to sustain this exploitation. Secondly, the inequity among peoples, classes, and individuals is now so accelerated that it threatens both the desires for domination entertained by states, ideologies, and religions and the persistent dreams of liberation that continue to inspire individuals and peoples. Thirdly, we are all willy-nilly immersed in an infoscape—or, better, a spectacle, an image economy or a regime of representation[6]—capable of the instant and thoroughly mediated communication of all information and any image anywhere. It is, at the same time, fissured by the uneasy coexistence of highly specialist, closed-knowledge communities; open, volatile subjects; and rampant popular fundamentalisms.

These developments have long prehistories within modernity; their contemporary configuration was signaled in the 1950s (not least in art that prioritized various kinds of immediacy), burst out during the 1960s, has been evident to most since 1989, and has been unmistakable to all since 2001. They are shaping the conditions in which we experience contemporaneity as, at once, the actuality of our individual being in the world, an historic transformation, and a concept still obscure as to its limits, fragile in its foundations, yet called upon to carry unaided the entire weight of a present that it has for so long (and without notice) named.[7]

As I have noted, the concept of the "contemporary," far from being singular and simple—a neutral substitute for "modern"—signifies multiple ways of being with, in, and out of time, separately and at once, with others and without them. These modes, of course, have always been there. The difference nowadays is that the multiplicities of contemporary being predominate over the kinds of generative and destructive powers named by any other comparable terms (for example, the modern and its derivatives). After the era of grand narratives, they may be all that there is. Indeed—who knows?—aftermath may last forever.

Art today is shaped most profoundly by its situation within contemporaneity. Certainly, the achievements and failings of modernist, colonial, and indigenous art continue to pose inescapable challenges to current practice, but none of them, singly or together, can provide an overarching framework for practice or interpretation. Contemporaneity manifests itself not just in the unprecedented proliferation of art, or only in its seemingly infinite variegation, but above all in the emergence of, and contestation between, quite different ways of making art and communicating through it to others. Within the vast, onrushing flow of contemporary art, one can, I believe, discern

three major currents, each of which is driven by a characteristic outlook, is drawn to specific sorts of content, uses a particular range of expressive modes, and prefers a certain system to disseminate its output.

The first current manifests the embrace by certain artists of the rewards and downsides of neoliberal economics, globalizing capital, and neoconservative politics. It is evident in the spectacular repetitions of avant-garde shock tactics pursued above all by Damien Hirst and the other yBas, but also by Julian Schnabel, Jeff Koons, and many others in the United States, and by Takashi Murakami and his followers in Japan, for example. In honor of the 1997 exhibition at which this tendency, in its British form, surfaced to predictable consternation on the part of conservatives but also mainstream acceptance, we might call it "Retro-sensationalism." Since the 1980s this approach has burgeoned in antagonistic but less and less disabling parallel with another, older tendency: the constant efforts of the institutions of modern art (now often labeled "Contemporary Art") to reign in the impacts of contemporaneity on art, revive earlier initiatives, cleave new art to the old modernist impulses and imperatives, and renovate them. Richard Serra, Jeff Wall, and Gerhard Richter are powerful examples of this tendency, which we might call "Remodernism." Together, these trends amount to the aesthetic of globalization, serving it through both a relentless remodernizing and a sporadic contemporizing of art. In the work of certain artists, such as Matthew Barney, both currents come together, generating an art tsunami. If this consummation had to be named, its embodiment of what Guy Debord theorized as "the society of the spectacle" might lead us to terms such as "Spectacle Art" or "Spectacularism." Similar fusions occur in the work of certain architects; for example, the cultural edifices of Frank Gehry, Santiago Calatrava, and Daniel Libeskind. "Spectacle Architecture" is a term with some currency in characterizations of their work.

The second current is quite distinct in origins, nature, and outcome. No art movements here; rather, something akin to a world wide cultural change—indeed, a postcolonial turn. Following decolonization within what were the second, third, and fourth worlds, including its impacts in what was the first world, there has emerged a plethora of art shaped by local, national, anticolonial, independent, antiglobalization values (those of diversity, identity, and critique). It circulates internationally through the activities of travelers, expatriates, the creation of new markets. It predominates in biennales. Local and internationalist values are in constant dialogue in this current—the debate is sometimes enabling, at other times disabling, but always unavoidable. We are starting to see that in the years around 1989,

shifts from modern to contemporary art occurred in every cultural milieu throughout the world, and did so distinctively in each. Just what happened is only now becoming clear, even to those who most directly participated in the events of those days. We can also see that, even as they were occurring in the conflict zones, these events inspired a critique of spectacle capitalism and globalization on the part of a number of artists working in the advanced economies. They developed practices—usually entailing research over time, widespread public involvement, and lengthy, didactic presentations—that critically trace and strikingly display the global movements of the new world disorder between the advanced economies and those connected in multiple ways with them. Working from similar perspectives, other artists were inspired to base their practice around exploring sustainable relationships with specific environments, both social and natural, within the framework of ecological values. Still others work with electronic communicative media, examining its conceptual, social, and material structures: in the context of struggles between free, constrained, and commercial access to this media and its massive colonization by the entertainment industry, artists' responses have developed from net.art toward immersive environments and explorations of avatar-*viuser* (visual information user) interactivity.

The third current is different in kind from the others, the outcome, largely, of a generational change occurring as the first two have unfolded. It is the very recent, worldwide yet everyday occasioning of art that—by rejecting gratuitous provocation and grand symbolic statement in favor of specific, small-scale, and modest offerings—remixes elements of the first two currents, but with less and less regard for their fading power structures and styles of struggle, and more concern for the interactive potentialities of various material media, virtual communicative networks, and open-ended modes of tangible connectivity. These artists seek to arrest the immediate, to grasp the changing nature of time, place, media, and mood today. They make visible our sense that these fundamental, familiar constituents of being are becoming, each day, steadily stranger. They raise questions as to the nature of temporality these days, the possibilities of placemaking vis-à-vis dislocation, about what it is to be immersed in mediated interactivity and about the fraught exchanges between affect and effect. Within the world's turnings and life's frictions, they seek sustainable flows of survival, cooperation, and growth.

This picture of the main currents in contemporary art became apparent to me, in broad terms, during 2000 as I traveled between Australia, the United

Kingdom, Europe, and the United States.[8] Since then, however, the details and the deeper structures emerged gradually, in fragments and patches, as distracting puzzles, or paradoxes disguised as certainties, while I visited museums and galleries, attended biennales and symposia in many different cities, and moved incessantly between the institutions and the less formal practices that display and disseminate art and those, formal and informal, that interpret it. The chapters that follow seek to reveal as much as possible about these experiences as they were happening, to show you how institutions, artists, and critics responded to the recession of the modern in art and the rise of the contemporary. Thus I report on repeat visits to key museums, profiling their attempts——often reluctantly, sometimes presciently—to deal with change as it was occurring. I do the same for key frameworks of interpretation; these, too, have increasingly struggled to deal with the emergent conditions, and the art being made within them. This book invites you to join a worldwide journey that looks into how these questions are being tackled: from well-known public venues (such as the Museum of Modern Art, New York) through lesser known settings (such as the Bienal de La Habana), to the sometimes esoteric, sometimes explosively public, debates between artists, critics, and, finally, historians that constitute the vital discursive structures of contemporary art.

The chapters are arranged so as to show the emergence of these currents in the both art institutions and the practice of art. "Museums: Modern / Contemporary" explores the triumph of the exhibition over the collection in contemporary museums, this being the main strategy adopted by museums that have been obliged to become sites of attraction within the globalizing culture industry. Their main focus has been the first current of contemporary art described above. Established during modernity, often in contrast to historical survey museums of the art of the past, their commitments to modern art—itself becoming rapidly historical—mean that they must continue to revise their own collection narratives *and* strive to become vital centers for art that does not necessarily take modernism as its premise. I profile a number of famous museums where this is double act is being negotiated: MoMA, Dia:Beacon, the Saatchi Gallery, and the Tate Modern. "Spectacles: Architecture / Sculpture" offers close studies of two works of art: Frank Gehry's building-as-sculpture, the Guggenheim Museum, Bilbao, and Matthew Barney's *Cremaster* cycle (1994–2002), especially as staged at the Guggenheim Museum, New York, in 2003. "Markets: Global / Local" examines the markets for two kinds of contemporary art, utterly distinct in their origins,

yet contingent in their contemporaneity: the market for contemporary art of the first (remodernist, retro-sensationalist) kind, and that for contemporary art by Australian Aborigines, a tendency emergent within the postcolonial turn.

In "Countercurrents: South/North," the focus shifts firmly towards the iconogeographic turning precipitated by decolonization and postcolonialism. This is explored as it manifested itself in key exhibitions such as Documenta 11, Kassel, in 2002, and the Bienal de La Habana of 2003. "Contemporaneity: Times/Places" traces typical themes and issues that arise within the third current, notably artists' treatments of time, place, and ethical action in the world today. The final chapter, "What Is Contemporary Art?" proposes that the approach used throughout this book might serve as a viable framework for writing the multiple histories of contemporary art.

Part 1
Museums:
Modern/
Contemporary

CHAPTER ONE

Remodernizing Manhattan

In the months leading up to November 2004, billboards all over the city of New York declared: "Manhattan is Modern Again." Each featured a high view-point photograph of sunlight raking across an elegant International Style interior. The subscript explained the locus of this repeat modernization: "The new Museum of Modern Art reopens in Midtown on November 20." It had been closed for four years to undergo a major rebuilding and expansion. MoMA's long and careful campaign generated breathless publicity and secured a largely reverential art world response; it brought in twenty thousand visitors on day one and has racked up record attendances ever since. Given the jewels of early- and mid-century modernism that are the core of MoMA's collection, nothing less was to be expected. But the reopening was not without its risks, for it exposed the museum—an institution of extraordinary art historical, cultural, even historical, significance—to some tough questions about its role and relevance in the twenty-first century, a time that seems to be shaping up to be modernity's aftermath.

MoMA director Glenn Lowry justified the expansion as meeting pressing needs: to show more of the collection, to show it in a more open, less directive (read: historicist) manner, and to keep the museum alive by showing contemporary art. This agenda invites some questions. Does the architecture declare and enable a renewed vision of the museum? Are the historical collections better—more generously, less narrowly, more intelligently—displayed in the new, expanded spaces? Has the museum met the challenges of showing contemporary art in ways that might serve as models for museums elsewhere? My short answers are, respectively: not really, yes (mostly), no way.

Architect Yoshio Taniguchi is famous in Japan as the creator of deftly spaced, opened out art museums, mostly small in scale and in relatively

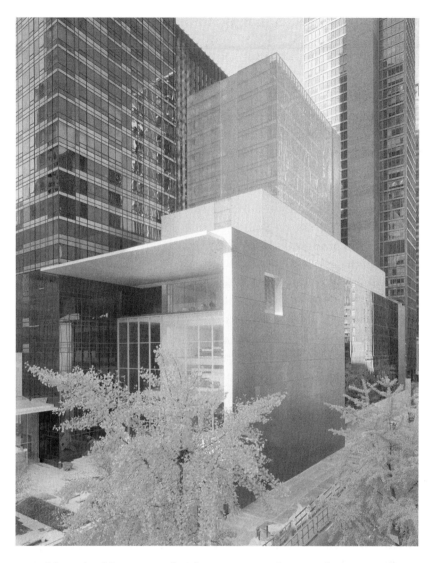

1.1. Yoshio Taniguchi, Museum of Modern Art, New York, renovation 2004. Sculpture garden and view of the David and Peggy Rockefeller building from West 53rd Street. (Photograph © Timothy Hursley. The Museum of Modern Art / Licensed by SCALA / Art Resource, NY.)

isolated settings. He managed to achieve this effect even in his Gallery of Horyugi Treasures, a pavilion in the Tokyo National Museum complex.[1] Midtown Manhattan is, of course, anything but isolated, and no friend to the small scale. Taniguchi's undeniable achievement is the subtlety with which he has conjured the transparency of the block between 53rd and 54th streets and Fifth and Sixth avenues, revealing the multiple spaces inherent within the city's grid structure. As an architectural fantasy about urban interiority, this is hard to beat. German photographer Michael Wesely evoked it precisely in his exposures of the museum as it was being built. These beguiling images were presented in the temporary exhibitions gallery on the sixth floor.

Transparency is achieved at the expense of MoMA maintaining a landmark look. Indeed, qua building, it has a scarcely visible externality, surrendering its own profile for a series of glimpses—as you approach along 53rd Street—of the museum's previous architectural incarnations. The design sets itself deliberately against the paradigmatic success stories of spectacle culture. If Frank Gehry's Guggenheim Museum at Bilbao seemed, when it opened in 1997, to be the pinnacle of destination architecture as art image, now, in the age of aftermath, reticence is the new excess. News media homed in on Taniguchi's remark to the trustees: "Give me your millions, and I will make you an outstanding museum. Give me more and I will make it disappear." This is, if we were to take it literally, an extremely literal response to the crisis of the museum of modern art in the age of the contemporary, after the advent of contemporary art. Yet spectacle values are alive and well in such seemingly modest intentions. The architect presents himself as an illusionist of ever more expensive refinement. He seems to say: if you permit me to make $858 million (actually $425 million in construction costs) evaporate before everyone's eyes, we will trump those who have made tangled wastage the iconic sign of elevated culture, because we will have rendered massive consumption inconspicuous. While this is hardly a new move in the internecine warfare of upper-class culture, it is a magical, up-to-date one nonetheless.

These considerations may not have been uppermost in the minds of those in the long queues who waited over two hours for entry. Subtlety does appear to its best advantage in the invitation to begin your experience of the museum in the enlarged Sculpture Garden, making this early 1950s refuge a welcome sight. Rodin's magisterial bronze *Monument to Balzac* does the inviting. The garden affords the best views of the subtleties of the renovation and is the best recipient of them from the inside.

Next, you ascend the stairs to the second floor, to be uplifted by a huge

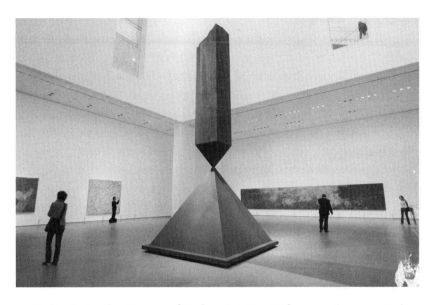

1.2. Yoshio Taniguchi, Museum of Modern Art, New York, renovation 2004. Atrium showing Barnett Newman, *Broken Obelisk*, 1963–69. Cor-Ten steel. (Photograph © Mario Tama / Getty Images.)

new space, a vast rectangular atrium that extends 110 feet to skylight monitors. Sections of its walls are cut out to serve as doors to lower galleries and to reveal glimpses of upper galleries fed by skyline walkways. Refinement quietly underscores this great space. Few visitors consciously notice the thin, dark strip that sets back the point where wall meets floor, adding lightness to the great expanse of wall. The same effect is generated by the same means throughout the museum. So, this is where much of that money went!

The atrium is nailed down at its center by Barnett Newman's *Broken Obelisk*—reprising the welcoming gesture made by another edition of this sculpture outside the Rothko Chapel in Houston. Although Newman's work is one of the few in the collection that could survive in such a space, it establishes immediately a double message: modern art is iconoclastic—see how we endorse the artist's attack on classicism—but don't you love *how* he does it—such élan, such risky solidity, such authority, so modern, yet already a classic. Here we are. And there you are. Passing each other, comfortably, en route to the next art excitement. To me, this kind of messaging gets too close to a themed fountain in a shopping mall.

Which is what the basic design concept soon turns out to be. For all its beauties, and despite its refusal to be the apse of a Cathedral of contem-

porary Art (the ambition of the atrium at the Guggenheim, Bilbao), this great well is a dispenser of crowds into the galleries that cluster off it. It deploys a heady mixture of disorientation and directedness that typifies the postmodern foyer. We could, for example, stay in this space and satisfy ourselves with seeing the great *Water Lilies* by Claude Monet reduced to an emblem of the impressionism that, we will soon learn, precedes modern art. We could skim over the large, bland paintings by Willem de Kooning, Jasper Johns, and Brice Marden on the main wall, reading them as signals of the proximity of contemporary art. And move smartly on to the restaurant or café.

At which point, the building asks those who wish to actually look at the art in it to make a choice among four options: stay on this level and enter the contemporary galleries; head for the escalators and enter one after another of the smaller curatorial departments (drawings and printed books, architecture and design, photography, or film); take the elevators to the fifth floor, cross a suspended bridge and enter the painting and sculpture department's post-impressionist galleries; or go to the sixth floor for the huge temporary exhibition gallery. As a matter of experience, this sounds clearer than it actually is. The printed guides picture each floor as roughly equivalent in their offerings, which they are not, and are misleading as maps. Repeat visitors will not need them, but bug-eyed crowds will just follow the flow, cross and re-cross their paths, as at a multiplex on the weekend.

New York Times architecture critic Nicolai Ouroussoff had no doubt that visitors would get the messages that great modern art has to be sought out, and that it exists in a pure form in the fifth and fourth floor galleries. Up there, it sits at the apex of a hierarchy of artistic achievement, at a level to which more recent art can only aspire. Taniguchi's design, he recognizes, is "an overwhelming assertion of control, beautiful but chilling." It underscores "what powerful art institutions do: they set standards, they make evaluations."[2]

Alternatively, the design can be seen as an outcome of a program dominated by the territorialism of MoMA's curatorial departments. Medium overspecificity has pervaded the museum's history, generating its greatest achievements (outstanding special exhibitions, authoritative historical hangs) and its most abject shortcomings (academic conservatism, caution toward the contemporary). The new building miniaturizes and monumentalizes both. Each departmental section tells the same century-long story of internal questioning (European, mainly Parisian) leading to an embattled confidence (American, mainly New York in style). Each does so in the

absence of examples of the academic, conventional and, with exceptions, mass/commercial/pop cultural oppositions over which modern art did triumph. But each section does so at a different scale, scope, and depth, and in a distinct, hard-to-reach part of the museum, with the result that the sameness of the story becomes porous, and all but vanishes as it approaches the present. This is of course what actually happened during the 1960s, when reductive definitions of each artistic medium provoked a reaction that expanded the scope of them all. MoMA, however, cannot bring itself to contain its internal organization behind the scenes. It must be paraded front of house, with confusing results—especially when we come to recent decades, to which I will return.

If we take the elevators to the fifth floor, we do so in eager anticipation of seeing those masterworks of painting and sculpture that have come, through insistent repetition, to define modern art for generations of art lovers. Which ones will be there? What will be their arrangement? It is a relief to find the classics all there, interesting that some have moved into new places in the story, and a delight that they have been joined by more of their companions, as well as by works from long-ignored yet parallel traditions, especially those in South America. Nevertheless, for all the extra room (a 50 percent increase in exhibition space), these changes come across as tentative variations.

The displacement of Cézanne's *Bather* (ca. 1890) from its position of first painting to be seen—a status it had held for decades—and its replacement by Signac's *Against the Enamel of a Background Rhythmic with Beats and Angles, Tones and Colors, Portrait of M. Félix Fénéon in 1890* attracted much comment among first responses to the re-hang. Conjuring the figure of Fénéon as an art illusionist is a witty way of welcoming the public into the magic kingdom of modern art. This move enables a wider range of Cézannes to be hung and allows us to see the *Bather* as a more awkward, ambiguous painting, as an image about what it is like to hover on the edges of manhood. This first room has none of the force of moving through the rotunda of the Philadelphia Museum of Art, where one is able to see in quick succession consummate paintings of bathers by Renoir, Cézanne, and Degas, all made late in their careers.[3]

Crowds knot in front of the Van Goghs in the second room, especially the much-reproduced *The Starry Night*. On the opposite wall is our first taste of color painting, Matisse at Colliure, and Derain's early boldness. Fauvist and cubist strains play out in the rooms devoted to the futurists and the expressionists, until one enters the superb room devoted to Matisse, which

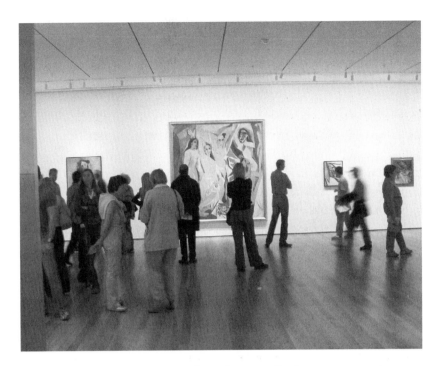

1.3. Museum of Modern Art, New York, modern art collection room, reopening 2004. (Photograph by Chris Ashley, 2005 [http://chrisashley.net/].)

features icons such as *The Red Studio* alongside ravishing recent acquisitions like *The Yellow Curtain* (1915). This room surpasses those in which Matisse features at the Musée d'Orsay, matches the display at the Barnes Foundation in Merion, Pennsylvania, and is surpassed only at the Hermitage (or would be, if all the works by Matisse in St. Petersburg were brought together).

It will always be wonderful to see what Picasso did to European, especially French, painting in the first two decades of the twentieth century. Wielding the visual coding of "the primitive," he suffused painting with the strangeness of Spanish outsider art, and thus rendered it forever provisional. While the *Demoiselles d'Avignon* is an almost brutal demonstration of this new power, you can see it most poignantly in an adjacent small room of analytic cubist works: as it impacts on Braque, who offers exquisite supplication in return. Stronger Braques from the period, of which there are many, would make a different point.

Overall, these early rooms repeat the museum's highly conventional narrative of modern painting (nailed into place by long-serving curator William Rubin) as a multivalent struggle between Matisse's color harmonies

1.4. Donald Judd, *Untitled*, 1989. Museum of Modern Art, New York, contemporary art collection, reopening 2004. (Photograph by Joe Roumeliotis. The Museum of Modern Art, NY. © Judd Foundation. Licensed by VAGA, New York, NY.)

and Picasso's trenchant line. Kandinsky is pinioned by this barrage, as are the futurists. This tug of war is picked up on the floor below by the juxtaposition of Pollock and Newman and echoes through to the 1960s, where it is absorbed into the work of single artists, such as Rauschenberg, is played out in Warhol's series screen paintings—and, we discover to our astonishment, in the high contrast coloring of the stacked I-beams of Donald Judd's *Untitled* (1989), which occupies a major external landing.

Along the way there are some outstanding concentrations. From behind a screen you are surprised by a stand of Brancusi sculptures that look as forceful as any showing of his work can, outside of the recreation of his studio on the grounds of the Centre Pompidou. In the room devoted to Duchamp and Russian art, medium divisiveness relaxes for a moment, and collage consciousness gets its (too brief) moment of glory. In this room there is, as well, a terrific wall that reads back and forth across Malevich's *White on White*, key works by Rodchenko and Klucis through to El Lissitzky's supremely subtle *Proun 19 D* (1922). (Project for the Affirmation of the New, indeed!)

Piet Mondrian is well memorialized, culminating in his hybrid homage *Broadway Boogie-Woogie*. Picasso and Bonnard reclaim the 1920s in their contrasting visions of their respective spouses: benign grotesqueries face off against quietly glowing self-effacement. Through these rooms the welcome additions appear: Joaquín Torres-Garcia (but nothing from the Madí group), a selection from the *Migration* series by Jacob Lawrence, *Agrarian Leader Zapata* by Diego Rivera, and David Alfaro Siqueiros's haunting *Collective Suicide* (1936), a nightmarish vision of organized society perpetrating—through its drive into lynching and fascism—a Last Judgment upon itself. What a prefiguration this is of a crucial turning point painting hung one floor below: Pollock's *Number 1A, 1948*. As you leave these galleries, however, there is disappointment: Sheeler, Hopper, and others occupy a kind of cloakroom, and paintings by other pre–World War II American modernists hang on a utilitarian wall opposite the escalators.

Down which one descends, against the flow of time. The fourth-floor rooms begin with abstract surrealism. Pollock's *The She-Wolf* (1943) sets the tone for the entire floor, setting up a second, complementary narrative: U.S. artists struggle with, absorb, and, eventually, triumphantly transform the

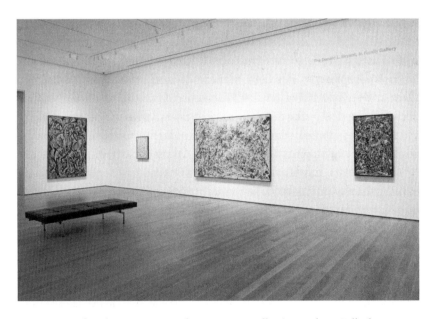

1.5. Museum of Modern Art, New York, postwar art collection, Jackson Pollock room, reopening 2004. (The Museum of Modern Art / Licensed by SCALA / Art Resource, NY.)

artistic possibilities and problems bequeathed by the predominantly European artists whose works hover one floor above them. The good news is that the Pollock room makes it unequivocally clear that this process began, at least, as a worthy endeavor: these half-dozen works, unmatched anywhere, show him rendering painting (this time European, including Picasso) as provocatively provisional, as did Picasso, and by essentially the same means: subjecting the classical (modern version), via "the primitive," to the misrule of its others.

The reinstallation pitches Barnett Newman in the role of Matisse on the floor above, leading us from the Pollock room to the great scarlet zones of *Vir Heroicus Sublimis*. Line and color battle it out in the following rooms, with Rauschenberg's combines and repetitions paralleling the role of collage earlier in the century, eventually making distinctions among mediums irrelevant. The pivotal contributions of postwar European and South American artists to this process are (at last!) acknowledged, but with too few examples. Single works by Yves Klein, Piero Manzoni, Armando Reverón, Lucio Fontana and Jesús Rafael Soto can only be hints of their substantial achievements.

It is regrettable (to say the least) that the next great wave of art's transformation exists in these galleries above all as awkward residue. Joseph Kosuth and Marcel Broodthaers are boxed into a small side room, reducing conceptualism to a minor cul-de-sac. Minimalism amounts to little more than wall (Judd) and floor (Andre) decoration, although it is leavened by the unusual inclusion of an Anne Truitt. Something labeled "Postminimalism" animates the last two spaces on this floor. Some fine works by Fred Sandback, Lygia Clark, and Hélio Oiticica look lost, and Robert Smithson shrinks into a corner while the disturbing dialogue set up between these works and those of Eva Hesse, Joseph Beuys, and Bruce Nauman arrives too abruptly, too late, and without explanation.

The historical narrative set out on these floors has not, of course, remained entirely unmodified. Two years after the reopening, the bright idea of beginning with the jazzy portrait of Fénéon seemed to lose its point. He was replaced with Van Gogh's *Portrait of Joseph Roulin* (1889), popularly known as "The Postman." Similarly, on the floor below, Pollock's *She-Wolf* now hangs in the Pollock room, and the second chapter of the grand narrative begins with a painting by a much-underrated Chilean figurative abstractionist Roberto Matta Echaurren, *Here, Sir Fire, Eat!* (1942). This gesture is both an acknowledgment of the contribution of artists from South America (a recognition amplified by the fine retrospective accorded Armando

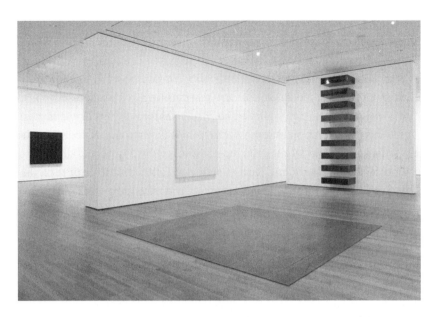

1.6. Museum of Modern Art, New York, minimal art room, reopening 2004. (The Museum of Modern Art / Licensed by SCALA / Art Resource, NY.)

Reverón early in 2007), and a neat introduction to the artist whose work paves the way for Pollock in these rooms: Arshile Gorky. Other changes are few, and mostly minor. Replacing Kosuth's *One and Three Chairs* with John Latham's amusing reduction of Clement Greenberg's famous text *Art and Culture* (1966–69) is a nice homage to the artist, recently deceased. It does little, however, to boost the inconsequentiality of the treatment of conceptualism. Replacing the isolated Smithson with a John McCracken slab brings more visual order to the exhibits in the "Postminimal" space, but no more depth to understanding that moment. Removing the works by Lygia Clark and Hélio Oiticica spares them the blank contextlessness to which they were previously subjected, but effectively removes Brazilian concrétism and neoconcrétism from sight altogether. The worst offense is the disappearance of almost all social realism, North and South American, and its replacement with a room full of Paul Klee's sweet ruminations. And we still leave the historical galleries through porch-like rooms devoted to precisionism and American scene painting on the top floor, and op art below.

During the reopening exhibitions, the collapse into confusion that occurred at the terminus of the historical galleries prefigured the great failure

of the contemporary art displays in three large and high-ceilinged galleries on the second floor. As you enter the first of these, a wall text announces:

> The second-floor galleries present a selection of artworks made since approximately 1970. They include not only paintings and sculpture but also drawings, prints, photographs, and videos. More than in the Museum's other galleries, they juxtapose works from the six curatorial departments: Painting and Sculpture, Drawings, Photography, Prints and Illustrated Books, Architecture and Design, Film and Media. This mix acknowledges and celebrates the interdisciplinary spirit that governs the art of our time.

This is the language of an institution that knows that art has changed beyond modern art, beyond the categories that museums have evolved to collect, preserve and display it, but cannot bring itself to change. It knows that other museums have had great popular and often professional success in making significant shifts in their practices to accommodate these changes. The Tate Modern in London, as I will show, has parlayed its lesser historical collection and its better contemporary collection into a site unafraid to try out multiple stories, often many at once. Its free-flowing building-inside-a-building design permits this in a way that the new MoMA does not. Offering a different kind of challenge, Dia:Beacon has massaged art consisting of anti-museum installations and site-specific environments into a suite of singular encounters that makes each piece look fresh from the studio. The architectural subtlety of its conversion was to call on the internal replicability of a factory dedicated to mass production in the first place, and thus imbued with the promise of infinite expansion. While the Tate is a museum of the same scope as MoMA, Dia:Beacon is clearly a specialist space, so it affords only a partial comparison. Yet it has set the standard for displaying one of the most powerful currents in late modern and contemporary art, an achievement that no serious museum can ignore.

How did MoMA respond in 2004? Stepping back again to the reopening display, we find that the gallery devoted to the 1970s is dominated by *Bingo*, a large slab of building stock cut down by Gordon Matta-Clark. Its impact is somewhat muted by the mini-narrative played out by the paintings and photographs hung alongside it: Gerhard Richter's *Cityscape* (1970), a surveillance-style gray image of an inner city seen from an airplane; a Thomas Struth deadpan of a Parisian street; An-Ming Lê's prospect of Ho Chi Minh City, complete with billboards advertising Western products; another black and

white photograph by David Goldblatt showing, in what seems here (but is not, when you recall his trenchant, stunning group of color images at Documenta 11) a Lewis Baltz/Grant Mudford manner, a tract house in the Transvaal. No surprise that the next thing you see is a view out the window The criteria for the selection of these particular works become clear: less their value as art, more their ability to aid in the coy suggestion that New York City is the greatest artwork of all. (Not that MoMA is alone is trading on such glimpses to cityscapes or pastoral settings: it has become a museum commonplace, and is no bad thing when set forth as a contrast.)

The remainder of this room toys, in a largely token way, with process and performance art. An exception is the wall devoted to what amounts to an extraordinary fantasy of modernity gone seductively dystopian: *Exodus, or the Voluntary Prisoners of Architecture*, devised by Rem Koolhaas, Elia Zenghelis, Madelon Vrisendorp, and Zoe Zenghelis in 1971. They imagine north-central London slashed by a zone of architectural forms so beguiling that the city's inhabitants clamor to enter it, leaving the old city a distant spectacle, lapsing slowly into ruination, while inside the new zone creative architectural forms are generated daily. Within the zone there is an area of respite, one that looks uncannily like the garden-style plots that some Londoners still maintain. The brilliant text that accompanies each frame ends as follows: "Time has been suppressed. Nothing ever happens here, yet the air is heavy with exhilaration." (Contemporaneity to a tee.) Irony like this is hard to find in recent architectural thinking, but desperation is not, so it is appropriate that the third floor gallery devoted to a temporary exhibition *Envisioning Architecture* begins/ends with the *Terrain Project* of 1998–2000 by Lebbeus Woods.

Returning to the contemporary art galleries on the second floor, perhaps one cannot expect a room devoted to the art of the 1980s to be anything other than a disappointment. We can see, on one wall, the rather obvious point being made about Warhol's legacy when his large, golden Rorschach blot skeleton accepts the homage of the works by Polk and Clemente that flank it, although it is a long, and erudite, stretch to include Richter's culminating Baader-Meinhof painting nearby. But what, apart from "Oh, look! They all respond to pop culture!" connects a Sherman film still, Koons's vacuum cleaners, Elizabeth Murray's goofy *Dis Pair* (1989–90), two Gobers, a Wool inscription painting, and a Nauman *Human/Need/Desire* neon piece? Just that they are American artists? If, however, the theme is high art's vacuuming up of popular culture, where are the yBas, the retro-sensationalists? Is it quality judgment alone that keeps Damien Hirst out of the collection? To me, this

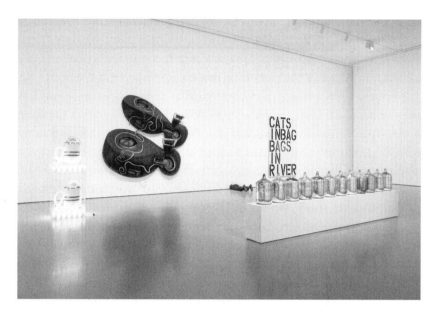

1.7. Museum of Modern Art, New York, contemporary art collection, gallery 2, reopening 2004. (Museum of Modern Art / Licensed by SCALA / Art Resource, NY.)

is a sign that a major tendency of contemporary art is abjured at MoMA. This museum remains the temple of what I will show to be a defensive remodernism—one that, unsurprisingly given its history, often goes on the attack. For the moment, however, let us resume our journey.

Superficial curatorial connections also prevail in the 1990s room. Most blatant is the positioning of Colombian artist Doris Salcedo's *Untitled* (1995), a work in which plaster "bleeds" out from architectural forms, allegorizing the all-pervasiveness of social violence in an excruciatingly material way. It is paired with Rachel Whiteread's *Untitled (Room)* (1997), a cast of the interior of a room that she built for the purpose of casting its void, of making solid an abstraction, of showing space to be palpable. Depth is recovered somewhat by Jeff Wall's *After Invisible Man by Ralph Ellison, the Prologue* (2001) and Andreas Gurksy's *Rhein II* (1999), both masterpieces, but "high art lite" remains the prevailing tone.[4]

In the media room, Warhol's *Screen Tests* (1964–66) face off against some of their recent progeny, notably Eve Sussman's film *89 Seconds at Alcazar* (2004), an enchanting pan around and through the tableaux captured in Velázquez's famous painting *Las Meninas* (1656). Yet new media is more than conspicuous by its total absence. The wall text offers us this solace:

A word about what is not on view. Many works of art made during the last few decades must occupy an entire room of their own. On the occasion of the building's opening, we decided not to subdivide the new contemporary galleries into separate chambers. In the future that will certainly occur and this new art will be explored.

Net.art—indeed, anything digital—does not, it seems, even enter into this pale apology. More than missing art movements, these galleries ignore what is now a thirty-year-long, richly ramified critique of, intervention into, and collaboration with museums of all kinds, not least art museums, by artists of all kinds.

Over a decade ago, in his Mellon Lectures, Arthur Danto put his finger on the underlying problem. Musing on the "very strong distinction between 'modern' and 'contemporary'" that became evident in the New York art world in the 1970s and early 1980s, he noted that this development had placed MoMA—and, we might add, all other such modern art museums—in an unanticipated bind. It was a shock to find that art that "remained under the stylistic imperatives of modernism" was no longer contemporary, except in the trivial sense of being still churned out, anachronistically. "But today," Danto observed, "as we near the end of the century, the Museum of Modern Art has to decide whether it is going to acquire contemporary art that is not modern and thus become a museum of modern art in the strictly temporal sense or whether it will continue to collect only stylistically modern art, the production of which has thinned down to perhaps a trickle, but which is no longer representative of the contemporary world."[5] The suggestion here is that MoMA should stick to its area of high competence, become a historical museum of modernism, and leave the contemporary to others.

The museum's answer came in 2000, just as it began closing for the four-year-long renovation. In the introduction to the book that accompanied one of the centennial exhibitions, *Modern Contemporary: Art at MoMA since 1980*, then chief curator Kirk Varnedoe asserted:

> There is an argument to be made that the revolutions that originally produced modern art, in the late nineteenth and early twentieth centuries, have not been concluded or superseded—and thus that contemporary art today can be understood as the ongoing extension and revision of those founding innovations and debates. The collection of the Museum of Modern Art is, in a very real sense, that argument. Contemporary art is collected and presented at this Museum as part of modern art—as be-

longing within, and responding to, and expanding upon the framework of initiatives and challenges established by the earlier history of progressive art since the dawn of the twentieth century.[6]

A softer version of the same stipulation appears in the introduction to the book *Modern Painting and Sculpture: 1880 to the Present* that accompanied the 2004 reopening. Curator John Elderfield returns more than once to a distinction made in the museum's founding statement by MoMA's first director, Alfred H. Barr Jr. For MoMA, Barr insisted, genuinely modern art was "the progressive, original and challenging rather than the safe and academic which would naturally be included in the supine neutrality of the term 'contemporary.'"[7] Elderfield explains in detail the evolution of the collections, primarily those in the painting and sculpture department, and patiently sets out the forces—especially those internal to the museum—that shaped the arrangement of the famous rooms. Despite his statements to the press that his goal in the current renovation was "to make familiar things strange again, as they once were," the gentlemanly caution that attends each sentence of his introduction attests to the powerful persistence of MoMA's past.[8] It is a modernist history that swamps perception of the present. Even the billboard captions that I quoted before are quotations from earlier MoMA campaigns and reports.

In Elderfield's book, recent art is included under the coy caption "Untitled (Contemporary)." A cute word play that is also acutely revealing of MoMA prejudices, for it labels everything after pop art as a parenthetic supplement to minimalist sculpture—which habitually used *Untitled* as a title. This echoed what happened out on the floors, in the contemporary galleries, during the reopening exhibitions: the museum's curators seem incapable of seeing (and certainly incapable of displaying) contemporary art as anything other than painting-like or sculpture-like. At best, they stretch to drawing-like or cinema-like. To *New York Times* art critic Michael Kimmelman, usually a huge booster of the museum, these rooms are "sparsely scattered with eclectic sculptures, paintings, photographs, and drawings that look washed ashore—the costly remains from a sea of curatorial indecision."[9]

MoMA 2004 could not cope with the paradox that much of the most successful and attention-getting contemporary art is conservative, derivative, and safe, because it seductively updates modernist procedures and tastes, whereas the contemporary art that is progressive, original, and challenging is so precisely because it challenges those procedures and tastes. In the reopening exhibitions, MoMA chose to show, mostly, those contemporary art

works that remained modern—modern in style and look. At the same time, the display as a whole managed to reduce the few nonconformist works to nearly total ineffectuality. MoMA offered, at best, tentative gestures toward the recent global shift to art that is "progressive, original, and challenging," art that emerges from the new senses that these values have, today, in the conditions of contemporaneity. In the reopening exhibitions, the museum seemed determined to celebrate its past and to wait out the future.

Where does such indecision come from? To be fair to all concerned, it must be acknowledged that conflicting motivations have driven museums of contemporary art from the outset, and that many of them have attempted to fulfill at least two—sometimes contradictory—purposes at once. Reflecting a widespread attitude, Gertrude Stein commented, "You can be a museum, or you can be modern, but you can't be both."[10] Stein had either misunderstood or rejected as temporizing the rationale of one of the explicit precedents to MoMA, the Musée des Artistes Vivants, established in the Luxembourg Palace, Paris, under the aegis of Louis XVIII in 1818. If not the first museum created explicitly to exhibit and collect the work of living artists, it quickly became the best known and the most influential.[11] In contrast to the other collections in Paris—at the Palais Royal (open since 1784), other rooms of the Luxembourg itself (since 1750), but above all the Louvre (since 1793), all devoted to old masters—it was conceived as a *musée de passage*, a site of display and judgment that would pass on to the Louvre, ten years after the artist's death, those artworks deemed worthy of permanent protection. Lesser works were destined for provincial museums or storage in attics. This multi-museum, cooperative system aimed to encourage artists, make their work available to interested publics, sort out good from bad, distinguish the serious contribution from the passing fad, judiciously expand the national patrimony and service the cultural needs of both the capital and the provinces. The scheme was one of many tried out with variations in all spheres of European cultural influence during the nineteenth century and since, in order to regularize the relationships between art as it was being made and what had become in some countries an extensive and much-valued accumulation of national artistic achievement. The crown or the state vested its authority in the visual arts professionals who performed the cultivating and vetting operations. This worked with varying degrees of success—in the Luxembourg case, more in the breach than the observance—until individual artists, such as Gustave Courbet in 1855, and then groups of artists, such as the impressionists in 1874, began producing work that challenged the assumptions of the established gatekeepers to such an extent that they

could not imagine them in any of the state museums, including that for living artists at the Luxembourg. The resulting confrontations are the best-known story of modern art, but they are grounded in, and react against, this economy of exchange between institutions.[12]

In mid-twentieth-century New York, Barr could point to the evident achievement of the European modernists and read it as an acceleration of selected elements of past art. He famously envisioned MoMA's collections as a torpedo hurtling into the future, with the works of the early moderns, from Goya to the impressionists, in its tapered tail, the 1875–1900 postimpressionists and Homer, Eakins, and Ryder in the body, with the avant-garde French and recent American, Mexican, School of Paris, and "rest of Europe" art at its large nose.[13] Barr was fully aware of the European museological precedents, now over a century old, that were making New York seem a less-than-civilized city. Like most other founders, he sought to emulate solutions that had succeeded elsewhere.

> The historical museum, such as the Metropolitan, acquires what is be-lieved to be certainly and permanently valuable. *It cannot afford to run the risk of error.* But the opposite is true of museums of modern art such as the Luxembourg Gallery in Paris, the Tate Gallery in London, or the Stedelijk Museum in Amsterdam. It is the proper part of their program to *take chances on the acquisition of contemporary painting and sculpture*, a policy which would be unwise on the part of their conservative counterparts, the Louvre, the National Gallery, or the Rijksmuseum.[14]

To remain modern, the museum undertook to deaccession the older works by sale, gift or exchange, or by transferring them to the Metropolitan Museum of Art. MoMA, like the others in Barr's list, would be a "transitional" institution, a crucial step in the chain of recognition from art that was merely contemporary through that which seemed, to its curators, genuinely modern art, en route to becoming "certainly and permanently valuable." As Angelica Rudenstine comments, "the original conception of the museum equated the notion of the modern with that of 'contemporary,' and it offered an interesting solution to the dilemma of institutionalizing the modern."[15] In fact, the value of the museum's holdings grew so quickly and became so identified in the minds of visitors with the institution that in 1953, MoMA ceased to pass on work to the Metropolitan, and it deaccessioned only to raise funds for acquisitions, relying on benefactions to finance growth in its collections, fund its major expansions, and stage its

path-finding exhibitions. Yet by April 15, 1940, the American Abstract Artists, a group of local practitioners whose work had been steadfastly ignored by the museum, circulated a broadsheet (designed in the style of a populist poster by Ad Reinhardt) headed "How Modern is the Museum of Modern Art?" Two years later, the museum staged Americans 1942: 18 Artists from 9 States, the first of what would be a string of influential exhibitions of selected U.S. artists curated by Dorothy Miller.

Since the 1960s, along with its collection and major surveys of modern masters as well as retrospectives of pivotal late modern artists, MoMA has presented a number of exhibitions that have defined crucial tendencies in new art. Even when the collection displays battened down to the resolute formalism that still haunts them today, provocative and prescient temporary exhibitions were mounted by curators such as Kynaston McShine—for example, Information, shown in 1969–70.[16] These have petered out in recent decades, not least because artistic practice has almost entirely ceased to coalesce into movements recognizable as art historical styles or into tendencies that seem familiar from modernist perspectives. Nevertheless, up until that point, MoMA could still harbor the goal of being, at the same time, a historical museum of modern art *and* a *musée de passage* for contemporary art—that is, a Luxembourg within its own Louvre, or, to put it in more local terms, a New Museum of Contemporary Art within the MoMA that it had come to be. This double role was the basis of the brief given to the architect of the renovations, and remains at the core of the museum's self-conception.

During the period in which the museum was closed for renovations, however, it became troublingly clear that something more significant than low-level changes in modern art's historical unfolding was occurring in art practice around the world. More broadly, it began to seem that something more far-reaching than a further development of modernity was taking place. The brief historical digression we just made has another lesson: that while major art institutions will always attempt to serve more than one simple purpose, and indeed are often energized by contradiction, they need constantly to orient what they do in ways that are precisely calibrated to their circumstances, including the activities of other, related institutions in their vicinity and in the spheres of their supporters and clients. In planning its appearance at reopening, MoMA had a choice to make—one that, in different ways, faces everyone involved in today's art. They could boldly reaffirm Varnedoe's argument that contemporary art of quality and interest is that art that takes up and presses hard at the issues raised by the great mid-nineteenth-century modernists, early-twentieth-century avant-gardes, and

their later successors. Show this type of art and to hell with the rest. In contrast, the curators could draw on the research occurring all over the world at present that proves the actual historical unfolding of modern art to have been a story of "multiple modernities"—connected in many ways ("cosmopolitan modernisms") but also locally embedded ("vernacular modernisms"). Restock and re-hang the upper floors so as mark out the trajectories of these currents, then show in the second floor galleries precisely that contemporary art which continues to elaborate them. Both of these solutions imply an identifiable historical sequence flowing throughout the museum, not a two-museums-in-one experience. Both refuse the third option: to show the unfolding of "multiple modernities" as above, but then trace the shifts, during the past thirty or so years, from them to the even more volatile currency that constitutes contemporary art all over the world today.

Faced with a cloud of criticism provoked by its supine faux-engagement with the contemporary during the reopening exhibitions, MoMA took none of these steps. It decided to not decide, to keep its options open, and thus to change the contemporary art rooms at least once each year, beginning in 2005 with "Take 2." The wall label announced that the galleries would show "significant preoccupations in contemporary art, including the notion of the sublime and the dematerialization of art, shifting perceptions of individual identity, and explorations of the political landscape." In the first room, a determined effort was made to give visitors some sense of the radical artistic aspirations, the way-out experimentality and the wackiness of the 1970s. A tough yet delicate hanging wall sculpture by Eva Hesse, *Untitled* (1966), oversaw a room that demonstrated the feminist questioning of role models for women: dominated by a large screen projection of Marina Abramović's 1975 self-abnegating performance *Art Must Be Beautiful, Artist Must Be Beautiful*, in which she abuses her face, it ranged from Rudolf Schwarzkogler's disruptive *1st Action: Wedding* (1965) through Mike Kelley's traumatic *Defamation, Soft and Hard* (1986) to Charles Ray's *Family Romance* (1993), this last a row of life-size figures, in which parents, children, and babies are exactly the same height. Perceptions of identity became very focused, and very moving, in the back room: *Solo Scenes* (1997–98) consists of 130 monitors arranged in banks, showing videos made from cameras that assemblage artist Dieter Roth set up in a number of places in his house and studio and programmed to run continuously during the last months of his life.

A very material version of the "dematerialization of art" was evident in Paul McCarthy's *Painting Face Down White Line* (1972), a video record of him pushing, with his head, a large bucket of white house paint along the floor,

his body shaping a crude line, until the bucket was empty—an amusing, in-my-face enactment of the then much-discussed concept of the "death of painting." Many artists pursued this kind of questioning. By linking a laboratory environment to a drumming machine via film of animals being tested in experiments, Bruce Nauman took subjection to science to nightmarish dimensions in his *Learned Helplessness in Rats (Rock 'n Roll Drummer)* (1980). A third theme was explored in the central rooms: art that appeals to one's political conscience. Key works were William Kentridge's animated video *Felix in Exile* (1994), a complex portrait of the end of Apartheid in South Africa as experienced by whites, and Oyvrind Fahlstrom's *Sketch for a World Map, Part 1 (Americas, Pacific)* (1972), in which the land masses are scaled according to the extent of U.S. aid and military intervention. In an edition of 7,300, it was originally distributed as a poster. Works by Yinka Shonibare and Kara Walker highlighted the politics of stereotypical identification, while Congolese artist Chéri Samba taught a generous lesson in political tolerance in a 1989–90 series of painted panels, *Condemnations without Judgment*. Little of this subtlety was evident in the largest painting in the room, Dana Schutz's *Presentation* (2005), a scene of anxious whites gathering as the dismembered body of an "Other" is tipped into a grave. Rendered in rave venue, neue wilden style, the painting's iconography mixes Ensor's *Entry of Christ into Brussels*, Courbet's *Burial at Ornans*, and Picasso's *The Charnel House.*[17]

In the remainder of the 2005 re-hang, in the rooms that could be the alternative entrance to where I began two paragraphs back, MoMA reverted to type. The tutelary genius of this space was a spare, gray-and-black Rothko from 1970, the year of his suicide. Nearby, a nearly invisible Agnes Martin. Robert Ryman and Brice Marden had set that tone during the 1970s, but their work was in other, modern rooms, outside and upstairs. In these rooms, however, the mystical edge of this current was represented by James Turrell's light projection *A Frontal Passage* (1994), a rare outburst of color, and James Lee Byars's conception of the essence of art, a gold orb on a plinth. Despite their preponderance, works by Alighiero Boetti, Vija Celmins, Felix Gonzalez-Torres, Mona Hatoum, and Shirazeh Houshiary—all of which are acute reflections on embattled rights and the threats to belief—were assimilated to a certain minimalist aesthetic, the signature style of remodernism.

In the first half of 2006, these galleries reverted still further. The exhibition *Against the Grain: Contemporary Art from the Edward R. Broida Collection*, celebrated a recent large donation to the museum. The "grain" against which Broida conceived himself to be collecting seems to be all of the tendencies that I have distinguished to date. Instead, he gathered in depth the

work of Philip Guston, Vija Celmins, Ken Price and Christopher Wilmarth. Yet the first two are major figures in the transitioning between these tendencies, the other minor ones. In the latter months of 2007—coincident with the reopening of the New Museum of Contemporary Art on the Bowery, in a funky yet elegant building designed by the Japanese architects Sanaa, and with opening exhibitions, entitled Unmonumental, devoted to low-rent assemblages—curatorial indecision in the contemporary galleries at MoMA reached, one hopes, its lowest ebb. The display was entitled "Multiplex: directions in art 1970 to now," and began with a wall text that announced the appearance of "pluralism" in art around 1970: "An earlier view of modern art, with a mainstream flowing from one 'ism' to another, had given way to a broader consideration of disparate practices." Without missing a beat, it went on: "This framework for understanding is still in place today." The poverty of thought here was also manifest in the rooms themselves. The curators could not resist identifying three currents within pluralism's whatever. No prizes for guessing the picks: "formal and conceptual approaches to abstraction," "mutability," and "provocation." In other words, updates of the MoMA staples: modernism, surrealism and avant-gardism. On the ground, the curators chose acute manifestations of these tendencies in their 1970s versions, showing powerful but rarely-seen works by Jack Whitten, Nancy Spero, and Adrian Piper, but lost their way as they approached the present. "Provocation," for example, consisted of a random collection of works that all seemed to be asking the same-old question: Is this art?[18]

One partial exception to this sorry tale occurred during late 2006 and the early months of 2007, when the galleries were devoted to *Out of Time: Contemporary Art from the Collection*, an exploration of the theme of temporality in recent art. Including works by artists rarely shown at MoMA, such as Cady Noland, Cai Guo-Qiang, Rineke Dijkstra, Luc Tuymans, and Bill Viola, it aimed to investigate, in the words of its wall text, "the cinematic perception and recording of 'real time' and its impact on other forms of art; the projection of an inner dimension of time articulated through fantasy and dreams; and a reconstruction of time that is based on archives, memory, and history." Finally, the collection galleries of the paradigmatic museum of modern art take a step into some of the elements, and issues, fundamental to contemporaneity. But, in the event, only a small one. Critic Michael Kimmelman found the show, as a whole, "so orthodox, so true to the Minimal-Conceptualist gene pool, so loyal to a familiar cast of pre-approved artists and so risk-averse and eccentricity intolerant that the art feels frozen and isolated, like deer in headlights." He was also right to observe that works by

some artists—Rachel Whiteread, Gerhard Richter, Robert Gober, and the sisters Jane and Louise Wilson—"made good on the exhibition's worn-out theme. But they also get a boost from reality. Each sheds light on the fix the world finds itself in by touching on desolation, waste, abuse of power, injustice, loss and death—of both individuals and cultures—all of which count among the vicissitudes of time."[19] These words take us to the heart of the challenges facing contemporary artists, and museums that would show their work, today. These challenges will be explored throughout the following chapters, including one in which I argue that, far from being worn out as a theme these days, time in contemporaneity is, always, just beginning.

The dilemma posed in this chapter might be encapsulated, *pace* Gertrude Stein, thus: "You can be a museum, or you can be contemporary, but you can't be both"—especially if you are already a museum of modern art, above all if you are *the* Museum of Modern Art. In 2007, MoMA director Lowry responded to the challenge of his museum's supposed anachronism by claiming that this was not a new problem, that "MoMA has had to balance and juggle its commitments to old and new art virtually since its birth," and that it would continue to do so, because "frictions like these are part of what makes the Museum so rewarding and vital." In this sense, he might (somewhat disingenuously) claim that the renovated MoMA does pay homage to the contemporary precisely in that it shows, at any given time and at the same time, art from a variety of periods, including the present. Further, as he notes, the normal visitor experiences these out of chronological sequence, ascending upwards through space and backwards in time, before reaching the temporary exhibitions on the sixth floor.[20] How much more contemporary, he implies, do you want us to be?

To Lowry in 2007, the contemporary was interchangeable with the postmodern: they are interesting, as eras and as art, only in their claim to come after and replace the modern. This, of course, they will fail to do. "The Museum . . . is fundamentally unaffected by those recent arguments about the death of modern art and the arrival of a postmodern era."[21] In taking this attitude, he follows his predecessors, who, during the 1970s and '80s, ignored postmodernism as a label in museum signage, exhibition titles, and publications while occasionally cherry-picking, for group exhibitions with other themes, the work of artists elsewhere regarded as working within that framework.[22] The anti-modern challenge of the postmodern was resolutely rejected by the modern art institution *par excellence*. We have seen it reappear in the mall-like atrium, but it subsists most strongly in Taniguchi's orchestrations of the museum's disappearance as a building. In this gesture, post-

modernist historicism reappears as a belated ghostly absence, years after the movement itself had declined into the background noise of normality.[23]

I have suggested in this chapter that, in fact, the pluralizing of art historical temporalities that one experiences at MoMA is an accidental outcome of the confused mix of contradictory intentions that it embodies. As we shall see in subsequent chapters, most contemporary art institutions have managed the paradox between institutionalism and contemporaneity by backstaging their commitments to continuity and opening themselves out as sites for events, as places ready for whatever *happens to them*. In contrast, MoMA's professed pluralism is undergirded by a firm resolve to accommodate only those aspects of the contemporary that accord with its fundamental commitment to modernism. Taking up Barr's 1929 distinction, but diplomatically omitting his predecessor's reference to the "supine" contemporary, Lowry reaffirms the institution's original devotion to art that is "progressive, original and challenging rather than safe and academic," but then adds an update: whenever it is made—now, then, or in the future.[24] The modern is dead, long live the modern! Earlier, Ouroussoff reminded us of MoMA's canon-forming role, and Lowry returns to it in his 2007 comments. This is, indeed, an institution that continues to insist that contemporary art *come to it*, to its management of what counts as today's art. An attitude that is evident not only in the disarray of the contemporary galleries, but also in the selection of contemporary artists—such as Richard Serra, Jeff Wall, Olafur Eliasson, and Marlene Dumas—for one-person exhibitions, and in the selections among their works for those exhibitions. The remodernizing instinct is to choose artists and works that, on the walls, in the galleries, and in the catalogs, read as contemporary moderns or modernist contemporaries.

From outside the museum, as the years since 2004 roll by and every change reverts to something familiar, this approach reads less as liberal-minded finessing of inevitable complexities than a reactionary insistence on preserving the remains, and the echoes, of modernism within, against and despite the changing conditions of contemporaneity. It mistakes most contemporary art as "failing" to be that which it does not intend to be, and cannot be: modern. Precisely here we discover institutional remodernism's major, albeit inadvertent, service to contemporary art. Art that lodges uncomfortably in its precincts, art that passes through its shadow, art that rejects its absorptive / exclusionary machine, that leaves it behind, commits to quite other criteria, and, eventually, forgets it: *this* art has the chance of being contemporary.

In the following chapters we will examine how four institutions estab-

lished in the early twenty-first century are tackling this set of problems. MoMA was present to all as the paradigm, the model of modernism. They are either supplements to it (Dia:Beacon), parallel institutions of another national culture (Tate Modern), or competitive initiatives—one private (Saatchi Gallery, London), the other corporate (Guggenheim Museum). They were conceived at a time when all concerned knew that modern art was changing—in exciting, crowd-pulling ways—but with unfathomable consequences for museums. Still in their early years of operation, they straddle the volatile cusp between the modern and the contemporary, and struggle with the dilemma of needing to be a creative, transformative presence within both *at the same time*. How they ride this paradox is their answer to the question: What is contemporary art?

Sublime-on-Hudson: Dia:Beacon Now

In May 2003 the international art world was positively abuzz with excitement as it gathered for the long-awaited opening of Dia:Beacon. Thousands traveled to the small town of Beacon, New York, on the Hudson River, just over an hour north of Manhattan. With 240,000 square feet of exhibition space, it matches the grandest city museums (such as the Metropolitan Museum of Art) and nearly doubles that of the renovated MoMA. It has no rivals as the world's biggest museum of contemporary art—at least in size. In marked contrast to the "storybook" museum, it shows only art made since the 1960s, by fewer than twenty-five artists, and exhibits only key works conceived on a large scale, often for a specific site in the museum itself. Does it demonstrate, as Michael Kimmelman enthused on the cover of the *New York Times Magazine*, that this is "the Greatest Generation" of American artists, whose accomplishments outshine even the abstract expressionists?[1] Or does it do more, and, as Dia founder Heiner Friedrich believes, reveal that the work of the American and European artists shown at Beacon rivals the pinnacle of art, the Italian Renaissance?[2] At such levels of achievement, contemporary art ceases to be a question.

Dia:Beacon is the realization, on a grand scale, of the original vision of the Dia Art Foundation. Conceived by Friedrich, a dealer and entrepreneur (or perhaps enabler—*dia* means "through" in Greek) of contemporary art, it was founded by him, heiress Philippa de Menil, and art historian Helen Winkler in 1974. Since then, it has sought to patronize the projects of certain minimal, process, post-studio, environmental, and conceptual artists that were too grand in scale, too long in their duration, too demanding in resources and money, too exclusive of the company of other art, to fit into any private collection or into any version of the museum then conceivable. Other collectors elsewhere had the same idea earlier. Fabric maker John Kaldor brought to

Australia a number of such projects, beginning in spectacular fashion with Christo & Jean-Claude's *Wrapped Coast—one million square feet, Little Bay, Sydney, Australia*, in 1969.[3] Friedrich has pursued a similar ethos, but on a much grander scale. Impressed by Walter de Maria's *New York Earth Room*, twenty-two inches of raked earth that filled his Wooster Street gallery in 1977, Friedrich abandoned the space to the work and has had it maintained and manned ever since. He did the same with De Maria's *The Broken Kilometer*, five hundred brass rods, each two meters in length, arranged in five parallel rows in a ground floor space on West Broadway. In 1977, the foundation bought twenty-two square miles of desert in New Mexico for De Maria's *Lightning Field*, four hundred stainless steel poles arranged on a grid that rarely attracts lightning but looks stunning as the light changes and weather pass through it. Dia also maintains perhaps the classic piece of land art, Robert Smithson's *Spiral Jetty* (Great Salt Lake, Utah, 1970), and is a major contributor to what will be, in size and scope, the daddy of them all: James Turrell's *Roden Crater*, a space-watching earthwork in central Arizona. Additionally, Dia sponsors dedicated spaces in Manhattan for ongoing works by Fluxus artist La Monte Young and light sculptor Marian Zazeela, a performance space for Robert Whitman, a sculpture studio for Fred Sandback in Massachusetts, and a permanent installation of Dan Flavin's fluorescent light works on Long Island, and has contributed to the installation of works by Donald Judd and other, related artists on an Army base in Marfa, Texas, now managed by the Chinati Foundation. What unites all of these projects is a commitment to the idea of providing individual viewers of the work with both the challenge of finding their way to it, and then the reward of having the opportunity to view the work—or a substantial body of an individual artist's work—in uncontaminated settings, over long periods, uninterrupted. Ideal observers meet specific objects, once and forever.

The impact of Judd's obsessively designed staging of his own and other minimalists' work at Marfa is evident in other small-scale, special-purpose museums in Europe (for example, the Hallen für Neuen Kunst, Schaffenhausen, and the Müller collection at Insel Hombroich), which have private collections of such work at their core.[4] Judd's thinking marks the entire Dia ethos. Dia artists received monthly stipends over many years. All Dia projects were private initiatives, mostly funded by Philippa de Menil, who gave $30 million before running into financial difficulties in the mid-1980s.[5] In 1987, Dia became a public corporation, opening a Manhattan gallery space, the Dia Center for the Arts, on West 22nd Street, which presented a mix of some permanent installations (Dan Graham, on the roof), temporary exhibitions, and

regular, focused and important discussions concerning contemporary art that were quickly published and widely distributed. All activities followed the key commitment to setting agendas, not only in close consultation with the core group of artists, but also in ways that instituted their aesthetic in all spaces and publicity, and they followed the logic of their work in all aspects of planning and programming. In its four-story building in Chelsea, Dia exhibitions followed the policy: one artist, one floor, one year. This spirit, in which resolute structural symmetry underlies unspecifiable outcomes for both artist and viewer, follows directly from the practice of artists such as Judd and Weiner and the explicit instructions for works set by Sol LeWitt.

These activities sparked a real estate boom: contemporary art galleries moved into the surrounding factories and machine shops, creating an art neighborhood that soon eclipsed SoHo, outstripped the more established areas of midtown, and persisted through strenuous efforts to create gallery districts closer to where artists lived (Brooklyn, for example). By 2006, over 150 galleries of contemporary art had opened, a concentration unmatched elsewhere in the world. Every month, more appear, and existing ones expand. This influx has, of course, exploded property values in the Chelsea area. It has, paradoxically, driven Dia to seek another New York space, while staging temporary exhibitions in sites elsewhere in the city.

Dia:Beacon cost $50 million to establish. Nabisco donated the building (its box-printing plant), while New York State, through then governor George Pataki, put in $2.7 million. The foundation anticipated a hundred thousand visitors and hoped to take in $7.4 million a year. As an element within a state initiative to upgrade and reenergize the Hudson River Valley, not so long ago a major industrial zone, Dia:Beacon has many parallels with the Guggenheim Museum at Bilbao. As a museum form, however, it is the differences that are most striking. The refurbishment of the reinforced concrete, daylight factory shed by the Manhattan-based firm OpenOffice echoes the precedent of architect Richard Gluckman's renovations of the Dia Center in Chelsea and the Andy Warhol Museum in Pittsburgh (another initiative in which Dia participated). Hal Foster comments that Gluckman is "as much an architect of the Dia aesthetic—a Modernist transparency of structure rendered with a minimalist sensitivity to space—as any of the artists."[6] The vast spaces of the building and its surrounds are, on the whole, discretely subservient to the artworks, as befits Dia policy of respectful homage to the intentions and ambitions of the chosen artists. The approach and service buildings are modest in scale, even domestic in their detailing. The low-key geometries of the garden settings were designed by artist Robert Irwin.

2.1. Walter de Maria, *Equal Area Series*, 1976–90. Fifty stainless steel plates, sizes variable. Dia:Beacon, Hudson River, New York, view inside main entrance. (Dia Art Foundation. Photograph by Deborah Ripley., Courtesy of Walter Robinson, *Artnet Magazine*.)

Yet this lulling comfort is exploded on entering the galleries. The visitor moves from a small, dark vestibule into an apparently limitless corridor of light—two, in fact, because immediately in your face is a wall's edge that forces you to step to left or right, into one or the other of these bright corridors. In each of these adjacent galleries are the elements of Walter de Maria's *Equal Area Series*. Carefully cut stainless steel circles and squares alternate in pairs down each length. They increase barely perceptibly in thickness from one pair to the next. And they fall from opaque to mirrored surface as one passes to sufficient distance from them. Yet they are not large enough to command the space given them. They seem like quoits—silver, yes, but lost in an abandoned playground.

In contrast, some late modern and contemporary classics are displayed to great effect: Dan Flavin's elegant *"Monuments" for V. Tatlin* (1964) and other key walls of neon, Robert Ryman's suite of white rooms randomly filled with his homages to whiteness, Joseph Beuys' *Arena (Where I would have got had I been intelligent)* (1970–72) and his *News from the Coyote* (1979) are integrated into a set of felt and steel pieces that show the German political performance

artist to be an assemblage sculptor with an approach to sorting out space as purposeful as that of the American minimalists—not least, Judd and Serra. In a sequence of side rooms, the alternation between Serra's steel slabs and thrown latex scatter-pieces is breathtaking. Where possible, the artists themselves supervised the hang. This is an echo of the fundamental Dia policy of paying homage to living artists, especially those whose work seemed uncollectible, and to banish the very idea of the museum. Yet the foundation, during its thirty adventurous years, has will-nilly "acquired" a large number of these works. How to show them without enveloping them in the museum's institutional embrace is the core challenge. Dia's intended answer: single artist exhibitions, one after another, at the same time, in the same place.

Andy Warhol's *Shadows* (1978), which consists of seventy-two vibrantly colored, sharply contrasting screen paintings of the same elusive image, is the most enveloping flat surround. It announces the convergence of surface and screen with magisterial assurance while opening up folds of ambiguity and drift. In Hanne Darboven's *Cultural History 1880–1983* (1980–83), a vast array of gridded text pages, photographs, diagrams, cutouts, postcards, and other ephemera of record, her painstaking assembly demonstrates the macabre quality of everyday human persistence. Both works are exhibitions in themselves, works that would so dominate any similar space that the larger question of their being somehow reduced by the museum's embrace is overridden. This is less true of other art at Beacon.

It was land artist Michael Heizer's *Double Negative* (1970), two massive cuts into a Nevada mesa, requiring the removal of 240,000 tons of rock, which first attracted Heiner Friedrich to "the scale, the ambition, and the uncompromisingly noncommercial purity"[7] of this kind of art. *Double Negative* came under the permanent care of the Museum of Contemporary Art, Los Angeles, through a gift of the artist's dealer, Virginia Dwan, when that museum opened in the early 1980s. At Beacon, in his work *North, East, South, West*, conceived in 1967 and realized there, Heizer sunk four steel-lined holes—cube-, wedge-, and cone-shaped—up to twenty feet into the floor. Their yawning depths heavily weight down one entire side of the museum, drawing the eye into darknesses beyond ready viewing (necessitating, in fact, transparent railing to keep viewers at a safe distance).

Paradoxically, it is the pictorial quality of minimalist sculpture that emerges most insistently in these spaces: its appeal to the eye, its opticality—in a word, its modernism rather than its contemporaneity. But this does not occur simply or as a mere throwback to an imaginary early 1960s. A large room full of plywood boxes by Donald Judd eventually attracts

us to the patterning of the material, as exuberant as any tiger-skin couch (by Claes Oldenburg, say). A section is devoted to Judd's *Untitled (slant piece)* (1976): a plywood fence divides a room space, implying an empty area beyond it, but as one approaches and looks over, a slab of plywood slants down to the wall and floor line. For the most trenchantly anti-illusionist of artists, these are strange deposits to fortune.

They were taken up, at the time, by Fred Sandback—to a greater and more subtle degree, it now appears, than any of his older contemporaries. At Dia: Beacon, his delineations of volume, achieved with means so minimal (store-bought wool), are the embodiment of quiet precision. In his conception of delimited volume, the wool strands form "slabs" of delicate fragility. They hover in space, but it is space through which one can step, as if through Cocteau's mirror, into the unknown, only to find oneself in the same kind of ordinary life as before. Here the spirit of Lawrence Weiner's anti-object axiom—"the piece need not be fabricated"—is most fully realized. Sandback's art seeks maximal meaning, to be about everything, but to use nothing—to disturb nothing on the earth—in being so. Alongside these works, a piece by Weiner is astutely placed: *5 Figures of Structure* (1978) consists of instructions and diagrams as to how to set "slabs" in various configurations. It mediates between the heavy breathing of the industrial material minimalists and Sandback's ephemeral gentility. (Such smart curatorial juxtapositionings are the chief delight of a visit to Dia:Beacon.)

Artists of the unconscious fare less well. Bruce Nauman's powerful explorations of stressed obsession, of the splintering of mind and body, of the decenteredness of personality, are located in a gloomily lit basement. Centerpiece is the projection on all walls of *Mapping the Studio I (Fat Chance John Cage)*, a large-scale video that records the nocturnal activity in the artist's studio of his cat and an infestation of mice during the summer of 2000. In contrast, Louise Bourgeois' late surrealism is confined to a string of cage-like spaces on the top floor. What were the offices of the factory management may seem to have found a fitting afterlife in housing works such as *Death of the Father* and *Spider*. In the latter, a large, male-devouring insect hovers over a cage decorated with tapestry fragments that show worn and faded putti replete with baby-like bulges and flashing vacant grins, but with their genitalia savagely removed. Classic works, by any account of the art of the past century, but here they seem to be aberrations. They oblige us to cease experiencing Dia:Beacon as a suite of flexible passages through a ground plan viewed from above and, suddenly, see it vertically: in three-part section, that stands before us, like an exquisite corpse, unfolded for the first time.

2.2. Fred Sandback, installation at Dia:Beacon, 2003. (Dia Art Foundation. Photograph by Nic Tenwiggenhorn.)

The great yawning strangeness at Dia:Beacon is the absence of those artists who took minimalism into its shadows. Robert Morris, above all, is conspicuous in this regard. And Robert Smithson is significantly under-represented by three site-non-site works that seem lost in their particular spaces.

No such doubts attend the presentation of the work of Richard Serra. More than any other artist, his work has come to represent what late modern sculpture means within the frameworks of official contemporary art. His "process pieces" of the 1970s have given way to an art that defines what it is for art to be portentous, these days. The factory railroad shed and loading dock at Beacon are filled by his three gigantic *Torqued Ellipses* and the single steel slab constituting his *Torqued Spiral*. With their resolutely clear command of space and their muscular dialogue with their surrounds (an outmuscling, actually), and above all their clarity of form as read by the moving body (what might be called their crisp phenomenology), these works seem to best represent the Dia aesthetic, as expressed already by Friedrich: "Art has no history—there is only a continuous present."[8] The unadorned

desire is to transcend the trammels of sociality, the messiness of actual history, to banish everything from consciousness but the pure consciousness of art, concentrated in these singularities, as if each were its own icon. All of art's history arrives at *this* school, *this* movement—indeed, at this moment of experience. These works embody pure contemporaneousness; they nail the spectator with this quality of the always present, and lift him or her into the sublime of the now.

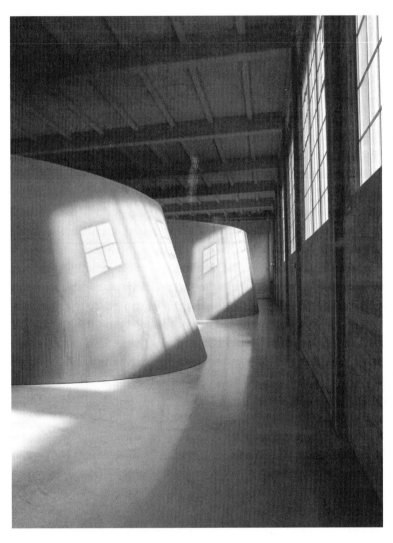

2.3. Richard Serra, *Double Torqued Ellipse*, 1997. Cor-Ten steel, installation view at Dia:Beacon. (© Richard Serra. Dia Art Foundation. Photograph © Richard Barnes.)

. . . At least, they do so, at your initial moment of consent to their command, of submission to their seduction. But moments pass, and questions return, teasing, testing

After all, visions of escape from history, through art, into the immediacy of the eternal present have their own history. It is now over two hundred years long, and as wide and rich as might be expected from such longevity. Even Friedrich's formulation has quite specific antecedents: not only in some of the instincts of his namesake, the Romantic painter Caspar David Friedrich, but in a 1797 text by Wilhelm Heinrich Wackenroder, *Outpourings from the heart of an art-loving friar,* in which the fairground atmosphere of current museums is deplored, and an impassioned appeal made for art galleries to be "temples" enabling visitors to raise their hearts in marvel at the icons left for us by artists, the highest of earthly beings.[9] The impassioned friar—and the passionate gallerist after him—articulate one apex in the arc of the values pendulum that has been swinging from the secular to the spiritual within the discourse of the museum since its beginnings.[10] For those, such as Friedrich, who came to their "love of art" in Germany after World War II, a landmark of their yearning for a conflict-free modernity was the exhibition Documenta I, which, in 1955, offered "a vision of a universal, timeless contemporary art [and] . . . a model for the exhibition as a utopian and redemptive experience."[11] Yet the pendulum does not simply swing from one place to another. It transfers qualities between them. A dialogue between the art museum and the various kinds of history museum, or, more deeply, the doubled desire for attraction as well as information, for pleasure and knowledge, has driven museums as such from the beginning, and still does. Rushes of cultural interest go in both directions, and the transmission of qualities from one the other occurs constantly: historical displays employ techniques of deliberate aestheticization, while art museums are steeped in competing historicizations of art. Dia:Beacon is the latest convolution of opposites. Which highly aestheticized history museum might we compare to it? The one being conceived for Ground Zero?

On his first visit to Dia:Beacon, Hal Foster was entranced by many of the works installed there, but he was also moved to raise some sharp questions. One of them ties the works at Dia:Beacon to an earlier moment in the history of American art: "One hundred and fifty years ago the Hudson River School also trafficked in an American version of the sublime. Might Dia:Beacon constitute a Hudson River School II, with aesthetic contemplation reworked as perceptual intensity on an industrial scale?" We have already answered this question. His next is exceedingly pertinent: has contemporary art's success

in shaping its display in museums led to a problem for both? His answer is acute: "What is more fitting than royal portraits in palaces, paintings of modern life in national museums, abstract works in white-cube museums and Minimalist installations in industrial sheds? The problem is that it fits too well, and contradictions are papered over in the process."[12] Dia:Beacon is a celebration of its late modernist moment, of advanced art frozen in historical aspic at the cusp of its turning into something else, a range of imagined other kinds of art that this art called for but could not quite reach.

More than many of their predecessors, minimalist, process, and installation artists have insisted on controlling the physical conditions for the display of their work. Recently, this development has converged with its aesthetic opposite: late capital's ideological address to the consumer as a special subject, unique in his or her consumption of the same product as countless others. It is a conjunction that has led many museums to, in Peter Schjeldahl's words, "cast every art work as an icon," to put at the heart of their offering to visitors the experience of being "alone" with a site-specific work seemingly addressed to that viewer exclusively.[13] To be invited, as a member of a mass audience, to undergo a supposedly individuating experience is the central—but entirely typical—paradox of current museum going. The rush to provide it has shaped most of the recent major museums of contemporary art: we have already seen its effects at MoMA and will soon see them at other sites. Many smaller museums are being designed to achieve the same result. Outstanding among those architects who serve this goal is Tadao Ando, who has created a number of what Schjeldahl would call "boutique" museums, usually for collector clients. These include the Pulitzer Foundation Museum in St Louis, which was designed in dialogue with the work of two artists, Ellsworth Kelly and Richard Serra, and two museums on Naoshima Island, Japan, for the Benesse Foundation, both of which show selected works by a limited number of outstanding, mostly contemporary artists. To visit them is to be aware not only of the architectural force—and, at times, overreach—of minimal sculpture as its major proponents undertake increasingly ambitious projects, but also of the maximal force of Ando's own understated aesthetic, of the presence in these buildings of a quieter, more subtly persistent power. We will return to this paradox, and others, in subsequent chapters.

Of Dia:Beacon, Foster asks, finally: "Often intensity seems a norm of contemporary culture—the action movies at the mall, the night bombings of Baghdad. What relation does this art have to these experiences? Does its intensity counter theirs or sublimate it? Whatever the case, the art at Dia:

Beacon exists in a perpetual moment of intense experience, without the testing of prior art or social context."[14] This desire on the part of the modernist museum to find ever-fresh ways to enable the experience of beauty——one that seems unmediated by critics, curators or external realities—is inevitably shaped by the museum's own unique ways of seeking to render its hand invisible. Architecture manifests the institution's guiding principles, as surely as its publicity. Most of all, it is the hanging, the setup, the arrangement of the work into a journey, or set of passages, that intrudes through even the most determined efforts of the institution to disappear itself. The exhibition is in ascendancy at the moment: it will not readily retreat. In the smaller contemporary art museums in recent times, it is the dream of art that inspires the collector that animates the entire edifice. These vary from the beneficent to the banal, depending on the depth of engagement of all concerned.

Nevertheless, the key question remains: Does contemporary art set out to encounter the conditions of contemporaneity, and to bring those who view it to the surrogate site of that encounter, or does it, having registered these conditions on a horizon, offer a sublimation of their worldly presence, a detour signposted as an escape route? Exactly the same challenge faces the museum and the exhibition. As the contradictions of contemporaneity deepen, the experience museum, with its intensity exhibits, and above all its not-so-secret desire to remain modern, may not be the answer for too much longer.

CHAPTER THREE

Sensation = Saatchi

Following his 1990 purchase of Damien Hirst's *A Thousand Years,* a two-chamber installation of bluebottle larvae feeding on the carcass of a cow, advertising executive Charles Saatchi became such an aggressive collector of work by this generation of British artists that he was able to single-handedly control its marketing and distribution for a number of years. In a series of exhibitions at his own gallery he tagged it with a name that seems to be sticking as an art historical term: "yBas," or young British artists. The local and international success of the yBas was one of the key factors in creating a climate of receptivity to the idea of a major museum of contemporary art that was realized, in 2000, in the Tate Modern. Yet the iconic works of the movement remained in the hands of a private collector whose relationships with the Tate have been variable. In the early and mid-1980s, when Saatchi was collecting and promoting American art, notably that of Julian Schnabel, he was active in the Tate's Patrons of New Art group, and, like other dealers in the group, he was not above donating to the museum the work of artists that he was collecting and placing into auctions.[1] By September 2003, however, he turned caustic:

> Many in the artworld, artists included, feel contemporary art can only be seen properly in a perfect white space. After years of showing art floating in pristine arctic isolation, it's a revelation to break out of the white cube time warp. If art can't look good outside the antiseptic gallery spaces dictated by museum fashion of the last 25 years, then it condemns itself to a worryingly limited lifespan. What's more, that once cutting edge gallery style is beginning to look like a cliché trendy bar or loft conversion.[2]

Nor is it a secret that one source of Saatchi's bile was the success of the Tate Modern, after its much publicized opening in May 2000, in attracting

attendance away from his St John's Wood gallery.[3] These remarks overlook that fact that his own gallery was one of the most elegant and expensive examples of white-cube-meets-factory-conversion. To an advertising man, quick turnarounds are the name of the game, especially if they stand a good chance of triggering a new trend. This is exactly what Saatchi himself set out to do. In May 2003 the Saatchi Gallery opened in County House, the sprawling Edwardian pile on the south bank of the Thames, directly over the Westminster Bridge from the Houses of Parliament, and right next door to the biggest tourist attraction in town, the London Eye.

Built between 1908 and 1922 as the administrative headquarters of the London County Council, County Hall was expanded in 1974 to accommodate the Greater London Council. Under attack by Margaret Thatcher (whose advertising company was Saatchi and Saatchi), the council was disbanded in 1986, and the building fell into disuse. By 2003, however, it was again housing shops; games alleys; restaurants; the ticket offices of the London Eye, the Dali Experience, and the London Aquarium; a McDonald's; and, in its main ceremonial rooms and offices, the Saatchi Gallery.

Everyone associated with the Saatchi Gallery—from the owner through the artists to the publicists—knows the value of the incessant, repetitive promotion of singular images as at once absolutely up-to-date, simple to grasp, and seemingly profound. All publication and presentation is organized around these staples of sound advertising. Damien Hirst is heralded as the master artist, and his *The Physical Impossibility of Death in the Mind of Someone Living* (1991) is labeled "the main icon of yBa art."[4] A string of other works—Tracey Emin's *My Bed* (1998), Marc Quinn's *Self* (1991), Marcus Harvey's *Myra* (1995), Christopher Ofili's *The Holy Virgin Mary* (1996), the Chapman brothers' *Hell* (1999)—are described again and again as "icons." They condense some of the main complexities of contemporary art into readily reproducible, in-your-face one-liners. Saatchi himself was quick to recognize this, and to encourage it in the art he would support. He also set the terms for the promotion of this art. Evoking the title of the famous Pop collage by British artist Richard Hamilton, he asked this rhetorical question:

What is it about the life cycle of flies, someone's old bed, a portrait of a child killer made with children's handprints, mannequins with knobs on, someone sitting on a toilet holding a cistern that makes British art so different, so appealing?

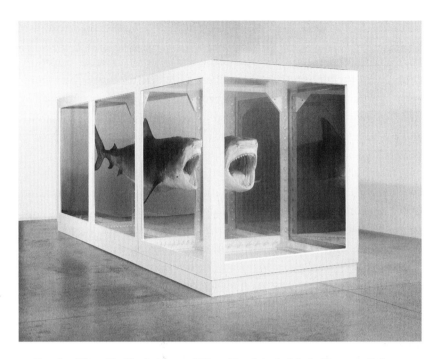

3.1. Damien Hirst, *The Physical Impossibility of Death in the Mind of Someone Living*, 1991. Glass, steel, silicon, formaldehyde solution and shark. Collection of Steven A. Cohen, Greenwich, CT. (©2008 Damien Hirst. All Rights Reserved/ARS New York/DACS. London. Photograph by Prudence Cuming Associates.)

His immediate answer is less successful than this evocation, but it does describe the curatorial logic of the Saatchi Gallery in County Hall: "There's no neat link, no school, just a very direct, almost infantile energy that gives the work here its full-on, check-this-out force."[5]

The campaign has been extraordinarily successful. Saatchi retained within his collection the hundred "icons" by the thirty-eight artists he regards as essential to this movement. The gallery at County Hall was their showcase. The most famous works were located in its central rotunda, like so many icons in the chapels around the altar of a church. The entrance foyer featured an intensely disturbing and disorienting installation by the Chapman brothers. Entitled *Hell*, it consisted of nine vitrines arranged in the shape of a swastika, each one a miniature battlefield or part of a war zone, in which toy-like but mutant Nazi soldiers committed unspeakable acts upon others and on themselves. In the corridors approaching these icons, lesser works led us on. The mood drifted between adolescent jokiness and

whimsical eccentricity, or shifted sharply from being engagingly amusing to outright shocking. At times—especially during the Chapmans' show in late 2003—the tour became a boat ride through a House of Horrors. Sprinkled throughout the building were a number of life-size triomphe-l'oeil sculptures by Duane Hanson: tourists gawped in surprise or froze benumbed by tiredness, while elsewhere stood an exhausted jogger, a black cleaning lady, and a housewife pushing a shopping cart. These prefigured the scale shifts in Ron Mueck's similarly exact figurines of his father, young brother, his own face and an angel who looks down on the crowds and artworks in the rotunda with a bemused smile. With their gentle parody of the experience of the museum itself, Meuck's art dilutes the *Rocky Horror Picture Show* aspect of many others on display. This mood extends to blatant, we-can-laugh-at-ourselves irony when, in one of the rooms, we encounter Ashley Bickerton's painting *The Patron* (1997), a gross image of a bulging, balding collector, clad only in underpants, sprawled on a Sottsass couch, ignoring his Mondrian and Brancusi as, legs akimbo, he plays with both himself and his television remote . . . which is pointed at us.

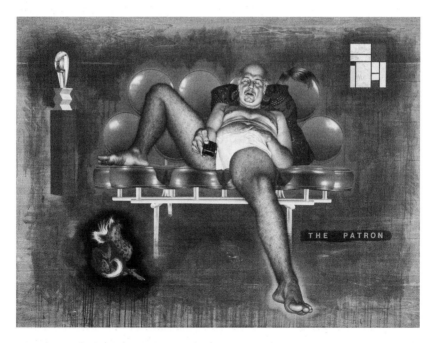

3.2. Ashley Bickerton, *The Patron*, 1997. Oil, acrylic, pencil, and aniline dye on wood. Collection of Frank Gallipoli. (Courtesy of the artist and Lehmann Maupin Gallery, New York.)

By prioritizing location, Saatchi seemed, in 2003, to have sold himself a problem. The densely detailed wood paneling of the County Hall interiors, the mismatch between these quasi-domestic, quasi-office spaces, and the extraordinary artworks gave the installation of his collection a bizarre, and above-all, a temporary, look. The experience made less sense as a museum visit, much more as a preview of a private collection that is up for sale. Saatchi is infamous for the ruthlessness with which he is prepared to sell works that, as a collector, he carefully nurtures. In December 1998, through Christie's London, he sold 130 works of 1990s art from his collection, including works by Damien Hirst, Rachel Whiteread, and Cindy Sherman, as well as lesser-known artists (at the time) such as Gary Hume, Ron Mueck, and Hiroshi Sugimoto, for prices well above those being asked by the artists' galleries. In January 2005 Saatchi sold Hirst's "iconic" shark—which he had acquired from the artist in 1991 for £50,000—to an American collector for £6.5 million.

The symbiosis between a type of art and a kind of museum is a delicate one, and it is a two-way street. Now that the yBas have been embraced (although not, given its limited holdings, overemphasized) by a major national civic institution like the Tate, what will become of this art's antiestablishment energy? Late in 2001, Julian Stallabrass raised this issue:

> One reason that so-called young British artists have died a death over the past year or two is that the Tate Modern is so official, so much an arm of the state—and is so much, as has been said, tied up with being modern. The oppositional impulse of cutting-edge art was pitched partly against the cultural conservatism of Thatcher and Major, but also partly against the stuffiness of the art institutions themselves, and the old Tate was symptomatic of that. That art no longer has anything to turn against. One might argue that the radical allure of that form of art was always a bit of a fake—I would—but it was an engine that drove something. And that has passed away.[6]

Comments like this, from an alert observer, point us to the subtle shifts of art and its institutions within contemporaneity. They drift and spurt like the winds of fashion, to which they are so closely tied.

This is a fate that Charles Saatchi worked strenuously to defer. Three hundred thousand people visited his new gallery in its first six months. New shows were needed to bring the people back, especially members of the art-world, most of whom have yet to return to Bilbao, for example. Saatchi is

gambling on the productivity, the longevity, and the continuing capacity to shock of a small group of artists whose work he has done so much to provoke and promote. But despite his barbs against the "white cube time warp," the exhibition logic at Country Hall was museum-like, though in a premodern way.[7] Indeed, it had more in common with the other attractions in the tin-pan alley of sideshows that have accumulated along its stretch of the Thames than with other museums of contemporary art. Sensing this, Saatchi sought to regain the lost high ground by announcing another paradigm shift in contemporary art: a series of exhibitions beginning in 2005 entitled *The Triumph of Painting*. Characteristically bold, uncharacteristically backward looking, the exhibition cycle opened with great fanfare and some fine works, but soon lapsed into the quiescence of a poor idea. Saatchi made a much stronger showing in 2006, when the Royal Academy galleries accepted his recent purchases of American art in the form of an exhibition *USA Today, New American Art from the Saatchi Gallery*. One of its highlights was the 2005 installation by Josephine Meckseper, *The Complete History of Postcontemporary Art*, a pivotal work to which we will return. Meanwhile, Saatchi looked elsewhere for another, more suitable venue. He sought space in unused sections of the Tate Modern itself, but the museum demurred, preferring to gamble on a spectacular extension of its own. In 2007 the Saatchi Gallery moved to the Duke of York's headquarters, Sloane Square, to 50,000 square feet of gallery space, unapologetically designed as a return to the sequence of white cubes, yet accompanied by the most open-ended and aggressive online presence of any gallery in the world.

Saatchi was the most adventurous of the new collectors who emerged in the 1980s, astutely playing sectors of the art world against each other, not from a fixed, external position but as an activist within a number of them. His modus operandi parallels that of globalizing businesses that search for profits from mergers and connections rather than core productivities. They know that it is the movement of capital itself that is, these days, generating the most extreme and speedy profits, so they seek to accelerate genre exchange at any cost. Waiting to absorb the windfalls is the luxury goods industry. It is no surprise, then, that hedge fund managers such as Steven Cohen and luxury goods magnates such as François Pinault have come to the forefront of collectors. The latter declined official inducements to house his collection of contemporary art on the Ile Seguin, Paris, preferring instead an 80 percent stake in the Palazzo Grassi, Venice. Refurbished by Tadao Ando, this new gallery opened in mid-2006 with a sprawling exhibition, curated by Pinault himself and his curator, organized into these sections: "Figuring

modern life," "Material as metaphor," "Styles of negation," and "This is to-day."[8] Across the famous façade stretched a membrane designed by Olafur Eliasson; it changed hue according to the natural light but also evoked the colors used by Canaletto in his paintings of Venice. Visitors were greeted by balloon dogs and a hanging heart by Jeff Koons, a Carl Andre floor piece, 1,700 handcrafted, pink Technicolor raindrops by Urs Fischer, some anime sculpture by Takashi Murakami and, at the top of the stairs, an irradiated skull of Pinault by Piotr Uklanski. The exhibition's very contemporary title was Where Are We Going? Of course, it was taken from the title of a 2000–4 work by Damien Hirst that was on display, *Where Are We Going? Where Do We Come From? Is There a Reason?* When Gauguin asked questions like these in his famous painting of 1897, they were very modern ones, not least in that he pointed to idealized premodern communities as harboring answers. Now, they are very contemporary questions, precisely in that, for all of our compulsion to ask them, they seem to have no such readymade and readily distanced answers. Whatever answers may exist are here, right at hand, but very hard to find.

CHAPTER FOUR

Contemporizing the Tate Modern

In their submission to the Millennium Commission, a government organization charged with distributing funds gained from national lotteries on the occasion of the year 2000, the Tate Gallery trustees did not hesitate to use the language of economic rationalism as it was then being applied to the "cultural industries" in order to secure a substantial sum for a proposed Tate Gallery of Modern Art:

> At the heart of the capital, it will establish a new landmark and an outstanding public space for the nation and enhance London's position as a world center, bringing cultural, social, and economic benefits to millions of people in the nation as a whole.[1]

The Tate Modern opened in May 2000, in the Bankside Power House, Southwark, designed by Sir Giles Gilbert Scott in 1947 and reconfigured in 1963. In stark contrast to the brand of architecture pursued by the Guggenheim Museum's franchise-driven expansionism, the Swiss architects Herzog & de Meuron maintained the older building's profile—albeit with much "cleanlining." On the inside, they lined up its huge factory spaces, above all the turbine hall—at 35 meters high and 152 meters long, it is ideal for temporary exhibitions of large sculptures and installations—alongside seven floors of white cube galleries (which offer 35,520 square feet of exhibition space). Channel 4 made a television series about the project and produced a book to commemorate the event entitled *Power into Art*. Perhaps this was what British performance artists Gilbert & George had in mind when they announced, gleefully, during the opening celebrations, that the Tate Modern demonstrated that "Art is Power!" They were pointing, mischievously, to the massive conjunctions of private and public patronage that lay be-

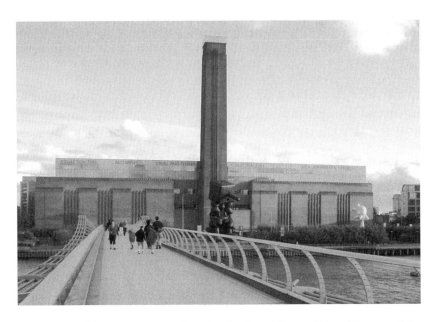

4.1. Herzog & de Meuron, Tate Modern, London, 2003. External view. (Photograph by Miguel Rojas-Sotelo.)

hind the raising of £134 million to convert the building, and to the political maneuvering that would be required to maintain it from here on in.[2] Being erudite avant-gardists, they would also have been punning on the famous slogan of Joseph Beuys: "Kapital = Kunst" (to be found, not so incidentally, scrawled by him on a preserved blackboard in the Beuys room inside the museum).

In some ways, Britain came rather late to the institutionalization of contemporary art. Although the Institute of Contemporary Arts, London, was established in 1947, the international flowering of new museums of modern and contemporary art has occurred since the 1960s. How was living art exhibited in the United Kingdom prior to that date? The Tate Gallery was founded in 1897 as the national gallery of British art (in contrast with the National Gallery, Trafalgar Square, which is devoted to the art of the world, brought from everywhere as the spoils of victory and placed on show before a grateful populace). The Tate began collecting modern (a term that then meant "foreign contemporary") works in 1916. Its officers have long been closely connected with the Contemporary Art Society, an organization established in 1909 with the sole object of facilitating the entry of new work by living artists into public art collections, not least the Tate. CAS offices were located in

the Tate at Millbank from the 1940s, and moved to the Tate Modern with the other contemporary functions of the Museum when it opened in 2000.

Until the opening of the Tate Modern, those Londoners interested in contemporary art would regularly visit the Institute of Contemporary Arts. Founders such as Herbert Read and others wished to promote an "experimental" approach to art. It moved into the central premises it still occupies in the Mall in 1967. While the Tate at that time was actively presenting American modernism, the ICA created a separate identity by promoting political art (in the 1970s) then postmodern art and theory (in the 1980s). Elsewhere in London, the Hayward Gallery on the south bank of the Thames, part of a cultural complex that includes the Festival Hall and the British Film Institute, had served as a museum of modern and contemporary art since 1968, presenting large survey and retrospective exhibitions. Its future is uncertain, now that the Tate Modern is clearly staging show after show that include, and often focus on, contemporary art. In contrast, fear of being overshadowed has not cowed the South London Gallery, located near the Tate Modern; it decided in early 2003 to ditch its major collection of Victorian art, developed since 1868 to enlighten local working men, in favor of becoming a center for contemporary art. Other new art venues have included the Serpentine Gallery in Hyde Park and a host of smaller, scattered locations around London and the provinces—such as the Museum of Modern Art, Oxford, and the Ikon Gallery, Birmingham—many overseen by the Arts Council of Great Britain. Despite the substantial work of these essentially not-for-profit alternative venues, the privately owned Saatchi Gallery has, since 1985, set the running for the showing of contemporary art—first American, then emphatically British. It was, as we have seen, a pivotal factor in setting the stage for the creation of the Tate Modern.

Back in December 1992, the Tate trustees announced that they planned to redefine their collection by dividing it conceptually and physically into two parts: the Tate Gallery of British Art and the Tate Gallery of Modern Art in London (there being other Tate Moderns in both St. Ives and Liverpool). "None of the anticipated cavils arose over the division of the displays on two separate sites, nor was it suggested that the claims of the regions had been ignored."[3] In this decision, modern art was acknowledged as primarily international, an implication that (one might think) should have disturbed British artists of a nationalistic bent, as it did those of the Basque region when the Guggenheim franchise rolled into town. But the yBa phenomenon and the style set by the patronage of Charles Saatchi had shifted local art to a point where it was clearly both distinctively and aggressively British and an

international success story. More pragmatically, attendance at art museums of all kinds was becoming so great that visitors could no longer be accommodated at the Millbank premises of the Tate, nor were these galleries large enough to house the blockbuster style of exhibition that was then, as now, spearheading art museum programming everywhere. Could it be that the Tate Gallery had finally found its way out of what Richard Cork, art critic for *The Listener*, labeled "the Millbank Muddle"?[4]

The yBas certainly helped contemporary art become hot. It was what people anticipated when they headed for the Tate Modern. Attendance began at a level double that predicted—120,000 visitors on day one—and grew by tens of thousands per day, approaching the numbers that regularly fill the galleries of the Metropolitan Museum of Art, New York. There were 2.7 million visitors in the first five months (118 percent over target), and 5.25 million in its first year of operation.[5] Crowds came from Europe, Asia, and the Americas, and ranged in age from early twenties to late sixties, mostly female but not overwhelmingly—a demographic profile true of museums of modern art everywhere. This profile has now spread to those with an emphasis on the contemporary. Visitor demand so overwhelmed expectation that, after a year of operation, the Tate Modern was obliged to go to public bodies, cap in hand, for funds to cover increased staff and expanded ongoing operations.

To open a museum of *modern* art at time when art practice and discourse had been concerned for a generation with the issues raised by postmodern critique, when other museums, collectors, curators, and consumers of art all over the world were taking the currency of contemporary art for granted, was to invite, at the very least, paradox. The Tate's response was to add "Modern" to its brand name—in deference to MoMA, known in the artworld as "the Modern"—while orchestrating the display of its modern works through the framework of contemporary art. It did so quite literally; works of contemporary art were seen first, early in one's passageway through the galleries, and then were seen alongside earlier modern art throughout the journey. More and more contemporary work was seen, until it became the culmination of the visit. Additionally, all rooms were presented as if they were temporary exhibitions, implicitly open to change.

This contemporizing of displays that are intended to be long-term arises directly from the first attempts of curators to devise modes for the display of conceptualist and political art, from their paradoxical struggle to at once respect and circulate the anti-display, counterinstitutional imperatives of this work. Pathfinding exhibitions such as When Attitudes Become Form,

staged first at the Kunsthalle, Berne, in 1969, have remained iconic for subsequent museum hangs of art from that moment. They have had pervasive effects on exhibition design, not least on what has been called the "ahistorical exhibit," in which a curator will bring together works of art and artifacts from many times and places to suggest previously unseen affinities.[6] The affinities highlighted are usually those between artworks that, unexpectedly and without regard for actual historical time, seem, to a contemporary observer, to share a similar mode in their pursuit of a topic, or to pursue a closely related topic in dissimilar ways. Curators are fascinated by what seems to be a conversation among artworks, one that they might conduct in our absence.[7]

A recent outcome is the "zone" museum, an arrangement of spaces that encourages the viewer to enjoy conjectural interactions between artworks, to come across particular works more than once in a self-selecting journey, and thus to experience them perhaps differently each time. In the words of Nicholas Serota, director of the Tate galleries, no visitor need feel obliged to follow the "path laid down by the curator" or find him- or herself stranded on the "conveyer belt of history."[8] His models are the Hessische Landesmuseum, Darmstadt, featuring works by anti-institutional artists such as Joseph Beuys, which one reads as a temporary exhibit that is paradoxically frozen in time, and the Museum für Moderne Kunst, Frankfurt.[9] Despite its name, the latter museum is devoted entirely to staged selections of contemporary art from the collection, buttressed by special installations and temporary exhibits. Its director, Jean-Christophe Amann, stresses that the priority given to the viewer's encounters during his or her voyage of exploration means that "each individual room could be seen as an event, heightening the impact of its intrinsic contrapuntal dynamic."[10] To accommodate and to signal such shifting experiences at Frankfurt, architect Hans Hollein stretched the modernist white cube in extraordinary ways—no room is the same size or shape within the museum's triangular envelope—producing thereby one of the first postmodern museums.[11] The white cube, however, has been extraordinarily persistent: even at the Guggenheim Museum, Bilbao, one wing of off-white rectangular rooms abuts the bursting curvilinearity of the central spaces and the other wings.

Was the "zone" model realized at the Tate Modern during the opening installation of the collection? A bold attempt was made. Each side of the two main exhibition floors invited entry into one of four pathways through modern to contemporary art. In this way, the idea of historical narrative was modified by the suggestion that there were a number of possible "pas-

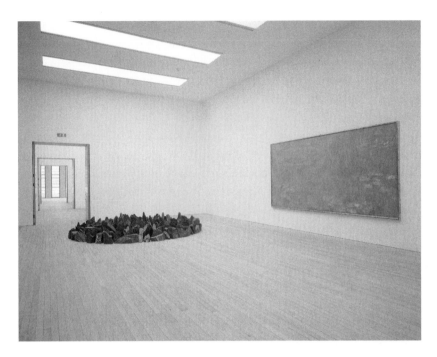

4.2. Tate Modern, London, gallery installation showing Claude Monet, *Water Lilies*, after 1916, and Richard Long, *Red Slate Circle*, 1988. Shown as part of the "Landscape / Matter / Environment" sequence, opening exhibitions 2000. (© Tate, London 2008.)

sages." The universal survey museum surrendered to the conception of the museum as a concatenation of exhibitions. Each display began with rooms in which important works by the modern masters quickly gave way, often in the same room, to works by artists who have come into prominence in recent years. Near the beginning of the "Landscape / Matter / Environment" sequence of galleries, for example, a major Monet water lilies painting was eclipsed by a Richard Long floor piece and one of his mudwalls. Not far into the "Nude / Action / Body" pathway, Matisse's wonderful sequence of *Jeanette* backs faced off, in gentle struggle, with Marlene Dumas' watercolors that meditated, in a way only possible after feminism, on the exigencies of being in a woman's body. Darkened rooms featuring powerful video pieces (by Steve McQueen, for example) broke up modernism's usual sequence of white cube galleries. A different kind of convention-breaking move was the placement, at the heart of the "Nude / Action / Body" circuit, of a large space filled with minimal art, from Richard Serra to Eva Hesse. Minimal art's investment in multiple, active relationships between the sculptural object and

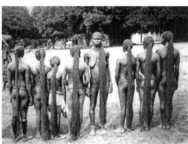

4.3. Marc Allégeret and André Gide, *Voyage to the Congo*, 1925. Film. Shown as part of "Nude / Action / Body" sequence, opening exhibitions, Tate Modern, London, 2000.

the viewer's body—often eclipsed by stress on the overwhelming machinist masculinism of this art—was subtly underscored.

Africa appeared as a subject of primitivist fantasy on the part of the early modern Europeans (Picasso, Modigliani, Epstein), an emphasis underlined by the showing of *Voyage to the Congo*, a quasi-anthropological film by Marc Allégret and André Gide. Similarly, in their effort to stock a vitrine in the "Subversive Objects" room so as to recreate a Man Ray photograph of the installation at the Surrealist Exhibition of Objects presented at the Galerie Charles Ratton, Paris, in 1936, the curators brought together a Hopi Indian kachina figure, a Papua–New Guinea mask, a miniature totem pole from Haida, British Columbia, alongside mathematical models and Duchamp's 1921 *objet trouvée, Why Not Sneeze Rose Sélavy?* These are accurate evocations of the "primitivist" fantasies held by these artists. They are also neat anticipations of the current interest in the museum as an archive, an interest pursued by a number of works in the collection, such as Susan Hillier's *From the Freud Museum* (1991–96) and in the work commissioned for the opening: artist Mark Dion directed excavations of the river sands at both Tate sites and exhibited the resultant artifacts in nineteenth-century cabinets. The problem arises when we search elsewhere in these rooms for some sugges-

tion that an artist from Africa or any other colonized continent had made modern or contemporary art worthy of inclusion in the displays. Indeed, works by artists from places outside Europe and North America were rare to the point of near invisibility. In London, center for so long of a great and powerful empire, this was an unreconstructed colonialist reflex.[12]

More constructively, the displays, on the whole, gave an unusual (and welcome) prominence to art concerned with questions of self and body, to unofficial and outsider art, and to the continuing echoes of surrealism throughout the art of the twentieth century. Something of the spirit of certain artists' "counter-museums" was in the air (those of Arman, for example, or the many quasi-museums of Marcel Broodthaers). Meanwhile, at the far end of one level, a multistory room was devoted to major works by Joseph Beuys, on the model of the recent special collections museums in Europe. In the main turbine hall space, visitors queued for over an hour to climb and descend the three 30-meter-high towers making up Louise Bourgeois' *Untitled* exploration of her psychic chambers, and to walk beneath the spider legs of her giant *Maman* (1994). This sculpture was to appear, three years later, on the river walk at Bilbao, as if it were a signature strangeness spawned by the specular Guggenheim Museum itself. It reappeared in 2003 as one of the main public artworks in the grounds of the Roppongi Hills Tower, Tokyo, where it remains. The first temporary exhibition at the Tate Modern was an entire floor given over to installations commissioned for the occasion, in order to explore the dialogue, in video artist Gary Hill's words, "between cinema and a hard place." Despite the presence of some outstanding works, one's overall impression is that the ahistorical/zone model remains a confused pluralism.[13] Is this not, however, a state, an experience, absolutely to be expected at a contemporary art institution?

Yet the curators at the Tate were trying for something more focused than this. Their initial failure is a sign that they were collateral damage within a large conflict: the struggle of the contemporary to be born out of the womb of the modern, its emergence as an artworld paradigm of its own (paradoxically, in the form of an antiparadigm, a dispersive set of forces), and the efforts of the modernist institutions to reign these changes back in. It is significant in this context that the Richard Long works were removed, after the first year, from their face-off with Monet's *Water Lilies*. Marlene Dumas disappeared from the Matisse rooms—indeed, from the portable guide to the displays altogether.[14] Responding to critique of the implied racism of the opening treatments of indigenous art, in 2004 the museum added a small room hung with recent works by contemporary indigenous artists, devoted

to the theme "Racism and Art." Overall, however, the blatant framing of the modern by the contemporary proved too much for too many. But the Tate has weak collections of early modernism, compared with the great museums of Europe and the United States. So, to emphasize the contemporary *was* a solution of sorts.

But, apparently, only for a time. After many attempts to adapt the opening four themes, the museum, under new directorship, replaced them in 2005–6 with another set. Although flagged with generalized titles, they actually cluster around well-known high points in the story of modern art. "States of Flux" centers on cubism, futurism, vorticism, and their legacies; "Poetry and Dream" on surrealism and its considerable resonance in recent art; "Material Gestures" on the "new forms of abstraction and expressive figuration that emerged in post-War [sic] Europe and America"; while "Idea and Object" focuses on minimalism, its precedents in movements such as constructivism, and on its legacy in conceptual and installation art.[15]

No one could possibly miss the point in the introductory galleries to each of these sections. "States of Flux" is announced by the juxtaposition of Boccioni's *Unique Forms of Continuity in Space* (1913) and Lichtenstein's *Wham!* (1963) that seems more a one-two punch than an instance of the multiplicity to come. "Poetry and Dream" begins with de Chirico's *Uncertainty of the Poet* (1913) and an *Untitled* (1979) installation by Jannis Kounellis that does little more than explode de Chirico's ambiguity gently around the room, making both seem surprisingly literal. In the first room of "Idea and Object" the deliberate, flat literalism of the steel and copper plates that constitute Carl Andre's *Venus Forge* (1980), laid out along the floor of the first gallery then running into the second, seem a neat contrast to Martin Creed's *Work No.232: The Whole World and the Work = The Whole World* (2000), with its title spelled out along the upper walls in white neon letters, sans serif à la Joseph Kosuth. This amusing pairing nevertheless runs some risks: it implies that the ideas are upstairs, not at your feet; it reduces conceptualism to tautologous conceptual art (and further implies that all post–conceptual art can do is wittily repeat its founding gestures). First prize for obviousness, however, goes to the introduction to "Material Gestures," which begins with Anish Kapoor's double life-size, fiberglass and lacquer sculpture *Ishi's Light* (2003). This work invites you to peer into the vertical split in its enveloping, egg-like shape. As you do so, you see your distorted image shining back, upside down. You also see, inverted, two large paintings by Barnett Newman: *Eve* (1950) and *Adam* (1952)—hovering presences from the wall behind you.

The good news is that the rehang of the following galleries in each of the sequences—after all, the main experience—show that the curators have learned much from the experience of the opening exhibitions in 2000. For example, the Edwardian smugness, narrow domesticity, and sensuous aestheticism pervading the third room in the "States of Flux" stream is disrupted in the most riveting way by Maurizio Cattelan's *Ave Maria* (2007): three besuited arms jut out from a stark wall, raised in unison in the fascist salute. No simple pairings here: this is a provocative shock, one that seems, quickly, to be right as a prefiguration of what is to come. Pop art fills the core room of this sequence, yet while each work is a significant one, the overall effect is of a set of somewhat tired artifacts, with no Fluxus in sight.

Steve McQueen's three-screen video projection *Drumroll* (1998) attacks this placidity with a vengeance: mounting three cameras just inside the top, bottom, and one side of a barrel, he rolled it the length of Manhattan, down its main avenues, recording the sound of his performance, as well as whatever met the eye of the continuously filming cameras. Two of them registered both sides of the street at their level: a revolving flow of lower shopfronts, stoops, entrances, alleys, parked and moving cars, standing and walking figures viewed just below their waist. The other camera, projected centrally, caught the sidewalk, the looming shadows of tall buildings, and the artist's pink shirt and dark head. This frame seemed to spin much faster—to the point of becoming a blur of film through a shutter. The "State of Flux" sequence was capped, in 2007, by a room devoted to "Popular Painting" from Kinshasa. These mural-size contemporary history paintings by leading artists Chéri Samba, Bodo and Chéri Chérin show Africa entangled in a world consumed by violence and exploitation. Images of child soldiers, deadly medicines, terrorist threats, and local complicity are modified somewhat by signs of humane connection ("*secours humanitain*") in Bodo's *Turbulent World!!! Where are we going?* (2006).

The museum played to its strength by putting out most of its large collection of surrealist art, hanging it floor to ceiling. Artists from seemingly all parts of the world appear in joyous profusion, dancing through the decades, from de Chirico to Pollock then the Cobra artists. It is disorienting in a precisely surrealist manner and releases a comic strangeness that occurs over and over again in subsequent galleries. Breakout spaces featuring a single artist worked well within this sequence: for example, the rooms devoted to Francesca Woodman's self-presentations to the camera, from the age of thirteen to her death at twenty-two, images that extend Claude

Cahun and anticipate Cindy Sherman, yet remain absolutely specific to her self-haunting.

The flow of connections in the "Idea and Object" sequence was much enhanced by quasisurrealist works such as Richard Hamilton's *Shadows Cast by Readymades* (his 2005 film of Duchamp's suspended found objects for a Merce Cunningham performance), and by Rivane Neuenschwander and Cao Guimarães in their 2006 film *Ash Wednesday,* which delightedly tracked ants as they tirelessly collected the confetti discarded after the Rio Carnivale. The core room, a powerful collection of minimalist works, also held its ground— as it did, because of its own strengths, in 2000. The same, of course, must be said of the room housing the peerless Rothko paintings, rejected, to our benefit, by the Four Seasons Restaurant in New York decades before. A taste for the tasteless match-up reappears, however, when the Monet *Water Lilies* (ca. 1916) is paired with a middling Rothko of 1950–2 that happens to have some of the same colors on its surface. Nevertheless, this sequence ended on the right note by including an exhibit conceived by the The Wrong Gallery, an artist-curator collective that has for years maintained a nongallery in the Chelsea district of New York, and in recent times, staged a series of brilliant shadow exhibitions of outsider, criminal and otherwise subversive art. One instance of an intriguing series of mini-exhibitions: in early 2007, Welsh artist Cerith Wyn Evans chose to install behind the recessed doorway labeled "The Wrong Gallery" Brancusi's bronze sculpture *Maiastra* (1911) on the grounds that, when he began work as a gallery attendant at the Tate some years before, his first job was to dust this work.

Where to for the Tate Modern? In its efforts to create a museum of modern art that is approached through a celebration of crowd-pleasing, spectacular contemporary art, it has become a delighted but concerned victim of its own success. With 25 million visitors since opening, 60 percent of whom are under 25, and 2005 attendance figures of 4.1 million (in comparison to 2.67 at the reopened MoMA), it justly claims to be the "most popular museum of modern art in the world." Some temporary exhibits, notably Olafur Eliasson's The Weather Project in 2003, attract even larger than usual crowds. The museum claims to add between £74 and £140 million annually to the economy of the city of London. It has launched a campaign for a £165 million extension, to open in 2010, in order to meet its obligations to show new media, large-scale works and installations, and art from China, Latin America, and India, all of which remain poorly served by the current arrangement. The Tate Modern will, the publicity claims, be "the world's first museum designed to show the full breadth of contemporary art in the new century."[16]

4.4. Herzog & de Meuron, Tate Modern 2, projected for 2010. (Photograph © Odd Andersen / AFP / Tate Modern.)

This is an ambitious claim, yet it responds frankly to a real problem. Most large-scale museums designed in the last years of the twentieth century, even those with an anticipated emphasis on contemporary art, have fallen short of a continuous engagement with the diversity of current practice. When the formation of canonical or representative collections and the occasioning of historical witnessing were the museum's chief purposes, the time lapse that blinked out the present was common—to some, even defensible. But no longer. The Tate's leadership recognizes this—and is, perhaps, also propelled by a fear of another, stereotypically British belatedness. How, then, might it find a way through the conundrum caused by the fact that its own careful and enormously successful steps towards popularity have been outstripped by the worldwide spread and the proliferating multiplicity of contemporary art?

Swiss architects Herzog & de Meuron, who designed the first conversion, have been retained to design Tate Modern 2. The extension will increase existing space by 60 percent, mainly by adding an eleven-story ziggurat to the south side, in the form of stacked, rectangular boxes, many transparent, all brightly lit, angled at odds to each other, and reaching up towards spaces that will house "cutting-edge contemporary art" and be topped by an observation platform. To the architects, the form may be read simultaneously

as "the erosion of a pyramid and, in contrast, its emergence and growth." Clearly, they have begun from an imagery that, in its embrace of internal and outward contradiction, displays exactly, and poetically, the plight of the museum—indeed, of all official structures—today. In section, the design recalls Vladimir Tatlin's *Monument to the Third International* of 1920, a project that took as its engineering inspiration the lower portion of the Eiffel Tower, so is based in a raking steel framework, within which the meeting and administrative rooms of the worldwide Communist brotherhood were bound together in a spiral that ascended to the communication and broadcast centers at the top. Too radical even for Leon Trotsky, it remained a model (and was rebuilt as such by Swedish architects in 1968). Perhaps, as a building, it will appear, at last, in Southwark. Having converted an industrial modern, but not modernist, edifice to create a museum of modern art, the architects now reach out to make the Tate (or, at least, part of it) contemporary through grafting on a set of forms that are marked by both the strange luminosity of a hybrid excrescence and the dramatic impact of a collision.

Part 2
Spectacles:
Architecture/
Sculpture

CHAPTER FIVE

The Experience Museum: Bilbao and Beyond

When you stand in the atrium of the Guggenheim Museum, Bilbao, you know that you have arrived at contemporary art. If, at the end of the twentieth century and the opening of the twenty-first, there is one place on the planet where it can not only be found, but also experienced to the maximum, surely, it is here. A gently rustling buzz fills the air: people gaze up in awe, cluster in small, silent groups, and in murmuring couples or simply alone, stand rapt. You have entered through a narrow passage, from beneath curving balconies. A huge, refracted window fills the opposite wall—sections of an iron bridge can be glimpsed through the haze, as well as buildings, set against green hills and strung along a river—a cityscape warping in and out of focus. Around you, glass elevators rise through transparent shafts, sharply raked or gently billowing, animated by excited visitors. Curvilinearity predominates, so walls as such cannot be made out. Plaster surfaces are everywhere a brilliant white. One shooting column is round, but another is prowed and still another drops like a giant sheet. Stairs rise between these shapes and shift out of sight. Over there, left of the entrance passage, is a pair of possible exits from this warm and brilliant cave: an architectural call to move from bedazzlement to enlightenment, with instruction unspoken.

Opposite, a very different invitation: this wall seems to consist of a snaking, expanding column that culminates in a gigantic altar or tribune: its honey-colored marble hovers over you, an authoritative, declarative gateway to the treasures beyond. You glimpse a great room, cut by snaking steel, rolling away into immeasurable distance. Above, suspended walkways bridge over the chasms, balcony edges appear, and, as your eye ascends, the white surfaces, the marble, glass, and steel rear up and up, twirling, jostling, reflecting, notching and replaying, switching between positive and negative forms of themselves. As it rises, this overarching ensemble seems to lean in,

71

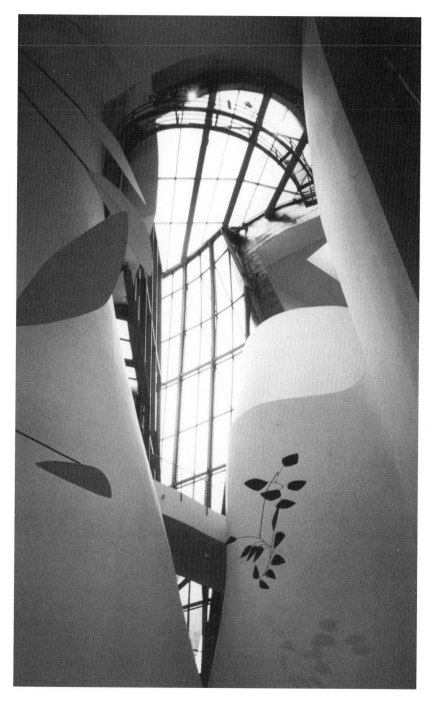

5.1. Frank Gehry, Guggenheim Museum, Bilbao, 1997. Atrium, view toward window. (Photograph by the author.)

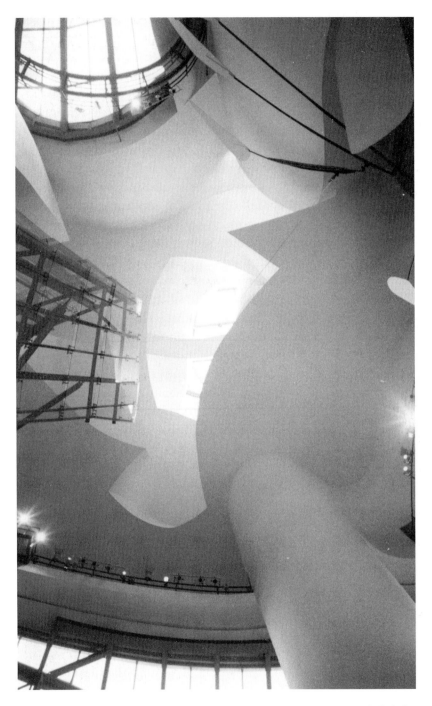

5.2. Frank Gehry, Guggenheim Museum, Bilbao, 1997. Atrium, view toward skylight. (Photograph by the author.)

crossing itself, hovering here, leaping and darting there, but also cupping and showing its cusps, like petals unfolding in cinematic slow motion, culminating in the light energy at its core, which then glows downward, as if a benign spirit were settling on all with eyes wide shut.

Where are the works of art? Is this not an art museum? Sometimes, you will see a few in the atrium. During the opening exhibitions, the gargantuan feathers of Claes Oldenburg and Coosje van Bruggen's *Soft Shuttlecock* flopped over balconies into the airy space (amplifying the impact that they made during the 1995 Oldenburg retrospective at the Guggenheim Museum, New York). The atrium turned into a resonant gallery setting during the 2003 exhibition of sculptures by Alexander Calder. Indeed, something of Calder's mobiles may have entered Gehry's design thinking: many of his volumes seem to be realizations in three dimensions of the sculptor's typical shapes. You had, of course, passed some art on your way in. Jeff Koons's *Puppy* sits expectantly at the point where the entrance plaza commences, as if marking the sidewalk of Alameda de Mazarredo, the main street between the town and the museum. To some, this silly sentinel is a populist gesture rather than public art. Yet the museum has no qualms about blurring the boundaries between "high art" and "popular culture," so assiduously policed but so porous during the previous centuries. It energetically circulates a photograph that shows a view of the museum's titanium sheets glimpsed against the gentle curve of green hills beyond. Tourists instantly recognize a natural setting, but this is misleading. These hills are a park within a city that has industrialized to a stagnant saturation. Koons's *Puppy* stands guard in front of the museum, which is framed by the buildings on either side of Calle de Iparraguirre, an important though not major street of the city. *Puppy* signals to the people that contemporary art is not threatening, not complex, and definitely not elitist: it can be kid's stuff. And as much fun as a day at the park. (A mini-park is what, indeed, it is. Bilbao's Parks and Gardens Service was working on it the day of my visit, inserting fresh blooming spring flowers all over.)

In the atrium, the question "Where are the works of art?" is the wrong one, because you are standing in it. Gehry had begun by conceiving the atrium as one among the many galleries he was being asked to provide, but Guggenheim Foundation director Thomas Krens told him that it was "not necessary to create exhibition spaces in the atrium. The atrium is yours; you're the artist here. This is your sculpture . . . you then make perfect exhibition spaces around it."[1] Obviously, the space had to serve a practical purpose: to be the beginning, transition and end point of circulation to,

between, and from the surrounding galleries. Given that, Gehry was free to fly. Which he did, creating what almost all artists, writers, and critics who have seen it say is one of the definitive works of contemporary art of the late twentieth century. What does this mean, exactly?

As we walk around and then through the building, an array of historically modernist art styles appear—cubist, constructivist, organic abstraction, minimalist—but none sets the entire aesthetic agenda. This structure does *not* qualify as art due to the degree that it looks like already-accepted art. It qualifies because it is an instance of a specifically late-twentieth-century way of generating original art, one that emerges from (among other causes) a contemporary hybridization of mediums that had previously—under a certain, strong (that is to say formalist) current of modernism—tended toward separation ("medium specificity," in the recent mantra). Gehry is aware of this: "To say that a building has to have a certain kind of architectural attitude to be a building is too limiting, so the best thing to do is to make the sculptural functional in terms of use. If you can translate the beauty of sculpture into the building . . . whatever it does to give movement and feeling, that's where the innovation in architecture is."[2] Translation probably is not exactly what is going on here. Rather, it is the meeting of "the sculptural" and "function" that is definitive, with the former in the driver's seat.

Gehry's design process—so thoroughly revealed in the many studies of his work, by his own office in their design of the exhibition of his work at the Guggenheim Museum, New York, in 2001, and lovingly traced in Sidney Pollack's 2005 film *Sketches of Frank Gehry*—is evidently a matter of matching these elements with and against each other. His primary artistic effort is to manipulate a variety of materials, to generate a multiplicity of forms whose aesthetic coherence is discovered as he works. The list of specified functions serves as a framework of reference, a set of anchors in relation to which the malleability of forms constantly returns, less to accept a limit, more to agree to a fit. The result is a kind of built form that is both sculptural and architectural—that is, it is like both, but not exactly either. It is a hybrid in which a very complex "sculpture" works as a building (here, an art gallery) and a very complex "architecture" exists as sculpture. More exactly, at Bilbao the main interior galleries and the dedicated spaces that house shops, ticketing, cloaks, restaurants, and so forth are architecture in the traditional sense, whereas the atrium, some of the smaller galleries and the major external configurations are essays in sculptural works of contemporary art. This collision of form and purpose is striking when one follows his design process step by step. It is also evident in the plan—especially of the second and

third floors. Its main dynamic results from a shafting of rectilinear boxes into an array of jumbled blobs. The end result, however, is a collision become a conjunction. This almost literal deconstruction creates an enormous tension within the edifice, one that the atrium and the detailing throughout has to work overtime to resolve. Yet incessant excitement and random stimulus can turn tedious. This is the risk that Gehry's projects constantly run.

It is important, here, to be accurate about "the sculptural." For Gehry, in this context, it means, first of all, late modern sculpture: specifically, minimal art—not so much in its later-1960s, early-1970s aggressive, anti-aesthetic, conceptualist phase, rather, more in its recent, huge-scale, Dia:Beacon "baroque" phase, exemplified above all by the work of Richard Serra.

In a prescient 1990 article, "The Cultural Logic of the Late Capitalist Museum," Rosalind Krauss noted the impact on museum design of this shift (or, better, drift) within minimalist art.[3] Her epiphany occurred when she experienced renovations to the Musée d'Art Moderne de la Ville de Paris— changes that had been made to house an exhibition of classic minimalist works, including the carefully wrought steel objects of Donald Judd, Carl Andre's laid industrial materials, phenomenological installations by Robert Morris, and Dan Flavin's fluorescent tubes. She was struck by the ways that this art had influenced the architects to modify the interior spaces of the museum so elegantly that these spaces attracted as much, if not more, aesthetic attention than the works they were ostensibly meant to house. "We were having this experience, then, not in front of what might be called the art, but in the midst of an oddly emptied yet grandiloquent space of which the museum itself—as a building—is somehow the object."[4] Expanding her point toward the kind of museum then emergent in the United States, she referred to Guggenheim Foundation director Thomas Krens's revelation that it was minimalism "that has reshaped the way we, as late twentieth-century viewers, look at art: the demands we now put on it; our need to experience it along with its interaction with the space in which it exists; our need to have a cumulative, serial, crescendo towards the intensity of this experience; our need to have more and at a larger scale."[5]

These words describe many subsequent projects, not least the Massachusetts Museum of Contemporary Art at Williamstown, a museum in which one large hall after another is given over to massive, single works. In 2000, Tim Hawkinson's 90 × 900-meter *Überorgan* was installed in its largest gallery. Krens's words prefigure both Dia: Beacon and the Guggenheim Bilbao. The first follows them programmatically, its plan steering experience, whereas Gehry does this by alloying minimalism's challenge to the

spectator with evocations of earlier, easier art, laced with the seductions of current computer graphics.

The Guggenheim Museum, Bilbao, may be the most elaborated version yet conceived of Carl Andre's famous three-concept definition of the base line of modern sculpture, that it has progressed from "sculpture as form," through "sculpture as structure" to "sculpture as place."[6] In the sensual curving of Gehry's forms there are explicit allusions to the organic abstraction of early modernism (Matisse's cutouts, Calder's mobiles). At the same time, the gigantic junk sculptures of Mark di Suvero—in effect, big-scale found-object collages—have been important to Gehry for decades. In the models for this building, they appear as flotsam cast up onto the site by the river. CATIA (computer-aided three-dimensional interactive application) modeling aided his freewheeling approach to designing without the constraints of Euclidean geometry, structural limits, and standardized building techniques. "Blob architecture," itself much indebted to Gehry's personal form/repertoire, is also relevant. The sculptural here is an aesthetic of assembling and modeling, of accumulation and shaping (a kind of carving). These are the main trajectories of modern sculpture, seen in a more conventional art historical manner than Andre's reductive version. Gehry evokes all of these types and instances, as images fleetingly recognized by us as having inspired him. (This is their postmodern quality.) But more importantly they have become internalized as procedures within his design process. (In this, they are prime examples of deconstructivist architecture.) Which raises a deeper question: Does Gehry's drawing on all of these sources—at times randomly, at others cohesively—add up to more than just extremely well-executed late-modern architecture? Producing exactly this latter is what the architects often, and inexactly, known as "Deconstructivists" resolutely set out to do in the last years of the twentieth century.[7] Did Gehry, at Bilbao, arrive at something more, at a distinctively contemporary kind of art?

Thomas Krens established the architectural program at Bilbao in a single statement: "The idea was that the museum had to be able to accommodate the biggest and heaviest of any existing contemporary sculpture on the one hand, and a Picasso drawing on the other hand."[8] To be, that is, a museum of both contemporary and modern art. In the event, Gehry produced a building that, in its combination of huge ground-floor galleries and sets of smaller, "classic" spaces on the upper floors, serviced both of Krens's requirements. But he also produced a building that was intended to be *the* biggest contemporary sculpture in existence. Nor are certain qualities of Picasso's draftsmanship entirely absent: in Gehry's early sketches for this project, forms emerge

from a play of line that toys with figuration as loosely, yet inevitably, as did Picasso, especially during the 1930s.[9] "Heaviness," however, is not a concept that fits it at all: for the most part, the museum sits lightly on its site, suggesting flow across the river's edge site, a ship-like movement, like hulls lurching at sea, and a rustling of sails, or that of a reptile, stirring within its scaled skin.

To Coosje van Bruggen, this quality of the design recalls that which Gehry employed at the Frederick R. Weisman Art Museum, designed at the same time as Bilbao and, like it, located on the edge of an important industrial river—the Mississippi, as it flows through the city of Minneapolis. She cites Gehry on the experience of sailing, literally, close to the wind, and comments: "The fleeting trapped within the immutable creates a sense of displacement so necessary for an architecture embodying sculptural or pictorial, emotive relationships."[10] The first metaphor here recalls Baudelaire's famous statement of the core values of *modernité*, conceived by him in relation to the experience of the fast-modernizing city. But both he and his successors constantly compared this elusive yet unmistakable novelty to remembered experience of natural elements, as if the vast repository of that-which-was-not-the-city continued to flow beneath its newly swirling currents, and erupt through its interstices. By "displacement," Van Bruggen probably means the sense of switching between mediums that we have already discussed. But there is a more interesting sense to this term. That of being abruptly shifted, without explanation, from one place to another. Yet that place need not be a natural one. Sudden time warps, spatial fissures, historical disjunctions, cultural strangeness, the experience of being thrown out of human time—none of these increasingly common experiences in the new world disorder necessarily results in our becoming in tune with "natural time," that of the days, the seasons, the growth and decay of living creatures, or the entropy of objects. Nor, necessarily, with the senses of place that were, with whatever difficulty, to be found in "second nature," the industrial, urbanized, transport-connected, technological, commoditized, and thoroughly mediated world of modernity. Guest workers, forced immigrants, refugees, and multinational workers all know that the "place" to which we are shifted may not, for us, be a place at all. It might be a transitional situation of unknown temporality (one in which time is conditional). This points us to a key condition of contemporaneity (itself a state that might be amounting to a "third nature"), one that frames the Bilbao project—among, of course, all other creative production these days—in subtle ways.

The Weisman Museum in Minneapolis is much smaller than the Guggenheim at Bilbao: a patrol boat rather than an aircraft carrier (although a $10 million expansion is planned to open in 2009). This highlights the fact that the Guggenheim is also a work of restraint-breaking, vaulting ambition. Van Bruggen hints at this: "Gehry had in mind an instant of released plastic freedom and beauty, the result not of a contrived feat of the extraordinary, but rather of the transformation of the accessible ordinary."[11]

Victoria Newhouse is more precise. Observing that CATIA became available to Gehry between these two projects, she points out that it allowed him to design on the assumption that whatever shapes he conceived could be programmed for construction, thus surpassing earlier limitations on materials and building practice. The alacrity with which he seized this opportunity is, for her, the decisive leap forward at Bilbao:

> The Bilbao Guggenheim effectively points to a new kind of museum. Its sculptural galleries are among the most evocative forms ever made, and they offer an architectural context for contemporary art equivalent to what many artists and critics have demanded for centuries. Gehry's architecture of movement has produced flowing forms that appear as film stills: motion caught and made definitive at a particular moment.[12]

The Bilbao museum is also contemporary in that it is the outcome of a consciousness that is historically inclusive, unlike much doctrinaire modernism that sets itself against the past. It is remodernist in its inclusion of references to modern masterpieces as past works that can still, although dated, be suggestive for the present. Newhouse's reference to the film still alerts us to ask: Does this mean that the general effect of arrested motion conveyed by a film still is a quality of Gehry's design? Yes—as Van Bruggen has noted. And we can add that the other quality of the film still—that it is not always a frame extracted from a film's flow, rather, it is often a scene, approximating one that occurs in the film, staged by the actors for photography—is also a quality of the movement of form at Bilbao. We might also ask: What kind of film is relevant? Even, which film? When we gaze upwards in the atrium, the city scenes in Fritz Lang's *Metropolis* come inevitably to mind, with their famous crowding of temple-like high rises, crisscrossing elevated roadways thronged with cars, toy airplanes buzzing and banking between them. It is less the stilled extract from narrative movie that seems pertinent than the actual scenes of such silent films, with their long but slightly shaky takes by a fixed camera of scenes that are staged as imagined spectacles.

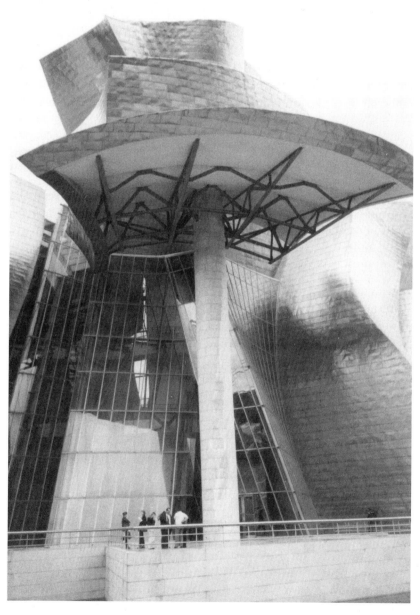

5.3. Frank Gehry, Guggenheim Museum, Bilbao, 1997. External view from riverside. (Photograph by the author.)

In its associative generosity, Gehry's historical inclusiveness is wider even than this. Art and architecture from all over Spain resonates through the building. The elegant interiors of the Moorish and Mudéjar palaces and, above all, the fabulous honeycomb ceilings of the Alhambra, the Seville Alcazar, and elsewhere are evoked in the upper reaches of the atrium. Yet in these buildings, as in the Moorish mosques, it is the autonomy of decoration, not sculpture, that subsumes architecture. Spain is, however, home to a more recent instance of innovative and supple stylistic hybridity. A late-nineteenth-century sense of the sculptural inspired famous *modernistas* such as Antoni Gaudi. His architecture is explicitly acknowledged at Bilbao: the columns of the Sagrada Familia echo in the columns of Gehry's atrium, and Gaudi's subtle sense of "organic" interplay between steel and stone is, I believe, heralded in the great canopy that opens out the river side of the building, lifting a section of its side onto a massive column and supporting it with a branch-like steel frame. It may, however, be a coincidence that the disposition of gallery rooms around a open central space, unfurling like leaves around a stem—the ultimate design solution that married the atrium to the rest of the building—is a solution arrived at nearly a hundred years earlier by Gaudi in the plan of the Palau Güell, Barcelona. More generally, Gaudi's transformation of architectural elements into sculptural forms is justly celebrated, although Gehry takes this further than Gaudi's free-form chimneys, balconies, screens, and molded walls, into the structural fabric of the entire edifice, into its planning from the ground up.

When, however, the mechanics of metaphor remain open to the eye, are too easily seen, the fragile radicality of Gehry's design collapses into mediocrity. This occurs in the "tower" east of the Puente de la Salve Bridge. This edifice is a residue of the original design inspiration, evident in the first sketches: to dispose the museum on either side of this bridge, in a manner recalling the unrealized city projects of the Italian futurist Antonio Sant'Elia. Responding to the *genius loci*, this would enable the shipyards and factories that had thrived on the site for decades to continue their symbolic life, so that the site might remain one that linked the city on both sides of the river. More: on the apex of the curving river, the museum would change this area from a marginal interstice, and instead accentuate the "cultural zone" as the primary nexus of the city. This was the central motivation of the Basque government in commissioning the museum as the symbol of its $1.5 billion effort to renew Bilbao as a high-tech and cultural center for the region.

As it evolved, however, the design accumulated the main activities to the west of the bridge. The tower shape remained always higher than the

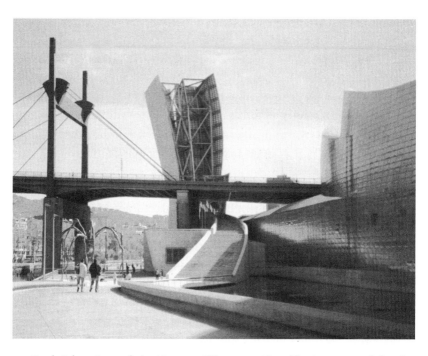

5.4. Frank Gehry, Guggenheim Museum, Bilbao, 1997. Riverside view, Puente de la Salve (Bridge of the Savior) and the "High Reader." (Photograph © Phillip Capper. Creative Commons 2.0.)

uprights supporting the cabled bridge, but varied drastically in function and appearance. At times a gallery, at others an observation post, it became an oversized piece of signage, advertising "Guggenheim" on its flag-fall (Gehry calls it the "high-reader"). Mostly, it was an accumulation of abstract forms at one end of the models, varying in style from a wildly wired up version of a Gehry sketch, through a number of three-dimensional collages in the manner of, in turn, Henri Laurens, Julio González, Aleksander Rodchenko, and Kurt Schwitters. As actually built, it became a twisted vertical sheet of marble that, when split open, reveals its steel framework. It thus became a sign of three things: that something aesthetic (as distinct from industrial) was here, that this something was architectural, and that it was aspirational in spirit. Yet all of these qualities (however worthy) are conveyed in the most evident of ways. Its upward-reaching, open-hand character is a banalization of what is achieved in the main building.[13] On the other hand, a more generous reading of this aspect of the design is possible. If one acknowledges that Gehry was aiming to energize the entire basin from within which his

building would be visible, that the museum's footprint includes the river and all the buildings, parkland and infrastructure within sight of it, then the "tower" becomes a bold gesture through which the architect wraps into his new forms the one other dramatic structure near to it. Close up, however, this shape loses its power, and becomes more like the interlocking of quasi-organic, quasi-mechanical forms much favored in commissioned public sculpture throughout the world during the 1950s and 1960s.

Turning to the building's interiors again, we might ask: How does the museum work as a set of spaces—nineteen in all—for the display of modern and contemporary art? Semiofficial documents celebrate this is "a place where art and architecture finally meet in harmonious amplification."[14] Commentators around the world agree that here, "art and architecture find a perfect match."[15] Newhouse spells this out:

> Spatial complexity—rectilinear, loft like and sculptural—introduces a new inclusiveness. Up to now, most museums have acknowledged a single attitude towards viewing art Even Wright's Guggenheim offered only one option To date, Gehry is alone in achieving this diversity so skillfully and on such a grand scale The architects of several recent museums (the Groninger, for example) have attempted to resolve the contentious container versus content conflict by including different kinds of space to accommodate various art forms; only at Bilbao are such disparate spaces brought together into a synthetic whole. Gehry's invention of new forms, and his plurality of forms, provide a model for future museum architecture that must now be taken into account.[16]

The last two sentences of this quote are the conclusion to her argument for the most desirable "new museum." They echo a set of distinctions made by British architect Ian Ritchie in his 1994 discussion of the new European museums as having been pushed by changes in contemporary art to redefine the relationships between "content" (the art), "container" (structural design and built form) and "image" (look of the building when seen externally and reproduced).[17] In offering this diversity, Gehry succeeded in ways that Taniguchi, at MoMA, was unable to achieve.

Yet a close examination of the gallery spaces at Bilbao complicates such a contrast. For the most part, they are quite conventional rectangular rooms that work adequately for the showing of modern art. For the site-specific installations in the galleries that circle the atrium, Gehry curved the walls. The major space, the rolling ground-floor gallery that is 130 meters long and

30 meters wide is a shell for works such as Richard Serra's *Snake* (1994–96). Commissioned for the space and conceived in parallel with the designing of the museum itself, there is no doubt about the aesthetic success of this sculpture. Three sheets of Cor-Ten steel curve through 30 meters. All are tilted, with the central panel leaning so that one's passage down one side feels more confining than passage down the other, and vice versa. Such simplicity of positioning the spectator, such symmetry, certainly has its own elegance. *Snake* is presented with so much space around it that the primary experience of the work is just what has been described: that of passing through it, and walking around. Unlike most of the other settings in which Serra's work is located—converted sheds, warehouses, boat yards, machine shops, and so on—there is no dialogue between modes of industrial production. In this situation, neither Gehry's nor Serra's art seems industrially based. Mystification is going in both directions, and in circles. The reality here is that the art of both is postindustrial.[18]

In calling the Guggenheim, Bilbao "the best museum of this century," Serra commented that the long ground-floor gallery has "the neutrality of an industrial space."[19] I think that Serra must have been looking down, at the gray concrete floors, not around (at the white walls) or above (at the curling ceilings) when he made this remark. In sharp contrast to his conception at Bilbao, Gehry's most successful creation of a set of spaces that reflected the industrial settings in which much minimal and post–minimal art was made is his conversion of a warehouse in the Little Tokyo area of downtown Los Angeles in 1983 to temporarily house exhibitions by that city's Museum of Contemporary Art while its permanent home was built according to the design of Arata Isozaki. Alterations to the existing fabric consisted of joining two adjacent warehouses, cleaning them up, installing a system for hanging mobile white walls, and adding a canopy of steel and chain to the entrance (the only symbolic surplus). A chorus of artists, critics, and curators praised the brilliance of this restraint. It made the much-celebrated democratic transparency of the Le Centre National d'Art et Culture Georges Pompidou, Paris, seem like an exercise in symbolic signage. Wouter Davidts articulates the promise made explicit in Gehry's ostentatious under-designing: "The raw character of the space extends the promise that anything is possible anywhere at any time to anything *stays* possible anywhere at any time. To achieve flexibility, the shed no longer needs to be well-serviced, but undecorated, to the extent that it looks like a construction site or a building in progress."[20]

The building was dubbed the Temporary Contemporary, a strange coupling that actually evoked the opposite of the literal meaning of both terms:

it was intended to suggest that that the museum could show, at once, the "temporary" qualities of contemporary art while at the same time prefiguring those contemporalities that might persist to become part of the history of modern art. It was Los Angeles's answer to Gertrude Stein's pronouncement, the city's *musée de passage* for contemporary art. Yet when the Isozaki building opened in 1986, the first exhibition, Individuals: A Selected History of Contemporary Art, 1945–85, split this time frame into two twenty-year blocks, with art made since 1965 displayed in the Temporary Contemporary. In 1996, in recognition of a huge donation from a Hollywood mogul, the building was renamed the Geffen Contemporary. By then, it must have seemed, the permanence of the contemporary was well established.

Similar museumizations of the contemporary have been occurring ever since. In June 2005 at the Guggenheim, Bilbao, the "fish" gallery was filled with what will become its permanent installation, Richard Serra's *A Matter of Time. Snake* became the centerpiece of an eight-work installation, over 430 feet in length. It joined seven other Cor-Ten steel works that summarize major pieces from the artist's previous decade. Each one differs in the nature of the "internal" journey that it invites its spectators to undergo. Each evokes a specific instance of the play of openness and closure, expansion and contraction, threat and embrace that has long characterized Serra's art. Together, they uncoil through the gallery, creating something unusual in his oeuvre: a plethora of "external" spaces between each sculpture, and between them and the architecture of the gallery. All of these vestibular journeys take time to become a fact of experience for those who undertake them. The kind of time they take is not prefixed, ritualized, exactly the same for all. Nor it is entirely random, virtual, and thus unique to each viewer. Elements of both kinds of experience interact, yet they do so in ways strongly determined by the artist's placement of the weighty steel walls, that tower over viewers, channeling them along determined pathways, promising something in the way of a revelation. The "time" aspired to here is more than the actual time taken by the viewer, more than measurable time, or that of history: it is the "eternal" time of "great" art, its suspension, at once, of both history and contemporaneity.[21]

From a more independently critical point of view, we might see *A Matter of Time,* as installed in the Guggenheim, Bilbao, as making explicit a paradox in Serra's art, and in the status that his art has achieved with contemporary art as such: it is one that is also present in Gehry's architecture, and is particularly evident in this building. Both artists aspire to a kind of "greatness," and do so right here, before our eyes and moving bodies. This occurs as a fact of

our experience of their creations, but also as an effect of their evidently high ambition. Yet this effect is achieved by some decidedly low-rent means, and these have, in turn, potentially fragile effects: after their vestibular muscling of our bodies in motion, Serra's sculptures can be abstracted as diagrams of what it is to circulate among works of art in a museum, particularly a museum of attractions. Additionally, their juxtaposition here evokes something of the entertainment logic of a fun fair. These impressions are unavoidable when you look at *A Matter of Time* from above: down into the gallery from a balcony in the atrium. Similar qualities pervade Gehry's architecture: both embody perfectly Thomas Krens's idea that the new middle class audiences for art want above all the basic elements of an art theme park: "a theme park with four attractions: good architecture, a good permanent collection, prime and secondary temporary exhibitions, and amenities such as shops and restaurants."[22] When *A Matter of Time* meets the Guggenheim Museum at Bilbao, the result—in a reversal of Krauss's 1990 comment—might be said to be a consummately replete yet oddly grandiloquent object. Within the framework of my larger argument, we can see that this devout conjunction is a prime instance of contemporary art in its high, remodernizing mode.

At Bilbao, Frank Gehry, Thomas Krens, and the Basque Regional Government gave us the world's spiritual home of official, international contemporary art, turn-of-the-millennium version. It exists as an actual place to be experienced as itself an artwork, as an image marking the destination to which a cultural pilgrim might travel to have this core experience, and, more generally, as an image that, when reproduced and contemplated from elsewhere, arouses the desire to experience contemporary art, design, architecture and style. The container has become the content, and has done so as exhibited image. Architecture has become art, and has done so in the form of an inside-out exhibit. This is the logical consequence of a tendency increasingly evident in the last decades of the twentieth century, first declared in the façade of the Centre Pompidou, and subsequently to be seen everywhere: that the exhibition purpose of the museum is, in the age of the spectacle, its preeminent function.

What does the concept of "experience" mean in such a context? Given the ever-accumulating cultural power of the institutions of contemporary art, it is whatever these institutions say that it is, whatever they exhibit to us as contemporary art, whatever they decide to offer us as an experience. Obviously, I am using the idea of occasioning experience in a special sense—at once reflexive, circular, and specular. Its staging—through the new totality, intensity, and flexibility of the idea of the exhibit—is the main work

of the generic museum of contemporary art. Welcome to the experience museum.

There are, nevertheless, a number of different kinds of art museum in the anxious new world disorder. The Guggenheim at Bilbao represents one option: the conjunction of a public museum given over to private management, and of an architect/artist providing an artwork-like stage for artists who work, mostly, in architectural or architecture-like modes. The net result: contemporary art inside the whale. We have seen in these opening chapters that there are other options for the contemporary art museum early in the twenty-first century. Like the Guggenheim Museum, Bilbao, most were conceived in the last days of spectacle capitalism, yet they have been realized in the dubious dawn of contemporaneity. A private foundation, if it is sufficiently well-heeled, can create a public museum that embodies a highly particular approach to contemporary art, one that serves that approach on its own terms. Dia:Beacon makes publicly available the inadvertent collection of a foundation dedicated to the hands-off sustenance of artists whose work was, and remains, inspired by anything but the museum and the market.

Our upcoming exploration of the market for contemporary art will show that collector museums are the latest thing. As New York art adviser Allan Schwartzman observes, "Money that would have gone to museums is now going into a parallel world."[23] Although extremely varied, the collector museums all manifest at least some of the qualities that characterized the manner in which their founders accumulated their wealth—or, at least, wish to project as associated with their names—singularity of vision, innovative thought, vigorous action, impatience with regulation, and distinctiveness of personality. The Saatchi Gallery led the way in an attempt to make the private and personal collection of a public figure, collector and dealer extremely and widely popular. It did so along business lines. While some, such as those funded by Soichiro Fukutake on Naoshima Island, continue to celebrate the architect—in this case, Tadao Ando—as a creative spirit equivalent to the artists whose work is housed in the museums he designs, others, such as Miami-based collectors Don and Ira Rubell, favor the warehouse model, perhaps because it echoes the look and feel of the art fair, primary source of their collections. Some collectors are reveling in the joys of curating their own collections. The most striking recent example is Ydessa Hendeles, a former gallery owner and director, whose foundation in Toronto presents exhibitions, curated by herself and consisting of works that she has acquired expressly for the purpose, presented according to her own timetable in order to create "new metaphorical connections" for herself and visitors.

In contrast, Artpace in San Antonio, while it displays the collection of its founder Linda Pace, also responds to lacks in the local contemporary art scene by running a judicious artist-in-residence program and intensive educational programs. A small but growing number of philanthropists interested in contemporary art are creating foundations that seek to serve specific, local needs rather than stand as monuments to their wealth and taste.[24] This attitude informs the design by Herzog & de Meuron of the Schaulager, near Basel, that houses works from the Emmanuel Hoffmann Foundation collection. While some works are displayed in conventional gallery settings and are open to the public, those that remain in storage are installed in very open settings, so that museum workers, conservators, curators, researchers, students and teachers, may readily access them.[25]

Whatever form it takes, the independence of spirit shown by the new collectors is causing consternation within the museum world. This exploded in January 2008 when real estate mogul Eli Broad announced that, contra expectation, he would not donate his private collection of contemporary art, or the even larger collection of the Broad Art Foundation (1,800 artworks in all), to the Los Angeles County Museum of Art. One month later, the museum opened the first stages of its $56 million redesign by Renzo Piano, the main element of which is the Broad Museum of Contemporary Art, a museum-within-the-museum. It was filled with loans from Broad. His reasoning was that he was saving the museum storage and insurance costs, and keeping the works of art, most of which would languish in museum storage, available for touring to needy venues (since 1984, the foundation has lent over 7,000 works to 450 institutions, reaching more than 100 million people). The museum, however, would rather have accepted the burden, and sought help from trustees, among them Broad, in sustaining its costs, including those of traveling exhibitions.[26] How the "parallel world" of collector-driven contemporary art institutions will develop is, as yet, unforeseeable. For all of their much-vaunted independence, most of them are active in other parts of the art system in more conventional ways, and are motivated to seek recognition within its framework of values. Their shaking of the tree is no more radical than that of the artists and curators who, for centuries, have sought new ways of putting their wares before the public.

Nevertheless, an epochal difference distinguishes these machinations from those of nineteenth-century Paris. In the early twenty-first century, such impulses on the part of artists, curators, collectors, city officials, and state planners continue to feed the burgeoning, world-wide cultural indus-

try, of which contemporary art in its most spectacular forms has become the leading edge. In February 2007, the Tourism and Development Investment Company of Abu Dhabi announced plans for a cultural quarter on Saadiyat Island, a 27-square-kilometer tourism and residential reclamation now under construction, and due for completion in 2018 at a cost of $27 billion. Its town plan combines Key Biscayne with ancient Rhodes. The cultural quarter will be conjured around four museums: a Guggenheim by Frank Gehry, a classical museum by Jean Nouvel, a performance arts center by Zaha Hadid and a maritime museum by Tadao Ando. At 320,000 square feet, this Guggenheim will dwarf Bilbao's 24,000 square feet of floor space. It will feature four stories of central galleries arranged around a courtyard, which will in turn be surrounded by "raw and industrial" galleries and "homes for a new scale of contemporary art"—precisely the shift we noted above.[27] The Louvre lent its name to Nouvel's museum at a fee of €400 million. This is part of a total of €1 billion (US$1.3 billion) that will be paid to the Agence France-Muséum, which will administer this capital sum to the benefit of the participating French museums. Hadid's organic geometries will house a five-theater cultural complex, while Ando's expressive concrete structure continues his career-long meditation on buildings by the sea. A biennale park was also planned, its nineteen pavilions around a 1.5-kilometer canal being designed by architects including David Adjaye, Greg Lynn and Pei-Zhu, although its future was in doubt by 2008.

These initiatives are intended as iconic attractors for high-spending cultural tourists with the aim of making the city the cultural center of the region, in the manner of Beirut before its destruction by U.S. and Israeli bombing in 1982. They are the cultural sector equivalent of the business districts, such as Pudong and Shenzhen, that have sprung up in the Asian "tiger economies." As well as iconic buildings and brand-name high culture institutions, these initiatives are buying in high-level providers of cultural and educational infrastructure, such as New York University. All this is leading to the creation of a Middle Eastern version of the sunbelt city. Meanwhile, at Dubai, a 1.5-billion square-foot Waterfront City has been designed by Rem Koolhaas; it seeks to fit his concept of "the generic city"—a sprawling metropolis centered on transport hubs, "home" to the globe-trotting transients who are the major and minor players in the world today—to the needs of what is already a fast-growing, and geographically concentrated, local economy.[28] The bet at Abu Dhabi, at Dubai, and at a number of other sites on the Persian Gulf, is that their enclaves of ex-

traordinarily wealthy people—who naturally will have wide-ranging connections throughout the global economy—will sustain the local economy when the oil runs out. Will they continue to do so as the world economy tanks?

How has art responded to the enveloping embrace of the experience museum? We shall return to this theme throughout the book, so I will make only introductory remarks now. One reaction was what became known, through the subtle and acute work of artists such as Hans Haacke, Fred Wilson, and Andrea Fraser, as "institutional critique."[29] Haacke made a number of works that exposed the increasing corporatization of art museums, especially during the 1980s, when this nexus was at its most pernicious. Fred Wilson developed techniques for the redisplay of museum objects, often bringing up works that had been confined to the storage areas, always with the purpose of making visible the ideological currencies in which the museum traded, notably those that involved questions of race. Andrea Fraser has brilliantly parodied the promotional activities of museums, their often egregious efforts at self-description, not least in her *Little Frank and His Carp* (2001), a performance that used the Guggenheim Museum's acoustaguide to demonstrate, hilariously, that the experience of wonderment that I evoked at the beginning of this chapter is the museum's first and primal product.[30] In a similar spirit, for the 7th Istanbul Biennale in 2001, Scandinavian duo Michael Elmgreen and Ingar Dragset showed a white cube building poking out of, or more likely, subsiding into, the ground. Above a door, the letters "TEMPORARY ART" could be read. As a simple visual joke, these words merely described what the work indeed was. Yet the cutting off of the text also implied that the building was a museum of contemporary art. To the artists, this piece is one of an ongoing series entitled *Powerless Structures*, and has the subtitle *Traces of a Never Existing History, figure 222*—as if it were an illustration from a textbook published at some point in the future, one devoted to the archaeology of our present. This is their clever answer to the dilemma pinpointed by our earlier fast-forwarding of Gertrude Stein's remark to Alfred H. Barr Jr.: "You can be a museum, or you can be contemporary, but you can't be both."

In recent years, however, there has arisen among artists an acceptance of the museum as just one site among others for the exploration of relational activity. Curator Nicolas Bourriaud is quite explicit about this:

> While the exhibition site constituted a medium in and of itself for Conceptual artists, it has today become a place of production like any other

. . . . It is the *socius*, i.e., all the channels that distribute information and products, that is the true exhibition site for artists of the current generation. The art center and the gallery are particular cases but form an integral part of a vaster ensemble: public space The gallery is a place like any other, a space imbricated within a global mechanism, a base camp without which no expedition would be possible. A club, a school, or a street are not "better places," but simply other places.[31]

Elmgreen and Dragset have already parodied this shift of mood. For a work entitled SPECTACULAR (2003), the Museum Kunst Palast in Düsseldorf underwent the transformation of having its entire collection dismantled, packed into trucks that were driven once around the building, then reinstalled exactly as before. It is difficult to imagine a more exact metaphor for the current standoff between artists and museums. With critique coming from one group of artists, and accommodation being pursued by another, while the institutions struggle to resolve the pull of contradictory purposes, what seems to be a fascinating flurry of activity is actually going nowhere.[32]

We are tracing the spectacularization of culture that reached unprecedented levels in the years around 2000. Two other factors must be noted. As museums seek ever fresher ways of breaking in new audiences for contemporary art, they transform at least parts of their premises into fun palaces. Crucial to this enterprise is the commissioning of attractor art, such as Jeff Koons's *Puppy* or Louise Bourgeois' *Maman*. This is a popularizing move that goes back at least to Nikki de Saint-Phalle's *Nana* (1966) at the Moderna Museet, Stockholm: a giant, reclining, female-shaped installation that was entered between its splayed legs. Current attractor of choice is Tim Hawkinson. His *Überorgan* has been mentioned before. Along with other intricate quasi-machines, it was installed in 2007 at the Getty Museum, Los Angeles, to signal that institution's shift away from its founder's antipathy against modern art, its openness to accessible contemporary art. Artists become more and more drawn to this kind of role. Those, such as Ron Meuck, with gifts for the bizarre, come to be preferred, and those gifts encouraged. Sensationalism loses even its parodic shock value: it becomes a self-taming sideshow, predictably retro.

A second, related response on the part of many artists has been to embrace the museum as a complete showcase for one art idea (on analogy to "theming" a department store, or "branding" a company, or creating an "attraction site"). In Matthew Barney's *Cremaster* cycle, especially when staged at museums such as the Guggenheim in New York, we experience contemporary

art in its most developed, and enveloping, form—indeed, as an all-around experience, one that immerses its audiences in the everyday now, just as it reaches for aesthetic sublimity. At the very moment that they are subsumed within the all-pervasive interflow of cultural production and consumption, exhibition and museum become one spectacular whole.

CHAPTER SIX

The Intensity Exhibit: Barney World at McGuggenheim

It is February 2003. The Rotunda of the Guggenheim Museum, New York, spirals up and away from you, into a chaste light, whiter than usual. A corporate logo hovers above the skylight: the lozenge shape seems familiar, but what is that brand? Cobalt blue swims up from the carpet beneath your feet. Pink patches, bright banners, and competing noises compose a swirling panorama. From every side and above you, video monitors, particularly the giant, five-screen Jumbotron, flash out images of fantastical yet clearly fashionable characters involved in high-speed action or ritually sedate posing. Punk rock explodes through attenuated sounds, ambience Muzak murmurs then surges to a crescendo. You have paid your money and entered an exhibition of the *Cremaster* cycle of films, videos, installations, sculptures, and drawings by U.S. artist Matthew Barney. Everything is evidently related to everything else, but in strange, ambiguous ways. Is this the ultimate art theme park that, in the booming 1980s, the museum set out to become, here realized in its infantile regress version, as a set for an episode of Playskool for *wunderkinder*? Or is it, as *New York Times* art critic Michael Kimmelman believes, "an inspired benchmark of ambition, scope, and forthright provocation for art in the new century"?[1]

That it may be both is an unmistakable sign that we are, again, experiencing contemporary art itself, as we stand inside one of its most highly developed yet typical forms, and as we were at Bilbao, in the atrium of the Guggenheim Museum there. In its quest to take from MoMA the mantle as the leading contemporary art institution in the world, the Guggenheim Foundation has invested heavily in a globalizing conception of what a museum might be, and what kind of art might be shown in it. Barney began work on his *Cremaster* cycle in 1994. Within two years, the museum had awarded the young artist its major prize and begun to collect his work assiduously;

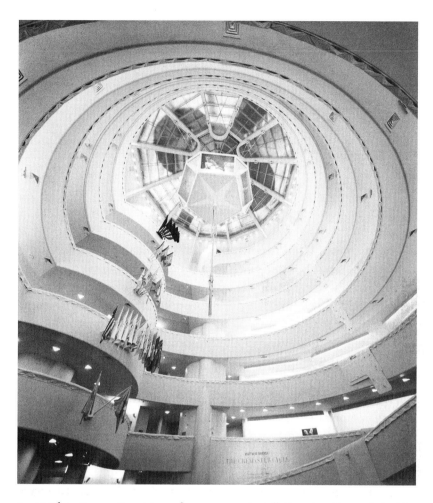

6.1. Matthew Barney, *Cremaster* cycle, 1994–2003. Installation view, Guggenheim Museum, New York, 2003. (© 2003 Matthew Barney. Courtesy of Barbara Gladstone Gallery, New York.)

the Guggenheim both supported it directly and assisted in raising the considerable financing it requires for its realization. "The site is specific: *The* '90s artist should appear in *the* museum of the '90s—the one that mainlined that decade's model of corporate branding and globalization and echoed the corporate idea of total control and continuous expansion of identity."[2] The exhibition of Barney's *Cremaster* cycle was delayed two years while the museum adjusted to the consequences of its national and global overreach during the 1990s (closing its SoHo branch, sacking over two hundred

staff, backing out of overseas projects from Geelong to Rio de Janeiro, and putting into limbo its most ambitious expansion plan: a $678 million New York Guggenheim on the East River, designed as a baroque Bilbao by Frank Gehry). When the exhibition did open, it was immediately seen to be the expression of an artistic vision that was not only extraordinarily elaborated on every aesthetic level but also unconstrained as to the conditions of its making. Its "production values"—to use a term common in the film industry—seemed not just high but extravagantly expensive, commanding resources beyond anything most artists might imagine. For an artwork that took as its central trope the muscle that governs the chromosome switch from female to male and then controls testicular contraction, such heavily invested enterprise seemed more than over the top. Yet it worked, at least in terms of numbers: the three hundred thousand visitors it attracted made it the most-visited of all the museum's single-artist shows.

As at Bilbao, surplus value was everywhere evident. To some, it seemed thrust in the faces of spectators, as if the famous ramps of the Guggenheim were catwalks.[3] To others, especially of a younger generation, such daring mixes of far-out art, music video, cool design, ambient technology, and crossover fashion are definitive of contemporary experience. When allied to themes such as the endangered ecology of the planet, the arbitrariness of power or the desire for peace, these mixes seem purposeful. "Young fans . . . get Barney instantly," as they do fashion designers such as Alexander McQueen, and with equal enthusiasm.[4] It does the Barney buzz no harm that he was a male model and that he has been in a long relationship with Björk, the brilliant and eccentric Icelandic pop star. The music videos made for her by Christopher Cunningham match those of Barney for stylishness. They were shown in the 2001 Venice Biennale, and a more ambitious video by Cunningham, *flex*, was included in the Royal Academy exhibition Apocalypse: Beauty and Horror in Contemporary Art. Such crossovers between artists and designers are becoming increasingly exact: among many other parallels, both McQueen and Barney have used paralympic athlete, actress, and model Aimee Mullins in their work, and both emphasize her prosthetic legs to undergird their multiple messaging.[5]

Is this the answer to the problem posed by the "oddly emptied yet grandiloquent" spaces of the minimalized museum of contemporary art?[6] Is it, at the same time, the answer to the art world anxiety, in the years around 2000, that Gehry's achievement as a contemporary artist at Bilbao seemed to overwhelm, outshine, out-art even the most powerful art being made anywhere? In my view, the importance of both is that they have found distinctive

ways of synthesizing the two vital elements of the most prominent, high-end contemporary art, those I have dubbed "Remodernism" and "Retro-sensationalism." We have just seen how Gehry does this. Barney's achievement also requires sustained and searching examination.

The promoters of the *Cremaster* cycle are less cautious:

> Matthew Barney's five-part *Cremaster* cycle is a self-enclosed aesthetic system. Born out of a performative practice, in which the human body—with its psychic drives and physical thresholds—symbolizes the potential of sheer creative force, the cycle explodes this body into the particles of a contemporary creation myth. Since its inception in 1994, the *Cremaster* cycle has unfolded in time as well as space to render visible some of the processes by which form—in its biological, psychological and geological states—comes to be.[7]

These are the opening words of Guggenheim curator Nancy Spector's essay in the catalog of the *Cremaster* cycle exhibition. The claim here is that Barney is presenting an art of profound ontological significance, an art that reconceives not only what it is for humans to be in the world, but what it is for the world to be—in its becoming, as it is, and as it might be.

If we add to this the estimate of *Artforum* writer Daniel Birnbaum—that "No one makes a stronger case than Matthew Barney for *visual* art today; *Cremaster 3* is proof of this. *All that the world most needs today is combined in the most seductive way in his art*"—then the claim is that Barney's art is as profound as the content that it lays before us.[8] Art cannot be more highly valued than this. These comments indicate the nearly unanimous acclaim with which the professional art world greeted the Cremaster exhibition.[9] Birnbaum is riffing on a remark of Nietzsche's: "Wagner is *the modern artist par excellence*, the Cagliostro of modernity. In his art all that the modern world requires most urgently is mixed in the most seductive manner: the three great *stimulantia* of the exhausted: the *brutal*, the *artificial*, and the *innocent*."[10] In context, for Nietzsche, "the exhausted" meant an exhausted people, a subjugated mass, "the brutal" has the connotation of directness of address, "the artificial" of a sexualized seduction, and "the innocent" of the idiocy that results. In a gesture typical of our times, Birnbaum goes on to repeat Nietzsche's list of stimulations, but substitutes for innocence (a quality actually not so hard to find in Barney's world, where it takes the form of a total openness to experience), "the pure joy of the beautiful." To do so, however, he has to omit the political force of Nietzsche's insight, which we

might update (via Benjamin and Debord) as follows: a total work of art, in the conditions of contemporaneity, presumes as its audience a constantly stimulated, perpetually distracted but fundamentally inert, exhausted people. The most pertinent question we can ask of the *Cremaster* cycle is this: How, and how suggestively, does it both acknowledge and seek to overcome this condition?

The impact of the Cremaster exhibition was so great that it overwhelmed many of those who were disposed toward posing such critical questions. *Village Voice* art critic Jerry Salz, known for his antipathy to the seductions of the institutions, and alert to the politics at stake in the early months of 2003 as the United States prepared to invade Iraq, nonetheless celebrated Barney's art as "absolutely American" and as having come just in time to save an "art world . . . in crisis." He concluded: "Even though his art can be oppressive, fussy, grandiose, melodramatic, supermale, hollow, hokey, dogged, and daft, I'm smitten by it."[11] Sadly, this list of adjectives could have been applied, with little modification, to U.S. foreign and domestic policy under the Bush administration.

The *Cremaster* cycle takes the form of five feature-length 35mm films and a growing number of videos, drawings, collages, sculptures, and installations that relate directly to the films. Spector accurately characterizes Barney's visual language as "protean: drawing and film unite to engender photography and sculpture, which in turn produce more drawing and film, in an incestuous intermingling of materials that defies any hierarchy of artistic mediums."[12] This adroit switching between mediums gives much contemporary art its instant recognizability as contemporary art.

Cremaster 1, made in 1995, is set in the Bronco Stadium, Boise, Idaho, the artist's hometown. In one of the two Goodyear blimps that float above the field, a woman personifying the Goodyear tire company uses bunches of grapes to manipulate the troupe of dancing girls—clad in updated Busby Berkeley costumes—into various formations on the blue Astroturf below. They take the shapes of still-androgynous gonads, symbolizing pure potential.

Shot in the Canadian Rockies and Utah in 1999, *Cremaster 2* has three contrasting themes, yet each relates to the desire for backward movement in time. The movement of glaciers, replicated as reflections, the stories of Mormon murderer Garry Gilmore and of escape artist Harry Houdini (the latter played by Norman Mailer, whose book *The Executioner's Song* was a study of Gilmore), and the life of bees, whose behavior patterns are shown to play out in Gilmore's life.

6.2. Matthew Barney, *Cremaster 1: The Goodyear Waltz*, 1995. Production still. (©1995 Matthew Barney. Photograph by Michael James O'Brien. Courtesy of Barbara Gladstone Gallery, New York.)

Cremaster 3 (2002) connects the construction of the Chrysler Building in New York to that of Solomon's Temple and provides a setting for an escalating clash between personifications of Hiram Abiff, architect of Solomon's Temple and archetypal Master Builder in the Masonic Order (played by sculptor Richard Serra) and the Entered Apprentice (played by Barney). Surmounting the five levels of initiation into the Masonic rites drives this episode, as its does the interlude (subtitled "The Order"), in which Barney overcomes complex obstacles at each level of the Guggenheim Museum's rotunda, themselves now symbolic of each of the films in the *Cremaster* cycle. This film is framed by a prologue and epilogue steeped in Celtic mythology.

Filmed on the Isle of Man during 1994, *Cremaster 4* stages a motorcycle race between two teams traveling in opposite directions around the perimeters of the roughly circular island, representing in turn the cremaster muscle ascended, thus undifferentiated but tending to the feminine, and the muscle descended, thus tending to differentiation and the masculine. The teams are, however, symbolically tied to each other. Meanwhile, Barney plays the Laughton Candidate, a satyr growing toward maturity as a four-

horned ram: he tap dances his way through the floor of a pier, drops into the water, then burrows along a Vaseline-molded, intrauterine underground tunnel, striving to reach the finish line before the cyclists arrive and thus achieve a biology-transcending unity of opposites. Just before the convergence occurs, the screen goes white.

Declension is finally attained in *Cremaster 5* (1997). Set at key sites in Budapest—the Széchenyi Lánchíd (Chain Bridge), the Opera House and the Gellért Thermal Baths—it performs, as if in a dream, the longing, despair and eventual death of the Queen of Chain (played by Ursula Andress) and her diva, magician, and giant (all played by Barney).

This description is just the most schematic outline of a set of films and related works in various mediums that not only contain a multiplicity of allusions to other films, art, historical situations, and mythologies, but also are also replete with cross-references to the details and the connotations of each other.[13] Yet narrative is the driver of the *Cremaster* cycle—and it drives it in a masterly fashion, even though, as I will show, its message places masculine power plays into an ambivalence that strives, nonetheless, to remain powerful. Despite its frequent indulgence of high camp smarts and its warm embrace of over-the-top satire, the cycle offers no easy exits into the smug mockery that characterized superficial lifestyle postmodernism. I take Barney to be an artist who means what he shows. As Birnbaum gasps: "His ironic sophistication notwithstanding, Barney is a believer in the 'meaning of meaning'—in the possibility of sense and actions to carry it."[14]

In mainstream movies, highly stylized performance is a common contrast to the naturalism or genre acting that still prevails. In genre parodies, such as those of Quentin Tarantino, George Miller, and the Wachowski brothers, over-the-top becomes the prevailing register. Some directors, notably the Cohen brothers, combine both. All roles in the *Cremaster* cycle are allegorical enactments of a part in the overall narrative described above. Many characters, especially the women, are ciphers, and there is abundant use of choruses (dancing girls, scantily clad hostesses, TV presenters, and water sprites). The major characters move between striving for selfhood, for some kind of effective agency, and becoming the personification of an ideal, a state of mind, or some zone of achievement. Like all hermetic presentations, the spectator is invited to become a fascinated participant, one who succumbs to seduction on its terms, to the conceit that this enormous effort is being put out to communicate to you, just you. An element of the fascination is that you feel, at the same time, that all this would occur, in some mythopoeic world, anyway. As if these characters are destined to pursue their fates on

the other side of the glass wall between you. By opening this aperture to the imaginary, the *Cremaster* cycle—like other quest adventures (such as the enormously popular *Lord of the Rings* and *Harry Potter* films)—asks you to suspend disbelief and sign up for the ride, or spurn it and walk away.

While strikingly novel, Barney's imagery always seems to evoke an earlier image, style, or look. Sometimes this is because the images have been seen before, but in different, now marginalized contexts. Popular culture is a typical source of imagery: in this case, Barney uses the aesthetics and ritual of particular subcultures to the full, to both show off their wares and to advance his plot—the ethos of the cheerleaders and airhostesses in *Cremaster 1*; of Utah State Troopers, the Mormon Tabernacle Choir, and a Western tap-dancing duo in *Cremaster 2*; of Masons, builders, bartenders, and horse-handlers in *Cremaster 3*; of motorcyclists in *Cremaster 4*; and of the fantasy world of opera in *Cremaster 5*. It adds up to an iconography that gains its decodable meanings, its iconology, from its place in the plot. And the hired protagonists seem proud to pose for photographs documenting their roles, however bizarre their performance may seem in comparison to their usual behavior. For example, during an interlude on *Cremaster 3*, professional handlers conduct a race at Saratoga Springs in a regulation manner, with all the usual panoply, accoutrements, and care, except that it occurs between flayed, écorché horses.

"The sculptural" in the *Cremaster* cycle is even more volatile than it was in the hands of Gehry at Bilbao. Barney insists that his basic vision is sculptural: "The project was always going to be sculptural work that had a moving narrative component and a still-image component, and then collectively it would be a projected sculpture."[15] His earlier work consisted mostly of performances in which he would put himself through exacting tests, using equipment derived from body shaping and athletic training. He was in fact an athlete, and the five tasks of "The Order"—the centerpiece of *Cremaster 3*, the central film of the cycle—involved him scaling the inner walls of the Guggenheim Museum rotunda, and emerging victorious (or at least on his feet ready for the next trial) from a set of physical and psychological confrontations on each floor. This was a time trial: Barney had to overcome the obstacles before some Vaseline—its blocks smashed by the sculptor Richard Serra until they became liquid then fed by him into a conduit commencing at the top floor—flowed down to the bottom. That Barney in this ultimately narcissistic exercise went too far over the hi/lo boundary is demonstrated by the fact that having to describe "The Order" tempts Spector into her one somewhat caustic comment in her long hagiography of the

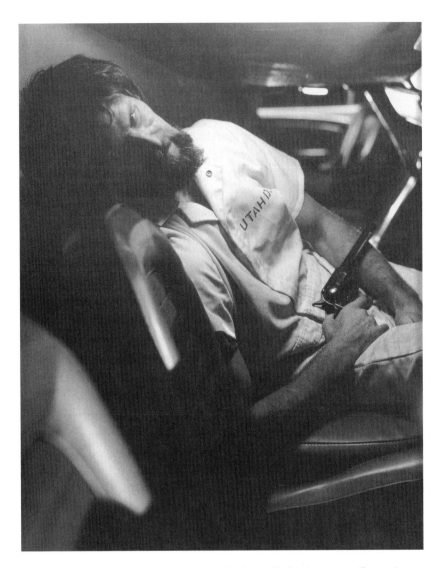

6.3. Matthew Barney, *Cremaster 2*, 1999. Production still showing Gary Gilmour in car. (©1999 Matthew Barney. Photograph by Chris Winget. Courtesy of Barbara Gladstone Gallery, New York.)

young master, when she characterizes it as "*Let's Make a Deal* meets *American Gladiator*."[16]

Time is treated in so many distinct ways that it becomes like a set of accents. Not only were the five films created out of sequence, but also their internal sequencing allows for multiple points of entry and at least two sets of

beginnings and endings. Their pacing varies considerably, but not randomly: the spare rhythms of Michelangelo Antonioni haunt *Cremaster 2,* while the operatic scenarios of Lucio Visconti adorn *Cremaster 5.* The narrative itself moves chronology forward in increments that seem to be evolving a logic of inevitability even as they loop back over the time apparently being specified to merge into a previous time, often long before: the warping between Gilmore's murderous moment in the 1950s and Houdini's act at the World's Columbian Exposition of 1893 in *Cremaster 2* is an obvious instance. It is astonishing to realize that only ten lines of dialogue are spoken in the five films: Jonathan Belper's score drives much of the mood. But images are the main currency, images of objects and people and places, brilliantly lit and tonally consistent, stunning to look at, then converging in ever-increasing intensity, one astonishing visual hit after another.

The *Cremaster* films are sculptural in that their timing is shaped as if modeled: for example, there is a strong preference for camera takes that imitate the movements of a spectator around a three-dimensional work of art. The effort of these films to generate volume is palpable. The demolition derby in *Cremaster 3* is a dramatic realization of the process of pounding material into shape. In the same episode, the Master Builder, played by Richard Serra, builds a sculpture within the upper room of the Chrysler Building in order to ascend to his apotheosis in the building's famous art deco cone. (None of this fits Serra's aesthetic, especially the idea of building a sculpture in order to climb on it to get somewhere else.) The actions of the characters are, constantly, spatial. For the ubiquitous production stills, they regularly fall into positions in relation to the objects within the film with which they have so closely interacted. Object, body and space regularly interpenetrate throughout the films. This occurs quite graphically at times, at others by inference, at still others with a touching awkwardness, as if the actual, material limits on merging one kind of matter with another was being sensed. These latter moments, however, are rare: mythic metamorphosis seems, most of the time, ready to occur at any moment.

Of course, objects from the sets of the films become in themselves sculptures, to be displayed in galleries as installations and as freestanding art works. Some *Cremaster* sculptures remain quasi-props; others stand out as emphatic, if hybrid, sculptural statements. *Partition* (2002) consists of an undulating bar stool made of cast thermoplastic, Masonic bar stools, an overspill of jellied potatoes onto Astroturf, and a built-in refrigeration system that spawns crystals. It evokes an important sequence set in the lobby of the Chrysler Building from *Cremaster 3,* but fails to engage and challenge its

space when shown in isolation. In contrast, *Lánchíd: The Lament of the Queen of the Chain* (1997), while also a hybrid structure derived from *Cremaster 5*, is self-sufficient as an installation that seeks to materialize the state of mind of both the grieving queen and the spirit of Houdini, alluding to both the bridge in Budapest and the chimera of melancholy memory. Also powerful as sculptures are those inspired by the demolition derby in *Cremaster 3*, but in no sense a prop or an illustration. Notable among these is *Imperial* (2002), which forces together great blocks of marble, casts of car hoods, concrete slabs, and steel clamps into a form bursting with tension, and does so in a manner that combines the gravitas of minimalism, the grace of good design, and an undercurrent of collapse and injury that animates the whole with a quality of performed perversity that is a signature mood of the artist.

All of these objects, inside the films and out, have the pronounced quality of a fetish. They tremble with the aura of being taken for something more than their material character, they are invested with the desires of *Cremaster* characters, and they bear the traces of having tried—and failed—to limit the enactment of desire, thereby generating yet more delirium. In this sense, they become mechanisms of desire, models of what Deleuze and Guattari call "desiring machines."[17] There are well-known precedents in the history of art, from the great allegorical cycles of the pleasures in baroque and rococo painting to Marcel Duchamp's *Bride Stripped Bare by Her Bachelors, Even* (1915–23), a famous symbolic rumination on onanism and impotence. The *Cremaster* cycle is an even more elaborate allegory of the nature of gender, voyeurism, spectatorship, and fetishism than Duchamp's preoccupations (themselves persisting throughout his life, culminating in *Etant donnés* [1946–66]). The cremaster muscle provides imagery throughout. Oedipal struggle is the upfront action in *Cremasters 2, 3*, and *4*. Socially fixed gender roles are shown in their most conventional forms in each of the films. But the main activating force is the mutability of gender, the transmissibility of qualities between the sexes, their splitting and fusing. This happens in a variety of dispersed but connected locations, all of which treat the body as the site of the psychic: inside bodies (the ongoing saga of the cremaster muscle), between bodies and objects (insemination by a séance table), bodies and territories (the muscle and the cyclists racing around the Isle of Man), objects and other embodied objects (the twin Mustangs of Gilmore and his girl joined at the gas station by a honeycomb tunnel), and many other combinations. We arrive at what may be the main theme of the cycle: the fantasy of a sexuality that goes beyond not only the socially-constructed roles of male and female, but also the fluidities of masculinity and femininity. A

"third" sex, free from the normative ideological pressures of the past, able to switch gender qualities at will, to mobilize aspects of sexualities of all sorts, wide open to the multiple possibilities of the future.

This theme takes a strong current in the sexual politics of the last three decades, and ratchets it up one notch, into a kind of overdrive. Into a domain in which excess alone rules, and does so in a sea of undecidability. The work invites our surrender to this state, offering us manifold pleasures if we do so. But it offers no way forward, nor any substantive connections to the world we have left. This state is dramatized in *Cremaster 5*, the "last" film in the cycle, at the "conclusion" of the narrative, at least as it concerns the muscle metaphor. The moment of its "declension," its definitive move towards masculinity is played out in the gorgeous Gellért bathhouse. As the personification of the giant, emergent from the barnacles that shackled him, Houdini-like, in the river, Barney stands naked except for the fish-scale sheathing of his legs. The pool water laps at his scarcely visible genitals, as do a chorus of Eurasian water sprites. It is a staggering visualization of the scene of masturbation. But the climax is, of course, an anticlimax: six white doves flutter upwards, lifting the colored streamers that in turn elevate—or do they?—the defining muscle.

Theorists of the representation of sexuality often point to the preponderance in erotic imagery, advertising, pornography, and film—to say nothing of the history of Western art—of the female form and to the seductive call of degrees of explicitness in showing its erogenous zones. A corollary of this is that the revelation of the male form depends, for its impact (both erotic and as a symbol of power), on its inexplicitness with regard to genitalia. The phallus is evident metaphorically, in the whole or parts of the figure. The penis itself is hidden or diminished. The *Cremaster* anticlimax may be the visualization of this phenomenon, and therefore, relatively conservative. (This may be an effect of the increasing explicitness of porn during the Internet era and the prominence of aroused genitalia in even "soft porn" broadcasts during the past decade.) Or—given that it is not the last scene of the film (that, like the exhibition, is reserved for a mortuary display of Houdini's manacles around which live chickens roost)—it may be an instance of a structure that, as we have seen, animates the entire cycle: the powerful pulls towards binarism, to the either/or of divided genders, cultures, and societies that Barney recognizes but constantly opposes with a refusal of the binary, with the seductions of the unformed, the uncertain, the undead, the undecided, the ambiguous, the ambivalent, the both/and. In my view, the bathhouse fantasy is an instance of the latter, realized in a childish fairy-

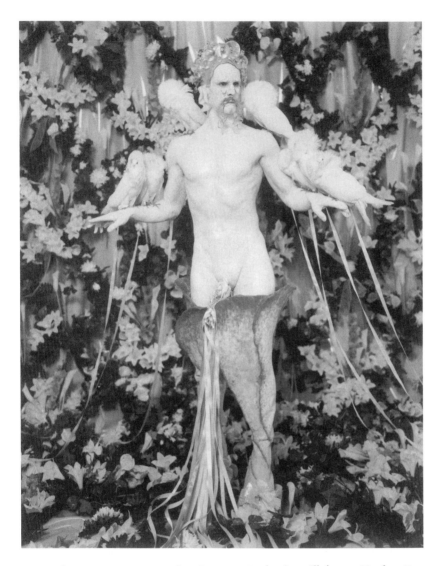

6.4. Matthew Barney, *Cremaster 5: her Giant*, 1997. Production still. (© 1997 Matthew Barney. Photograph by Michael James O'Brien. Courtesy of Barbara Gladstone Gallery, New York.)

land, one that consciously recalls the angel iconography of Philipp Otto Runge's images of the soul's innocence. That is, it is an example of a moment where the social circulation of ideas has outdistanced the artist's art. It is a (rare) failure of Barney's projective imagination. Yet it occurs at the "climax" (in narrative terms) of the entire *Cremaster* story.

We have come to the crunch. How successful is the *Cremaster* cycle in showing us what it feels like to *be* these days? The romanticism revived so yearningly in *Cremaster 5* recalls the earlier reference to Wagner. In a 1998 conversation between Daniel Barenboim and Edward Said on the topic of the nature of the shift in Western music between Beethoven and Wagner, the conductor says that "The thing that has always struck me as quite extraordinary about Wagner (and also the parallel development in the late nineteenth century of the huge novel by Balzac and Dickens) is the feeling that you can no longer rely on the world, but you have to make your own world. For me, the most extraordinary moment in Wagner is the beginning of *Rheingold* where, in a long series of sustained E-flats, he wants to give you the illusion that the world is being born, and that he is making it come alive." To which the literary critic replies: "Look at the switch from Bach on the one hand, and Hayden, Mozart, Beethoven on the other hand, and then the switch from Hayden, Mozart, Beethoven to Wagner. You could say that you could rely on God in Bach's time, but in Beethoven's time, you couldn't rely on God anymore. You had to rely on mere mortals. And Wagner says we can't even do that. We have to create a new kind of human being."[18] The interlocutors go on to discuss the Nazification of Wagner in detail. The question for us is how to make sense of an art Wagnerian in shape and scope, yet presented to us with dazzling deceits worthy of Count Cagliostro, an art that—while being, resolutely, the most up-to-date *haute couture*—calls on forms and impulses not just one hundred, but two hundred years out of their time. And how to make out this sense when this art comes to us, as it inevitably must, *after* the twentieth century?

One way would be to see it as an effort to demonstrate, via displacement, precisely those horrors that came to define the last hundred years as, for most, a time of inescapable trauma. Direct depiction of the causes of trauma is impossible: television news has the job of flooding our imaginaries hourly with surrogate images of acts of unimaginable but nevertheless unceasing inhumanity. This creates a visual repertoire that rotates between the inner lives of all of us and the public sphere in which we live out our social lives. Jacques Lacan labels this zone, located in his schema between the Unconscious and the Symbolic, as "the Real." It is described by Slavoj Žižek as "the non-symbolizable traumatic kernel that finds expression . . . in the very distortions of reality, in the fantasized displacement of the 'actual' . . . in the guise of apparitions."[19] Is it these that Barney shows us? Or, rather, is this what shows itself in the *Cremaster* cycle, what emerges unbidden through the dense thicket of the artist's intentionality? Is this what the Real looks like at the end of modernity? In its aftermath?

Let us take up this question in more specific ways. We might begin from some particulars. Why should such a "third sex" be so utterly onanistic?[20] Does the Barney persona not look a lot like the "metrosexual," a style-making identity of much interest during the 1990s to marketers who pursue with dogged desperation the behavior of trendsetters? Is the *Cremaster* cycle destined to become a minor cult, like that attending the film *The Rocky Horror Picture Show*? When we recall the perverse fantasies that became official ideologies and state systems throughout Europe in the earlier twentieth century, can we swallow the idea that "Only the Perverse Fantasy Can Still Save Us"? In the glare of the stunted ideologies and crippled state systems that currently predominate, we might ask: whose fantasy? In whose interests are we being invited to surrender in order to be saved? And from what?

Retreat from commitment—to which the artist, attuned to the driving forces of the world, is obsessively committed—vitiates the entire cycle. Indeed, it is this retreat that makes the series into a cycle, that turns narrative back to its own beginnings, and holds it short not only of artificial closure, but of accountability for the issues it raises. Barney is irresistibly drawn to narratives of staged competition, of ascension achieved through individual prowess, of weakness and irresolution being banished by conformity to tasks, attitudes, appearances set by the strong who have gone before. There is a huge popular appetite for such narratives (evident in the global consumption of quest films) and for such conformity (as the vast membership, world wide, of cults, organized religions, and civic organizations demonstrate). In the *Cremaster* cycle, their presence invites banality, no matter how luscious their appearance, how anthropologically ironic their staging.

In his early work, especially the *Drawing Restraint* installations of the late 1980s, Barney developed a three-part system as a framework for his art. Based on an athlete's understanding of the mobility of the body's energies, he generalized his system, applying it to all kinds of development. "Situation" refers to pure psychic and raw physical energy, full of embryonic potential, yet unformed and genetically indeterminate. "Condition" is the internalized disciplining and shaping of this energy. "Production" is the moment of its manifestation in the world.[21] As philosophy, this is not exactly profound, and operates to limit the conceptual depth of Barney's subsequent work, especially when he takes the step—as he did by the early 1990s when the *Cremaster* cycle was conceived virtually out of whole cloth—of believing that he could dispense with the third step and make an art that manifested the circuitry between the first two.[22] Here is one source of the underlying emptiness sensed by some commentators. It remains a yawning lack, no matter

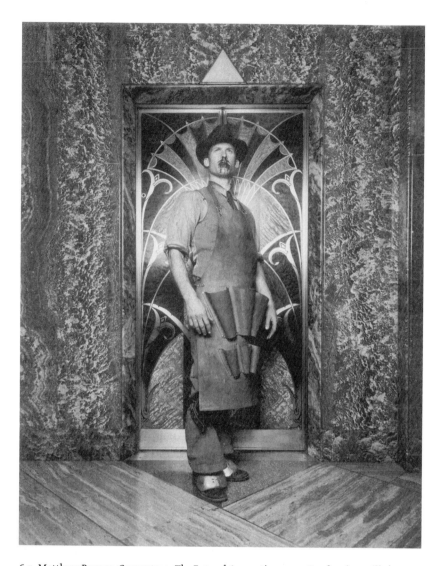

6.5. Matthew Barney, *Cremaster 3: The Entered Apprentice*, 2002. Production still. (© 2002 Matthew Barney. Photograph by Chris Winget. Courtesy of Barbara Gladstone Gallery, New York.)

how elegantly it is stylized (perhaps intellectualized) as the predictable falling-short of every imperfect, merely human product.

The Oedipal struggles that are staged throughout the cycle are subject to a similar logic. For members of the contemporary art world these struggles are most strikingly embodied in the explicit competition between Barney's

"third sex," "postmedia" aesthetic and that of Richard Serra, emblematic of macho minimalism. The drama at the core of *Cremaster 3* is a pitched battle between the apprentice, played by Barney, who is seeking to work his way through the levels of Masonic initiation by ascending the Chrysler Building as it is being built, and the architect of the building, already a Master Builder, played by Serra. Both characters reach an apotheosis of sorts, and both die—as myth demands, the architect at the hand of the apprentice, who in turn is brought down by the tower itself. An awkward plot point is that the apprentice cheats his way up the ladder, by casting a "perfect" cube shape, rather than carving it from rough stone. By implication, his character has been falsely formed, and he is destined to fail. On the level of the art world imaginary, this means that Barney has built into his own storytelling the inference that his art will always fall short of Serra's.

For many members of the contemporary art world, the fascinating puzzle here is how such a proudly independent, notoriously aggressive artist such as Serra—one who, above all, insists on the specificity of the conditions under which his own sculptures are to be seen—could submit to a subsidiary role in the art of another, an art, moreover, opposed in most aspects to his own? Above all, how could he actually act out the scene in which he splashes Vaseline, in an overt parody of a famous film and photo sequence in which he—in a gesture that has become iconic of late 1960s "process art"—threw molten lead to create anti-form works (in the warehouse of dealer Leo Castelli, in 1969)? That he did all this seems, on the face of it, not only a testimony to Barney's persuasive powers—matched only by Christo, perhaps, among contemporary artists—but to the power over all men of the Oedipal scenario.[23]

Let us return from these depths to the issue I have pursued throughout this chapter: Given that the *Cremaster* cycle set out to be the *Gesammtkunstwerk* of official contemporary art and was instantly celebrated as such by most art world gatekeepers, how does Barney's project stand to the broader conditions of contemporaneity outlined in my introduction—the multeity of incommensurable but bound together cultures, the untimeliness of multiple temporalities, the inequities accelerating everywhere, at every level? The comments and descriptions above show how imbricated the *Cremaster* cycle is in both multeity and the untimely, albeit as an indulgent celebration, mostly, of the most extreme of their paradoxes and challenges to selfhood. What about the inequities? The cycle's own form of production is relevant here: each film is distributed in an edition of ten, with two artist's proof copies. The Guggenheim curator comments: "Although copies are available for

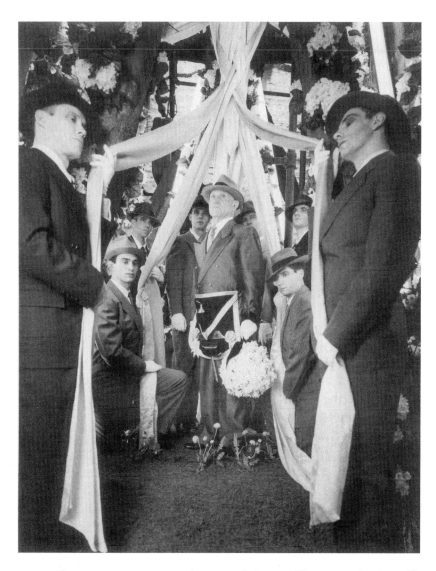

6.6. Matthew Barney, *Cremaster 3: The Dance of Hiram Abiff*, 2002. Production still. (© 2002 Matthew Barney. Photograph by Chris Winget. Courtesy of Barbara Gladstone Gallery, New York.)

screenings, this edition allows individuals and cultural institutions to actually own the film and the special vitrine that houses it."[24] There is no thought of equity here. The market rules when it comes to setting the highest possible price on scarcity. This is the other side of the coin of populist publicity, the aim of which is to bring into the museum the greatest possible numbers.

In terms of its content, the cycle, for the most part, floats above inequities. Its fantasies of control, combat, and surrender are played out between phantasmagoric figures: Goodyear and the marching girls, Mormonism and Gilmore, the Laughton candidate and the motorcyclists, the queen and her chimera. But in the centerpiece of the cycle, *Cremaster 3*, an overt battle between Capital and Labor is staged, in both symbolic and specific forms, as a struggle between class representatives and between individuals. *Metropolis*, Fritz Lang's film of 1927, appears, again, as a precedent, mutating with *The Godfather* cycle. Unionists are presented as both workers and gangsters (as some were, in actuality and in both films). The entered apprentice becomes their victim, while they attend the architect's apotheosis as fairies dancing around the maypole. The apprentice is also victimized by the Masons, who would elevate him, undergoing symbolic castration so that he might progress.

All of these personifications present work as an infantile abstraction, with workers appearing as figments floating up from an overheated unconscious. Achieving selfhood becomes a process of individual striving against odds set externally, for rewards that are proffered to the most resolute, the most conformist, the one who is most self-interested yet receptive to the unknowable system. The realities of the accelerating gaps between the lives of the rich and the poor all around the world—obvious enough in the 1930s, yet now even more vast—are entirely absent from this apparent rehearsal of the icons of class struggle. It is idealization, pure and simple. If it is satire, it is more Sterne than Swift, more *Magic Flute* than *Ship of Fools*. For all of its postmodern self-mockery in style and image, for all of its ease and innovation within the image economy, the *Cremaster* cycle contains within its core a deep desire to submit to the specular, commoditized, disjunctive world of global capital.[25] The Barneyworld logo hovers on the Guggenheim skylight as the goal of the striving apprentice clambering up the five rungs of "The Order" but also as the phantasmal limit to everyman's upward mobility, already an afterimage of that which could, at any moment now, be blinked out of sight.

Awesome. To many, however, there is something missing from the contemporary art world's institutional picture of infinite plentitude, its ecstatic subsumption to sensation. The Guggenheim Museum, Bilbao, however hard it tries, remains, as we have rephrased it, a replete yet oddly grandiloquent object. This is as much an effect of the art that is chosen for exhibition (with

6.7. Matthew Barney, *De Lama Lâmina (From Mud, A Blade)*, 2004. Performance, Salvador, Bahia, Brazil. View of undercarriage. (© 2004 Matthew Barney. Photograph by Chris Winget. Courtesy of Barbara Gladstone Gallery, New York.)

exceptions such as Jenny Holzer's bilingual installation), as it is the architecture. In a parallel sense, Roberta Smith gets it right when she sums up the *Cremaster* cycle as "a *Gesammtkunstwerk* for one, enacting a fledgling artist's search for himself in stupendously extravagant, implicitly oppressive and yet weirdly vacant terms."[26] The vacancy might result from one particular artist's shortcomings, as might the emptiness that haunts Bilbao. But it might also be a sign of the times. It may be exactly *contemporary* in the most obvious sense. "Experience" here is not only reflexive: it is being kept deliberately open, as an "empty signifier," by the museum, by contemporary art's own institutionality. Contemporary art, qua institution, has to bet that the art of tomorrow will be at first glance bafflingly other but, at base, an exten-

sion of the art of today (thus its relentless remodernizing). Yet it also knows, from experience, that some contemporary artists are capable of coming up with an art that is fundamentally other, that will force the institutions into doubt and redefinition. Barney might have been such an artist. This examination has shown that, in the *Cremaster* cycle at least, he is not.

What has happened to Barney since 2003? He followed up the *Cremaster* cycle with collaboration with American-Brazilian musician Arto Lindsay for the 2004 carnival in Salvador, Bahia. *De Lama Lâmina (From Mud, A Blade)* was a scripted performance within the parade, involving a bloc of musicians dressed as trees, a float representing a slab of the earth, and a complex narrative tracing symbolic interactions between mythological forest figures, including Ogun, Ossiam, and the Greenman. Played by an actor slung beneath the chassis of the float, Greenman masturbates against its driveshaft, which is covered with the shit of a golden lion tamarin monkey, represented by a doll with which he has intercourse. Barney acknowledged the legitimacy of criticism that he was an interloper, but concluded, "Ultimately, the situation was out of my control, so I stopped worrying about how the performance was functioning in real time and started thinking about what we needed to capture on video."[27] No immersion in the other here, just a quick visit, and a smart exit. In his reach for the postcolonial, Barney was seeking to expand his currency, but not at the expense of engaging in any kind of criticality. In the film *Drawing Restraint 9*, released in 2006, Barney returned to his initial themes, this time pursuing them through an elaborate discontinuous narrative, set on a Japanese whaling ship. He costarred with Björk, who wrote the soundtrack.[28] A renewed currency, but the same lack of criticality.

Part 3
Markets:
Global/Local

Going Global:
Selling Contemporary Art

The spectacular results achieved in recent years at much-publicized auction sales and at even more-publicized art fairs have added to the celebrity of a number of contemporary artists, and, of course, to their pockets and to the pockets of those around them. Not only dealers and curators, but now also collectors and auctioneers, line up at the studios of the most famous, impatiently wanting a piece of the action. With typical savvy, Damien Hirst leads the pack: in 2006, when he was listed as the third highest income earner in Britain (eclipsing even his first patron, Charles Saatchi), he coyly admitted, "I know I'm richer than any artist has ever been at my age."[1] In June 2006, he announced his intention to make a work that would, at an estimated £9 million, be the most expensive ever produced: a skull cast in platinum and encased in diamonds, "ethically sourced," of course. A year later, *For the Love of God*, a platinum cast of a human skull covered in 8,601 diamonds, was offered for sale at £50 million (close to $100 million). During the subsequent months it emerged that a consortium led by hedge funder Nat Rothschild had been formed to buy the work. The consortium included the artist himself and his London dealer Jay Jopling. As of late 2008, it had not been sold on. This work counts as art, not least because it unexpectedly, yet precisely, melds a centuries-old symbol of life's transience (the skull as *memento mori*) with modern consumerism's flashiest promise of eternity ("diamonds are forever," the advertisements chime). It continues the artist's signature exploration of the industries of death in contemporary life (these include religion—the work's title is both a declaration of pious hope and a colloquial expression of disgust, exasperation, and stunned admiration, precisely the mix of qualities in which his art trades). And it does so in an intensely concentrated way. The diamonds seem like a swarm, almost a disease, or at least an encrustation that has outlasted and transformed human substance.[2] There is a

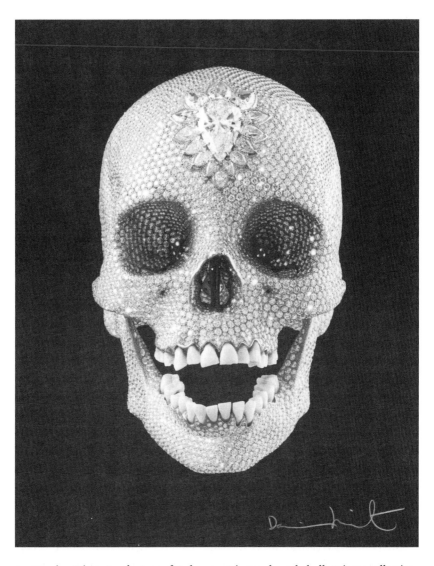

7.1. Damien Hirst, *For the Love of God*, 2007. Diamonds and skull. Private collection, London. (Courtesy White Cube Gallery, London. Photograph www.othercriteria.com. ©Damien Hirst. All Rights Reserved/ARS, New York/DACS, London.)

similar conjunction in Mexican popular culture (recently, Hirst has spent part of each year in Mexico); decorated skull imagery predominates during the Day of the Dead celebrations. The difference is that there, the skulls are made of sugar and are eaten by everybody as part of the festivities.

As a move within the market, Hirst's basic step in works such as this is to

take the principle of the "top of the market" luxury good—so central to an era that has generated astronomical profits for the few—and offer a work of art that would itself, in its singularity, be the ultimate imaginable "high-end" item. What greater convergence of art and money could there be? In this sense, it seeks to stand for art itself, as imagined by the market. The danger, of course, is that this invites money to be the primary, and ultimate, arbiter of art. While accommodating that power, yet lacing it with the message of death's inevitability, Hirst may be holding out a poisoned chalice, which attracts an even greater danger: a circuitry between art and money, accelerated by the excesses natural to both.

It is exactly this danger that is evident in the recent work of Jeff Koons, who has made a spectacular career out of selling back to the market instantly recognizable images of its own desires: such as gargantuan diamonds in gold clasps, or huge heart-shaped baubles, all polished to reflective perfection. Examples of each led the New York sales in November 2007.[3] Although instant impact imagery and outrageous expense are the most visible identifiers of contemporary art today, they are but one end of a concatenation of practices through which artworks are actually created and exchanged. Certainly, the agenda-setting dissemination of contemporary art is intensely concentrated in a few centers and is carried out by a relatively small number of dealers and auction houses, but these agents do need to go on regular searches to expand their reach, to try to capture new sources of income (both artists and buyers)—thus, the exponential growth of the art fair since 2000. Such globalizing thrusts, however, soon run into smaller scale, local arrangements. Both are changed as a result. How does contemporary art fare within this play of forces? Has it become, as some commentators fear, exceptionally and excessively market-driven? Or is its diversity outwitting both the most ham-fisted and most subtle efforts at globalization?

In Western societies during the past two centuries, and more recently in Asia and elsewhere, the primary mechanisms for selling art as it is made have evolved through these forms: the commission, the studio, the shop, the salon or academy annual exhibition, the art society or artists' association show, and the commercial or dealer's gallery. Recently, an online market has emerged, mostly for works priced modestly. Artists' collectives, government-supported art spaces, informal groups, and community associations also sell works of art, but doing so is not their main purpose. Art museums will occasionally deaccession works and will regularly refer enquiries to dealers. During the twentieth century the commercial gallery emerged as the major vehicle of the primary market. Galleries clustered in historic

city centers, close to shops selling luxury goods or near museums. Others emerged in districts where artists lived, rapidly advancing local gentrification. "Gallery districts" appeared in global cities and regional centers: in New York, for example, midtown Manhattan in the 1950s, SoHo in the 1970s, and Chelsea in the 1990s stand out in the rapidity and extent of their growth, less so their difference in character.[4] In Beijing, 798 was the first gallery district; others, such as Chaoyang, have become the centerpieces of enclaves of new wealth. From the strict "rational choice" perspective of neoliberal economics, these districts have been, and are, swarming hives of self-interest. Yet insiders claim that, for all the hype, at its core this is actually a finely honed, carefully considered system for the formation of values; that the calibrated exchanging of aesthetic values through specific venues, behaviors, and relationships is at the heart of any "art scene." To Olav Velthuis, in his *Talking Prices*, even the setting of prices for artworks participates in practices of negotiating "symbolic meaning."[5] His comparative study of the Amsterdam and New York markets for contemporary art is alert to many of the relevant distinctions, including those felt by players on both sides of the line between primary and secondary markets. Yet the scale is beyond anything experienced before, and it occurring in more places than ever before. What have been the significant changes? How has this entire structure become contemporary?

We might begin from the evident fact that contemporary art has come to dominate the market for art in general, and that the most spectacular recent sales of contemporary art have occurred in auction houses—that is, at the traditional site of the *secondary* market for art, the locus of trade in art that had stood firm in applying the tests of time and taste. This status is what every auction sets out to confer or deny. At the turn of the twenty-first century, these houses seemed not only the places of greatest excitement in the international art world but also its most visible and headline-grabbing economic driver. If we ask the basic historical question—when did this move by the auction house into the contemporary first occur, then become regular?—two results leap out from the record. The first frequent usage of the term "contemporary" in the titles of catalogs occurs during the 1960s, in connection with sales of "primitive," specifically African, art. Typically, it was allied with and distinguished from the term "traditional." It denoted art by African artists that, while perhaps derived from traditional motifs and themes, was produced recently and currently, often hybridizing Western mediums and modes. The word "modern" was rarely employed for this art (and then mostly when the artist was a long-term practitioner in a Western

metropolitan center); it is as if artists with any degree of indigenous background were deemed incapable of modernism. However, it was acceptable for them to be categorized by the (then) relatively neutral term "contemporary."[6] This distinction has persisted, most evidently in the case of contemporary Australian Aboriginal art, the market for which I will discuss in the next chapter.

The second, also surprising, result is that, while sales that included current art had always occurred, albeit sporadically, it took the auction houses a very long time to establish *departments* dedicated to contemporary art: the early 1970s for Sotheby's, the late 1980s for Christie's. Now, however, regular auctions of contemporary art seem to be leading the entire market. In June 2004, *The Art Newspaper* reporter Roger Bevan commented: "Now that a single sale has earned in excess of $100 million, as happened at Christie's on the evening of 11 May, it can safely be said that Contemporary art is the new Impressionism."[7] The implication was that contemporary art had become the latest surefire way to achieve astronomical prices and to lead sales of other categories of art. Indeed, in the sales held in New York in May 2004, contemporary art achieved more than the total paid for impressionist and modern art during that season. Additionally, the May 11 sales gained big prices not only for Jeff Koons but also for lesser known artists such as Maurizio Cattelan: $1.8 million for his suspended horse sculpture *The Ballad of Trotsky.* By season's end, in the November sales, Phillips, de Pury & Company (which entered this market in 1999) sold Cattelan's *The Ninth Hour,* the installation of the pope struck down by a meteorite, for $3 million.[8]

At the time, thirty-eight of the world's top one hundred artists were those who had become prominent since the 1980s—according to ArtFacts.Net's Top 100 Artist Ranking, which reaches back to Monet and Cézanne. If you take Warhol, Nauman, Beuys, Richter, and their ilk to be contemporary artists, a further thirty-eight would be added, making it the most prominent category. In early 2006, Picasso and Warhol outstripped all others by a factor of two, the rest of the pack being led by Nauman and Richter. Twenty-two modern artists—including Van Gogh, Duchamp and De Kooning—appeared. ArtFacts.Net calibrates its rankings according to an "economy of attention," that is, the amount of professional attention invested in artists by curators and other art world agents, and is, the site insists, "disconnected from the artist's economic success."[9] Believe that, believe anything.

Hyperbole is the lingua franca of the market; it thrives on talking itself up, pointing to the hard cash of exceeded expectation, and falling silent when reserves are not met. Let me suggest that something more interesting

is going on here. The 2004 sales confirmed the long-held perception that the auction house—or, at least, an important section of it—had shifted from its secondary, historical, supplementary role within the art system as a whole to a primary position within it. The March 2007 purchase by Christie's of the leading London-based contemporary art gallery, Haunch of Venison, along with Swiss gallerist Pierre Huber's sale through Christie's New York of part of his private collection, were further signs that these always-porous borders had eroded into invisibility. An equally interesting outcome is that the auction house has joined the modern and contemporary art museum as the most important agency in transforming contemporary art into Contemporary Art—institutionalizing it as at once a renovated modernism and a cannily retro avant-garde. In the museum world, this process has been underway for some time. But it is not a simple transfer of value: witness the problems of incompatibility that we have seen besetting these venerable institutions of modern art as they struggle to adjust to their superannuation.

Another equally interesting sign of this difficult negotiation has been a noticeable shift, since the 1970s, in relationships between contemporary artists and art museums. The hostility towards museums manifested by political, conceptual, post-studio artists was gradually replaced by the negotiations of institutional critique—not least because of the flexibility shown by curators who, as generational peers, in-house sympathizers, or independent consultants, sought to redefine their role in fresh ways, consonant with the changes in art practice. Recently, as we have also seen, a convergence of interests has become the rule—or, at least, a strong model. Yet museums, in so far as they remain modernist, simply cannot encompass those artists—such as Allan Sekula, Thomas Hirschhorn, Georges Adéagbo, the Atlas Group, Kutlug Ataman, Huit Facettes, et cetera, et cetera—whose operational strategies remain profoundly anti-institutional. At most, they may do so in token ways. While museums can comfortably show the work of a certain strong strand of contemporary art, they face significant difficulties in dealing with art that emerges from the deepest conditions of contemporaneity: from the experiences of cultural diversity, asynchronous temporalities, and accelerating inequity.

Can the auction house encompass this kind of contemporary art as it happens? Or must it persist with its established practices, hoping that a sufficiently important current of today's art, or a sufficient number of artists of any sort, will adapt to it, enabling it to stay in touch with such a lucrative source, and save it from falling back into its previous secondary position? In this and the next chapter, I propose to examine the kinds of currency

that flow around the global art market by juxtaposing the ways in which it currently operates in two quite contrary settings. First, the domains of contemporary art, most of which is produced in or near the great metropolitan cultural centers, and then, in far-flung contrast, the art of perhaps the most indigenous peoples on the planet, the Aborigines, who live in remote communities in central and northern Australia and yet produce what has turned out to be an aesthetically powerful and very marketable form of contemporary art.

Defining a Specific Market for Contemporary Art

It was in the United States after World War II that the conditions for creating a new market for (relatively) new art came into most profitable conjunction. In retrospect, it is strikingly evident that this new sector began by treating recent and contemporary American art as if it was early modern European art. In New York, a turning point was the $30,000 sale of Jackson Pollock's *Autumn Rhythm* immediately after his death in 1956 to the Metropolitan Museum. Another was the 1973 sale of his *Blue Poles* to the National Gallery of Australia for $2 million.[10] Since the 1980s, this same system has fundamentally updated itself: it now treats contemporary art as if it was modern art already. This is the market's bottom-line efficacy: if the punters come to the party, a punt becomes not simply an economic but also an art historical fact.

Among auction houses, Sotheby's New York led the way with its first "Post-war and Contemporary Art" sale in 1959. It was responding to the interests of a new kind of collector, strikingly exemplified by Robert Scull, owner of the city's fleet of Yellow Taxis, who was willing to pay top dollar for recent and contemporary art, especially if it was endorsed by such prestigious institutions as MoMA. Alfred Barr's purchase of three works by Jasper Johns from his first show at Leo Castelli's in 1958 sent out a powerful signal, as did MoMA's granting of a mini-retrospective to Frank Stella in 1961. Sculls's 1965 purchase, for a reputed $60,000, of James Rosenquist's *F-111* posited high market values for an entire generation, mainly the pop artists. But Scull also represented the new collector of contemporary art in another sense; treating art as investment, he was willing to sell as soon as profits looked ready for the taking. The sale of his contemporary collection in 1973—an art event curated by dealer Castelli—signaled that, in the words of art market historian Peter Watson, "contemporary art was at last taken seriously by the salesrooms."[11] At the conclusion of the sale, and in front

cabbies accuse Scull of profiteering at their expense. They carry signs reading "Robbing Cabbies is his Living Buying Artists is his Game" and "Never Trust a Rich Hippie." Art Worker Coalition members stage a street theater event—mock beautiful people exploiting mock artists. Women artists protest that work by only one woman, Lee Bontecou, is included in the sale. The night-time scenes outside Sotheby Parke Bernet are shot with a camera confusion reminiscent of the filmic reporting of the anti-war protests of the late '60s. Demonstrators are contrasted markedly and pointedly with ticket holders pushing by them to get in. Robert and Ethel Scull arrive in a chauffeur-driven Checker limousine. They are ushered in the back way, and up in the freight elevator. Ethel wears a long black jersey sheath emblazoned with the emblem of the Scull's Angels taxi fleet.

The auction itself is remarkable and dramatic in its filming. John Marion, president of Sotheby Parke Bernet and auctioneer for the sale, knocks down each piece emphatically. The camera pans the audience like the auctioneer searching for bids. It follows the intense round of bidding on de Kooning's *Police Gazette* ($180,000) and on Johns' *Double White Map* ($240,000). Intercut between the shots of bids being made, and as prices rise rapidly in $5,000 increments, the Sculls are shown reacting. He cranes his neck to see from where the bids are coming, while Ethel, less curious, contemplates the event with an almost sad introspection.

Robert Rauschenberg and Scull.

Robert and Ethel Scull at the auction.

At the conclusion of the sale, which comes perhaps a little too rapidly in the film, confrontation breaks out within the house itself. After making a statement in favor of artists' royalties and after kissing Ethel, Robert Rauschenberg engages Scull for the camera and accuses him of profiteering at his and other artists' expense. (A combined collage and painting of his, *Double Feature*, bought by Scull for $2500 in 1959, was sold for $90,000.) Drunk, but quite aware of his purpose, he shoves Scull rudely—"I've been working my ass off for you to make that profit." He wants Scull to buy his next piece—"at these prices." Scull concedes that he will look at it anyway. Both men are obviously conscious of the media presences and therefore the public nature of their pronouncements. Scull maintains that he's done only good for the artists by raising their prices—"I've been working for you too. We work for each other." Their

points are made and the confrontation ends in a stand-off between them. Scull, however, is clearly angered when a young, unknown man (perhaps a reporter) challenges him on the same issue of exploitation and profiteering. A yelling match takes place—"who the hell do you think you're talking to?"

It's over. Just before the Sculls leave they are told that Ben Heller had taken Johns' *Double White Map*. Ethel is saddened by the news—"it's a shame; it should have gone to a museum." Robert comforts her—"it will eventually. It will." A certain tension between them is evident. The Sculls leave, and the camera in a classical movie ending follows the tail lights of their limousine down Madison Avenue. The closing titles are followed (somewhat awkwardly for the edgy viewer) by a brief coda in which workers (again mostly black) are shown packing the pieces—most obviously Johns' bronze *Ale Cans* ($90,000)—for shipment. A worker avoids removing an awkwardly placed sticker from the bronze base of the cans—"if the patina comes off, I don't want to know about it." The finished crates, stacked against one another, are stenciled:

"Keep Dry"
"Work of Art"
"FRAGILE"

From the point of view of the film the auction is seen not simply as self-contained historical occurrence, but as a media event. The film opens, as already described, with a network report on the auction as seen on a television monitor. In another sequence before the auction Scull is shown on a television talk show which we witness on the bank of monitors in the studio control room. There, in answer to a question about his cabs, he says that his cabs will pick you up anywhere and take you to your door—"you don't have to walk anywhere." That remark ironically and unwittingly sets Scull's own privileged situation against the larger reality of the city and its common fears.

In other sequences before the auction we witness interviews with the Sculls at their apartment, where Alfred Leslie's giant portrait of Scull and Warhol's multiple photo-booth portrait of a younger and more spirited Ethel are incorporated as part of their domestic environment. In these scenes the camera focuses primarily on the Sculls and their interviewers, but also opens the frame to include the media equipment and personnel. Brief

7.2. E. J. Vaughn and John Schott, *America's Pop Collector: Robert C. Scull—Contemporary Art at Auction*, 1973. Film still of sale at Sotheby Parke Bernet, New York, October 18, 1973. (As shown in *Art Journal* XXXIX/I (1979): 50–4. © College Art Association.)

of movie cameras, Robert Rauschenberg—two of whose paintings had just appreciated thirty-six times their first, quite recent, purchase price—accused Scull of profiteering and challenged him to buy his next body of work for such sums. The artist's gesture dramatized the gap between primary and secondary sales—an absurdity when the time span was so short, an injustice when the price differential was so great. Rauschenberg was promoting resale royalties to artists as one way of bridging this gap. Auction

houses resisted this, preferring the blindstorm of steeply escalating prices.[12] They continue to do so, despite growing pressure from artists and their representatives, in most art markets around the world.

During this period, Sotheby's switched the naming of its twice-yearly sales between "Post-war" and "Contemporary," depending on the nature of the lots. In 1973 it established a contemporary art department, and has staged "Contemporary Art" sales twice yearly ever since in its London and New York houses. Parke-Bernet, having become affiliated with Sotheby's in 1964, presented the first of a series of sales, *Paintings and Sculptures, Including Important Examples of Impressionist, Post-Impressionist and Contemporary American Art* in its New York galleries in 1968. "Contemporary" meant mostly "modern," but this sale did include recent work by Ben Nicholson and Franz Kline.[13] Christie's presented its first contemporary art sale in London in 1974, and, from 1978, has held regular sales twice each year in both London and New York. By the 1990s, auction houses everywhere tended to divide their sales into this historical sequence: impressionist, modern, postwar, and contemporary. The borders could become quite fluid, and were often paired, depending on the capacity of the works available to maximize prices on any given night.

Irresolution as to the names of house departments reflects the fact that, despite the famous sales mentioned above, the secondary market for contemporary art took some years to become firmly established. The primary reason for the delay may have been the uncertainty of the global economy during this period: the unpredictable booms and crashes after the oil crisis of 1973 that continued until the severe shock of 1987. Yet art in general attracted enormous amounts of money during this same period. The Mei Moses Annual All Art Index clearly shows that from 1953 to 1983, the total spent on art in the United States matched closely with the total return from shares in the top five hundred U.S. companies as measured by Standard & Poor's. From 1973, those with money began to place more and more of it in art. Reacting sharply to the stock market collapse of 1987, investors shifted in droves to art; in 1988 art values were four times higher than returns from stocks. Over the entire period, however, the annual rate of appreciation from both remained roughly the same, at a little over 12 percent.

Contemporary art benefited from this larger shift, but did not at this stage have a prominent role within it. Christie's New York office waited until 1988 to create separate departments of postwar art (1945 to the late 1960s) and contemporary art (defined as works dating from the prior twenty-five years). In November of that year, the house sold thirty-two works from the

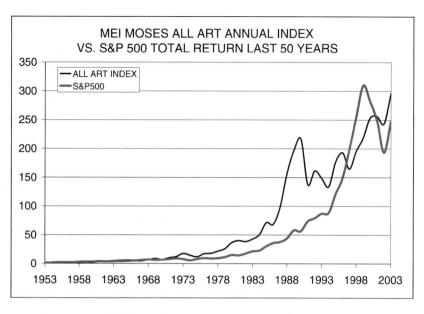

7. 3. Mei Moses Annual All Art Index vs. S&P 500, 1953–2003. (Reproduced by permission of Jianping Mei and Michael Moses, *Mei-Moses All Art Index*, http://www.stern.nyu.edu/om/faculty/moses/FineArt/2004ALLARTINDEX1953.pdf.)

Tremaine collection, including a 1955 Johns, *White Flag*, which made $7 million. The next day, dealer Larry Gagosian paid $17 million for a later Johns, *False Start* (1959) from the Ganz collection. This sale, along with that of the Ströhler collection of pop art the same month, established Johns, Warhol, and other pop artists as key transition figures from late modern to contemporary art and arguably marks the beginning of a boom in contemporary art at auction that continued until 2008.[14] It also showed that the auction houses were poised to take over from all but the most resolute dealers the trade in recent, even new, art. The secondary market, long devoted to trading in historical commodities and to consolidating the fallout from the testing process, was being primed. The economy in its most unadorned form was meeting contemporary creativity with the same one-to-one exactitude that it did in everyday retail. To an economic rationalist, no more basic indicator of the deep entrenchment of the contemporary in reality could be imagined.

The Mei Moses index also shows that while the buying of art dipped somewhat during the early 1990s, it picked up strongly as the decade progressed, reflecting, above all else, the rapid growth of the market as a whole and the

quite spectacular rises in the value of the leading companies. By the end of the decade, returns and art matched each other, switching back and forth at stratospheric levels. There was simply lots more money available for purchasing luxuries such as works of art and a greater need on the part of those with enormous wealth to circulate it. Economists all over the world have tracked the recent concentration of wealth in the hands of smaller percentages of people within national economies, as well as their increased capacity to spend and invest it abroad. In their study of income distribution in the United States from 1917 to the present, Emmanuel Saez and Thomas Piketty show that the wealthiest 10 percent of the population have recently recovered the 50 percent of the national income that their predecessors enjoyed during the boom of the 1920s. Since the 1980s, the corrections introduced by the Depression, welfare state policies, and World War II have been rapidly erased. Income is being concentrated at unprecedented rates and in unprecedented quantities.[15]

Why Spend It on Contemporary Art?

These remarks relate to the increasing capacity of the very wealthy to buy art—any kind of art (indeed, almost anything). Why, then, their growing concentration on *contemporary* art? One negative answer might be that other sectors, such as European old masters, have become a finite resource: those in private hands are less subject to being prized loose by economic necessity, war, or taxes, and museums, already inherently conservative, have become less and less likely to part with their masterworks. Sales of late-nineteenth- and early-twentieth-century modern masters have remained strong, but a gradual decline in quality has been noticeable, especially since around 2000. The prominence of contemporary art in the secondary market is the result of a number of particular factors working together.

From the late 1980s, the leading houses cultivated new clients who were encouraged to buy from them—often in much publicized sales—rather than from commercial dealers in more private circumstances. The booming interest in Soviet pop and conceptual art (known as Sots Art), for example, led houses such as Sotheby's to go straight to the artists for stock. Certain collectors bought new work at such high prices and on such a scale that their tastes began to have a definitive impact on the nature of the art being made—as we saw in the case of Charles Saatchi's support of the yBas. These changes led Watson to observe that, "By 1992 collecting contemporary art had turned on its head. It used to be that this field took nerve and involved

going out on a limb, but in the Seventies and Eighties this changed. More and more people were at home with newness and thrived on change; the shock of the new was less and less disconcerting."[16] One reason perhaps for this confidence was that the market for contemporary art was, by then, a generation old. Despite the incoherent confusion that naturally attends the present, sage observers could see that contemporary art had developed its distinctive structures for processing value: its major masters, its identifiable trends, its capacity—amply demonstrated by artists such as Koons, Hirst, and Murakami—to keep up the shock value while actually making judicious compromises with collector taste.

For auction houses around the world, Andy Warhol is the figure who defines the transition from modern to contemporary art. Works by him— inevitably tagged as "icons"—frequently appear as the last works to be offered in sales designated "postwar." Typically, they will be the first on the block in contemporary sales, not only in New York and London, but also in peripheral and new markets. Discerning houses will confine his work of the 1960s and 1970s to the first category, and his later work to the latter. When the two categories are combined, however, he becomes a central figure, setting the look, buzz and standards for both. Such positioning reflects not only the art historical facts (for the United States, Warhol is the switching point between modern and contemporary culture, albeit one that keeps on being thrown), but also the greatest potential to reap high prices. Celebrating its $239.7 million, world record–breaking postwar and contemporary sale in New York on November 15, 2006, a Christie's representative noted:

Never before had a group of Warhol works of this magnitude been presented in one auction and Warhol's genius hovered over the sale throughout the evening. The choice selection of the artist's works attracted bidders and buyers from around the globe. The top Warhol of the evening was *Mao*, one of the finest examples of Warhol's greatest and most sensational series of the 1970s, which realized $17,376,000, a new world auction record by the artist. *Mao* was bought by Mr. Joseph Lau, a private collector from Hong Kong. Mao's image was closely followed by that of unforgettable Hollywood legend Marilyn Monroe. *Orange Marilyn*, estimated at $10–15 million achieved $16,256,000. *Sixteen Jackies*, a reverent depiction of an exceptional First Lady and a sober artistic response to the assassination of John F. Kennedy in 1963, brought $15,696,000. In total, the eight works by Andy Warhol offered in the sale realized $59,712,000.[17]

Within six months the single-work record was eclipsed by the $72 million paid for Warhol's *Green Car Crash (Green Burning Car I)* at Christie's in New York, itself topped a few months later by U.S. hedge fund manager Steve Cohen's purchase of the artist's *Turquoise Marilyn* (1964) from a Chicago collector for $80 million. These sales helped make Warhol the overall market leader in 2007: seventy-four multimillion dollar sales of his works from the 1960s to the 1980s netted a total of $420 million, eclipsing sales of works by Picasso, which made $319 million. For the first time, a contemporary artist topped the ranking based on total revenue generated by public sales of his or her work.[18]

A blunter measure of the viability of the demand for contemporary art during this boom period has been the fact that those who returned their collections quickly to the market or who handed freshly bought work over to public institutions in exchange for massive tax breaks found that they had made considerable gains.[19] Almost all the prominent collectors did this, with as much calculation (but much less sentiment) as they showed in forming their collections. Outstanding among these was the disposal by Charles Saatchi, through Christie's London in December 1998, of 130 works of 1990s art from his collection, including works by Damien Hirst, Rachael Whiteread, and Cindy Sherman, as well as lesser known artists (at the time) such as Gary Hume, Ron Mueck, and Hiroshi Sugimoto, for prices well above those being asked by these artists' galleries.[20] Even quite esoteric collections gathered by art world insiders could secure high prices and loads of publicity—thus the forced sale of Dr. Bernardo Nadal-Ginard's collection of cutting-edge art, at Sotheby's, London, in May 1997. On January 16, 2005, Saatchi sold Hirst's *The Physical Impossibility of Death in the Mind of Someone Living* (1991)—which he had acquired from the artist in 1991 for £50,000—to American collector Steven A. Cohen for £6.5 million (then US$8 million). In the May 2006 Christie's sale in New York, Saatchi secured $1.19 million for a "small and provocative" Marlene Dumas, *Feathered Stola* (2000), that he had featured in The Triumph of Painting, Part I, exhibition at the Saatchi Gallery in 2005.[21] He had bought the painting two years prior at Christie's, London, for £184,450.

While the thirst for quick profit drives these men in their collecting as their other money-making activities, the income of some of them is so great that these outlays are relatively minor: in the year that he bought Hirst's shark, hedge fund manager Cohen earned over $1 billion. As Velthius notes, "These buyers have a tremendous surplus of economic capital and an equally large deficit of social and cultural capital," which leads to the problem that

"this quest for status has introduced more money into the contemporary art market than it can readily absorb."[22] What this feeding frenzy does to the contemporary artist is at once celebrated and ironized in Tracey Emin's photograph "I've Got It All" (2000), in which she depicts herself, clad in a Virginia Westwood dress, spread-eagled on the floor of her studio, stuffing gold coins and notes into her crotch.

Also relevant to the boom was the "monetarization" of collecting itself during the later 1980s: at the initiative of Geoffrey Deitch, then at Citibank, banks began to lend to clients against the paper value of their art collections. This released vast quantities of money into the hands of those most likely, and best positioned, to spend it on art. It did so at a time when money was extraordinarily cheap: interest rates between 6 percent and 10 percent in the 1980s soon fell, arriving at 1 percent in 2003. At the same time, auction houses themselves began lending clients funds against their intended bids for high priced items (a lucrative practice, even after defaults—Sotheby's recouped its losses on Van Gogh's *Irises* [1889] when the Getty Museum picked it up in 1990 after the financial meltdown of Allan Bond, corporate criminal from Western Australia). This practice has expanded since that time, with auctions houses conducting bidding wars for much-sought-after items by offering to sellers very high guaranteed minimum prices. The abstract value of money, its potential to activate any type of exchange, meets art in its most abstract form: the innovative creation of new value that is embodied in all art, and which is definitive of contemporary art.

This attraction is, at root, the driver of the art-money exchange. It is known that the sudden boom in the international market for impression-ist and old master art during the 1980s was propelled, in large part, by the need to rinse illicit Japanese capital. The recent, rapid accumulation of large amounts of money in post-Soviet Russia has led to a similar effect, although its beneficiaries seem to be concentrating on Russian art and modern mas-ters. While these were, to a degree, adventitious occurrences, the globaliza-tion of international economies and the deregulation of national ones has led to an expectation that new players able to expend vast sums will continue to appear. The leading auction houses have, in recent years, initiated sales of contemporary art in Tokyo, Shanghai, Beijing, Dubai, and elsewhere. These have included the classic offerings of works by Warhol, Koons, and Hirst, but their main purpose is to establish high prices for local or regional art-ists who are achieving some success on the international circuit. All of these cities are centers of sudden bursts of economic growth, and are the homes of small numbers of potential collectors with extraordinary, recent wealth.

7.4. Tracey Emin, "I've Got It All," 2000. Polaroid print. Saatchi Collection, London. (Courtesy of the artist and Jay Jopling/White Cube, London, and Lehmann Maupin Gallery, New York.)

The market is globalizing: new collecting styles are being created. In 2007, China displaced France as the third largest market in the world for art, after the United States and the United Kingdom.[23] In April 2008, Sotheby's sold $51.77 million worth of contemporary Chinese art in three auctions in Hong Kong, mostly to buyers from the region. A record price of just over $6 million was achieved by Zhang Xiaogang's *Bloodline: The Big Family No. 3*, a "cynical realist" painting of 1995 depicting a family posed for a photograph during the Cultural Revolution: the bright uniform of the child contrasting with the muted tones of his haunted parents.

A further factor may be that contemporary art—the production and

reception of which is often tied to generational turnover, and the value of which is, in significant part, its very contemporaneousness—is especially suited to service a ruthlessness deeply rooted in a kind of collecting that prioritizes return on investment. It is, perhaps, one of the characteristics of our contemporaneity: the cacophonous simultaneity of generational succession as distinct from its orchestrated progression, the instant attraction of presentness as opposed to history's gravity. Another characteristic, not so new but perhaps unprecedented in its speed of execution (and therefore naked to observation), is the coexistence of aesthetic values at their most creatively disinterested and the stripped, value-free drive of money towards the conditions of its maximum replication. Everything—making, consuming, retailing—is fixated on happening *now*. Noting that the art market was now dominated by what he called "a superbreed of the new rich" whose primary interest was contemporary art, a representative of Sotheby's, London, interviewed after the company achieved £88.7 million at its July 2006 auction, commented, "People making large sums of money want new things. The kind of work being made at the moment also helps, because only a limited connoisseurship is required. Anyone can tell what is going on in a Damien Hirst."[24]

CHAPTER EIGHT

From the Desert to the Fair

"White people say what's good. White people say what's bad. White people buy it. White people sell it." So says Australian Aboriginal artist Richard Bell, from the Murri people, in his "Theorem on Aboriginal art." The occasion was his winning of the 2003 Telstra National Aboriginal and Torres Strait Islander Art Award of $40,000 with his painting *Scientia E Metaphysica (Bell's Theorem)*, inside which he had inscribed the words "Aboriginal Art—It's a White Thing."[1] Bell was describing—incompletely, provocatively, but in general correctly—a situation that was well-known to most of those involved, including the artists, and plainly evident to anyone with the slightest interest in the matter. Yet, despite the racism that laces Australian life like an insidious poison, there is a widespread acceptance of Aboriginal art by the broader, overwhelmingly white community and a high regard for it as a proud and positive contribution to the national culture. Australians have had a history of exceptional support for their living artists, especially since the 1960s. The local market has welcomed the entry of buyers looking for new styles of art, and is willing to collect in specialized ways, as distinct from those seeking to build a wide-ranging collection of art across time and place.[2] This attitude extends to Aboriginal art, which is one reason why, since the early 1980s, its accelerating powers of aesthetic self-replenishment and the steady spread of a deep and diverse market for its products have been unstoppable.

The emergence of the Australian Aboriginal art movement in the years around 1970 at the isolated settlement of Papunya in the Western Desert of Central Australia, and its subsequent growth throughout the Australian continent, is a great and by and large inspiring story, yet is too complex for me to tell here.[3] Essential points are that the artworks made available to the

8.1. Richard Bell, *Scientia E Metaphysica (Bell's Theorem)*, 2003. Synthetic polymer paint on canvas. Collection Museum and Art Gallery of the Northern Territory, Darwin. (Purchased 2003. Telstra Collection, Museum & Art Gallery of the Northern Territory. Winner, 20th Telstra National Aboriginal and Torres Strait Islander Art Award. Courtesy of the artist and Milani Gallery, Brisbane.)

market are not secret ceremonial objects, but surrogate items deliberately made for circulation *beyond* the remote communities. They are intended to carry sacred meanings but not reveal the hermetic knowledge that would deplete their sources. They are an attempt by Aboriginal elders to communicate their spiritual truths to the *kardiya* (a term for "white ones" widely used by desert peoples), while protecting their essential separateness and strength. A bold and risky strategy, especially for peoples living in conditions of extreme scarcity. In economic terms, the big shift from the early 1970s to now has been an upmarket one, from the intermittent provision of tourist artifacts to a fully fledged contemporary art movement. A network of nearly one hundred art centers in remote communities all over the continent has grown up sustained by government funding, staffed by mostly white professional officers versed in local, national, and international art worlds and overseen by local Aboriginal elders. These are key distributors to markets in the capital cities, primarily commercial galleries specializing in

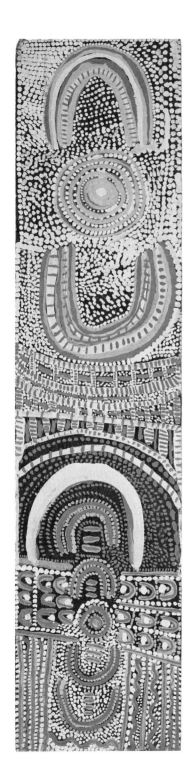

8.2. Johnny Warangkula Tjupurrula, Pintupi/
Luritja (ca. 1925–2001), *Water Dreaming at
Kalipinya*, 1973. Enamel paint on composi-
tion board. (Courtesy of the National Gallery
of Victoria, Melbourne. © 2008 ARS, New
York/VISCOPY, Australia. Estate of the
artist licensed by Aboriginal Artists Agency
2008.)

contemporary Aboriginal art, although there is much informal trafficking as well. An important part of the picture is art produced by Aboriginal artists living in the cities, usually presented in hybrid styles and often devoted to issues of minority living and ethnic identity. Of a total Aboriginal population of around four hundred thousand, between five thousand and six thousand produce artworks on a regular basis, accounting for approximately 70 percent of art sales nationally. In comparison, around ten thousand nonindigenous citizens in the overall population of around twenty million register themselves as artists. The prices for work by many Aboriginal artists have risen steeply. At Papunya Tula in the early 1970s, Johnny Warangkula Tjupurrula painted a number of works on the theme *Water Dreaming at Kalipinya*. One related to that illustrated was first sold in 1973 for $150. It reached $210,000 at a June 1997 sale at Sotheby's, Australia, and in 2000 it fetched $486,500. The artist died in poverty in February 2001.

In 1995 Sotheby's held the first Aboriginal art only auction in its Melbourne salerooms. Auction turnover for this sector exceeded $1 million for the first time (dollar amounts in this section of this chapter are Australian, then 75 percent of US$, now close to parity). In the following years, this kind of report became typical: "Sotheby's July 2003 Aboriginal art auction at the Museum of Contemporary Art Sydney was a run-away success. The record-breaking, standing-room only $7.4 million sale achieved at least one significant new auction record, established broad scale benchmarks for many artists, and firmed up more than a few trends in Indigenous art sales."[4] The "significant new auction record" was $509,300, for Emily Kame Kngwarreye's *Untitled (Spring Celebration)*, a large acrylic on linen painting of 1991 similar to figure 8.3. She died in 1996, at which time a painting such as this would have sold for around $20,000—a price closely comparable to those fetched by major living white Australian artists for works of this size and relative quality.

The highest price for a work by an Aboriginal artist ($2.4 million for *Warlugulong*, a major Fire Dreaming painting of 1977 by Clifford Possum Tjapaltjarri) was paid on behalf of the National Gallery of Australia at a Sotheby's auction in Melbourne in July 2007. It eclipsed the record set two months earlier: $1,056 million for *Earth's Creation*, a major four-panel painting of 1995 by Emily Kame Kngwarreye. Since the later 1990s, sales of new Aboriginal artworks have been reliably estimated as at $100 million annually, rising in recent years to $400 million. There is a growing international demand for this work—in the United States, for example, there are three extensive private collections and one major public one, the Kluge-Ruhe collection at the

8.3. Emily Kame Kngwarreye, *Untitled*, 1991. Acrylic on linen. (Courtesy Sotheby's Australia. © Emily Kngwarreye, licensed by ARS, New York/VISCOPY, Australia, 2008.)

University of Virginia, Charlottesville. In 2004–5, Sotheby's sold 70 percent of its lots overseas. All four major Australian auction houses held specialist Aboriginal art auctions for the first time in 2004, selling 2,500 works at a total of $11.7 million. These successes led to a glut of auctions—seven in Australia and abroad—followed by a scaling-back in 2006 towards offering fewer works of higher quality. Christie's left the Australian market altogether (the reason: at just a few percent of its world sales, the operation was too small, however locally viable), and Sotheby's cut back to single annual sales, making $8.5 million in 2005 and $3.4 in 2006, the latter including a Rover Thomas for $600,000.[5] While these sums are small compared with the spectacular prices achieved for market leaders in the New York and London sales rooms, from the perspective of the history of the local market, they are strong in two senses: they are high for works of high quality, and they show a pattern of growth and continuity.

But the current market price of these works is only one factor among many that makes them contemporary. The protest by Richard Bell cited above was targeted against the ethnological fantasy of nonindigenous people still wishing to determine the "authenticity" of the cultural work of indigenous people—a modern mindset (and therefore, by now, old-fashioned). Bell is insisting, instead, that he and other indigenous artists were quite capable of projecting artworks into a world of extraordinary

cultural multeity—including art, such as his own, that takes this very condition of contemporaneity as its subject. This is contemporary cultural value in the process of being created: in Brisbane, in his case, as it is in art peripheries elsewhere in the world.[6]

The individualization of artistic creativity and the treasuring of the artwork as a trace of the artist's uniqueness are so precious in the Western art system that it would be surprising if its influence was not felt in the making and marketing of Aboriginal art. Complex works by key artists—for example, Michael Nelson Jagamarra's *Five Dreamings* (1984) or Uta Uta Tjangala's *Yumari* (1981)—were treated as canonical, often reproduced and used as standards against which to measure similar work. They became, in a word, icons of the movement as a whole. Nowhere was this process of individualization taken to so great an extreme as in the case of Emily Kame Kngwarreye, a major painter from Utopia. Having become, in her mid-eighties, one of the most sought-after artists in the country, she spent much of her last two years coping with daily, sometimes hourly, visits from a coterie of art dealers, each of whom was marketing her work as possessing a distinctive style. They had each latched on to one aspect of her style as the "essential Emily" and were insisting that she keep producing more works in that manner for them to sell.[7]

Another reason why this art is contemporary, and quite properly marketed as such, is that the artists mentioned so far managed to create the richest and most diverse art being produced in Australia at this time. Their sale prices match those of nonindigenous artists of similar stature. Taken together, the twenty or so top Aboriginal painters have, over the past twenty years, produced symbolic abstractions the like of which is not matched by any other group of artists from any other country. Announcements of the revival of pure painting appear in art journals or in museum exhibitions every six months or so: The Triumph of Painting at the Saatchi Gallery in 2005 was yet another addition to a long line. Such exhibitions are usually feeble affairs compared to the achievement of the best of the Aboriginal artists (not one of whom appeared in the London show). In my view, only certain individuals, such as Gerhard Richter and Sean Scully, working largely against the grain of their contemporaries, could be said to be turning out a kind of abstract painting (a different kind in both cases) that matches the achievement of these Aboriginal artists, taking as criteria the terms for the acceptance of their art as art set by each of these artists themselves.

Such judgments do *not* assimilate Aboriginal art to the criteria for modernist abstraction that Scully brilliantly perpetuates and Richter brilliantly

subverts. On the contrary, they recognize the possibility that a quite other, quite specific kind of modernization of traditional painting practices has been undertaken by certain Australian Aboriginal artists, one that has entailed, as well, a strenuous and far-reaching renovation of the "arts and crafts" that they had been previously generating in missionary, tourist and educative exchanges with their colonizers.[8] These efforts have not been expended in order to place certain paintings using natural ochres on bark and acrylic on canvas into any universal art historical canon. They are the products of necessity, and of a reach (the most successful to date) toward reconciliation with the colonizing other.[9] This, too, is a contemporary creation of value, perhaps the most important one. It places, simultaneously, one, pre-ancient temporality against another, modern one. And it asserts the necessity for their coexistence, their coeval right to persist in the world as it is, and their right to contribute to the conversation that is forming the future.

Compare and Contrast

If one compares the marketing of the yBas to that of contemporary Australian Aboriginal art, it is evident that despite everything that is utterly different between them (and almost everything is), they have both benefited from the recent collapse of the distinction between primary and secondary markets, from the convergence between what used to be the quite separate provinces of the commercial gallery/specialist dealer and the auction house. None of this is accidental, although it is, precisely, fortuitous. It is exactly what makes them contemporaneous to each other, and contemporary in the sense of being of their time.

Globalization emphasizes the high premium of the present, the value of seizing opportunities offered by both scope and diversity—in art as in any other kind of business. Market-defining houses such as Christie's and Sotheby's, especially their New York and London offices, in their quest for constant replenishment of stock and basic business expansion, have come out of the secondary closet, raging. Their example means that they now face competition from new houses, internationally and in local markets, many of which seek even closer connections to art as it is made. Among the commercial galleries and at the art fairs, freshness has become itself a premium: much clamor attends shows by new artists, including those still at art school. For many buyers, contemporary art is the logical object of investments that may be most readily realized. For those who seek more from their art, the ideological grinding between globalization and decolonization that charac-

terizes contemporaneity is seen to be reflected in the most contemporary art, precisely because it is at once *of* and *out of* its time in ways that seem unique to these times. In the case of Aboriginal art, the circuitry of cause and effect is quite concrete: it is the insistence, by the artists themselves, that the prices they get through the art centers and the commercial system match those for works of similar importance and competence that they read about in newspaper reports of auctions in the capital cities. They are not interested in fine distinctions between primary and secondary markets and are in a position to withhold much-desired works if their prices are not met. A similar idea is occurring to more and more nonindigenous contemporary artists, not least Damien Hirst, who has had, in Charles Saatchi, the example of the world's most effective blurrer of these boundaries exceedingly close to hand. Hirst can now afford to have dealers such as Larry Gagosian and White Cube dance to his tune. Sotheby's, London, launched its autumn 2008 season with a one-artist exhibition by Hirst, Beautiful Inside My Head Forever, consisting of two hundred new works made for the purpose—a first for the major houses, a highpoint in the convergence between markets that we have been tracing. At the centerpiece was a life-sized animal immersed in formaldehyde, encased in a gold-plated steel box and mounted on a Carrara marble plinth. Sold for £10.3 million, it was entitled—what else?—*The Golden Calf.*[10]

When did the market for contemporary art peak? In mid-2006, market analyst Roger Bevan, who made the 2004 remark that "contemporary art has become the new Impressionism," sounded a warning. Speculating as to the trends indicated by the May sales in New York—at which Christie's made $143.19 million (returning here to US$ values), Sotheby's $128.75 million and Phillips de Pury, a house devoted to selling the newest art through auction, made $29 million, all at a 90 percent sold rate—he noted that the most hyped, most expensive works bought results from one bid only. These key examples of the work of Warhol, Hockney, Klein, and Lichtenstein were secured at high prices by dealers and collectors already heavily committed to these artists as being at the core of their collections or stables. The lack of competition led him to ask, "Have we reached the cusp of the boom?"[11] Comparative figures in the November 2006 sales were $239.7 million (although this was a postwar *and* contemporary art auction) at Christies; Sotheby's, $125.13 million; and Phillips de Pury, $26.69 million. All doubts about the perpetuation of the boom were, however, swept aside by the May 2007 figures: $870.7 million among the three houses, with prices for over one hundred artists reaching record levels. Compared to other sectors of the art

market, to previous staples like European old masters, eighteenth- and nine-teenth-century British and pre-impressionist French art, the contemporary art sector may be a massively inflated bubble representing, in the words of veteran Chicago dealer Richard L. Feigen, "distortions in art market values too blatant to be sustained."[12]

In its summer 2006 issue, *ARTnews* published its annual "200 Top Collectors" list, describing it as "a veritable who's who in the fields of finance, technology, entertainment, publishing and manufacturing." Over half lived in the United States, most of the rest in Europe, and a few in Japan, Brazil, and Venezuela. Seventy-five percent collected contemporary art. The list is based entirely on the amount of money spent each year. Expert commentators estimate that there are between 1,500 and 3,000 collectors willing to spend $1 million on art each year, and between 12 and 30 who could spend around $100 million. Opinions were divided on the fundamental strength of the market, prices having taken seventeen years to return to the highest levels of the 1980s, a moment widely (and wisely) understood to be a bubble market. Contemporary art is seen as the most inflated sector, with commentators cautious about whether it had become "a hard part of the market" or remained "an aberration." While all expect the market to change (a commonplace caution), a leading analyst remarked of the current burgeoning growth, "No one sees an end in sight."[13]

This kind of confidence needs to be measured against analyses of market trends by economists. In 2000, Robert J. Shiller published the results of his study of stock market levels in historical perspective, exploring the actual trends behind phenomenon identified in a famous remark, made in 1996, by long-serving chairman of the Federal Reserve Board of the U.S. government that markets might be subject to what he termed "irrational exuberance." Shiller undertook a long-term study of many factors, not least the differences between stock prices and composite earnings in the United States from 1860 to 2000. Not surprisingly, he noted a close relationship between the two, with the exception of the Wall Street collapse in 1929 and the subsequent Depression, until the 1960s and 1970s when prices leap, only to be brought down in the crisis of the late 1980s. Subsequently, however, stock prices took off through the top of the chart, creating what he and others dubbed "the millennium boom."[14] He was in no doubt that, to the extent that planners and others were taking stock prices as indicators of real value, the U.S. economy at least was a "bubble" economy. In 2007, he updated these figures, tracking their behavior during recent years, showing a sharp drop in stock prices and in earnings followed by more recent rises. The gap between

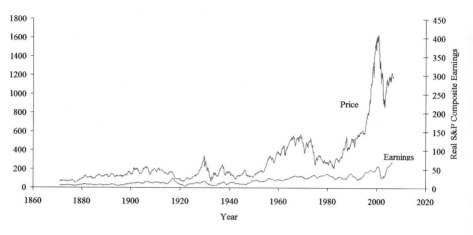

8.4. Real S&P Composite Stock Price Index vs. Real S&P Composite Earnings, 1871–2007. (Reproduced by permission of Robert J. Shiller, *Irrational Exuberance*, New Haven, CT: Princeton University Press, 2005.)

them, however, remains rather constant. And as we noted in the previous chapter, art prices remain closer to those of stocks.

The uncertainties in the market in 2007 and 2008 precipitated by the subprime mortgage crisis led to concern within the artworld as to whether the system-wide fallout will impact the market for art. After all, 2007 was the seventh successive year of price inflation. Globally, art prices rose 18 percent. Total fine art market revenue was up 43 percent to $9.2 billion, driven by 1,254 sales over $1 million; as Artprice.com commented, 2007 was "a veritable annus mirabilis for the art market." At the spring 2008 postwar and contemporary sales in New York, the three houses (Sotheby's, Christie's and Phillips de Pury) netted $972 million, eclipsing the $606 million achieved at the impressionist and modern sales held the previous week.

On September 15 and 16, 2008, the high-wire act traced in this chapter staged its peak performance. Sotheby's London offered 223 works by Damien Hirst (who else?), made by the artist and his two hundred assistants specifically for the occasion. Anxious yet eager buyers paid out $200.7 million.[15] The next day, the New York stock exchange succumbed to panic, precipitating a market freefall that tore the cover off what soon emerged as a worldwide depression. October sales of contemporary art, including Chinese and Aboriginal art, faltered. In November, works by "blue-chip" artists, such as Warhol, Bacon, Judd, Doig, and Hirst, failed to attract interest. The major houses lost $40 million each in unrealized guarantees,

and Sotheby's share price declined steeply. While the art fairs continued to do reasonable business, at the top end of the market the bubble had burst.[16]

In recent years the contemporary art fair has come into its own as an intermediary site of exchange between the primary and the secondary markets, the dealers, and the auction houses. Indeed, from the historical perspective supplied by this analysis, it may be argued that their recent rise was, precisely, a response by art dealers to the sudden prominence of the auction houses. By concentrating their otherwise disparate and largely local powers in one place, and by drawing interest from all over the world to that place, they could compete against the auction houses, themselves tending so close to monopoly that during 2000 and 2001 Christie's and Sotheby's were prosecuted for their collusion. In the early 1990s, European fairs, such as that at Cologne and ARCO (Feria Internacional de Arte Contemporaneo) at Madrid, were moderately successful.[17] From 1994, however, Art Basel undertook a deliberate globalization of the primary market, inviting dealers from all over the world (with the exception of those dealing in contemporary Aboriginal art, still regarded by the conveners as "tribal.") It has since become the world's leading art fair, rivaled only by its offshoot, Art Basel/Miami Beach. Both attract tens of thousands of visitors and exceptional media attention, have become essential high-society gatherings, and move millions of dollars of art, much of it made by artists and placed by dealers specifically for the purpose. By 2007, areas north of the city center of Miami—Wynwood and the Design District—had begun to resemble SoHo and Chelsea in Manhattan. Smaller scale fairs abound all over the world; older ones, such as FIAC (Foire Internationale d'Art Contemporain) in Paris, are experiencing revivals of interest, while new ones continue to open: the first Gulf Art Fair, for example, in Dubai in March 2007. Inspired by Damien Hirst's early efforts at promoting his art and that of this friends (the 1988 Freeze exhibition in the London docklands), the Frieze Art Fair opened in London in 2003. Two years later, it sold out its offerings, and for record prices.[18] By 2006, 152 exhibitors from 21 countries attracted 63,000 visitors, including 115 who came in their private jets. Auctions houses and galleries all over London staged special sales, making £74 million in 5 days.[19]

The art fair phenomenon has three specific features of interest to this analysis. As prices are reported quickly and become widely known, they make the private market more public, approaching that of the auction sector. They encourage private dealers to seek primary prices closer to that which the artist is gaining on the secondary market. And they offer the leading,

8.5. Miami Basel Art Fair, December 2007. General view. (Photograph by Bill Wisser.)

or the most voracious, collectors another outlet to resell recently acquired works. Some apply these principles not merely to individual artists, but to a group of artists—the "Leipzig School," in the wake of the success of Neo Rauch, for example—or even to the art of an entire city or region—that of Los Angeles, currently promoted by the Miami-based collectors, the Rubell family. Collectors are making visible the desire that drives many of them: the excitement, and satisfaction, of exercising a judgment, one that feels right in itself, and is, soon, shown to be ahead of the game, out there in front of the pack, in advance of everyone else. It is no coincidence that this is a value that parallels those that impel artists, critics, curators and even historians, who arrive in their wake, brandishing up-to-the-minute interpretations. *New Yorker* critic Peter Schjeldahl—self-confessed fan of "the erotic clarity of commerce—I give you this, you give me that," opened his column on Art Basel/Miami Beach 2006 with this observation:

> In contemporary art, this is the decade of the fair, as the nineties were the decade of the biennial. Collectors, with piles of money, have displaced curators, with institutional clout, as arbiters of how new art becomes known and rated, and therefore what it can mean: less and less, after qualifying as the platonic consumer good.[20]

Art fairs are only the most evident art world manifestation of the contemporary emergence of the superrich, those who have benefited most from the intense concentrations of wealth made possible by the expansion of capital markets within globalization. More than a spectacular purchase at auction, buying at an art fair enables the exercise of rapid judgment across a range of possibilities, with seemingly less mediation by inherited privilege, snobbish protocols, and arcane expertise. They are closer in feel to the financial markets from which most of the new collectors come. Yet the extraordinary interest aroused at the Basel, Miami, and Frieze fairs has attracted such large attendances to their main and satellite events that visiting them has come to resemble the consumerist hysteria attending sales days at department stores. Don Rubell has commented: "If you are not there in the first twenty minutes, you can lose everything."[21] Leading collectors have already found ways of securing desired purchases prior to opening. Auction houses have to fight back hard to secure premium works. There may be limits to the continuous production of cashed-up private buyers. The question "Has the art fair phenomenon peaked?" has joined the chorus of concern about the downward plunge of the entire sector. "Is this it, or are things going to get worse?" asked Sotheby's chief executive William F. Ruprecht in January 2009. He went on to predict that "You will see fewer bidders, especially from some of the emerging markets," while reverting to the mantra that sustains his profession: "there's a foundation of great collectors with great wealth who continue to be consumed with art."[22] These comments testify to the end of the boom and a return to basics in the market for contemporary art.

By focusing on the recent history of contemporary art in the auction house and its impacts on other parts of the distributive apparatus, we have highlighted just two aspects of the workings of the market for art in the conditions of contemporaneity. We have seen that its pursuit of the "top dollar" reinforces modern and contemporary art's tendency to the institutionalization of value. On the other hand, its principle-free urge to make money out of anything that someone is willing to buy makes it open to art (that is to say, new cultural value) from the most remote, non-Western cultural formations. In these ways, the market is a crucial medium not only for the circulation of contemporary art, but is also a generator of its currency. Yet this seems to have some limits. How does it stand to the other great drivers of contemporary art: esoteric commitment to its own internal interrogation, and to overtly political questioning of the world around it? The auction house has, since the 1970s, substantially backed off from these motives as too difficult to deal with, as too evidently antimarket, or as unmarketable. But, like the

commercial galleries and art fairs, it does distribute them when they take forms that are not too confronting or are purveyed by artists of incontestable stature. Outside these circumstances, such work is more commonly put into circulation by public museums, nonprofit agencies, alternative spaces, and artists' collectives, and through print and virtual mediums. There are marketing aspects to these modes, but they are minor.

Overall, we are led to complicate long-standing perceptions of the market as a reductive, convention-supporting, and culturally reactionary force. The fall of the auctioneer's hammer does, indeed, seem to freeze frame value, to hold this elusive, contingent, and contested quality in the clearest light of publicity, naked to every gaze, exposed in all its contemporaneousness, as one pure thing against every other. In fact, however, within a scenario that has been orchestrated for months so that each work targets its most likely buyer, the theater of the auction works to purify the artwork, turning it into an absolute abstraction that can be matched to a particular amount of money—that is, to an exact quantity of the greatest abstraction of them all. But it does this only for the briefest moment, for it has arrested currency at its critical point . . . within seconds, the variegated rush of values that had accumulated, then concentrated to establish this price, assert their bustling presence, quickly attracting new ones, even as the item is removed, and taken off to new settings, into the company of other carriers of value, that is to say, resumes currency.

Has this ancient system changed in response to the demands of contemporaneity? We have seen that it has let loose its inner anarchism—the "anything goes" in the pursuit of profits that is at the heart of capitalism—and has developed an increasing capacity to promote diversity as it happens in art. All of the qualities of the contemporary come into play in such a market. Cashed-up collectors seek primacy in the list of clients of top dealers who represent the most desirable artists. Information about who is offering, who is buying, and for how much flashes around the circuit immediately. Artists are induced to bypass the dealers and consign their studio holdings. Collectors are persuaded to part with cherished items. All this is fed into the ever-narrowing funnel of the limited number of lots able to be sold on a particular evening (usually, this means one work each by the ten or so most famous artists of each decade—an increasingly short and exclusive list). Splashy sales also achieve instant public notoriety, not only for the house but also for those seen to be expending, so coolly, such huge sums. Art that has immediacy of appeal and the strong possibility of rapid appreciation is valued highest and bought instantly. Criticality loses its independent edge:

what becomes "critical" is access to the information and ability to make effective judgments within this framework. Artists join collectors and dealers in playing the same game. For Koons, Hirst, Murakami, and a horde of wannabes, this very game becomes the form, content, effect—in a word, the core meaning—of their art.[23] Asked to suggest reasons for the recent "out-of-control" market, New York–based art advisor Diego Cortez listed three:

> One is that there is too much opportunity and too much product, which makes finding something good a harder job. Second, the art world is at a stage, like many commercial markets, where democracy has turned into glut. Third, it's created a whole generation of young artists who cannot make, and do not care about making, good art—they just want to be successful.[24]

Nevertheless, from the broader perspective provided by the comparison of the two markets we have considered, it is important to keep in mind that, however wide-ranging its scope, however with-it and responsive it may be to its constantly changing and changeable product, the market (in all of its many forms) remains just one factor among the many that inspire the creation of contemporary art and which establish value within it.[25] Let us turn to those others for the rest of this book.

Part 4
Countercurrents: South/North

CHAPTER NINE

The Postcolonial Turn

While the art market and the major museums continue to hype the contem-
porist, remodernizing allegories of Barney, Koons, Hirst, and Murakami, a
different kind of contemporary art has appeared from under the horizon.
Its deepest impulses are locally specific yet worldly in implication, inclusive
yet oppositional and anti-institutional, concrete but also various, mobile,
and open-ended. In 2002, after two decades in which it propelled the rapidly
expanding biennale circuit, it swarmed the precincts of contemporary art,
unmistakably and irretrievably, via the Platforms of Documenta 11.[1] Stuart
Hall rightly saw this phenomenon as an outcome of years of resistance to
colonization and globalization:

> One of the most transformatory things in the last two decades has been
> the way in which the thematics of visual representation have been mas-
> sively rewritten from the margins, from the excluded; and this is pre-
> cisely the contest being played out within that global circuit of cultural
> production. It's not just that folks are being kept out of the mainstream,
> but their historical experiences, their trajectories, are what people have
> been trying to write back into the centre. This year's Documenta got am-
> biguous press because it did not show the best that has been thought and
> said and written in Western Europe, which is what you expect from a big
> international modern art show. You walk through all these halls and you
> see massively excluded discourses, images, including forms of represen-
> tation, using the media, using multimedia, using the modern forms of
> technology in order to give voice to the marginalized, the migrant, the
> endlessly mobile, the homeless.[2]

For the first time in a major international survey exhibition, art from the second, third, and fourth worlds, as well as art concerned with traffic between them and the first world, took up the most space and set the agenda for the whole. The postcolonial had come to the metropolis, and the world of art had turned. One important outcome was to realize that the division of the world into these worlds had been a ruinous enterprise, and that the connections that make up the world picture were being rapidly redrawn, not least by artists. Another was that, while the quality and depth of the work on display varied as much as in any other mega-exhibition, much of it was powerful, and some of it was as astonishing as any of the art we have discussed so far. From where did this energy, and these qualities, spring?

Meeting with Fidel

Curators outside of Europe had seen this change coming some years before. Indeed, some had set out to make it happen—not least the curatorial teams who, beginning in 1984, have staged the Bienal de La Habana. Why Cuba? Why has this biennale been so significant? Where is it at now that the art world has turned?

At a meeting in Havana in 1983, Fidel Castro, Lou Laurin (the widow of artist Wifredo Lam), and a number of officials from the Ministry of Culture envisioned a process through which the revolution could pursue its goals in the visual arts with the kind of success, both local and international, that had been achieved by the country's filmmakers, poster artists, musicians, and writers during the 1960s and 1970s. The results of their brainstorming are set out in Decree #113 of the Executive Committee of the Council of Ministers, 1983. I will cite it at length, to give the full flavor of the thinking behind it—the kind that, in many places throughout the decolonizing world, set out to link previously isolated peripheral art communities with each other and to propel the results of this newly-forged consciousness back to the metropolitan centers. The decree begins with certain stipulations of principle:

Because: Wifredo Lam is considered one of the greatest artists of the 20th century and because he made art work of international projection and reach, endowed with the most precious aesthetic value, and because it constitutes a plastic expression from the deepest wells of our culture.

Because: It is convenient to create a Center that bears his name and

that would contribute to the appreciation, signification, and relevance of his legacy and work.

Because: The future Center has to be conceived as an institution in charge also of organizing activities in the field of visual arts, on the national and international level, in order to make relevant the values in this sphere of the arts of the peoples of Asia, Africa, and Latin America. Finally, the Center will help (in conjunction with the art system) the development of artistic creation as well as aesthetic enjoyment in all strata of our society.

It then decrees the following structure and purposes:

1. To create the Wifredo Lam Center, under the administration of the Ministry of Culture.
2. The Center will have as its attributes and functions:
 a. To promote the study and dissemination of the work of Wifredo Lam as a universal expression of contemporary art.
 b. To promote internationally the work of artists from Asia, Africa, and Latin America, as well as the work of other artists who struggle for cultural identity and that is related to those territories.
 c. To endorse international activities in the field of visual arts in order to develop and establish cultural ties.
 d. To facilitate the development of the visual arts in Cuba and to promote the contemporary manifestations of Cuban artists of most significance.
 e. To offer services of specialized information about contemporary art, artists, critics, and researchers.
 f. To enrich the cultural patrimony of the country through the creation of a permanent collection of visual arts and the systematic exchange of artistic and cultural documentation.
 g. To present periodically national and international events related to the visual arts and to give artistic recognition in the form of grants and prizes.
 h. To promote a broader interest in the visual arts to society through didactic and artistic activities and the use of mass communication.

Signed Armando Hart Dávalos (Minister of Culture), Fidel Castro Ruz (President of the Council of Ministers) and Osmany Cienfuegos Gorriarán (Secretary of the Council of Ministers), March 30, 1983.[3]

The language of this decree shows that the biennale emerged from the ideological engine room of the Cuban Revolution. Castro and his ministers recognized that the visual arts scene in Cuba was abuzz with energy, that the Lam bequest was an opportunity to fund its further development (and do so in a way that honored his achievement), and that the visual arts had the potential for international connection such that Cuba could benefit by exporting revolutionary ideals and importing tourist dollars.[4]

In art world terms, the Havana biennale was conceived in deliberate contrast to what was seen by Cuba as the "comprador" outlook of the Bienal de São Paulo, founded in 1953 to match local artists against the major Euroamerican art stars.[5] Throughout South America and the Caribbean during the twentieth century, avant-garde art and modern culture more generally had been sustained more by social elites and private corporations than governments. As Néstor García Canclini puts it, "To be cultured, even in the modern world, is not so much to connect oneself with a repertoire of exclusively modern objects and messages but to know how to incorporate avant-garde art and literature, as well as technological advances, into traditional patterns of social privilege and historical distinction."[6] This affiliative contemporaneity, he argues, arises because modernism in societies characterized by massive disparities of literacy, cultural inheritance, wealth, and power is never simply the expression of socioeconomic modernization, but rather, "the way in which the elite takes charge of an intersection of different historical timetables and uses them to try to forge a global project."[7] In socialist Cuba, government took a strong role in the organization of culture, but chose to do so through the creation of semi-autonomous agencies, such as the Latin American Theater Festival, the *Festival del Nuevo Cine Latino Americano*, the international program of the *Casa de la Américas*, and, for the visual arts, the Centro de Arte Contemporáneo Wifredo Lam.

The organization of the Havana biennale was carried out, in the Cuban manner, by a curatorial collective. This was the first instance of what is now a common model for large exhibition planning. Led for many years by Llilian Llanes, they set out to plug local and regional art into the growing international art circuit, yet to do so as far as possible in terms of local and regional values. This meant, above all, a welcome to art that focused on the specifics of practice at the peripheries, that was suspicious of the globalizing tendencies of the Euroamerican official circuit, and that made its connections laterally, between the cultures of the south, those with the most direct experience of decolonization. This *tercomundismo* ("third world–ism") echoed the

dreams of region-wide political transformation that had arisen during the 1960s—and which had precipitated repressive reactions, including military dictatorships, throughout the continent. By the 1980s, this reaction eased, yet Cuba remained a socialist outpost, dependent on an increasingly fragile Soviet Union. Meanwhile, the geopolitical order based in Europe was undergoing shocks of its own, leading to the collapse of the Soviet system in 1989, and the withdrawal of support to Cuba in 1990.

In these circumstances, certain Cuban intellectuals—notably Geraldo Mosquera, art critic, cultural administrator, and chief ideologist of the Havana biennale—argued that the conditions were ripe for the artists of the third world to take global leadership in the creation of contemporary art. He dismissed the idea that avant-garde art in the region was a blend of external modernism and local, indigenous and other folk traditions. Rather, he insisted, the avant-garde arts of the region had always been responses to Western cultural influence, a process that had been going on long enough to generate powerful contemporary art of world relevance. It was up to the artists of the south, he proclaimed, to "make Western culture."[8] Indeed, by 1980, a number of Cuban painters, sculptors, and installation artists were working effectively in a distinctive range of styles, most of them parodic, eccentric, and subtle—the best-known being Kcho, the boat builder, a wistful and elegant metaphorist of escape. Their work was quickly labeled "New Cuban Art."[9]

By 1989, these elements had coalesced into the biennale's most complete realization of its goals to date: under the heading "Tradition and Contemporaneity," the third iteration used a theme-based curatorial methodology (another first for an exhibition on such a scale) that displayed the volatile gaps between tradition and contemporaneity as manifest in techniques, outlooks and cultural power. Postmodern installations from all over the world were set against North Korean scroll paintings and Sri Lankan batiks, ancillary exhibitions on topics such as Angolan Chokwe sculptures, Cuban ceramics, and kitsch itself were scattered throughout the city, while local artists such as José Bedia, Carlos Cárdenas, Ciro Quintana, and Robaldo Rodríguez presented powerful works, and others staged independent shows in shops and houses. The contrast with the most-discussed exhibition of that year—Magiciens de la Terre, at the Centre Pompidou and at La Villette, Paris, organized by Jean-Hubert Martin—was palpable. Magiciens consisted of works by fifty folk and indigenous artists from all over the world and showed them, under the rubric of the supposed universality of artistic re-

sponses to spirituality, in careful pairings with works by fifty European and U.S. contemporary artists who used similar forums.[10] In Havana, however, the meeting of cultures was messier, more like real life.

Havana's self-made successes inspired other "peripheral" voices. Biennales sprung up in Cairo, Cuenca, and Istanbul during the 1980s, then in the following decade in Dakar, Sharjah, Brisbane (the Asia-Pacific Triennale of Contemporary Art), Gwangju, Montréal, Taipei, Porto Alegre (Mercosul Biennial), Liverpool, Berlin, and Shanghai. This proliferation soon led to changes in form: Manifesta is a biennale that, since its commencement in Rotterdam in 1996, has migrated between European cities. Kassel, home since 1955 to the Documenta exhibitions, took notice. Okwui Enwezor's Documenta 11—built around its globally dispersed "platforms" and taking globalization and postcolonial critique as its themes—is, as we have observed, widely and rightly regarded as the moment when the peripheries took over the center of the global art spectacle. A backlash was to be expected. It appeared straightaway in much of the art world response to the exhibition.[11] Traditionalists hoped that the next big show, the 50th Venice Biennale of 2003, would restore Euroamerican cultural dominance. But director Francesco Bonami was bent on his version of a globalized exhibition—a multivenue event dispersed into discrete but randomly connected exhibitions (dubbed "archipelagos") that were staged, with predictably uneven results, by no less than a dozen curators.[12]

Meanwhile in Havana

During these same months of 2003, the Bienal de La Habana was having troubles of its own. For the preceding few years, the Cuban government had been investing hard-to-come-by funds in fixed asset cultural institutions, above all, major buildings holding permanent collections. This policy was due in no small part to the increasing impact of the biennale in challenging local artists, attracting international visitors, and stimulating a small but strong market for contemporary Cuban art. Leaving the Museum of the Revolution in a late-1960s time warp, the state transformed the palatial headquarters of the Sociedades Asturianas de Cuba to house "arte universal" in the collection of the Museo Nacional de Bellas Artes, featuring its extraordinary holdings of the major Flemish, British, and French schools in vast, belle epoque halls. And it renovated the 1960s museum building nearby to show Cuban art of the past two centuries, from the Spanish and other itinerant artists to living moderns. The work of chosen artists, culminating of course

in Wifredo Lam, is presented generously, in what amounts a sequence of mini-retrospectives.

We have seen that the political project of the biennale echoed that of the revolutionary government itself. It still does, but tensions continue to surface. The Castro government won few friends with its 2003 crackdown on Cuban cultural and social activists, arresting seventy-five and sentencing them to imprisonment for up to twenty-eight years. In response, two of the key international agencies sponsoring the biennale withdrew their funds. The Prince Claus Fund for Culture and Development, based in The Hague and a leading promoter of "intercultural exchange" throughout the world, had provided €90,000 to the 7th biennale in 2000. It withdrew its support on the grounds that the biennale "did not distance itself from this policy of prosecution."[13] The decision drew an angry reaction from Dr. Rafael Acosta de Arriba, president of the national plastic arts council and the biennale board. In his preface to the catalog, he labeled it part of "the wave of hostile actions carried out by the European Union against Cuba, unleashed in the initial days of June."[14] Sanctions go down hard in a country still so visibly suffering from the collapse of Soviet support after 1989 and the continuing U.S. embargo.

Nevertheless, the biennale organizers pressed on with their plan: to show the world that "in Asia, Africa, the Middle East, Latin America, and the Caribbean there are material and cultural conditions different from other regions, which condition a type of expression," and that "the diverse cultural expressions establish a type of relationship with the public that are considered part of life, without mediation of any institution or specific technological requirements."[15] Thus the exhibition theme: *El Arte con la Vida*—art with / in / and life—which implies that one reason why third-world art is different is that it emerges naturally, from the everyday life of the people. The exhibition presented an array of art from outside the main European centers and the bustling Asian economies. No big-name Western artists, nor any of the recent global superstars from China. From Latin America, Ernesto Neto would be one of the few with instant name recognition outside the region. Throughout the city one found art that was primarily about publics specific to its conditions of creation, or that emerged from exchange and encounter with them. These were accompanied by a weeklong talkfest that became a useful forum for the exchange of strategies between artists committed to different kinds of public art. A recurrent theme was the link between the exigencies of making art in conditions of scarcity and the obligation to negotiate a practice that connected with conditions in which survival

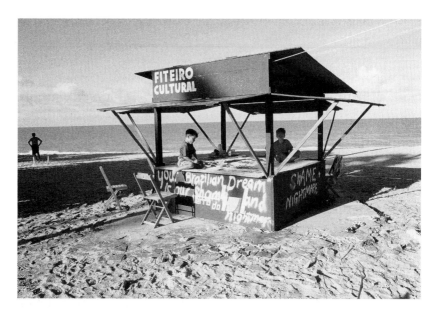

9.1. Fabiana de Barros, *Fiterio Cultural*, 2005. Mixed media. (© Fabina de Barros. Courtesy of Galeria Brito Cimino, São Paulo, Brazil.)

was the foremost concern. In these discussions, the well-financed, market-dominated, spectacularized international art world loomed as a spectral Other. Speaking against this division, Uruguayan artist Luis Camnitzer warned, in his catalog essay: do not mistake this Other art for all of "Art," nor one's own struggles for the only authentic "Life." Corruption should be opposed, he argued, wherever it occurs, in both art and life, by an ethical searching in both art and life.[16]

Some of the work—such as the multimedia installation by the French group RAIN at the Pabellón Cuba—was actually located in public venues. Others—notably Fabiana de Barros's much-traveled, multipurpose, demountable structure *Fiteiro Cultural*—were to be found in outer lying districts such as the Alamar. Most, however, were concentrated in an exhibition venue that was, at once, a reminder of Cuba's colonial past and an example of recent cultural heritage recycling: the Fortaleza San Carlos de la Cabaña, strung out along the hilltop across the bay from the old city center. The Spanish fort's guardrooms, dormitories, powder storage cellars, offices, and church housed installations, videos, sculptures, photographs, and the occasional painting in crisp and spacious settings. The same generosity of display was accorded each artist in the other venues around

the city itself, including the squares that became temporary stages for performances.

As in other large-scale exhibitions, one-idea artworks vied with those requiring at least two steps to comprehend them. While there were some of the former, there were so many more of the latter that the exhibition as a whole was richly rewarding—and often challenging. In Brazilian Siron Franco's *Intolerance*, figures made of stuffed clothing suggestive of workers' and peasants' bodies were piled across each other, filling a room, "face" down, it seemed, until you saw them to be headless. The arbitrariness of political disappearance was the theme of *Devotionalia* by Mauricio Dias and Walter Riedweg, also from Brazil. In this work, video records of the impact of the not-so-mysterious "disappearing" of slum children were matched with elegant photographs of plaster casts of remnant hands and feet. Columbian artist Fernando Arias fixed the violence that pervades his country's culture and threatens the world through the AIDS virus in a grainy black and white video, *Infidelity*, that repeated a double image of a young black man pointing a rifle at the viewer and an ejaculation reversing back into a penis head.

Cuban artist Yoan Capote attacked the manipulation of the masses by the media by placing prison bars across the empty blue screens of sculptmetal video monitors. Martin Sastre from Uruguay presented videos that, with arch style and trenchant humor, parodied U.S. cultural dominance by announcing the coming of the Era Iberoamericano. Given recent population movements, it is indeed not far-fetched to imagine both American continents succumbing to a Hispanic "soft revolution" in the coming decades. Not a bad future for all concerned. Sastre's big hit was presenting himself as a transfiguring quasi-monster in his *Videoart: The Iberoamerican Legend*, with its winning line: "Matthew Barney killed the video star."

Other artists made their points with greater indirection, and perhaps more potency. In her work *Sustained Suture*, Nigerian artist Otobong Nkanga installed a long skein of black wool along the outside of one set of buildings, which then entered a spare room (perhaps once a cell or an officer's room) through the wall near the door, traversed the space, penetrating the wall at various points, appearing as a photograph of itself at others, until being tied off at a stake in the floor. In contrast, for his photographs and video installation *Fémme terre*, Ousmane Ndiaye from Dago painted mud over beautiful young African women. In work such as this, the search for beauty turns into a conventional cover-up.

Certain kinds of obsession can, however, generate a deeper resonance. Cuban artist Ivan Capote had been exploring what we call "learning disor-

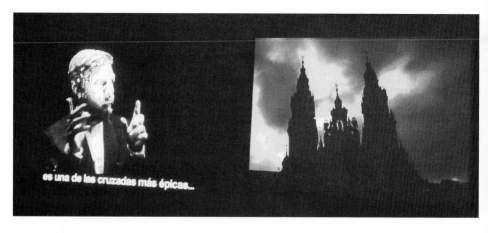

9.2. Martin Sastre, video still from *Videoart: The Iberoamerican Legend*, 2003, showing Sastre as Barney. (Courtesy of The Martin Sastre Foundation. Photograph by Miguel Rojas-Sotelo.)

ders" for some years. He presented a crazy machine, like a stripped-down Jean Tinguely junk sculpture, the small motor of which drove a looped belt that pushed a rod bearing a sink plug at its point across a tray carrying a thin layer of viscous sump oil. At each push, the plug would clear a narrow space and mark the base of the tray, bringing some letters, perhaps a phrase into brief visibility. Immediately, however, the oil would flow back in, obliterating both space and mark. It is difficult to conceive a more dramatic visualization of the experience of someone suffering from severe dyslexia, as they struggle to recall the look of the letter that they saw just a millisecond ago. The title of this work is, indeed, *Dyslexia*. And it takes just one step to see this as a metaphor for social amnesia, a disease of epidemic proportions throughout the world. This subject is treated graphically in his 2001 installation *History*: a machine drives two circling arms, one of which marks the glass with texts that the other as quickly erases.[17]

Uruguayan artist Marco Maggi's extraordinary nanovariations of computer chips—such as the miniature world *PreColombino & PostClintoniano* (2002)—also explore this aspect of contemporary experience. His work *Incubadora* (2003) is a major, and extraordinarily subtle, statement of the themes we have been exploring in this chapter: What is to make art in the socioeconomic peripheries after decolonization? How are works created that manifest this condition, comment on it from independent perspectives, and

do so in ways that resonate with one's immediate audiences and with viewers in cultures elsewhere in the south and in the west?

Incubadora consists of fifty thousand sheets of zinc white paper, stacked into a hundred or so piles on the floor running the length of the room (one of the gunpowder storage cellars of the fort). Spaced according to a grid, but differentially disposed on it, the piles moved from geometric order at one end to random, scattered, collisions at the other. For three days, Maggi worked at the top sheet of each pile with a pair of fine scissors, cutting a

9.3 Ivan Capote, Dyslexia, 2003. Metal, grease, and machine parts. (Photograph by Miguel Rojas-Sotelo.)

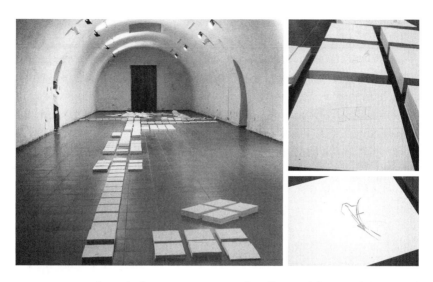

9.4. Marco Maggi, *Incubadora*, 2003. Cut paper installation. (Photograph by Miguel Rojas-Sotelo.)

single sheet into a different shape. In almost every case, he cut just a part of the sheet, raising the incised parts, which cast delicate shadows. The cut-out shapes varied from configurations that recalled constructivism or early sculptures by Anthony Caro, to the preliminary drawings of architect Zahir Hadid. None took on organic or animal shapes, but they all seemed alive, as if (as the work's title implies) they were parts of an unseen but felt female body that had given them delicate birth. Each tendril responded to the faint movement of the air. Indeed, the drawing—for that was what this activity of careful cutting most definitely is—drew us to, as it were, *listen* to the space of the room, to hear its faint sounds. The "sounds," perhaps, of this work—a field of fecundity—incubating . . . in Cuba.

Which brings us back to the overtly political question of Cuba now. How did the local artists tackle the representation of their own situation? Havana itself was gently parodied in Armando Mariño's *La Patera*: the hulking chassis of a 1950s Chevy—the semi-private taxi of choice around the old city—was held up by dozens of plaster-cast legs in brown, white, and black. Nelson Ramirez and Luidmila Velasco featured another Havana icon, the Independence Tower erected under Battista to celebrate patriot José Martí—famous since as the centerpiece of the Plaza de la Revolucion, set for Fidel's lengthy exhortations—in a plethora of collages and kitsch assemblages. Under the title *Absolut Revolution*, they collaged this icon into a vast and always amus-

ing range of postcard images, from German Romantic sunsets to Warhol's Factory, evoking the famous series of advertisements for vodka, designed by well-known contemporary artists, that for almost twenty years filled the inside back cover page of *Artforum*.

Installations consisting of collected junk are an international contemporary art *lingua franca* (or should we say, these days, English?). In another of the barrel-vaulted storage rooms of the fort, Cuban Wilfredo Prieto assembled discarded, found, and stolen objects from the streets of Havana in a long line, stretching from the smallest pebble to a Coco Cab and a fruit drink stand in the form of an orange cut open. But his most powerful, political work was *Apolítico*, a stand of thirty or so flags of many nations in the world—not least Cuba and the United States—fluttering in the sunny breeze along the skyline, but in black, white and gray. This visual fissure was a stunning, uncannily spectral effect. In its voiding of faux nationality, it was anything but apolitical.

Tania Bruguera is probably the best known of the current generation of Cuban contemporary artists. At the previous biennale she drew extraordinary international attention with her installation in one of the cell-like

9.5. Wilfredo Prieto, *Apolítico*, 2003. Flags on poles. (Photograph by Miguel Rojas-Sotelo.)

rooms at the fort, *Untitled* (2000). It featured live actors, naked on rank, and rotten *bagazo* (sugar cane husks), frozen in corpse-like attitudes or moving among the spectators. Colonial Cuba's enslavement to the sugar industry was vividly imagined. The inference that revolutionary Cuba was inclined to incarcerate its citizens—to reduce them to silence—was not too difficult to draw. In the courtyard of her own house, Bruguera remade a set of works by a Cuban artist well known in the West, although not as Cuban, the ill-fated Ana Mendieta.[18] In 2003, Bruguera was not included in the official list of invited artists, but a single work, *Autobiografía*, was the main one to be shown in the temporary exhibition space of the Museo Nacional devoted to Cuban art.

This was a bold and brave gesture by all concerned. The large space was void of all but two speakers at either end, and a platform at its center, on which a microphone stood, framed on three sides by a curving wall. All this was made with the rawest of materials: cardboard, packing cases, palette planks, and the like. Sound was vividly present, as surging slogans, the calls to arms of the Cuban Revolution, above all such oft-repeated phrases as "Libertad o Meurte!" "Hasta la Victoria Siempre!," and "Viva Fidel!" Most of the time, however, these were scarcely distinguishable. But careful listening—especially if you stepped up to the microphone—disclosed their rhythmic power, their relentless presence, their selection of willing subjects, their shaping of crowds, their womb-like comfort, their obliterative omniscience, and their falling short—a landscape of memory of what it must have felt like, within the body, in the mind's ear, to grow up during the revolution. Visitors were invited to record their own slogans, statements, or speech of any kind, which were then added to the mix. The implication here is that the voices of the people might eventually drown out those of the ones who claim to speak for them. Or perhaps not

Autobiographia echoed, and in a sense completed, an earlier work of art, a painting by Antonia Eiríz exhibited in the historical survey of Cuban art at the Museo Nacional. In 1969 Eiríz made *Una tribuna para la paz democrática*, a large vertical painting that locates the spectator as the speaker about to step up to the microphones on the speaker's stand at La Plaza de la Revolucion. The stand is black, the barricades around the square are red, as are the waving flags—actual flags, pasted into the painting. But the crowd is an undulating mass of surging gray and white marks, shapeless, ominously empty—waiting to be formed, or forever formless? In a similar way, Bruguera puts us, alone yet in public, alone yet with countless others, into that same space. With the difference that, in her installation, the barricades are down. Form-

9.6. Tania Bruguera, *Autobiografía*, 2003. Sound and mixed media installation, 8th Havana Biennale. (Courtesy of Tania Bruguera. Photo: Museo Nacional de Bellas Artes, Ricardo G. Elias.)

lessness is all around. But the state, we plainly hear, can take form at any time. Which form it takes depends, partly (but which part?) on us.

The next biennale, three years later, set out to explore one of the great challenges facing cities in both the south and the north: the explosive conurbations that now house most of the world's people. Yet the exhibitions were eclipsed by an ideological struggle being waged, through visual media, by the governments of Cuba and the United States. In January 2006, staff of the U.S. Interests Section installed a huge LED display on the façade of its building in downtown Havana across from a major parade and rally square.

9.7. Monument to Martyrs of the Revolution, 2006. Flags on poles opposite the US Interests Section building, Havana. (Photograph by Miguel Rojas-Sotelo.)

In Jenny Holzer style (but in opposition to her usual content), they projected statements extolling the "freedom," "liberty," "equality," and "democracy" to be found in the United States, in contrast to the limitations of Cuban "dictatorship." The Cuban response displayed the kind of visual wit that has inspired the biennale since its inception: between the U.S. building and the square a dense forest of titanium poles was erected, and huge black flags raised, obscuring the messages. Officially, this was deemed a memorial to the Cuban heroes who had fallen at the hands of "American terrorism." But its conception owed everything to a work in the previous biennale, Wilfredo Prieto's *Apolítico*.

An Iconogeographic Turning

How representative of the postcolonial turn is the experience of artists working in Cuba, and Cuban artists working abroad? Artists from South America and the Caribbean, Africa, East and Southeast Asia, Oceania, (Central) Europe, and the Middle East have pursued many paths since the 1960s. There is no shared pattern, but all have been touched by aspects of the twentieth-century legacy of closely contested nationalisms, civil war, ethnic cleansing, foreign interventions, and displacement due to economic necessity. African artists, if they were participants in a struggle for liberation or were active during the early phases of decolonization in their countries, often felt the call to manifest their belonging, to emphasize in their work the ethos of their

people, the spirit of their religion, or the values of their group, in the context of these qualities being endangered, newly-asserted, or revived. After a time, however, many reacted against these identifications—because the social formations were becoming, perhaps, more and more institutionalizing, reductive, open to manipulation, and covertly or explicitly coercive—in favor of their personal imperatives as individual artists. Simultaneously, they were attracted towards seeking some profile within the proliferating circuits of international contemporary art, especially the biennales. For many artists today, the contradictory calls from within and between these elements is the problematic that both drives their art and becomes, often, its content.[19] This is a problem that extends well beyond Africa. Most artists whose work was shown at Havana in 2003 were in this situation. A few, as we also saw, have forged a hard-won but still tentative alloy of these elements and are setting out the lineaments of a distinctive, contemporary kind of cosmopolitanism.

During the later 1980s and through the 1990s, parallel developments occurred at the shrinking peripheries of empires everywhere, including those at the borders of the expanding European community and the evaporating Soviet empire: the zone that Marina Gržinić calls "(East of) Europe."[20] They continue to unfold. For obvious reasons, rewriting history is a fraught compulsion in this region, and it is shared by states as much as interest groups. As István Rév shows, this thirst is driven by a desire for justice that, in withering paradox, tends always to operate retroactively.[21] Artists have reacted to this situation in a variety of ways. Jane and Louise Wilson's four-screen video projection *Stasi City* (1997) is a frenetic tour of the recently abandoned headquarters of the East German secret police: by mounting their camera on dumbwaiters that track relentlessly, yet bumblingly, through these chaotic rooms and corridors, they imply that even seemingly absolute authority is a fragile compound of the ordinary, destined for abandonment and extinction.[22] More overtly optimistic in spirit, the *East Art Map* (2002) was a project in which Group Irwin mobilized twenty art critics, curators, and artists to present up to ten crucial art projects from their respective countries during the past fifty years, consequently redrawing the art historical map of the region.[23] This is one of many efforts by artists to reimagine nationality, the structures of states, and the nature of borders.[24] Since the mid-1990s, Hungarian video artist Péter Forgács has been reusing found home movies to trace shadows of the Holocaust, failed totalitarianisms, and the false promises of global development in the personal memories of individuals. These include the visualized remembering of not only Jewish and other victims,

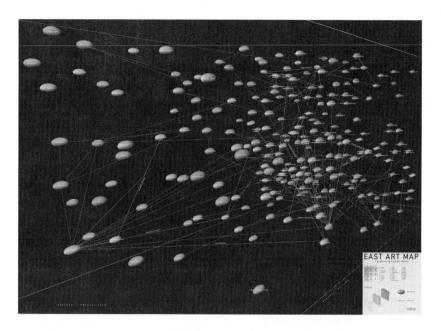

9.8. Irwin, *East Art Map*, 2002. Web site homepage. (Courtesy of Irwin.)

but also the Nazi perpetrators.[25] Such experiences echo well beyond national boundaries. In his Sher-Gil archive project, Indian artist Vivan Sundaram is engaged in a parallel search through the photographic archive of his own family for ghosts of artists whose dreams were both in and out of place—including, in this case, Bombay and Budapest.[26]

In China, the situation for artists opened up considerably after the Cultural Revolution ended in 1978. Western modernism and Enlightenment philosophy, as well as examples of avant-garde art practice, were most eagerly sought out during the 1980s by artists who still saw their enterprise as a collective effort, as a contribution to societal construction. The most contemporary manifestations of these traditions in the West itself at the time were, however, postmodern in style and poststructuralist—or, more accurately, deconstructive—in substance. Subsequently, modern art (*xiandai yishu*) became contemporary art (*dangdai yishu*) during the 1990s, particularly after the Tiananmen Square "incident" of 1989 destroyed illusions of collectivity for many, precipitating a widespread sense of estrangement. This is manifest in many works, for example, Song Dong's 1996 performance *Breathing*, during which the artist exhaled across one of the concrete blocks of the Square for forty minutes, creating a small ice sheet in this vast space, then repeated

his action on a nearby frozen pond that absorbed his breath without observable change. International interest in Chinese art created opportunities to tackle larger subjects and provided patronage and markets. It also encouraged the use of sensational imagery, preferably with recognizably Chinese connotations—for example, in the firework spectacles of Cai Guo-Qiang. Against this tendency, some artists have sought to revisit more authentic cultural roots: in 2002, under the leadership of Lu Jie, over a hundred artists retraced the route of the famous forced march of the Communist forces undertaken in 1934–35, interacting with local craftspeople along the way, and subsequently exhibiting their work in Beijing and elsewhere. Meanwhile, in China's exploding metropoli, especially Beijing, Shanghai, and Guangzhou, the relentless pursuit of the "four modernizations" has created conditions that are uncannily like those in European cities in the nineteenth century. Whether this will lead to the emergence of a specifically Chinese kind of critical, realist art remains to be seen.[27]

Overall, these postcolonial and antiglobalization tendencies have disturbed, to the point of nearly overturning, the implicit (and at times quite explicit) world picture that came to sustain high modernism, and to which remodernist and retro-sensationalist art clings. A number of artists, especially those from South America, have been alert to this situation and have made works highlighting it. Joaquin Torres-Garcia's 1936 sketch of the continent inverted, the signature image of his "School of the South," intended as a sharp reminder of where "our north" was for artists of the region, soon became iconic of Latin American art as such.[28] Many artists from the region have used the cartographic imagery of the two continents to draw attention to the excesses of colonialism. Two Brazilian artists will serve as examples. The bloody entrails bursting through Portuguese tiles in Adriana Varejão's *América* (1996) take on the familiar shapes, suggesting that colonization is built on sacrifice but that the bodies will return, as phantasmagoria, to reclaim the territory. In his collage *Right You Are If You Think You Are* (2004), Nelson Leirner conjured this battle less optimistically by using plastic paste-ons popular with children to profile the continents: Mickey and Minnie Mouse for the northern, Posada-style skulls for the southern.

Chilean artist Alfredo Jarr, in his 1998 work *Weltanschauung*, generalized this strategy by showing how different the world looks when mapped according to the Peters, as distinct from the Mercator, projection. Visiting Arno Peters in Bremen, he gave its author the opportunity to explain that this projection simply puts the equator in the center of the given space, rather than Mercator's lowering the equator line to allow more detailed rep-

9.9. Alfredo Jaar, *Project for a Revolution of the World Wide Web*, 2004. (© Alfredo Jaar. Courtesy of Galerie Lelong, New York.)

resentation of the northern hemisphere. In 2004, the artist began a Web site, Project for a Revolution of the World Wide Web, in which one can log on to a Peters projection, choose a country in which you would like to start a revolution, and then, after much apparent electronic activity, a message from Gandhi appears. "First they ignore you. Then they laugh at you. Then they fight you. Then you win." The message is the same, no matter which country you choose.[29] This quality of mild, indirect yet unswerving persistence towards liberation from oppression and manipulation is a powerful mood, one much needed in these times.

Think of a toy globe, a metal or plastic sphere with a world map on its surface. Think of it as a double cup, cut at the equator—two halves to be fitted together. So it might serve as a container. Think of it, circa 1750–1970, as having the Mercator world map on it, with the top and bottom halves connected by the two-way trafficking of global circuitry, but the whole being turned by the greater force of the northern metropolitan cultural centers. This kind of iconogeographic twisting persists until sometime in the 1970s, when the cultural centers in the bottom part of the world, and in all

the souths present in the northern hemisphere, themselves start to generate enough energy to do some turning. A struggle ensues, one that is still going on. But, as Jarr indicates, the Peters projection is taking over, the halving of the world will—eventually, after much struggle—cease to be definitive. The postcolonial constellation is coming into focus. The turning, however, will not stop.

CHAPTER TEN

Our Otherness: The Beauty of the Animal

In 2002, Jan Fabre's *Heaven of Delight* was installed in the Royal Palace, Brussels, at the behest of the Queen of Belgium. The ceiling and the chandelier of the main hall were covered with the wing cases of thousands of Asian jewel beetles. The wing cases were collected from the refuse of a number of restaurants in East Asia, the beetle being a delicacy in that region. This work is typical of the kind of contemporary art that remains unrepentantly committed to the beauty effect, to inducing in the viewer a speechless amazement, one that takes us from our rush of pleasure at the intensity of the green areas above—as resplendent as a sunburst through the canopy of a northern forest—and at the green suspension of the doubly-encrusted chandelier, to the *jouissance* of the contrast between these concentrated, glistening greens and the elegant rococo elaboration of the hall. It is as if the frozen decoration has suddenly become alive, transforming the building into a swarming hive, one that is gestating an unimaginable beneficence—or monstrosity. This pairing of highly refined architectural decoration and highly evolved insect life precipitates the fearful intuition that the lively rhythms of the architecture and the rustling of these countless wings—this stunning conjunction of the cultural and the natural—could equally be going backwards in time, making all that we see artifactual, discarded, reliquary . . . in a word, dead.

Does this mean that *Heaven of Delight*, contra its title, is an ironic commentary on the anachronism of the monarchy, a subversive, even postcolonial critique? I think not. I doubt that we are being invited to draw the analogy made explicit in, say, Fritz Lang's film *Metropolis*, to imagine that an insect colony—usually devoted to ant-like servitude in the cause of building wealth for the royal personage or the leading family—has suddenly swarmed in a brute urge to smother the source of its exploitation. Rather, transcendent aesthetic beauty offers itself as the mediator. As it has done

172

10.1. Jan Farbe, *Heaven of Delight* (detail, installation view), 2002. Wing cases of Asian jewel beetles. Royal Palace, Brussels. Left, chandelier; right, ceiling and moldings. (© Angelos. Photograph by Dirk Braekman.)

before in Brussels, in the work of Belgian symbolists such as Léon Frédéric, perpetrator of such favorites as the *Cycle of Life* triptych in the Royal Museum of Fine Arts, and of imagery such as the flood of healthy babies gushing from a woodland stream in his painting *The Source of Life* (1890), now in the Philadelphia Museum of Art. Given the colonial history of Belgium, of which the palace is not merely an outcome but an unrepentant museum, there is a very large work of forgetting and mystification to be undertaken by projects such as these. *Heaven of Delight,* then, offers the rush of beauty as an exquisite but of course fictive expiation, as a moment of unalloyed pleasure, one that subsides, slowly, into a kind of exquisite mourning.[1]

The friction between cultures so evident in contemporary life has led to art that advances quite other conceptions of beauty, as well as to art which questions these conceptions, and does so beautifully. A striking example of both is *Si Poteris Narrare, Licet,* an interactive installation developed in 2002 by Dakar-based artist Jean-Michel Bruyère. Digitally projected inside Jeffrey Shaw's EVE (extended virtual environment) dome, which is 12 meters in diameter and 9 meters high, viewers are surrounded by an unstable yet cathedral-like virtual edifice that rises in three tiers, replete with multiple galleries and niches, within which a panoply of complex narratives are avail-

able. As elaborate as the *Cremaster* cycle, and sharing with it a world picture made up of circling amphitheatres, it differs from Barney's *Gesammtkunst-werk* in a number of respects. It takes up an ancient, not a modern, tale and renders it at once discontinuous as narrative and relevant to the present. Secondly, its chief actors (known as "Vøspazàrians") are not the artist, a cast of celebrities, strange machines, or hybrid artworks, but members of theater ensembles in both France and Dakar, including street kids from the latter city with whom the director had worked for a number of years, notably in his photographic projects such as *Enfants de Nuit* (2002).[2] While visitors to the *Cremaster* cycle exhibition at the Guggenheim certainly had choices as to their pathways throughout it, a powerful narrative was present and made itself known, as we have seen. *Si Poteris Narrare, Licet*, on the other hand, is subject to the movement and the decisions of the viuser (visual informa-tion user), through a headset interface.[3] There is pretentiousness here, even portentousness, of a highly theatrical kind, yet it is quickly self-deflating. In the commedia dell'arte mode, mixed with a fine dose of avant-gardist mani-festo speak, the authors characterize the iCinema version of *Si Poteris Nar-rare, Licet* as "falsely commemorative, systematically gyratory, manifestly ritualistic and strictly non-productive."[4] And, unlike Barney's visit to the carnival in Salvador, Bruyère's work not only emerges from the history and present of his country, but also applies some of its questioning to one of the foundational myths of European culture. Postcoloniality is not merely a past, however recent, it is a returning, a giving back of the question, as a gift, and a challenge.

Si *Poteris Narrare, Licet* takes as its inspiration Diana's remark to Actaeon, who, out hunting with a large pack of dogs, came across her bathing and stood entranced by her naked beauty, a sight forbidden all mortals: "If you are able to speak of it, then you may do so."[5] At that moment, she trans-formed him into a stag, and his hounds tore him to pieces. The subject of this work, then, is silence before the ultimate vision—the state of being awestruck by pure life, or at least the essence of sexual difference—and the unspeakable, a state of being, before language, that invites the most horrible death, one that is executed by instinct, incomprehension, and the voiceless.

From this premise, Bruyère develops an extraordinary architecture. Pro-jected onto the central levels of the dome is *Cynepolis*, a caninorium built by Actaeon's dogs in his memory and dedicated to the film cult (*culte cyné-matographique*) of his devouring. It was conceived according to the plans of Al Asmunaim, the city that the philosopher Trimegiste erected at the

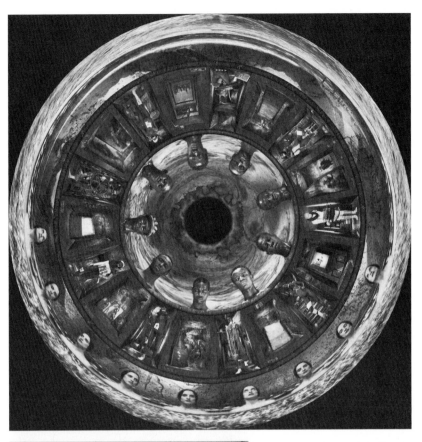

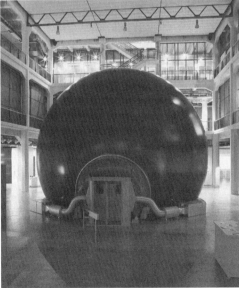

10.2. Jean-Michel Bruyère and LFK, *Si Poteris Narrare, Licet*, 2002. General view inside EVEdome, designed by Jeffrey Shaw. (Courtesy of Epidemic. Photograph © Franz Wamhof.)

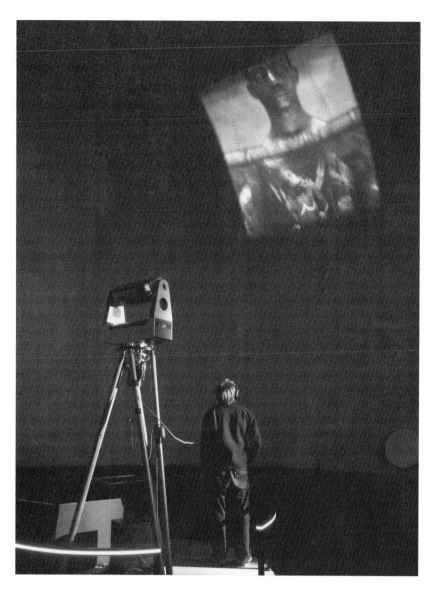

10.3. Jean-Michel Bruyère and LFK, *Si Poteris Narrare, Licet*, 2002. Viewing digital projection. (Courtesy of Epidemic. Photograph © Franz Wamhof.)

doors of Egypt. The enclosure of the city consists of nine doors, guarded by Chiron, the fabled centaur, who tutored Actaeon, unsuccessfully as we have seen, which is why he appears here as a defeated, braying donkey. The nine cavities between the now unguarded doors are "ancient cinemas" which project blurry and indistinct shadows, evoking those in Plato's cave. There

are three kinds of projection, each occupying three of the cinema's cavities. They take form according to these quasi-narratives:

Cavities of the first type show three young Vøspazàrian actors at three different times, each having taken on the name of Actaeon in order to represent the young man nine times altogether at his age of initiation. Each of them is running in non-landscapes, crossing immense flat spaces where water and earth often merge. Under the pomp of massive hunting gear, a tuft of fur is visible here and there on their bodies. At the instant when the young hunters suspend their course and seem to scrutinize the nothingness that surrounds them, one can discern the whiteness, the transparency of their eyes. Is it the divine nudity that they see, which pierces their glances thus? Were they already blind before having seen it or are they blind because they have already seen it? Are they on the search for a pure theophany or is this the moment of their escape from the pack? Are they on the road to their ruin, or are they trying to escape from it? And the fur appearing from under their dress, is it already a tuft from the stag that they will become? Is it a part of their real fur, that of the Vøspazàrian actor at the canine origin, that of the artist-dog born of the carnage that has not yet taken place? Or still further, the end, as we know, returns unavoidably to the beginning, so would it not be all that at the same time?

In the *cavities of the second type*, images are inscribed on their walls concerning three individual relations to the mystical, the mystical here being essentially what it is a matter of showing and of living without being able to seek recourse to language. These three relations, these complementarities, are eroticism, trance, and ecstasy. During each, Diana is present next to the image projected on the wall. The actor-dog-Actaeon-stag of the image seems to address his gestures to her, and she to react to them. Here, Diana makes her appearance clothed. The clothing itself is unimportant: it exists only in order that her inexpressible nudity remains unrepresentable.

Cavities of the third type show us the images of three collective solutions to the mystical. These three solutions, contradictory among themselves, are religious dogmatism, pantheism, and the gag. One of the cavities resembles a triptych of gestures derived from polytheism, prophecy, and shamanism. Another shows the silent gestures of a villager amusing his neighbors with a vulgar parody of the goddess, whose coat of arms and mask he is wearing. The third shows the final action that points to a pan-

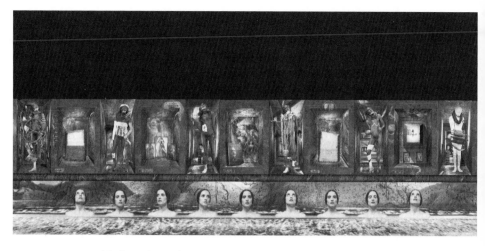

10.4. Jean-Michel Bruyère and LFK, *Si Poteris Narrare, Licet*, 2002, detail. (Courtesy of Epidemic. Photograph © Franz Wamhof.)

theist philosophy: of bodies plunging together into the earth for a collective, fated marriage with nature, naked and divine. An ancient key twirls around above this last image.[6]

The lower part of the dome shows a constantly changing circular landscape, within which nine Actaeons look at nine Dianas at the bath. Only her face is revealed. To Bruyère, this is sufficient to express what cannot be said, the absolute futility of human language in the face of divine expression. Recognizing this, Actaeon throws his humanity to the dogs.

Finally, Bruyère introduces into this array a documentary film that erases all of the above and unwinds in time (for one minute in every six). It shows a fragment of a trance ritual, the Ndeup ceremony of the Lebou culture (Peul people), recorded in the Senegalese desert. During the course of this ceremony, the great priestess Ndatte slits the throat of a cow, wraps an hysteric in the entrails of the animal, and abandons her own body and her own voice to a series of animals and spirits that, it is believed, wish to take possession of them.

The sudden irruption of this scenario into the highly stylized, profligate beauties with which we have been wrestling is a sharp shock. At first sight, it insists on the sway of a poor—indeed, poverty-stricken—aesthetic. It seems to have imposed itself upon us with the brutal authority that indigenous people might have experienced upon the arrival of the colonizer. We know,

instantly, that the documentary mode is necessarily that of a Western technology, in this case in the service of an anthropological gaze. A moment's reflection leads us to ask: What other filmic records of this ceremony exist? Probably none, so why not use this one? But the significance of this work is subtler than these politically correct contrasts, and these pragmatic concerns. While the Ndeup ceremony and the Diana-Actaeon myth clearly have separate origins, when brought together they amount to more than a statement of either cultural distinctiveness or, at the other extreme, generalized humanity. In the insistence of the erasure of one by the other, they reverse each other, and the older narrative, the Ndeup ceremony, insists on its priority. It shows us, after all, that—far from the fear of recursion to bestiality that the Diana-Actaeon story so dramatically embodies—our humanity, including (perhaps even especially) our sense of beauty, is sourced in our animality, and must constantly return to it.

Yet the Ndeup ceremony and the Diana-Actaeon myth have this in common: they are guides as to how to respond, through ritual repetition, to some deep facts about human difference, about lived necessity, about gods

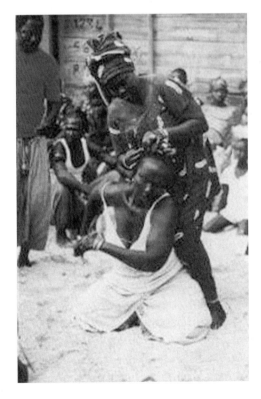

10.5. Jean-Michel Bruyère and LFK, *Si Poteris Narrare, Licet*, 2002. Still from ethnographic film of Ndeup ceremony, Lebou culture (Peul people). (Photograph by Dominique Moulon.)

as beliefs that can kill us, about the fragility of dwelling on the earth, no matter how elaborate its actual and metaphorical architecture. *Si Poteris Narrare, Licet* locates us right inside these endless conundrums. But it arms us with a capacity not always available. Through the interface, we can see the elements according to our preferences, to review them as we wish, to switch and match the parts, to follow its emergent narratives or counter them. With this freedom, however, *Si Poteris Narrare, Licet* challenges us to face the fact that, while much that we know of beauty arises out of our animality, some of it comes out as bestial. In this deep sense, Bruyère is acknowledging the power of the Western stereotype of Africa as the "dark continent," a vast repository of the less-than-human, but he is turning that presumption around, transforming it into a medium of human sharedness. Together, the Ndeup ceremony and the Diana-Actaeon myth take us from the heart of darkness to the eye of the light.[7]

It is this possibility, emergent from precisely this history, which Achille Mbembe sees as most characteristic of African art:

> If there is a characteristic trait of classical African art, it is that one always finds a violence at the beginning of the act of creation. In this act, we find a sacrilege and a mimed transgression, which we hope will make the individual and his community emerge from the world as it was and as it is. In this hope for liberating hidden and forgotten energies, for an eventual reversal of visible and invisible powers—this hidden dream of the resurrection of beings and things—lies at the anthropological foundation of classical African art. The body lies at its center, essential to the flows of power, a privileged location for the unveiling of these powers and the exemplar of the entire human community's constitutive debt, the one we inherit without wanting to and can never entirely discharge.[8]

Mbembe goes on to elaborate this idea in terms that could serve as a summary of the interpretation of *Si Poteris Narrare, Licet* offered here:

> Hence there has never been anything traditional in this art, if only because it was always designed to manifest the extraordinary fragility of the social order. It is an art that never ceases to reinvent myths; even as the art pretends to support and reinforce tradition, it subverts and undermines it. Hence art has always been about an art of sacrilege, sacrifice and expenditure, one that multiplies new fetishes for the purpose of a general-

ized deconstruction of existence, through games, leisure, spectacle and the principle of metamorphosis.

Does this utopian purpose—with its privileged role for art as the supplier of singularities—remain viable in contemporary conditions? We have noted some of the parallels and differences between *Si Poteris Narrare, Licet* and the *Cremaster* cycle as shown in the Guggenheim, New York. Both share with *Heaven of Delight* an attraction to all-round beauty, and a frank acknowledgment of its seductive draw toward death. All three are magnificent efforts to, in Geraldo Mosquera's words, "make Western culture"—by which the Cuban critic meant, as we saw in the last chapter, make it better, heal it, improve it, grow it.[9] But the possibility in Bruyère's work is larger still in scope and depth. It takes up a story about beauty and behavior that has been for centuries much loved by Mediterranean poets and artists, takes it on a journey to sub-Saharan West Africa, and then brings it back to Europe, taking us along with him, while handing over the tools to manage the journey. Unlike the spectacle offered by Fabre or the narratives offered by Barney, the passaging in Bruyère's work invites, but does not guarantee, transcendence. Rather, it goes to the recognition that deep differences have been shaping peoples here, on this earth, however disconnectedly, for centuries. They still do, now more than ever, with the differences more pronounced, yet their connectedness even more pressing. Imagining the other within us—or, better, the othernesses that are within ourselves; imaging our otherness within others; imaging possible exchanges between these othernesses as a worldwide economy, one that is occurring incessantly, everywhere, at once and in many distinct places, always concrete and always connected . . . this is the challenge to art, to all of us, now that the world has turned.

A View from the North

Challenged by the burgeoning of the postcolonial, certain artists from the West have sought more generalized allegories of the fears haunting globalization, and of the hopes for community that strive to oppose its deleterious effects. This spirit is to be found in some works of Anthony Gormley, notably his *Field* projects, consisting of handmade (indeed, hand-sized) clay figures, roughly humanoid in shape, each with uplifted head and haunting eye sockets, assembled in vast numbers, and organized so as to face their viewers. The first of these was *Field for the Art Gallery of New South Wales* (1989), the

most recent, *Asian Field* (2003), which consisted of 210,000 figurines made by 350 people from Xiangshan, a village northeast of Guangzhou. For the 2006 Biennale of Sydney, 180,000 of these figurines were installed in a century-old storage shed on a harbor-side pier, where they occupied much of a floor. Seen through a doorway, they flooded this space with their earthy light and spread around the remnants of wool-handling machinery. As a mass, they receded beyond the reach of vision, like a desert landscape. As a multitude, these small, creature-like humanoids advanced forward, their eyes raised, their faces open, as if asking a question. But which? To newspaper commentator Elizabeth Farrelly, the work elicited "awe, humor, pathos and, above all, fellow feeling." She felt that the figurines were "Not accusing, not angry; curious, perhaps, or pitying; interested, anyway, in you. In us."[10] Certainly, Gormley deserves credit for focusing so closely on the primary aspect of artistic communication, the face-to-face between a thing brought into the world and an existent human. And for avoiding stereotypical identity markers, those that prioritize categories and reduce individuals to instances.

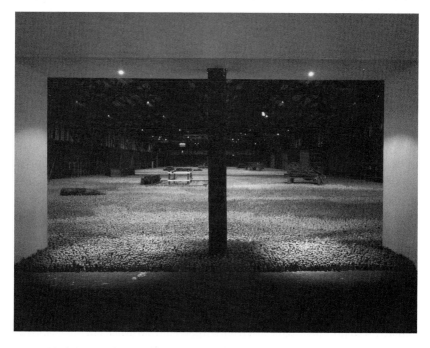

10.6. Anthony Gormley, *Asian Field*, 2003–6. Clay and photographs. Installation view at the 2006 Sydney Biennale. (© Anthony Gormley. Courtesy of the artist and Jay Jopling/White Cube, London. Photograph by Greg Weight.)

The other half of the installation consisted of close-up photographs of the heads of the villagers who made the figurines, alongside a single example of their work. While these photographs were attractive, positive images that recorded the villagers' pride and delight, their paired layout—and their Richard Avedon–style graphics—skated close to objectification.

In previous incarnations, *Asian Field* was installed in a vast underground car park of a new development in Guangzhou, the main hall of the National Museum of Modern Chinese History, Beijing, an upper floor of a riverside grain warehouse in Shanghai, a former underground air-raid shelter in Chongqing, and the hall of Jonan High School in Tokyo. In every case, the work would appear as a kind of surprising flotsam, an unexpected arrival from across the horizon of a sea of imaginary geographies. Yet this kind of imagery cannot avoid localization. To present a field of "Asian" faces in Australia, for example, is to evoke the racist chimeras that haunt this European settler colony, torn and distant from its homelands, a society that is still working on reconciling itself to its place, to its indigenous inhabitants, its waves of immigration, and above all, its regional location. From such a perspective, these figurines might seem to embody, at first, a nightmarish vision: the long-feared advent of the "Yellow Peril," the Asiatic hordes streaming southward to populate this "wide brown land." But then the ankle-height, low-key character of the figurines might assure nervous Australians that such an arrival would be a gentle beseeching for entry or, failing that, a soft colonization—somewhat akin, perhaps, to the Latino saturation now occurring within the United States. Wherever this work was shown, it would suggest, in the conflicted state that is contemporaneity, the irresistible presence of the Other, of otherness. And the hope that the coming confrontation will be nonviolent.

For the artist, however, the figurines symbolize human dimensions prior to sociality: "the project is to try to make a surrogate population, as the unborn, the future, the possible inheritors of the earth."[11] In Australia, these sentiments have an ancient resonance. Aboriginal representation of the ancestor figures usually shows them as humanoid forms, as partially formed, as attaining attributes as they go about elaborating their worlds. None of them, however, are brought together in a mass for a unified purpose. None of them represent all humankind. Mass action, crowds, humanity, everyman, and so forth are not ancient concepts. They are modern ones and appear precisely at the moment when they seem most threatened. Gormley went on to say in the interview just cited: "We are all conscious in this globalised world that in some way human beings are affecting natural systems that

have never been affected by one species . . . We have the ability to foul the nest for ourselves and every other species, or do something about it." He made these fields in England and Europe before extending them to Asia. His appeal seems to be that we must go in search of our common humanity, and that if we do, we might find it, already on the move, searching for us. This sense has, since the early 1990s, inspired Indonesian artist Dadang Christiano to develop the groupings of clay figures around which he builds his installations. In 1001 *Manusia tanah* (1001 Earth Humans; 1996), they seemed to emerge, earth-colored and partly formed, from the ocean at a beach just outside Jakarta, their heads uplifted, bodies thrust forward as if pleading.[12] Ethiopian artist Elias Sime addresses this theme from a more combative perspective. Using the clay from which rural people have for centuries made large storage vessels (*gotas*), Sime shapes them into souvenir and toy-like figurines that embody the stereotypes of transitional development, such as monkeys, frogs, and television monitors. Creating hundreds of these figures in varied, but mostly small, hand-held sizes, he leaves the clay in its raw state. The point of works such as *Untitled (monkeys, frogs, televisions)* (2006) becomes clear when he displays the objects in large numbers, thrown across the floor or piled up against walls or corners, as if they were refuse in a potter's yard, or leavings from a closed market.[13]

To Elizabeth Farrelly, and to many others, the symbolic level is the only one on which appeals of this sort may be properly made. Anything more direct, any explicit thematic, is not, in her view, the way of art. Indeed, she rejects everything else in the Sydney biennale—which was devoted to art that evidenced the zones of contact between people, peoples and cultures in the world today—as "meretricious global dross."[14] That she does so without naming any other work, without distinguishing in any way at all between them, is a significant coupling with her celebration of *Asian Field*. She treats the other art in the exhibition as an undifferentiated Other, as without significant difference, as lesser, indeed, than the figurines in the Gormley. To her, they all seem the same, garbage washed on to our shores, rejects from elsewhere, worth less sympathy than the refugees and asylum seekers, the "boat people," whose plight has so bedeviled the Australian polity in recent years. She is repulsed by the fact that these works have arrived from elsewhere (from forty-four countries, produced by eighty-four other artists). She sees these works as instances of a stylistic category, something like "globalist art," and thus by definition poor art. These presumptions are a regressive reaction. They are blind to the success of a number of artists who have, since the postcolonial turn, been forging a new aesthetic, one that foregoes

10.7. Shirin Neshat, *Passage*, 2002, video still. (Courtesy of the artist and Barbara Gladstone Gallery, New York.)

arm-length symbolism of the type Gormley uses for immersion in the fresh beauties of animality as it faces the violence all around it.

Passages to Iran

In the video work *Passage*, made in 2002 by Iranian artist Shirin Neshat, a group of black-clothed men carrying something at shoulder height move with urgency and great determination from the seashore across a dry, desert-like terrain. They do so for more than ten minutes, accompanied by the driving music of New York–based minimalist Phillip Glass. Lacking symbols, hierarchy, and any evident ritual, their purpose is as ambiguous as the state of the white shroud, and perhaps the body, that they bear. Their progress is constantly contrasted to the actions of a group of hooded women circled closely together who wail loudly and beat at something unseen in the dusty ground before them. In the penultimate scene, the men deliver their nearly invisible burden into the space cleared by the women. At the same moment, a fire breaks out and travels along a triangular stonewall. The camera pans to a young girl who has been hiding there all along—like us, a silent witness, learning something about her future.

This work exemplifies the kind of contemporary art that locates itself at the emotional core of a culture that seems to have nothing that is contemporary about it, yet persists in our time. Indeed, in many parts of the world, it is ascendant in our time. It is a culture that draws a worldly young feminist artist to it, to its implacable differencing between men and women, as an experience of trauma. As in Fabre's work, irony is irrelevant. Anachronism *is* relevant, but here, in Neshat's work, it is questioned. The very idea that one kind of culture, the modernizing ones, gets to decide that another is anachronistic is thrown into doubt. Before 9/11, *Passage* showed us that feudal structures were still so powerful that they shaped the everyday imaginaries of millions and would figure in the future of even more. And it concluded by showing us something even more powerful than that: that death exists beyond gender division, as does the recurrence of life.

The beetle casings in Brussels are an example of official, institutionalized contemporary art, dedicated to finding new, modern ways of re-presenting peculiarly aesthetic beauty. On the other hand, while Neshat is a celebrated contemporary artist—one who indeed has come to be better known than Fabre—and while there are many questions to be asked about the ambiguities of her situation as an artist who makes work about a country from which she is an exile, and from a culture which she cannot abandon, *Passage* shows us something that is, at the same time, incomprehensibly strange yet hauntingly familiar. The crucial thing is that, like *Si Poteris Narrare, Licet*, it does not give us the tools to resolve this tension in favor of one or the other, neither the strange nor the familiar. These days, a modern work of art would attempt to do so. A work that is sourced in the complexities of contemporaneity, however, cannot close itself down. It must leave itself open. For whatever is to come.

Before 9/11, in a number of powerful works—*Turbulent* (1998), *Fervor* (2000), *Rapture* (2001), and *Possessed* (2001)—Neshat showed that feudal structures persist, not only in the cultures of the Middle East and northern Africa, but that they are present at the roots of all of our relationships.[15] Neshat came to prominence as a visual poet of the inscriptions of power, tradition and institutionalized religion on the bodies of women in patriarchal cultures, notably in her photograph series *The Women of Allah* (1993–97). Iranian performance artist Ghazel approaches the same subjects, but from within a very different aesthetic. In her set of three videos, *Me in 2000, 2001, 2002*, she parodies both Islamic dress codes and the typical tropes of conceptual art by performing a number of nominated actions based on common sense sentiments while dressed in her burka. In *Everyone Dreams of Staying*

Young and Fresh, for example, she wraps her already fully clad body in food-preserving foil.[16] This rather desperate hilarity stands in marked contrast to the portentous character of Neshat's more recent epics, such as *Tooba* (2002) and *Women Without Men* (2004). Marjane Satrapi has pursued yet another route through these tortuous topics, that of the chronicler of her own life, akin to the webcam diaries popular on sites such as MySpace and YouTube in the West. Her medium is comic strips, gathered into books. Outstanding among these is *Persepolis,* published in France between 2001 and 2003—subsequently in book and (less successfully) film form—and her comic book on the women in her family, *Embroideries.*[17]

These concerns, of course, are not confined to artists from Iran, or to those from the colonized parts of the world. Since his exile from Chile in 1974, Juan Davila has highlighted—through an imagery of the unrepentant transvestite—the contradictions in the construction of sexual identity in Australian and Chilean historical and art historical memory.[18] Tracey Moffat has created a powerful and elegant sequence of films and photographic series that explore the fissures of relations between the races in Australia.[19] In the work of Adrian Piper, Glen Ligon, Lorna Simpson, Carrie Mae Weems, Kara Walker, and others, the visual resonance of race, language, and sexuality in the United States continue to be acutely mined. The achievement of these artists matches that of Neshat, and of Isaac Julien, to whose work we will next turn. One of art's roles within the circuitry of contemporaneity is to display the intimacies of living within cultures that impose on their members what seem to others, and to many within them, to be great constraints. This task is even more pressing when cultures constrain great or small numbers according to categories, such as their being women, or lower in caste, or from a designated minority.[20] Identity is, too often, a matter of imposed identification. It is no surprise that, in the aftermath of decolonization and the rise of globalization, interplay between these modes of selfhood is a preoccupation for many artists in many parts of the world. I will conclude this chapter by exploring the work of an artist who deals with these issues, directly and exquisitely.

Moving Passions Beautifully

In 1988, speaking on a panel entitled "Aesthetics and Politics: Working on Two Fronts" at the London Film-Maker's Co-Op, British artist Isaac Julien observed that "there exist multiple identities which should challenge with passion and beauty the previously static order."[21] This signaled a change in

approach, as for some years he had been a member of the Sankofa Film Collective, which had documented specific abuses of authority and freedom in England during the Thatcher period in direct, anti–mass media modes. His subsequent work has focused on how individuals experience and construct identity, often through the trope of the interracial male couple. In stating his position in 1988, he may have had in mind the precedent of American photographers Bruce Webber and George Platt Lynes, the films of Rainer Werner Fassbinder, the then-recent controversies over Robert Mapplethorpe's photographs, and the friendship between Andy Warhol and Jean-Michel Basquiat in the last years of both their lives. He would have known the work of Nigerian British photographer Rotimi Fani-Kayode, whose *White Bouquet* (1989) shows two naked figures positioned to evoke Edouard Manet's painting *Olympia,* so provocative when first exhibited in 1863, except that the flower-holding "maid" is white, the "courtesan" black, both are male, and viewed from behind.[22]

The reversals, inversions, and possibilities of interracial coupling are at the heart of the postcolonial turn: they are among the vital energies that set it in motion and keep the world spinning. While they pose the question of individuality as first of all a matter of collective identity, they do so in problematic terms. Collective identity is subject to various forces, both social and natural, yet open to active self-positioning. In his films and video installations since the late 1980s, Julien has pursued the passages of various actual and symbolic characters across these conditions. *Looking for Langston* (1989) evoked the private worlds of the artists, poets and writers who made up the Harlem Renaissance during the 1920s through the trope of homoerotic cruising. The feature-length film *Franz Fanon: Black Skin White Mask* (1996) used interviews, reconstructions, and archival footage to ruminate—through stylized performance of imagined scenarios—on aspects of the life and work of Fanon, who was a psychiatrist in Algeria during the war of independence, a member of the FLN (National Liberation Front), and the author of the widely influential, countercolonial and revolutionary texts, *The Wretched of the Earth* and *Black Skin, White Mask.* Julien's *BaadAssssss Cinema,* made in 2002 for public television, traced in reportage style the rapid rise and fall during the 1970s of "blaxploitation" films, a highly macho genre of commercial cinema created by independent black producers, actors, and directors.

Julien's multiscreen installations are more reflective in mode, evocative in mood, and cyclic in their temporalities. One recurrent theme echoes the concerns of the other artists discussed in this chapter: the nature of aesthetic beauty. Like them, Julien sees it as a highly institutionalized, exclusively

10.8. Isaac Julien, *Fantôme Créole*, 2005. Four-screen audio-visual installation. (Courtesy of the artist and Metro Pictures, New York.)

privileged cultural construct, which is nevertheless unfailingly seductive. In his installations, however, the viewer's experience of this beauty is mediated through the perceptions of diasporic colonial subjects who live and work in the metropolis, in the corridors of cultural power. His understanding of this condition moved from the literalism of *The Attendant* (1993) and *Trussed* (1996), in which gay men, both black and white, enact sexual fantasies in ways suggested by paintings in galleries, through *Long Road to Mazatlán* (1999), an on-the-road fantasy of homoerotic desire and loss shot in the desert towns near San Antonio, Texas, to *Vagabondia* (2000), in which a black female conservator imagines the extraordinary array of items in the Sir John Soane house museum, London, animated by ghosts of the peoples brought to the city by the colonizers during the eighteenth century.

Since then, Julien has pursued the imagery of *creolité*—the mixed languages, the hybrid mental states, and the territorial transpositions that arise when one lives in multiple cultures. *Paradise Omeros* (2002) is set in both London during the 1960s and the Caribbean island of St. Lucia today. Inspired by the poetry of Derek Walcott and developed in consultation with him, it deploys the production values and tones of tourist advertisement imagery

to create a series of reveries about selfhood and strangeness, displacement and homeliness, economic security and dependence. In stark contrast, *True North* (2004) is a meditation on the experience of Matthew Henson, a black American manservant who accompanied explorer Robert Peary on one of his expeditions to the North Pole. The interplay of sublime landscapes at the far reaches of the earth and the time-consuming directionlessness of individual questing across those spaces continues to preoccupy Julien in works such as *Fantôme Afrique* (2005), set in Ouagadougou and Burkina Faso, and *Fantôme Créole* (2005), which is set in both Africa and the artic. In these works, dancers enact trickster/phantoms, or play ghost-like witness to historical conflicts in these regions and to their transformation, by the intersection of local and global forces, into contradictory "no-spaces."[23] These aspects of Julien's work parallel those of filmmakers such as Hiroshi Teshigahara in *Woman of the Dunes* (1964) and Andrucha Waddington in *The House of Sand* (2006).

The work of the contemporary artists discussed in this chapter explore, with subtlety and grace, the circuitry of otherness and selfhood that passages within and around us today. They suggest that, slowly, sometimes barely perceptibly but nonetheless hopefully, the systemic violence of colonial relationships—and thus the resonance of images of bestiality—might be subsumed by the calmer prospect of states of being—including the sense of beauty—shared with other humans, other places, and, perhaps, other animals.

Part 5
Contemporaneity: Times / Places

CHAPTER ELEVEN
Taking Time . . .

On March 31, 1999, James Turrell completed his *Backside of the Moon,* an installation within Minamidera, a building designed for this work by Tadao Ando in the village of Honmura on Naoshima Island, Japan, in the Seto Inland Sea. Named after a temple that stood on the site and following a resolutely modernist rectangular plan, the building's charred cedar walls were cut according to traditional measures by local craftsmen. Its ground plan schematically follows the indirect route toward the destination favored in the design of Japanese temples. On entering the interior, you sit in darkness for between ten and fifteen minutes, until a large colorless rectangular shape appears before you. It can be approached as if it were an object in space, and looked into. Nothing is there. After some more time, faint colors can be seen—mostly purple, for most people. Then you leave. It is bright outside.

Just after the work's completion, Turrell and Ando visited the site; the following is an extract of the conversation they had while viewing it:

Ando: The color is really nice. I have no difficulty in being here for 10 minutes.

Turrell: Sometimes 19 minutes is difficult in modern life. This is fine that the work has been situated like this in a small town; it brings together the traditional and the contemporary. It's a way that makes some sense. I think that things in contemporary art must mean something to you. They need to be near your life, too. People here at first, may wonder about this work, and about the architecture. Over time, it should be interesting to them, because other people will come on a long journey to see their town.

Ando: I think it is very important that this work of art was completed at the end of the century.

11.1. Tadao Ando, *Minamidera*. Honmura, Naoshima, Japan. (Courtesy of Benesse Art Site Naoshima.)

Turrell: I think so. If we think of just the modern life, as in Tokyo or New York, we can adopt a way of thinking that takes away from the soul. When you take architecture and put it in nature, like Benesse House, and also take art and architecture and put it in the village, there comes a way that you can restore the soul.

Ando: I was astonished to see that this work expresses the essence of the core of contemporary art.

Turrell: Well now I think it's better to take another look at it, because now we are seeing . . .

Ando: Even though I can finally see it, it is nice that only here seems so deep. Let's take a look from over there.[1]

Turrell's installations are very literal instances of one pronounced tendency in many modes of contemporary art: the taking up of a viewer's time before the work provides enough information about itself for its point to become apparent. The sense of time "taken away" by an artwork contrasts with another prominent tendency—much in evidence in retro-sensationalist

art—the instant impact of the one obvious idea. Yet it also contrasts with the persistent presumption that earlier forms of art could be understood, if not at once, then quite quickly, yet were, at the same time and in various senses, "timeless." There is some lingering resentment that contemporary art is trying to avoid playing by these rules, accompanied by a belief that the best of it nevertheless will turn out to have a similar mix of qualities. In the modern era, experience museums, intent on attracting vast crowds but also needing to process them fast through relatively narrow spaces, have promoted the sense that the time that a viewer might devote to any given work is his or her choice, yet in practice they orchestrate crowd management so that untrammeled time is becoming increasingly rare. Thus the familiar trope of the distracted museumgoer, spending, on average, a few seconds before each painting or sculpture, while also, in quiet desperation, and not quite knowing how, wishing to find the kind of time necessary to reach the holy grail of aesthetic epiphany.

Contemporary art invites, or requires, many kinds of time from its audiences, and offers many in return. Its most typical forms—the installation, the participatory event, and human-machine interaction—have introduced a variety of distinctive demands on spectators and participants. Some of these are proximate to the modes of consumption within spectacle culture. For example, many installations are cinematic in character, entailing projections of various sorts, but set themselves against the clear schedules of television viewing and the standard lengths of different types of movies. In my view, objections to art that does not conform to the norms of proximate mediums are beside the point. They fail to acknowledge the presumption within all contemporary art that is worth the name since the great shifts of the 1960s: its deep engagement with the paradox that, as the world diversifies and complicates itself beyond all singularizing encompassment, artwork and viewer exist in that shared space and time, both doing the same kind of work (or, at least, similar, necessarily conjoint kinds of work) of bringing meaning into existence—together, at once, contemporaneously. This is why the installation, participatory performance, and digital interactivity have become such ubiquitous modes: they mark out a physical or virtual space, a part of the world, as a site pervaded by provisionality and possibility—a place in which, precisely by exempting itself from all external rules governing location, and by suspending for a time the operation of the world's increasingly multiplicitous temporalities, while yet acknowledging their powers in these very deferrals, the work of making meaning may be undertaken.[2]

Whatever mediums they favor, artists these days tend to focus on four concerns: time, place, mediation, and mood. More precisely expressed, artists are raising questions as to the nature of temporality, exploring experiences of location vis-à-vis dislocation, examining the world's immersion in mediated interactivity, and testing the limits and the potentialities of affect in these circumstances. These concerns are, by no coincidence, the key formations of contemporaneity as I have been defining it. Accordingly, they are always implicated in each other. Nevertheless, one or another tends to be the entry point, for both artists and audiences. This chapter is devoted to exploring just how a number of artists, beginning from a variety of experiences of time, are tackling both temporality and the other concerns just listed. It aims to chart the different kinds of time to which contemporary art subjects itself, the kinds that it is asking of its audiences, and what it seeks to give in return.

Kinds of Time

It is a commonplace that modern times recognized themselves above all in what was seen as the irresistible nature of the world's incessant shifting from past into present, processes that occurred in the name of the future. The current situation, I have been arguing, is characterized more by the insistent presentness of multiple, often incompatible temporalities accompanied by the failure of all candidates that seek to provide *the* overriding temporal framework—be it modern, historical, spiritual, evolutionary, geological, scientific, globalizing, planetary. . . . Everything about time these days—and therefore about place, subjectivity, and sociality—is at once intensely *here*, is slipping, or has become artifactual.

We might also say that time is, as well, moving in many different directions: backward traveling, forward trending, sideways sliding, in suspension, stilled, bent, warped, or repeated. Only for some, nowadays, does time move inevitably forward. It is, therefore, being experienced differently—as if we were all, all over the world, existing in different times and places, in distinct cultures and settings simultaneously. Moreover, we are all becoming increasingly aware of this accelerated differencing. These states indicate the coming into being of a new condition, or, better put, *situation*. It is not a period—periods may be past, at least in their claim to universality, even to widespread global reach.

Given these kinds of change, how is time treated within each of the currents that I have nominated as elements within my hypothetical description

of art in the conditions of contemporaneity? We recognize that they have, at their core, different commitments as to time. One of these is a persistence of the centuries-long search for the transcendence of time through art, of the quest for eternity. Modernist painting, sculpture, and architecture developed its own version of this deep drive: it continues in what I have named the remodernist tendency in contemporary art. Retro-sensationalist art, in direct but utterly implicated contrast, is consumed by instantaneity, by effects as sharp and cool as the most up-to-date fashions. Taken together, however, the mainline tendencies in contemporary art presume that, while they forge their inspirations in states of exception, the time and space occupied by all that is around them is pervaded by sameness, so that whatever differences it may contain, it is subject to a universal flow of time, of which those closest to the sources of power are the de facto managers. These presumptions shaped colonial time setting: certain European nations became powerful enough to impose their time-measuring systems on their colonies, thus Greenwich mean time throughout the British empire and beyond, or Moscow time throughout the Soviet Union. (Darren Almond's *Meantime* [2002] displays this effect single-mindedly: a giant LED clock is built into a standard steel shipping container; the clock is set to Greenwich mean time and then, accompanied by the artist, is shipped from London to New York.) More generally, the impact of the London and New York stock exchange trading hours was, and remains, far reaching (although of course those of Japan, and most recently China, are having their effects), as were the various time-based regimes of industrial production: Fordist mass manufacturing, Japanese "just-in-time" supply production. Together, we might think of these as constituting, along with their multiple cultures, *modern time*. Yet modernity has been, for decades, struggling to maintain its division of the world into those who live in modern time and those who, while physically present, were regarded as non-contemporaneous beings.

During the period of modernity's dominance, the downside of what used to be called cultural imperialism was a kind of ethnic cleansing carried out by the displacement of unmodern peoples into past, slower, or frozen time. But these peoples have come to claim their places, in history, in time, and, through migration, in place—that is to say, in the places of modernity, the neighborhoods of the north. We might relate this to the second tendency in contemporary art, and call it *postcolonial time*, or, making an analogy to the default category world music (and with acknowledgments to Fernand Braudel), *world time*.[3] Yet even this insurgency of the multitudes does not encompass all peoples these days, to say nothing of the heterogeneity within

them, nor does it fully account for the variety of their temporalities. In a mediascape characterized by such contrary forces as instant communication of key decisions by political leaders on one continent and the capacity to demonstrate against them on another within the same news cycle, the power to force everyone forward in broadly the same direction, no matter how diversified, has been lost. In this sense, globalization is a project that has run out of time: it is not complete, but it has gone as far as it can, according to its own ambitions and capacities.[4] In many parts of the world, consciousness is concerned with taking many steps, fast, not from the old to the new, but (in the case of the fundamentalisms) vice-versa. We therefore cannot speak of *contemporary time*, as that would presume a fictive unity. Multiple yet incommensurable temporalities are the rule these days, and their conceptions of historical development move in multifarious directions. This is not a neutral pluralism. The name for this immersion in a plethora of temporalities, of living with time in the most emphatic and extenuated sense, has already been proposed: contemporaneity.

In such a context, it is scarcely surprising that younger artists—those leading the third current that I have identified, art that manifests the conditions of contemporaneity—reject grand statements and find themselves exploring ways of taking small, but hopefully significant, steps within this seemingly limitless stream of times. Video artist Doug Aitken spoke for his generation when he said: "The question for me is how I can make time somehow collapse or expand, so it no longer unfolds in this one narrow form."[5] As if in illustration of this idea, one of his recent installations, *The Moment is the Moment* (2004), is made up of a corridor of broken, refracted mirrors. Nor is it surprising that Olafur Eliasson—master of installations such as *The Weather Project* that induce sublime experiences of apparently natural phenomena while at the same time overtly displaying the mechanics that create the special effects—chose *Take Your Time* as the title of the 2008 survey of his work at the Museum of Modern Art, New York.

Eternality

Almost all contemporary artists respond in some way to this circumstancing, to the thirst for situatedness that it calls forth (indeed, those who do not are scarcely *contemporary* artists). Elsewhere—on the island of Naoshima, for example—installations by other artists explore relationships between time and place in ways quite different from that of Turrell. In one of the larger old houses in Honmura village, Tatsuo Miyajima has installed his *Sea*

of Time '98. The floor of the shaded interior is a shallow black basin filled with water, in which 125 LEDs blink like night insects that have settled beneath the dark surface to become electronic water lilies. Ticking down from nine to one (the artist omits zero, believing it to represent a termination), the red, green, and yellow counters are each set at a rate determined by an individual resident. This establishes an uncanny connection to the duration of their lives, making the work a silent companion, a mute witness, and, in some cases, a memorial. In the Benesse House art collection, elsewhere on the island, Hiroshi Sugimoto's series of photographs *Time Exposed* hangs out of doors, on the walls of a terrace that, half way along the sequence, affords views of the Seto Inland Sea. Taken between 1980 and 1987 at sites all over the world, these profoundly minimal studies of featureless horizons use the basic elements of photographic seeing and printing to try to fix a mode of seeing duration itself.

Walter de Maria's *Time/Timeless/No Time* (2004)—the largest work in the Chichu Art Museum, another exquisite Ando structure on the island—is a less successful deployment of this vocabulary. Its arrangement of sets of gold geometries around a vast stepped chamber, at the center of which is a huge, reflective, dark green and black granite sphere, amounts to a movie

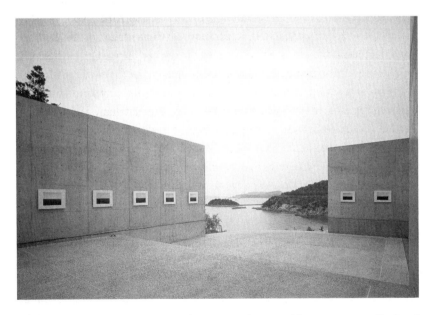

11.2. Hiroshi Sugimoto, *Time Exposed*, 1980–97. Photographic sequence, as displayed at Benesse House, Naoshima. Designed by Tadao Ando. (Courtesy of Benesse Art Site Naoshima.)

set–like evocation of a temple that might be suitable for every religion, and thus for none. In sharp contrast, Bruce Nauman's *100 Live and Die* (1984) engages the spectator in an aggressive dialog about language, media, life, and death. Four columns of brightly colored neon flash stacked rows of variations on the title statement, with "and" remaining in the center of multiple word combinations, thus connecting into curt statements words such as "eat," "shit," "piss," sleep," "scream," "love," "hate," "young," "old," "sing," "cut," "run," and "play." In its brash visual language, its unabashedly American self-subversion, and the rawness of the encounter which it sets up, this work disrupts the contemplative calm at the core of owner / donor Soichiro Fukutake's dream for Naoshima: that a carefully judged conjoining of the best of contemporary art and architecture can reveal what a new "spiritual backbone for the 21st century" would be like.[6] On the other hand, perhaps Mr. Fukutake imagines that one's spiritual journey at Naoshima begins with the worldliness embodied in the Nauman, and that as one explores the island, the other works in their various natural and ritualized settings gradually draw the art pilgrim towards a kind of enlightenment. There are, after all, four of Monet's *Water Lilies* paintings in a suite of rooms in the Chichu Museum: one approaches them across a corked floor in stocking feet.

However ludicrous it might seem to be, the desire to take certain kinds of contemporary art as the core elements of a contemporary religion cannot be dismissed as an idiosyncrasy. It is commonplace in the discourse surrounding culture that art, along with sport, has taken the place of organized religion in modern societies. For centuries museums have evoked the ethos of temples—museums of art especially so. In Japan, this connection has been updated recently in the Miho Museum, Shiga Prefecture, where I. M. Pei's elegant structure, arrived at after passing through blossom-bedecked passageways and a tunnel, houses an indifferent collection, but affords views of a nearby temple, the only man-made structure visible in the surrounding forests and mountains. We have seen that the urge to create a cathedral for contemporary culture was an explicit impulse in the conception of the Guggenheim Museum, Bilbao. While the modernist historicity, the "disappeared" building and, now, the thronging crowds, make it counterintuitive to read the MoMA as a contemporary place of pilgrimage for experiences that transcend history-bound art, something of this spirit, we noted, pervades Dia:Beacon. It is induced by the awe-filled respect paid, in every aspect of the institution's conception, organization and self-presentation, to the idea that the artist should set, absolutely, the terms of the spectator's encounter with his or her work, and that this encounter be one with that

artist's effort to produce art over a period of time. As the period becomes, inevitably, that of the artist's lifetime, this sacral mood will increase, as it does in an aging church, mosque or temple.

While the implacable materialism of most minimalist artists makes this tendency one that clashes against the deepest grains of their work, a number of post-minimalist artists, such as Turrell, entertain world outlooks in which certain kinds of spirituality are no longer foreign. Most prominent among these at the moment is United States video artist Bill Viola. While his conceptual / performance work in the 1980s was driven by explorations of the body (often, his own) subject to extraordinary stresses, most of which were resolved (at least for the duration of the piece) by the limits of the human capacity to go without air, his more recent work has been alive to many different kinds of time taken by a world that is, or can be, enchanted—that is, inhabited by gods. In *Observance* (2002), a seemingly neverending file of ordinary people, life-size and framed in a narrowly vertical format, approach the space of the spectator, become aware of something in front of and below them that horrifies them, and recoil into voiceless grief while reaching for the person beside them, before returning back into the distance. The "something" posited between these animated figures and the spectator is not shown, but is by implication something that both could see, at once, something that the figures do see but the spectator does not, perhaps because they are in a world of belief, and the spectator is not—or, at least, the artist may hope, not yet. That is the work's invitation: to observance, pure and complex. Only by implication and cultural resonance is the observance that of a horrible death (in fact, during the filming, the actors were instructed to respond as indicated, with a vase of flowers as the prop). Only by direct inference from the rest of Viola's work is the reaction a witnessing of the body of the crucified Christ. This association becomes explicit in a number of other works, notably *Emergence* (2002), which shows a Christ-like figure slowly rising out of a tomb and into the arms of two weeping women clad in ancient costume. While deliberately conjuring the coloration and tonality of an altar painting in the style of Piero della Francesca, *Emergence* attempts to picture the eternal / sacred time made available to humans by Christ's sacrifice.

Like most of Viola's work, these videos deploy the minimal elements of vision itself, which they then enrich with associative color and tone in order to render vivid the promise offered by what he (and too many others) calls "spirituality": that these two levels of temporality—the eternal and the human—can be integrated (in the case of Christianity, redemption is deemed achievable through Christ's sacrifice, and through belief in it). All

11.3. Bill Viola, *Five Angels for the Millennium*, 2001. Video/sound installation. i. "Departing Angel" (detail). (Photograph by Kira Perov. Courtesy of James Cohan Gallery, New York.)

of these urges are integrated in his installation *Five Angels for the Millennium* (2001), where they are shown as natural phenomena, cycling through time and space, water and air.[7] For all of Viola's evident urge to match his enterprise against that of the great past masters of religious art, sometimes to the point of almost literally animating their key works, it cannot be said that his efforts reach the emotional depth and the artistic subtlety or the dramatic clarity of, say, Caravaggio's *The Taking of Christ*, the version in the National Gallery of Art, Dublin, painted around 1602. In this painting, contemporaneity is manifest not only in the artist's cladding of the soldiers in seventeenth-century armor while maintaining for Christ, Judas, and others costuming imagined as of their ancient time, it is also present in the dazzling centrality of the reflection on the soldier's arm, the attention drawn to the weighty gesture of arrest, the freezing of the rhythms in and out of light and dark that undulate across the painting, the holding of the viewer's eye at just this moment of perception, the grasping of the viewer's soul at the moment of its submission to authoritative possession. Against precur-

sors such as this, Viola's efforts at telling anachronism seem awkwardly contrived.

Another, quite contrasting treatment of "eternal" time may be found in the work of contemporary Aboriginal artists, whose paintings evoke settings and stories from the Dreamings (Aboriginal originary narratives) that, while up to forty thousand years old, remain vivid, foundational, and a matter of everyday experience in the present. Pintupi elder Turkey Tolson Tjupurrula's mural-sized painting *Straightening Spears* (1998) is an acrylic-on-canvas evocation of a ceremonial sand painting, a focus of sacred witnessing set out on the desert "floor." It presents an originary event as powerful as anything imagined by Viola, and of much more ancient lineage. Without overt figuration, Tjupurrula shows the outcome of what was, for the first Pintupi ancestors, the moment of awareness of other people, of the threat of battle, and of the mitigation of this threat through the infinite care, and the extenuated time, taken in preparing for it.[8]

In the current situation, however, Christian hope—however strong its revivals, its new formulations—Aboriginal belief—however embattled yet persistent—and contemporary art and architecture—however well financed—are just several among many routes towards hoped-for redemption, isolated pathways along a multiplicity of roads that go in many other directions. This realization and many of its implications are imagined with uncanny precision in Paul Chan's *The 7 Lights* project (2005–7). This is a series of digital animations projected on to various surfaces—floors, walls, ceilings, furniture—each unfolding over fourteen minutes. Chan challenged himself: "After 9/11, after globalization, in the midst of the kind of radical and fundamental transformation of geo-political power and geo-political space, how do you visualize it? What is the new language to describe this new world? Rightly or wrongly I began to imagine shadows as the language to do that."[9]

In *1st Light* (2005), it is as if we are looking out from a building through an open door. An apparently simple occurrence slowly unfolds: against the changing daylight and the fixed profile of an electric light pole, the dark shapes of smaller, then larger, objects, animals, and finally, people rise steadily upwards until only the pole is left, its wires straining aloft until they break. A post-9/11 work, yes, but also an evocation of the Rapture so desired by certain evangelical believers. *2nd Light* (2005) continues this dreadful picturing, yet anchors it in a large tree. In *3rd Light* (2006), Chan projects the rising/falling figures across furniture in a bare room, suffusing the light

11.4. Paul Chan, *4th Light*, 2006. Projection on wall, as installed at the 2nd Seville International Biennale of Contemporary Art. (Courtesy of the artist. Photograph by Jean Vong.)

with red and blue colorations. Yet we soon notice that the table has the dimensions of the one pictured by Leonardo da Vinci in his famous mural *The Last Supper,* so the shadows are seen as if through the windows behind the absent holy figures. *4th Light* (2006) is a window set into the upper wall of a well-lit room, through which we see drastic profiles of destruction, after which a spider appears busily to recommence weaving its web. In *5th Light* (2007), the field in which objects—including many kinds of weapon—float, and come apart, is projected in a triangular format against the floor, one that reverses itself and simmers as if it were a ghostly reflection when it appears on the adjacent wall. *6th Light* (2007) similarly doubles the floor projection—of objects, people and hard-to-identify items rising into space, as in *1st Light*—with a second projection on the wall that shimmers, as if underwater. The score for *7th Light* (2007) recasts the entire series of projections as a musical composition, inviting us to imagine the tension between lightness and darkness within them as an interaction between silence and sound. With a relentless, compelling subtlety, these works succeed in "hallucinating" the days of creation, but as a world-making that is playing itself out in reverse. There are few more powerful evocations of the current apocalypse in contemporary art.

Measuring Presentness

Among the variety of digital photography shown in the "We're All Photographers Now" exhibition at the Musée de l'Elysée, Lausanne, in early 2007, Noah Kalina's *everyday* attracted most attention. It is a six-minute video compiled from the 2,356 self-portraits that the Brooklyn photographer shot between January 11, 2000, and July 31, 2006. In contrast to the commitment involved in making the self-portraits over a six-year period, producing the video via Windows Movie Maker software on his home computer took four hours. When he posted it on YouTube in August 2006, *everyday* became a standout among the seemingly infinite number of self-presentations that are at the core of the site. This occurred, perhaps, because of its combination of the low-grade narcissism ubiquitous on such contemporary sites with an earlier aesthetic priority: the long-term obsessiveness required to register the kinds of relationships between technology and selfhood that preoccupied many modernist artists, especially at the end of modernity. Curator William A. Ewing was moved to hyperbole worthy of *Wired* magazine: "Noah's video represents a phenomenal amplification not just in what he produced and how he did it, but in how many people the piece touched in such a short period of time. There is nothing comparable in the history of photography."[10] Have both curator and photographer forgotten not only the extraordinary spread in the popularity of photography in its earliest years, but also the fact that, since the 1960s, artists have attacked standardized devices and procedures for measuring time by taking modern practices of time control to their logical extremes, and by introducing elements of the randomness of everyday life, exposing the graceless, draconian character of this relentless measuring of everything and everybody?[11]

Andy Warhol's films not only record real time as it was unfolding—in *Empire*, from twilight at 8 p.m. on July 25, 1964, to 2:30 a.m. the following morning—but also project the footage at arbitrary rates: in this case, the single shot of the famous building in slow motion, stretching time to eight hours and five minutes. Time becomes thoroughly mediated, indeed, becomes the medium of exchange between artist and viewer. Time as medium is also the subject of Warhol's silk-screened paintings, but in the reverse sense: using images taken from printed or photographic mediums, he presented them singly, or in random repetitions, their effects as instant as advertisements. Immediacy has at its core the word (and the idea of) "media." Warhol sought an effect in which the medium disappears, and impact is all. He also sensed that, in that moment, all that exists is pure medium. When,

however, he made public statements about the more general condition he was seeking to embody in his practice, he would speak of contemporary life as a succession of samenesses, one thing after another, each equivalent, everything taking its own time.[12] In this sense, he remained a modern artist.

Time within media—the kinds of time peculiar to media, especially popular media, and the infiltration into our sense of time of the temporalities of these ubiquitous mediums—is a related Warhol legacy pursued in depth by many contemporary artists. Douglas Gordon's *24 Hour Psycho* (1993) is a projection of Alfred Hitchcock's famous 1960 film slowed to fit an entire day. Part of its precision is its punning on the 24 frames-per-second structure of cinematic pacing. Shown on a hanging screen in the center of a room, often with couches for viewing spread around, it invites us to contemplate the implied world within a media artifact with a mix of engagement and detachment distinct from that evoked by Warhol's film of nearly thirty years prior. Whereas then it had been the grain of film itself, so to speak, that absorbed our attention, while abstractions about New York city floated in and out as memories or perhaps fantasies, in *24 Hour Psycho* Hitchcock's movie becomes an artifact. In our reverie, it seems filled with actual space; we feel that we could walk around inside it, deliciously invisible to the actors, who go through their slo-mo "lives" oblivious as to our "presence." It is we, not they, who experience the rush of freedom from narrative, yet at the same time we are movie savvy enough to be alert to the *Jurassic Park* possibility—which, in the world of *Psycho*, could turn nasty. This sure beats a visit to Universal Studios! Are such reflections possible when we view Chris Bors's *24 Second Psycho* (2005), a digital video of the film projected at accelerated speed? The artist's general point is an allusion to "society's increasingly short attention span."[13] One interesting effect—an outcome presumably of the work's being, in fact, a compilation of stills for this black and white film—is that it looks like a sequence of Warhol source photographs collaged into a weirdly alien yet quite familiar silent movie.

In 1974, when Warhol moved his studio, the Factory, from 33 Union Square West, New York, to a new space on Broadway, he took up the suggestion that the boxes used in the move be employed as "time capsules" for the flood of ephemera that entered the studio each day. Devices for encapsulating items from a particular period, to be opened at a specified future date, were a common attraction at special events such as expositions (the 1964 New York World's Fair) and evidently historic events (the 1969 moon landing). Warhol applied them to a personal purpose, accumulating six hundred boxes by the time of his death in 1987.[14] In this project, that which is to come is primed for

disturbance by the reappearance within it of a relatively random but nonetheless heavily slanted sample of that which was.

How are chronophobia and chronophilia treated by artists working within the conditions of contemporaneity? Above all, by showing the workings of time in their personal experience of these conditions. For his *One Year Performance 1980–1981 (Time Piece 11 April 1980–11 April 1981)* Taiwanese artist Tehching Hsieh punched a time clock in his studio every hour on the hour for one year, filming the process by taking a one frame photograph at the moment of punching the clock, then spliced them together into a continuous film of six minutes' duration. As an internal witness to the passage of time, he shaved his head before beginning, and did not have his hair cut for the duration. In subsequent performances, Hsieh lived for exactly a year out of doors, no matter what the conditions; for another year in a prison-like environment in his studio, depending on a friend to supply him with food and to take away his waste; then he and performance artist Linda Montana were tied to each other with an 8-foot long rope for a further year, having commit-

11.5. Emese Benczúr, *Should I Live to be a Hundred*, 1988– (ongoing). Cotton. (Photograph by Roman Mensing/artdoc.de. Collection of the Ludwig Museum, Budapest–Museum of Contemporary Art.)

ted to go about their lives without touching each other for the duration. All performances were recorded by photographs, sound, the artist's notes and those of others, and were documented for their authenticity. Hsieh's persistence within each of these projects, and from one to the next, evidences either a pathology or a profound commitment to exploring his subject. But they amount to something more than actual yet symbolic demonstrations of the insanity that pervades lives ruled by measurement alone. The dumb mechanism of the premise underlying each of these works is transformed into a stark theatricality when we recognize that, set in New York, they enact the facts of his experience as an illegal immigrant. Indeed, once he achieved legal status, he ceased making works such as these.[15]

A similarly nuanced relationship to time is evident in Emese Benczúr's work *Should I Live to Be a Hundred*: in 1998 she ordered thirty-eight rolls of clothing labels machine-embroidered with the words "day by day." She then commenced sewing below this inscription the words "I think about the future," pledging to repeat the sewing of this one phrase each day for the rest of her life.[16] There are, of course, major precedents and inspirations: On Kawara's *Today* series, Roman Opałka's *1965/1–∞* series, for example. Artists working in this way share a certain quality of integration with everyday currents, an integrative atemporality—quiet, slow, unobtrusive yet committed, insistent, and independent—that is the ground zero of the ways in which contemporary artists approach the strangeness of their time.

In New York on July 28, 2005, Mary Ellen Carroll presented her video installation *Federal*. Exactly two years earlier she had filmed, simultaneously and in real time over one day, the northern and southern façades of the Federal Building on Wilshire Boulevard, Los Angeles. The two videos were shown, concurrently, for twenty-four hours. While evidently a homage to Andy Warhol's famous long takes, this work is more relevant in that it documents something definitive about the current American empire: its blandness, its blank face to those it purports to serve, its bureaucratic inertia, its institutional rigidity. The point here is that there is only presentness, and the implication is that presentness is the only kind of time that will go on through time, even as the modes of its recording—video, cinematic, photographic—age. A similar point is poignantly made in many of the works of Tacita Dean. Shot in 2006 at the Kodak factory, Chalon-sur-Saône, France, just as it was ceasing to manufacture and process analog film stock, *Kodak* is a forty-four–minute film consisting of approximately fifty slow, held frames. Each shot shows, in real time, through wide views and close-ups, an aspect of the factory—empty of workers, its sturdy machines idle,

its shimmering film stock hanging like veils, yet awaiting, not imprinting images from the world but its own obliteration. *Kodak* is an analog record of a site of the means of production of the analogic, captured as it freezes in time, on the cusp of its disappearance before the advent of the digital.[17] Compared with this range of explorations, Kalina's *everyday* seems to be a profile in puzzlement for its own sake.

Historical Time Now

Given the expansive popularization of art itself these days, it is no surprise that art historical time attracts many artists. Eve Sussman engagingly stages an art historical revival in her video *89 Seconds at Alcázar* (2004), a tracking shot around the setup of Velasquez's famous painting *Les Meninas*. For all of its immediate attractiveness—for who would not wish to be present at the gestation of a great, and much debated painting, to be its absolute contemporary?—this is, in the end, tourism of past art. As is her 2006 restaging of Poussin's *Rape of the Sabine Women*. Other artists treat artistic time travel with a little more subtlety. Centerpiece of Ricky Swallow's installation, on exhibit in the Australian pavilion at the 2005 Venice Biennale, was his sculpture *Killing Time* (2003–4). A range of items lie across a table, all related to food, to the dressing of animal life for consumption. The style is that of a seventeenth-century Dutch still life. Painstakingly carved from maple, then laminated to appear uncovered, the fish and flowers seem recently dead; the buckets, implements, and cloths seem recently discarded. Yet not so, because they lack the illusion of having been figuratively painted, and are quite plain, without the color of trompe l'oeil sculpture. They are, instead, artifacts of the image when drained of its potency, a subject Swallow treats more directly when he applies this approach to sculptures of contemporary mass-produced shoes. At the same time, and anachronistically, Swallow's objects embody the value inherent in the hours expended in the artist's artisanal labor.[18] In contrast, Wim Delvoye seeks the reverse effect—to display the prodigious wastefulness of modern societies through the transparent operations of machines that imitate human functions—by employing workers whose skills have been rendered redundant to decorate these machines. The result: a Peter Pan–like procession of Gothic pick-up trucks, royal wagons carved in Filipino wood by expert local craftsmen, Chinese tattoo artists expending their skills on pigs, or the toy store capped by *Cloaca*: a plastic ensemble that functions like the human digestive system.

A more pointedly political example of past time made present is Darren Almond's *Bus Stop* (1999): an exact replica of the two bus stops that currently stand outside the main entrance to what was the concentration camp at Auschwitz, exhibited in a room with the temperature turned down to close to freezing.[19] To achieve his coolly hair-raising images, Thomas Demand uses paper and cardboard to construct reduced, unmarked tableaux of the settings in which epochal events occurred—the security check point at Logan Airport, Boston, used by the 9/11 attackers, the podium of a famous political speech by Slobodan Milošević, the tables in the tally room in Florida in which the contested ballots in the 2000 U.S. presidential election were counted. He notes: "The surroundings that I portray are for me something untouched, a utopic construction. No traces of use are visible on their surfaces, and time seems to have come to a stop."[20] Time, in these cases, is a political medium. These are the purest slices of contemporary life, preserved in all their enigmatic emptiness.

A different sense of the historicity of ordinary life as it is resonant in art is subtly evoked in Ed Ruscha's revisiting, in 2003, a number of Los Angeles buildings and sites that had provided subjects for a 1993 series of paintings. Set low in the frame, against strangely cinematic skies, the most evident change in the 2003 works was the rebranding of the buildings due to new ownership—less obvious, but more profound, is the pervasive aura of decay. Ruscha's series was prepared for the U.S. Pavilion at the Venice Biennale; it was entitled *The Course of Empire*, presumably with reference to the contemporary debacle of the U.S. occupation of Iraq, to the overreach of the Bush administration in its efforts to establish a command post in the Middle East. When modern time persists like this—as a residue in the present of its inexorable decline—perhaps the only grace in presentness lies in the elegance with which, in certain settings, the near-imperceptibility of this decline may be observed.[21]

As decolonization continues to play out, the complexities and contradictions of historical recovery preoccupy artists everywhere. We have seen them to be crucial to the postcolonial turn. They inspired *The Long March: A Walking Visual Display*, initiated by Chinese artist and curator Lu Jie in 2003. For six months, he and a group of relatively unknown Chinese artists retraced the 10,000-kilometer route of the Maoist insurgents, whose strategy of tactical retreat and regroupment in 1934 is credited as essential to their eventual victory. Reacting against the recent international success of certain Chinese artists, and against what Jie and his colleagues regard as the "outer-directedness" of this art, the Long March artists created as they went, giv-

11.6. Lu Jie, *Long March: A Walking Visual Display*, 2003. Participation of Qin Ga, showing the back of the artist with tattoo of map of the March route, taken at Site 1 (Beijing) and Site 23 (Nanniwan, Shanxi Province). From the series *The Miniature Long March*, 2002–5. Type C color photographs. (Courtesy of the artist and the Long March Project, Beijing.)

ing away their works for free to interested locals, and inspiring large-scale production of local art forms en route. It is typical of present conditions that this initiative has excited the attention of both the national and international art worlds: the organizers have sent emissaries to exhibitions such as the ecologically focused Echigo-Tsumari Art Triennial in Japan, and set up a Cultural Transmission Center in Beijing in order to reassess the aims and direction of the project, as well as house its ever-increasing output.[22]

Contingent Temporalities

If the radical provisionalization of time (along with that of place, media, and affect) is symptomatic of the current condition of contemporaneity, we might expect that the past-present-future triad at the core of modern conceptions of time would be radicalized: not only by the mixing of these times, but their disruption and displacement by other kinds of time. Indeed, many artists around the world do precisely this. For a number of years Thai artist Araya Rasdjarmrearnsook has been singing songs, reciting poetry,

and telling stories to comfort those who have died alone. In her 2001 work *Reading Inaow for Female Corpse,* she read an ancient Thai text on the theme of female desire to the corpse of a woman who died in anonymity without family members or friends to perform appropriate death rituals.

Susan Norrie's 2004 video *Enola* tracks through a theme park near Nikko, Japan, that consists of miniaturized architectural monuments from all over the world, including the no-longer-extant World Trade Center. The mood of the piece is profoundly postholocaust; its leaden coloration evokes the current situation of all-pervasive aftermath. Yet its nymphet actors, dressed in futuristic costume, persist in their search for community. A more direct exploration of the multiple temporalities experienced by the victims of globalization occurs in Chien-Jen Chen's video *Factory* (2004): a group of workers return to the factory in Taiwan where they worked to view the artist's film of their protests, three years before, against its closure. This takes us to the heart of the processes that have created the figure of madly modernizing China, the delirium of which is conjured by the photographs of artists such as Weng Fen, Yang Zhenzhong, and Chen Shaoxiong, which show Shenzen for the Jetsonland that it is.[23]

In Peter Fischl and David Weiss's extremely popular 1987 film *The Way Things Go,* the camera follows an unlikely chain of implausible causes and effects in a world consisting entirely of objects found around the artists' kitchen and studio. Jeremy Millar describes the events that unfold: "And so the things are held in anticipation, waiting their turn, and then they go, one after another: bags spin, tires roll, ladders stagger, carpet rolls, chairs fall, fuses catch, fireworks blow, froth bubbles and bubbles froth. Everywhere things are transformed into actions, nouns become verbs. Things spark, things flame, things balloon, things roll; things thing, doing their thing and other things' things too."[24] Delightful and full of belly laughs, this work nonetheless evokes a parallel universe in which humans (in this case the artists), having set things in train, absent themselves (although remain ready to intervene at any time to keep the momentum going), leaving things to propel themselves however they will. As we become absorbed into the wacky illogic of the film, we witness the coming into being of a magical place in which things interact with natural processes, and processes work on each other, all in their own time.

Uncanny time, felt as a matter of acutely personal experience, is explored in the work of a number of artists. Doug Aitken's video installations track across the remains of a place: in *Monsoon* (1995), the location at Jonestown,

Guyana, where the Reverend Jim Jones and his followers committed mass suicide; in *Eraser* (1998), the island of Montserrat, devastated by volcanic eruption the previous year. In the first, isolated elements are quietly observed as a monsoon builds, but never arrives. In the second, the camera pans across a landscape of aftermath, the eerie beauty of which is undisturbed by any sign of living human presence. The eight-screen installation *Electric Earth* (1999) invites the viewer to accompany a young black man, perhaps the last person on earth, as he makes his way through the streets of Los Angeles late at night and finds himself in a world in which machines have come into their own, their movements eventually coming to determine those of his body. The protagonist, a pop-lock break-dancer, drones in voiceover: "A lot of times I dance so fast that I become what's around me. I absorb that energy . . . it's like I eat it. That's the only now I get." To which Aitken comments: "The absolute present is unattainable. If it is, it is only for a fleeting moment. The things in the protagonist's environment continue at their own rhythm."[25] Disjointed time, enacted differently.

This same theme is the subject of Aitken's *Sleepwalkers*, an eight-screen videowork that traces the daily lives of five New Yorkers—a captain of industry, a postal worker, an office worker, a cable layer, and a busker—played by well-known actors and performers (Donald Sutherland, Cat Power, Tilda Swinton, Seu Jorge, and Ryan Donowho); it is *Six Degrees of Separation* meets *Berlin: Symphony of a City*. Commissioned by MoMA and projected on its exterior during January 2007, the films' symbolic opening out of closed walls had the uncanny, voyeuristic effect of revealing the city enacting its current (forget-9/11, elite, glam-bang) fantasy of itself, for itself. Noting that the imagery lacked Aitken's usual evocation of implicit social turbulence, *New York Times* critic Roberta Smith commented that it "dovetails seamlessly with its rarefied setting, the sleek exterior of MoMA's newly expanded building. Not surprisingly, it is both dazzling and a bit bloodless."[26] Remodernism extracts its enervative price, yet again.

Turkish artist and filmmaker Kutlug Ataman pursues the kinds of time that define the lives of individuals and collectives. The four video projections of his *The 4 Seasons of Veronica Read* (2002) followed closely the annual cycle of growth, decay and hibernation of the amaryllis flower as it is cultivated by a collector whose obsession with the plant has made her slave to its temporality. In contrast, in *Küba* (2004), Ataman interviewed forty residents of an "outlaw" district of Istanbul, giving each of them the chance to tell the stories of how they pass their time in the suburb and how they feel about it.

11.7. Emily Jacir, *Ramallah/New York*, 2004–5. Two-channel video installation. (© Emily Jacir. Courtesy of Alexander and Bonin, New York.)

The installation consisted of forty monitors, placed apart and set up before homely chairs. Individuality is evident, but so is community, along with the complexities of the relationships between both. The installation invites you into the community, to take the time to learn what kinds of time it takes to create community.[27] Emily Jacir's two-video installation *Ramallah/New York* (2004–5) juxtaposes continuous streaming of shots of shops, public places, domestic spaces in the two cities, each carefully chosen so that the signs of their locality are scarcely distinguishable. She describes her intentions as follows: "*Ramallah/New York* was shot in 2004 and is informed by my experience of living in between Ramallah and New York for the last six years. The video, a kind of experimental documentary, interweaves travel agencies, hairdressers, delis, shwarma [*sic*] shops, and arghile bars, while recording the movements of people to and from both sites. It records the spaces in between war, exile and destruction, and preserves another history— the resistance of everyday life. It is a record of local, public, and daily exchange in both sites and between them. It is a document of a specific time that begins with personal exchanges from daily life as opposed to the official representations and narratives of history, CNN, or Al-Jazeera. It examines both the safety and familiarity of interiors as well as their entrapment and claustrophobia. It is my homage to the transcendence of spaces beyond official or recognized borders or actual site."[28]

Taking time to give it up to another. Taking time out in order to return it. Showing what time means to others, and to things, and to the natural world. Expending time so as to find time to spend together. Losing time as a way of finding it. Wasting time to make up time. Slowing time in order to acceler-

ate the grasping of it. These are just some of the kinds of time that contemporary art is taking, and offering, now. One hundred years after Einstein's breakthrough understanding that the world's time is, at its extremities, multiple, relative and fungible, contemporary artists are showing us that these strange aberrations now characterize what has become the contemporary world's "normal" experience of time.

CHAPTER TWELVE
Art, Truth, and Politics

To create today is to create dangerously. Any publication is an act, and that act exposes one to the passions of an age that forgives nothing.... The question, for all those who cannot live without art and what it signifies, is merely to find out how, among the police forces of so many ideologies (how many churches, what solitude!), the strange liberty of creation is possible.
—Albert Camus, 1957

After 9/11, after globalization, in the midst of a kind of radical and fundamental transformation of geo-political power and geo-political space, how do you visualize it? What is the new language to describe this world?
—Paul Chan, 2006

In 2005, Emily Floyd, a young artist based in Melbourne, Australia, produced an installation *The Outsider,* inspired by Albert Camus' 1942 novel *L'Étranger* (*The Stranger*). Six-inch-high pasteboard cut outs of letters, like those used for teaching children the alphabet, were strewn across the gallery floor. Some sentences could be made out, including the opening words of the novel: "Mother died today. Or, maybe, yesterday; I can't be sure." In parts, the scattered letters coalesced into a rough plan of Algiers, where Camus' novel is set, and were anchored by brightly colored architectural blocks that rise in evocation of the clustered minarets of the city. But the main movement of the piece undermined the Playskool brightness of the imagery, spreading such shining confidence about meaning around the harbor, into distance, to the beach, toward meaninglessness. Floyd went on to create a number of smaller works on the same theme, such as *Compulsory for Young Intellectuals, Camus 2005-6, Random Access,* and a related work that takes as its cue the

12.1. Emily Floyd, *The Outsider*, 2005. Installation, The John Curtin Gallery, Curtin University of Technology, Perth, Australia. (Courtesy of the artist and Anna Schwartz Gallery, Melbourne.)

opening words of Fyodor Dostoevsky's *Crime and Punishment:* "They didn't understand me."[1]

Floyd is not alone among artists today in pursuing so tenaciously these paradigmatic moments of existential doubt, and in scanning them so closely for lessons for the present. The emergence of this mood provokes some questions. Is the experience of strangeness an essential concern of art that would seek to show that which is deepest in contemporary life? Are the dangers in such a quest the same as those identified by Camus during and after World War II, or is contemporaneity calling up its own distinctive set? Is there now a different configuration of the ethical and the political in all spheres, including art?

In this chapter I want to revisit the hypothetical description of contemporary art in the conditions of contemporaneity that I have proposed, and, in the light of all the questions posed so far, to suggest some answers to these particular ones.

"Art, Truth, and Politics" was the title that British playwright Harold Pinter gave to his speech accepting the 2005 Nobel Prize for Literature. Awkwardly unfashionable, nerve-jangling topics within art world discourse, they

nevertheless continue to animate the interfaces between art and its broader publics. These zones of contact are actually more like borders than permeable boundaries. They are heavily patrolled on both sides; they invite incursion, which attracts reaction, and, too often, direct repression. Elsewhere, they lead to subtle evasion or the *huis clos* of self-censorship and betrayal. The wise men of Stockholm have been canny players across these contested domains for decades: their awards are, mostly, carefully calculated for maximal effect as symbolic gestures in support of genuine freedom. Pinter devoted much of his lecture to excoriating a "brutal, indifferent, scornful, and ruthless" United States as the greatest force for unfreedom in the world today, above all in its leadership in weaving "a vast tapestry of lies, upon which we feed."[2] Targets of his critique responded by doubting Pinter's capacity, as an artist, to make expert political judgments and by damning the Nobel committee for pretending to extol his plays when really they wanted to reward his political activism—which, conservative commentators held, is extra-artistic.

Clashes of this kind, these days, seem at once noisily pervasive as phenomena and painfully old-fashioned in form. The conservative side persists with the crude contrasts that surfaced—and succeeded—in the culture wars of the 1980s. On the other side, appeals to general principles such as artistic autonomy have provided the poorest cover, largely because they concede the main ground: that the battle is to be fought over categories and simple instances, not over processes, interrogations, and complex actualities. Pinter's speech was an effort to use the most public forum he would ever have to demonstrate what critical understandings of actual and possible linkages between art and politics are like. And to show that these links, like all others between humans, are a web woven in varying degrees and mixtures of good and bad faith. Is seeking to act within this web the way for "truth" to subsist between "art" and "politics"? What might this mean for the increasing numbers of contemporary artists who refuse this separation and, as Swiss artist Thomas Hirschhorn puts it, seek not to make "political art" but to "make art politically"?[3]

Responding in 2006 to questions about their pamphlet *Afflicted Powers*, the San Francisco–based activist group Retort offered an acute formulation of the general issues at stake:

> Everything about the basic furnishing of human oppression and misery has remained unchanged in the last 150 years—except that the machinery has been speeded up, and various ameliorations painted in on top. . . . Nevertheless we do think that there is something distinctive about the

Old New of the past four years. *Afflicted Powers* is an attempt to describe it. Very roughly, what seems to us unprecedented is the starkness—the extremity—of the confrontation between New Oldness and Old New-ness. No one, surely, came close to anticipating that the opening of the 21st century would be structured around a battle between two such viru-lently reactionary forms of world power (or will to world power), and that both sides would see so clearly that the battle is now to be fought by both bombs (crude attempts at recolonization, old-time resistance struggles, crowds waving the latest version of the Little Red Book) and images.[4]

To this list of what constitutes bombs we can add airplanes, explosives wrapped around a suicide, videotapes of all sorts, and so forth—a list of denotations that will soon merge into visual images of many sorts, as they call up settings in which images of the work of bombs—instantly and glob-ally disseminated—become vital to their effectivity.

Retort remobilizes Guy Debord's famous analysis of spectacle society, his condemnation of capital's commodification of all relations, its colonization of everyday life through saturation with the imagery of insatiable desire.[5] Retort is rightly skeptical of generalization and imprecision, but we might ask: Does Debord's concept of the spectacle encompass everything we need to know about the image in the present situation, especially that of recent years? Are not a number of artists and other activists responding to what Retort rightly poses as "the political question of the years to come"? Against the fundamentalists, against the supine compromise all around, they ask "what *other* imagery, what other rhetoric, what other set of descriptions might be possible—ones that find form for the horror and emptiness of the modern, but *hold out no promise of Going Back*?"[6]

What Lies between Art and Politics?

In his 2006 State of the Union address, President George W. Bush divided the world into tyrannies and democracies, and nominated "the advance of freedom" as the "great story of our time." In 1945, he noted, there were "about two dozen lonely democracies on earth. Today, there are 122." U.S. foreign policy, he urged, was committed to promoting "self-government" everywhere (there are U.S. troops in 125 countries around the world today), and to fighting those terrorists who opposed it.[7] Yet the leaders of many of these democracies have felt so threatened that they have been willing to suspend the exercise of fundamental freedoms, even the rule of law, not only

as these apply to others but also as they apply to their own citizens. They do this, they claim, in order to protect their citizens from actual or implied threats against them, to protect the law, and to preserve democracy itself. As he spoke, President Bush justified his secret ordering of wiretaps and electronic tracking of U.S. citizens as essential to the War on Terror.

Giorgio Agamben is one of many voices that has exposed the hypocrisy of these heavily cloaked assertions of the powers that be. "The normative aspect of law can thus be obliterated and contradicted with impunity by a governmental violence that—while ignoring international law externally and producing a permanent state of exception internally—nevertheless still claims to be applying the law."[8] Always entailing a claim of short-term expediency, and of response to external violence or internal insurrection, many democracies have brought themselves into a permanent or semi-permanent "state of exception." Indeed, faced with the complexities of contemporaneity, antidemocratic exceptionality has become the paradigm of government throughout the world. This form of governance exercises its sovereignty against all comers, including its own citizens, seeking to smother them in illusory comforts while actually reducing them to a "bare life," stripped of all rights and freedoms, isolated in collective solitude. Leaders of the governmental entities of the United States and Europe see themselves in constant economic and cultural struggle against their others: nowadays, the oligarchies in China and the Middle East, the left-leaning countries in South America, and the volatile autocracies in Africa. To many opponents, including Pinter and Agamben, this division of the world amounts to "a machine that is leading the West to a global civil war."[9]

Enmeshed within this network of what the Retort group rightly names "afflicted powers"—there are many other, closely implicated ones, such as globalizing companies, international agencies, affiliative quasi-communities—how might one act against its constrictive and destructive impulses? To Agamben, politics has been "contaminated by law," a rule of law that legitimizes state violence—actual or implied violence that, we might add, is overwhelmingly dedicated to the promotion of special interests, in all societies, everywhere. "The only truly political action, however, is that which severs the nexus between violence and law." In the space thus opened up:

We will then have before us a "pure" law, in the sense in which Benjamin speaks of a "pure" language and a "pure" violence. To a word that does not bind, that neither commands nor prohibits anything, would correspond an action as pure means, which shows only itself, without any relation

to an end. And, between the two, not a lost original state, but only the use and the human praxis that the powers of law and myth had sought to capture in the state of exception.[10]

"Pure action" and "human praxis" sound at once more desperate and humble, more naked even, than the "dignity of man" to which Pinter appealed.[11] Nor do they resonate like "the dignity of life and death" that, despite everything, Camus could, in his 1957 Nobel speech, still evoke as a value.[12] But they may amount to something like the same thing. Confined as we are within the vicious and delusory workings of the sovereignty machine, "pure action" may be the closest we can get, these days, to what used to be named by these values. But what, concretely, is this purity? When does it occur? How might it be found?

These considerations bear directly on the question of art, truth, and politics today. They open out the idea of politics, releasing it from the confines of official public spheres, in which the only permissible agents are professional politicians and their institutions of representation and dissemination. As a renovation of philosophy, deconstruction has already performed this operation on the idea of truth. A parallel opening out of the idea of art has been going on since the 1950s, led by artists, the lineaments of which (as I will show in my concluding chapter) have been picked up by many critics and historians, as well as philosophers. While the world seems to morph into an ever-deepening strangeness haunted by recurrent, chimerical familiarities, even as it seems to accelerate towards catastrophe, these kinds of opening strive to give us the tools to see the shapes of contemporaneity, and to glimpse modes of survival within it. Seeing the shapes and some possibilities for survival are the two main ways in which contemporary artists are responding to the present situation. In the remainder of this chapter, I will show how artists are doing each of these in turn.

Criticality

An important component of the postcolonial turn in art arises from the fact that spectacle capitalism and globalization has not won total consent from among artists in the advanced economies. Many are alert to its costs, both home and abroad. They have developed practices—usually entailing research over time, widespread public involvement and lengthy, didactic presentations—that critically trace and strikingly display the global movements of the new world disorder between the advanced economies and those

12.2. Allan Sekula, *Twentieth Century Fox Set for Titanic*, Popotla, 1997. Cibrachrome diptych. From the series *Titanic's Wake*, 1997–98. (Courtesy of the artist and Christopher Grimes Gallery, Los Angeles.)

connected in multiple ways with them. The "conspiracy" drawings made by Mark Lombardi during the 1990s offered detailed maps of the connections between major institutions, powerful individuals, governmental structure, legitimate markets, and the various black economies that shadow all of these structures.[13] Perhaps the most thorough work of this type is that of Allan Sekula, whose *Fish Story* series of photographs (1994–99) underscore the huge quantity of commodity exchange that is the material basis of globalization as well as trace in sharply observed detail the social impacts of this world culture of work. His 1998–99 series *Titanic's Wake* shows the worldwide decline of the shipping industry and its gradual replacement by cultural industries—often, as in the case of the Guggenheim Museum, Bilbao, on the very sites abandoned by the ship-builders. One image from the series, "Twentieth Century Fox Set for Titanic, Popotla" (1997) brings all of these elements together. On the Californian coast, not far from Los Angeles, a ship is built: a full-scale replica of sections of the *Titanic*. It is the set for the blockbuster movie. Sekula shows it as a beached whale, an industrial zone seen from beyond its security perimeter.[14] With a similarly acute sense for the presence of a powerful global force within a particular object, Zoe Leonard's ongoing *Analogue* project traces the trafficking in donated clothing from the United States to countries in Africa, where it is sold as new fashion.[15]

A number of artists seek to imagine the impacts of these broad scale changes on more psychic levels, showing them as discontinuous narratives of personal experience: since the early 1980s, Dennis Del Favero has been

staging projective installations evoking the dislocations of immigrant experience, of subjection to surveillance, and of family trauma, more recently as digital projections.[16] An important stream in Thomas Hirschhorn's work are installations that show globalization as a kind of war machine bent on creating nightmare scenarios, caves of banality and standardization, revelations of what the world would look like if these scenarios were actually realized. Fittingly, he concentrates on this topic in his installations at U.S. galleries, notably those at Barbara Gladstone in 2003 (*Cavemanman*) and the Institute of Contemporary Art, Boston, in 2005 (*Utopia, Utopia = One World, One War, One Army, One Dress*). In another stream of his work, for exhibitions primarily in Europe, he draws attention to the revolutionary potential of the thinking of certain philosophers and political theorists by establishing temporary memorials to them in the streets of poor neighborhoods: antimonuments in the form of community centers, cafés, temporary libraries, reading rooms, internet access sites. A controversial example was his *Monument to Georges Bataille*, situated in a Turkish guest worker neighborhood in Kassel during the exhibition Documenta 11 in 2002.[17]

In contrast to these exposés and engagements, much of art today seems

12.3. Thomas Hirschhorn, Utopia, *Utopia = One World, One War, One Army, One Dress*, 2005. Mixed media installation, Institute of Contemporary Art, Boston. (© 2008 ARS, NY/ADAGP, Paris. Courtesy of the Institute of Contemporary Art, Boston.)

random, apolitical, naïve, even wishful. I cite Kazakhstani artist Almagul Minibayea's statement accompanying her work at the 2006 Sydney Biennale simply as a representative sample:

> In my video performances I show my vision of the world through the prism of "Punk Romantic Shamanism," as I call it. It seems to me the perfect language of contemporary art. It is being alternative enough to reach out to the post-rebellious culture of the 1960s, '70s, and early '80s. It is poetic enough to reach out for the 'souls' of those who are bored with the present day "corporate consumerism." It is naïve, innocent, and anti-Hollywood. It also represents the animistic philosophy of my culture which is trying to leave its legacy in a globalized, technological society.[18]

Is there a more precise way to exercise judgment in the conditions of contemporaneity? I have suggested that at least four themes course through the heterogeneity that pervades the current situation. Thousands of artists are now focusing their wide-ranging concerns on questions of time, place, mediation and mood. More precisely, they interrogate the friction between multiple temporalities, the doubling of location and dislocation, the saturation of mediation in spectacle society and the fissures within it, and, above all, the question of how these factors shape individual affect and collective effectivity. In short, they are alert to the conditions of contemporaneity—bleak as they are—yet seek situatedness within them, however transient. Taken together, these concerns point to the changed terrains on which politics and ethics become possible these days, and to the different kinds of political action and ethical relationships that artists are seeking and forging now. In the previous chapter I discussed the ways in which a number of artists have tackled these issues through the prism of temporality. How are they approaching them through considerations of mediation, place and selfhood?

Mixed Mediation

"Media specificity" remains a concern of some theorists of contemporary art, yet artists have for decades been transposing the qualities of one medium into another with an inventive abandon that makes mobility as to media the most obvious marker of any art that is contemporary. Many do so at the level of style, creating hip, club-like storefront environments: for example, John Armleder, Jim Lambie, Imi Knoebel, and Assume Vivid Astro Focus (aka Eli

Sudbrack). Working against the celebration of industrial materials found in minimal and remodernist sculpture and the ostentatious glitz and instant iconicity of much retro-sensationalist art, a number of artists have returned to assemblage as a mode in order to create an "unmonumental" sculpture that, according to New Museum of Contemporary Art curator Laura Hoptman, is now "leading contemporary art discourse."[19] Outstanding among these artists is Isa Genzken. Her *Elephant 11* (2006) is a fragile accumulation of found objects, detritus from a culture devoted to the overproduction of trivial fetishes of its disjunctive obsessions. Like many similar works by artists such as Alexandra Birken, John Bock, Rachel Harrison, and Elliott Hundley, Genzken's assemblages display the violence deeply embedded in contemporary life as well as a mute but insistent striving toward ways of surfacing from within this mess. This theme was central to the majority of the work shown in the 2008 Whitney Biennial, where it was articulated with reference to "lessness," a concept drawn from the existentialist author Samuel Beckett. Curator Henriette Huldisch pointed to values such as "constriction, sustainability, nonmonumentality, antispectacle, and ephemerality" as being now widely shared among contemporary artists.[20] As the aftermath of 9/11 continues to play itself out, it is no surprise that New York artists and their institutions remain bound to the trauma of unbuilding unleashed by that event.[21]

Taking already-mediated imagery as their medium, artists such as Douglas Gordon and Stan Douglas remix it to imply different narratives and (as we have seen) to rethink time as itself a medium. Others, such as Liam Gillick, Pierre Huyghe, Candice Breitz, Martin Sastre, and Cliff Evans, do so to open out fissures in cinematic and media narration. Expanded cinema has been a concern of artists, such as Jeffrey Shaw and the EventStructure Research Group, since the 1970s, a radical reconception of the limits of mediums that, under labels such as "new media" or "digital media," became a major stream of contemporary art. In this book, however, I have deliberately not separated out such work, choosing instead to treat all of the art under consideration according to its content—that is, its contribution to understanding the ontology of the present. While the novelty and challenges of digitalization were a preoccupation in expanded cinema's experimental phase, content has become the pivotal concern in recent years. Like art made in any other medium, "new media" art that does not address the challenges of contemporaneity falls into irrelevance.[22]

Some artists seek to intervene directly by turning the manipulative potential of mass media back on itself, by dissing it. In the spirit of the 1970s

12.4. Isa Genzken, *Elephant 11*, 2006. Metal, glass, photograph, lacquer, plastic, fabric, and wood. (Courtesy of Galerie Daniel Buchholz, Cologne.)

group Antfarm, the Yes Men managed to convince BBC World that they were spokesmen for the Dow Chemical Corporation, and offered, on television on December 3, 2003, the company's apology for the deadly chemical spillage at its plant in Bhopal, India. A minor controversy ensued. This was a small contribution to the weight of negative opinion that led the company, some months later, to offer reparations to its victims.[23]

In Ayanah Moor's 2004 wall installation, *Never.Ignorant.Gettin'.Goals. Accomplished,* the words of the title—an exhortation used by the hip-hop group Dead Prez—are juxtaposed with a mural-sized image taken from a magazine color photograph of Condoleezza Rice being kissed by President George W. Bush during the presentation of her as Secretary of State. Seen one way, the words and the image are in exact complementarity, flush with self-evident realization of equal opportunity. This looks like what the tele-visual opportunity was intended to be: a resplendent advertisement for the

American Dream. When, however, we read the words as marching on the image, and link left to right the first letters of each word, the opposite meaning erupts. The moral vacuity at the heart of the Bush administration stands naked, smirking and squirming, in the light. The illusion of simple equality is obliterated, irretrievably, by laying bare its circumstantial cost. Moor has recently taken an oath to reject further offers to show her work in exhibitions that are framed in terms of black American identity, including those devoted to interrogating its conditions, and questioning its limits. This puts the entire trajectory of her work to date at risk. This depth of impatience with categorization of any kind is becoming more common, and it signals a shift beyond the issues at stake during the postcolonial turn.

Less direct strategies for interrogating the impact of mass media can also be highly suggestive of alternative ways of coming to know the world. In her 2004 performance *Lakonikon*, Pia Lindman mimed the facial and bodily expressions of those whose public displays of grief in response to terrorist attacks in Israel, Palestine, and New York had been selected by the *New York Times* photo editors since 2001. The artist's simple attire and the cool re-

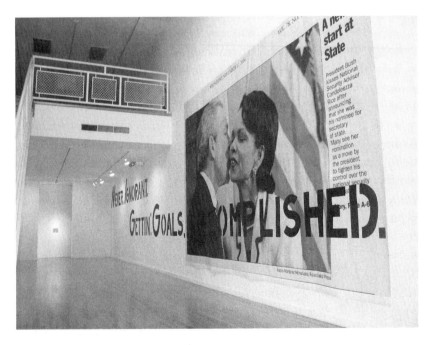

12.5. Ayanah Moor, *Never.Ignorant.Gettin'.Goals.Accomplished*, 2004. Wall installation. (Courtesy of the artist.)

straint of her movements between the enactments created an extraordinary contrast to the heated rhetoric in which these images are immersed when printed and telecast. It opens out a psychosocial space for the representation of the unspeakable.[24]

Despite the dominance of electronic and broadcast media, the public spaces of cities and towns continue to be dense communicative fields. Countless anonymous and pseudonymous graffiti artists are active on the streets. This form has evolved from the vivid "tagging" practices that emerged in New York and Philadelphia in the 1960s and spread to murals throughout North America, particularly in black and Puerto Rican neighborhoods during the 1980s.[25] Certain practitioners, famously Keith Haring and Jean-Michel Basquiat, engaged closely with contemporary artists, the art world, and the commercialization of their imagery. Others developed effective styles of spray-and-run commentary, notably the Sydney group B.U.G.A.U.P. (Billboard Utilising Graffitists Against Unhealthy Promotions), and a number of stencil artists in Melbourne, Australia, which boasts of being the world capital of the form.[26] The dissenting spirit of this kind of work is encapsulated by Bristol-based artist Banksy, who asks us to:

> Imagine a city where graffiti wasn't illegal, a city where everybody could draw wherever they liked. Where every street was awash with a million colours and little phrases. Where standing at a bus stop was never boring. A city that felt like a living breathing thing which belonged to everybody, not just the real estate agents and barons of big business. Imagine a city like that and stop leaning against the wall—it's wet.[27]

As Banksy's works are chiseled off walls and enter the art market, still other graffitists rise to take his place. Meanwhile, in Brooklyn and Lower Manhattan, a symbolic war has broken out: work by muralists and stencil artists is being defaced by splashers, who object to its being, in their eyes, "a bourgeois-sponsored rebellion."[28]

Location, Dislocation, Place-Making

In 1985 at the age of sixteen, Gregor Schneider moved into a vacant apartment in the grounds of his father's lead factory in Rheydt and began a process of subtle alteration that he intends to pursue without specifiable end: "The work actually consists in my beginning the work again and again."[29] As an artist's statement about contemporaneity in its starkest form, this

takes some beating. Entitled *Totes Haus ur, Rheydt* (Dead House ur, Rheydt), the minimal rooms suggest the rudiments of the barest life, a stage set awaiting its actors, the leavings of someone recently absent, or the self-sufficient dwelling of things. For exhibitions, Schneider installs a set of replicas of these rooms inside another set, matching them exactly, except in being slightly smaller. Or he might require the viewer to crawl through passageways between one set of room-like structures and other, which is never accessed. At Rheydt, the lack of indicators as to time, destination, and resolution fills the visitor's journey with a sense of dreadful anticipation. To be sure, a central room displays black and white photographs that show details of the most horrific crime scenes. Much less threatening psychological states are explored in the film installations of Finnish artist Eija-Liisa Ahtila. Her 2002 work *The House* shows the psychosis of a young woman who has identified herself with a house. Projected on multiple screens, and on models of parts of the house, it vividly evokes her mental states as free-floating identifications with another body, a shared mind, both of which grow and change, as if the house was another person, the young woman another thing. This interplay creates an environment in which the viewer is immersed as a curious, and welcome, visitor.[30]

The extroverted other of this type of inquiry is pursued by Liam Gillick in his work *Pain in a Building* (1999). A set of photographs taken at Thamesmead, near London, show the degradation of this 1960s housing estate, built with the highest ideals for mass habitation. Accompanying soundtracks remind us that this was the location for Stanley Kubrick's film of Anthony Burgess's dystopian novel *A Clockwork Orange*. While Burgess certainly anticipated

12.6. Eija-Liisa Ahtila, *The House*, 2002. DVD installation for 3 projections with sound. (Photograph by Marja-Leena Hukkanen. © Crystal Eye Ltd., Helsinki. Courtesy of Marian Goodman Gallery, New York and Paris.)

the eventual failure of these ideals, Gillick attempts to show their erosion as traces on the buildings, and in the spaces between them—that is, as a complex of emotions experienced by the architecture itself.[31] Jane and Louise Wilson take this kind of insight further in their multimedia work *A Free and Autonomous Monument* (2003). Pivoting around the Apollo Pavilion in Peterlee New Town, near Gateshead, a utopian structure designed by English constructivist Victor Passmore that was trashed by the residents, this installation projected multiple filmic sequences—the crumbling estate, a pristine microchip factory, rotting shipyards, empty factory canteens, robots feeding an assembly line, children skateboarding—onto a chaos of surfaces. *Guardian Weekly* critic Adrian Searle observed: "You are here, the work says, but also elsewhere. The world may seem alienating, but it is the only one we have. Focusing on the local, the near, the unregarded, *A Free and Autonomous Monument* achieves a kind of universality. Hence, I guess, its title."[32]

A number of artists base their practice around exploring sustainable relationships with specific environments, both social and natural, within the framework of ecological values. Andy Goldsworthy, Olafur Eliasson, and Carsten Höller are best known in art circles for installations that attempt to create an awareness of natural rhythms so intense as to be imaginatively, and in some cases actually, immersive. Some artists track the individual and institutional creation of landscapes out of bare earth: the Center for Land Use Interpretation creates isolated, do-it-yourself viewing stations in the lunar geographies favored by the U.S. military for its experimental schemes and overseas training camps. The center's laconic, "the facts only" approach is a consciously conceptual perspective towards what are, often, the traces of schemes abandoned as lunatic. Its office is located in Culver City, Los Angeles, next to the most understated but perhaps the most subtly subversive gallery on the planet: the Museum of Jurassic Technology.[33] With a similar sense of the relentless increase of absurdity in official mismanagement, other artists imagine the outcomes if attempts to correct human-induced degradation of natural processes were themselves strangely subverted. Eduardo Kac's *GFP Bunny* project of 2001–2 posited a white rabbit that had been genetically altered such that it glowed under ultraviolet light. In her 2005 series *Nature's Little Helpers*, Patricia Piccinini's lifelike mutant figures share the details of ordinary life with equally mutant humanoids.[34]

Increasing numbers of artist collectives are involved in direct action at local levels: these include Ala Plástica (Buenos Aires) Park Fiction (Hamburg), Wochenklausur (Vienna), and Huit Facettes (Dakar). Of parallel importance is the work of globally networked collectives such as Shack/Slumdwellers

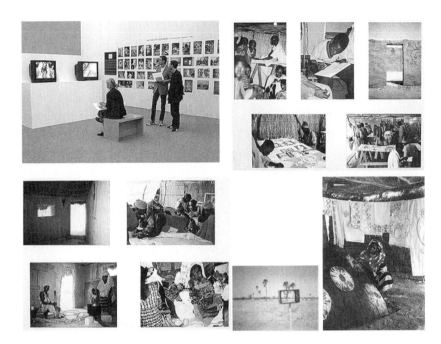

12.7. Huit Facettes, "Documentation of the Workshops in Hamdallaye, Senegal," 1999–2002. As shown at Documenta 11, Kassel, 2002. (© Universes-in-universe, Berlin.)

International and Global Studio, who bring a range of skills from a variety of distant sources to bear on specific, extreme problems of housing. Others, such as the Italian collective Stalker, seek out tangential, interstitial, non-invasive ways of experiencing cities. Increasingly, individual architects are turning to these issues, and offering practical remedies to the marginalized, the migrant, the endlessly mobile, and the homeless.[35] Since 2001, Estudio Teddy Cruz has worked with a number of local organizations in San Diego and Tijuana to offer frameworks that enable local residents to create living places, often by occupying public spaces and by recycling building materials from over-provisioned sectors. Crossborder art and architecture is an important way of registering place in the new conditions of transience, exclusion and surveillance. In a lecture in which he describes the forces that have occasioned his work, Cruz draws attention to a 1997 work by Tijuana artist Marcos Ramírez Erre, an enormous Janus-headed Trojan Horse mounted on a car that was driven to a point that straddled the U.S.-Mexico border at the much-trafficked crossing between San Diego and Tijuana. For a moment no longer than that of a "normal" passage, it was positioned in a place that, symbolically, dissolved that heavily patrolled division.[36]

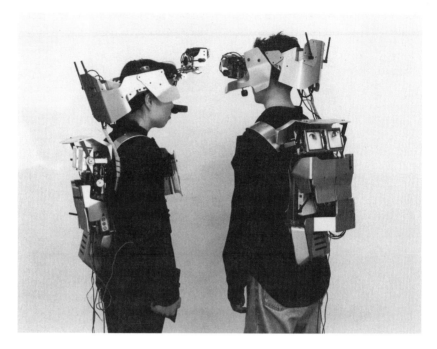

12.8. Krzysztof Wodiczko, *Dis-Armor*, 1999–2001. Prosthetic devices. (© Krzysztof Wodiczko. Courtesy of the artist and Galerie Lelong, New York.)

Small-scale interventions, do-it-yourself subversions, mutely stubborn refusals, gentle suggestions for living differently. Krzysztof Wodiczko has invented a number of media that enable the shy, the repressed and the marginalized to communicate their deepest thoughts to others, even to strangers, via indirection. These include wearable prostheses such as *Dis-Armor* (1995–), exploited workers in the border factories having their say as projections onto the dome of the Cultural Center in Tijuana (2003) and abused women speaking as twenty-foot high caryatids on the columns of the Zacheta, a major public building in Warsaw (2005).[37]

Contemporary life is laced with the fallout from the years of violent closure that froze so many societies in fear—and does so, still, in many places. Jorge Macchi extracts details from telephone books, street directories, and newspapers consisting of just a few words, or the blank spaces around words, and reassembles them into imagery of the absences in city life: skyscrapers, speakers' corners, meetings—an echo still, in Argentina, of those who disappeared during the years of the dictatorship. Working in a similar but perhaps more open climate in Brazil, Rivane Neuenschwander

has moved from works that record the passage of time across places to those that trace the incidentals of human usage: the maplike imagery in her series of "paintings" entitled *Starved Letters* (2000) was made by snails consuming the mounted rice paper; whereas in *Conversations* (2002), she collected the "sculptures" made by friends while unconsciously playing with items on a table during meals.

At quite another scale, this same spirit of gentle persistence pervades Francis Alÿs's 2002 project *When Faith Moves Mountains*. During the last months of the Fujimori dictatorship, at Ventanilla, a *pueblos jóvenes* (new town) near Lima, 500 volunteers worked to shift a 500-meter-long sand dune about 10 centimeters from its original position. Contrasting this act of defiant, poetic possibility to the icons of environmental sculpture such as Michael Heizer's 240,000-ton displacement *Double Negative* (1969–70), Alÿs described his intentions:

12.9. Rivane Neuenschwander, *Conversation 1–12*, 2002. C-print mounted on aluminum. (Courtesy Galeria Fortes Vilaça, São Paulo.)

Here, we have attempted to create a kind of Land art for the land-less, and, with the help of hundreds of people with shovels, we created a social allegory. The story is not validated by any physical trace or addition to the landscape. We shall now leave the care of our story to oral tradition. . . . Indeed, in modern no less than premodern societies, art operates precisely in the space of myth. In this sense, myth is not about the veneration of ideals—of pagan gods and political ideology—but rather an active interpretative practice performed by the audience, who must give the work its meaning and its social value.[38]

At the 1993 Whitney Biennial, widely criticized at the time for being too correctly political, the most-discussed work consisted of a set of lapel buttons of the kind that U.S. museums issue to their paying customers, each with separate words on them but together adding up to the statement "I CAN'T IMAGINE EVER WANTING TO BE WHITE." Author of the offend-

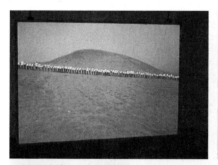
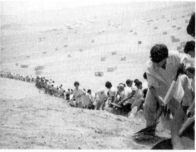

12.10. Francis Alÿs, *When Faith Moves Mountains*, 2002. Collective action. (Museum van Hedendaagse Kunst, Antwerp. Photograph by Christine Clinckxs/MuHKA.)

ing buttons, Los Angeles–based artist Daniel Joseph Martinez, has pursued a number of lines of inquiry since that time. One is a series of animatronic self-portraits in which a life-size hyperrealist robot of the artist responds to viewer proximity in ways that reveal a quite specific emotional state, a mental disorder or a social condition. His installation for the U.S. Pavilion at the 2006 Cairo biennial, entitled *Call Me Ishmael, The Fully Enlightened Earth Radiates Disaster Triumphant*, consisted of a figure lying alone on the floor a white cube space that convulsed as if undergoing seizure as viewers came near. Instantly, one felt that one was in a laboratory, or was a prison guard, with inhuman powers over another being. Another line of inquiry appears in *Divine Violence* (2007), shown at the 2008 Whitney Biennial. The walls of a room are tightly hung with 121 wooden panels of a uniform size, each sprayed with gold automotive paint and bearing the name of an organization formed to change political opinions and structures through violent means. This accumulation of both strange and familiar names is oppressive. "Divine violence" was Walter Benjamin's term, drawn from Messianic Judaism, for what would in revolutionary circumstances be justifiable political action by the working masses—an example, in those circumstances, of the kind of "pure action" that I mentioned earlier in this chapter.[39] The aesthetics of Martinez's installation evoke honor society walls, donor plaques, and crematoria. It becomes a house of memory, a record of short-term thinking and a testament to the failure of idealism. It becomes a golden cage of the present, because many of these organizations are still active, still deadly, despite their evident shortcomings. And it becomes a hall of witness to a future that will, in all likelihood, be the same.

The point of these examples is that, in contemporaneity, world-picturing, place-making, and connectivity take many forms, tend in many directions, and operate in many dimensions, but keep circling back to the four main themes that preoccupy contemporary artists: the changing sense of what it is to be in time, to be located or on the move, to find freedom within mediation, to piece together a sense of self from the fragmented strangeness that is all around us. It is this, rather than some more generalized, glib, and destined to be short-lived "political turn," that is at the heart of contemporary practice.[40]

Ruminating on the global mobility of artists from Africa, curator Simon Njami points to the essential isolation of the artist in the midst of his or her people, the exchange of rejection and obligation that is at the heart of the artist's social contract, no matter what the circumstances:

12.11. Daniel Joseph Martinez, *Divine Violence*, 2007. Automotive paint on wooden panels. (Courtesy of the artist and The Project, New York. Collection of the Whitney Museum of American Art, New York.)

There are many reasons for leaving beyond the obvious political and economic ones: no longer being able to share, in the case of contemporary artists, for example, your inner language with the people around you. Realising that you will have to go elsewhere to find a silence that corresponds to you. This is no doubt what being contemporary is all about. Artists share the same quality of silence, expressed according to different accents and sensibilities, and through these silences their background and vision of the world appear.[41]

This stress on silence goes back, of course, to Camus, to existential self-realization and social obligation in the context of the world's absurdity: no surprise that it has recurred today. It is an acute pointer to the inner trajectories of thousands of artists around the world. Think, then, of the richness in this regard of the work of artists such as Marlene Dumas, Georges Adéagbo, Jean Michel Bruyère, Kendell Geers, William Kentridge, and Steve McQueen, just to name a few of the artists for whom the problems of Africa are paramount.

In a recent article, Clare Bishop highlighted certain problems that limit collaborative art these days. One is an exaggerated split between "art" and "politics" such that the values of one are seen, from both sides of any ideological division, as antithetical to those of the other. Aesthetes see "community art" as unappealing, even ugly "social work," while those committed to the view that value resides above all in community consensus see considerations of art, from high style to skeptical imagination, as elitist impositions. As she acutely notes, these distastes subsume generalized notions of the aesthetic and the social/political within an equally abstract notion of the ethical.[42] That these ways of thinking generate opposite outcomes, depending on one's prejudices, is no surprise. It is the division into contra-categories that is the problem: this kind of thinking is not only inappropriate to the conditions of contemporaneity; it can, when applied to public policy and enacted by governments, be dangerous, for oneself and for others.[43] The works I have been citing are examples of what it is like to think, feel, make, and do beyond these blinkers. These works display, usually on their surfaces, the maleficent estrangements that are overtaking the present; they also show, usually through studied indirection, openings toward the creation of beneficent values, however odd or unlikely they may at first seem. These are the two great things that art can do, and do at the same time. Art does so both as overt showing and as inference, as a kind of withholding that slowly unfolds, from within its processes. These practices are its "truth," one that does not exist within categories, or between them, but uncategorically.

Artists such as the ones discussed in this book are making visible a paradox: a shared sense that the fundamental, familiar constituents of being are becoming, each day, steadily more strange, unfamiliar, and not shared. Along with many other kinds of action, art also shows that the urge to seek sustainable flows of survival, cooperation and growth continues unabated. Whatever the forces arraigned against these aspirations—including those of institution and exclusion, correctness, and cooption—they continue to engage the attention of the most interesting artists working today. In Jacques Rancière's terms, by activating the aesthetic regime that is their deepest inheritance as artists, they offer us disjunctive insights into what Harold Pinter characterized as the "tapestry of lies" out of which the current regime of representation is woven.[44] While the battle of the big categories—including those of "politics," "truth," and "art"—continues to rage across the surfaces of this public regime, it does so as a contest of crude polarizations, precipitating further devastation. In quiet contrast, by continuing their modest yet

committed questioning of everything, contemporary artists seek other ways to offer us places, pauses, and pathways through important aspects of our estrangement. With lessening fanfare, and without overt comment, more and more of them are pointing us toward instances of embodied connectivity and situatedness within the accelerating diversification of difference that characterizes our contemporaneity.

Part 6
An Art Historical Hypothesis

CHAPTER THIRTEEN

What Is
Contemporary Art?

The argument about the nature of contemporary art today advanced in these chapters has been put forward, for the most part, by way of show and tell. By giving priority to direct encounter with art and its situations of occurrence, I have deliberately not belabored the methods I have been using, nor paraded the theoretical armature that has been in play. Time to come clean, to relate my approach to others that are in contention, to show my disciplinary hand. I do so by asking: What are the implications for art practice, art criticism and art theory of posing the possibility that it is time that contemporary art was subject to a certain kind of art *historical* analysis?

Asking the Question

If we ask the question "What is Contemporary Art?" with capital letters on the words "Contemporary" and "Art," the answer is obvious—and has been since the 1980s. Contemporary Art is the institutionalized network through which the art of today presents itself to itself and to its interested audiences all over the world. It is an intense, expansionist, proliferating global subculture, with its own values and discourse; communicative networks; heroes, heroines, and renegades; professional organizations; defining events; meetings and monuments; markets and museums—in sum, distinctive structures of stasis and change.

Contemporary Art museums, galleries, biennials, auction sales, art fairs, magazines, television programs, and Web sites, along with whole ranges of associated products, seem to be burgeoning in both old and new economies. They have carved out a constantly changing, but probably permanent, niche in the historical unfolding of the visual arts, and in the broader cultural industries, of most countries. They are also a significant presence in the inter-

241

national economy, being closely connected with high culture industries such as fashion and design, with mass cultural industries such as those of tourism, and, to a lesser but still important degree, to specific sectors of reform and change such as those of education, media, and politics. How could one doubt this, when milling about at the *vernissage* of the Venice Biennale or any of the nearly hundred biennials and similar exhibitions staged cyclically in different cities around the world, when reading of yet another stratospheric price achieved at a contemporary art auction, when opening the advertisement-filled pages of *Artforum* or any other of the plethora of contemporary art magazines, when attending a lecture course on contemporary art (increasingly on offer in art schools and university departments), when scanning the list of cultural institutions in any tourist guide to any significant city in the world, or noting that anything to do with the building of new museums is guaranteed upfront treatment by both local and national news media? Indeed, nearly all of the ninety or so significant new museums or new extensions that were commissioned around the world during the 1990s were devoted to contemporary art. Post-9/11, many of these projects went on hold or were abandoned altogether. Recently, museum building has recommenced, and contemporary galleries—public and private—are leading the surge.

Contemporary Art is a culture that matters—to itself, as its own subculture, to the local cultural formations in which it is embedded, to the complex exchanges between proximate cultures, and as a trendsetting force within international high culture. Its globalizing character is essential to it, but it also mobilizes nationalities, and even localisms, in quite specific and complex ways. As we have seen, since its completion in 1997, Frank Gehry's Guggenheim Museum at Bilbao has become acknowledged everywhere as the paradigm of what a contemporary landmark, logo, or destination building should be. A supreme work of contemporary art in itself, it is celebrated as a cathedral of Contemporary Art for the globalized world, yet it is one that also serves—at official, if not local art world levels—a basque regional cultural agenda.

In settings such as these, the concept of "contemporary art" is in everyday usage as the general term for today's art taken as a significant whole, and understood as distinct from modern art—the art of a historical period that is substantially complete, however resonant it may remain in the lives and values of many. If used at all, the term "postmodern" recalls the moment of transition between these two eras, an anachronism from the 1970s and 1980s. These presumptions became the norm in art discourse throughout the world during the 1990s.[1]

This is how the contemporary art world—its institutions, its beliefs, the ensemble of cultural practices that go into making it a *socius*, a "scene"— answers the Contemporary Art question: it is what we say it is, it is what we do, it is the art that we show, that we buy and sell, that we promote and interpret. This scene is self-defining, constraining on practice and constantly inviting its own self-representation. Its inclination is to insist on complicity with itself: it often does this by recycling centuries-old, romantic, and

13.1. Navin Rawanchaikul, *Super (M)art*, 2000. Mixed media installation, Palais de Tokyo, Paris. (Courtesy of Air de Paris.)

mystifying modes of artistic practice, such as intuitive expressionism, genius, beauty, and taste. Look upward into the atrium of the Guggenheim at Bilbao. Or submit to the single tracking shot that sweeps through the Hermitage and through scene after lovingly observed scene of the last days of the prerevolution Russian empire in Alexander Sokurov's 2002 film *Russian Ark*. At the other end of the spectrum of contemporary art, Thai artist Navin Rawanchaikul ironized his own situation, and that of his contemporaries, in his work *Super (M)art*, an installation at the entrance to the Paris Biennale at the Palais de Tokyo in 2000 that obliged visitors to pass through a gateway that featured a vibrant image of an artist/barker who shouted out visual slogans exhorting us to celebrate this exhibition of work by young artists as if it were an art trade fair. This was an acute response to the advent of the voracious collector, a figure whose seemingly infinite funds, dedication to smart investment returns, unformed tastes, and taste for the unformed has come to dominate the international art scene in recent years.

Just because this scene can be so dazzling, so entrancing, so distracting, the question "What is contemporary art?" calls for further answers, drawn from wider perspectives. Let me propose another approach: one that is art historical in a number of senses. Yet it begins from art practice, from the evident fact that contemporary art practice is saturated with deep, detailed—but not always (or even often) systematic—knowledge of art history. In particular, critical art is alert to art's history within history, and responsive to the shaping powers of historical forces. This has been evident throughout this book, and is a subject to which I will return at its end. Before doing so, however, it is important to review the range of answers to the question of contemporary art that have been offered in recent years by commentators, critics, curators, and occasionally, historians.

Passing the Posthistorical

During the 1990s and around 2000 there was, paradoxically, a widespread sense of contemporary art as being made in a state "beyond history" or "after the end of history." Although it has the fragility of the Romanov empire as its overt subject, and that of the then imploding Soviet empire as its implied target, *Russian Ark* was just one among many melancholy yet lyric meditations on this broad, seemingly "posthistorical" state (and not the only one to offer art as the answer—or, at least, as the solace). This condition was theorized as definitive of the time, notably by Francis Fukuyama.[2] From present perspectives, however, it is the conjunction of historicism and blank-slate

naïveté that seems typical and mystifying. Rather than a deep, suggestive doubt about the practice of periodization, it turned into doubt about the efficacy of historical thinking itself.

If one stays within the frameworks of orthodox art history, with its sustaining narratives about the succession of "great schools" constituting the broken but incessant reflowering of art, this concern is understandable. As far as the visual arts are concerned, it is evident that, since the years around 1970, no tendency has achieved such prominence that it might be a candidate for becoming the dominant style of the period. Much effort went into promoting the "return to painting" in the early 1980s, while installation, large-scale photography, video, and digital projection have been ubiquitous in recent years. But nothing has succeeded minimalism and conceptualism as art styles. The closest candidate would be the spectacular adhockery of retro-sensationalist art, or perhaps the erudite refinements of remodernism. An attenuated, incoherent nexus between these new mediums and these shock tactics serves for many as the marker of international contemporary art, as a kind of taken-for-granted "house style," a signature exclusivity that sets it off from older or more prosaic modes. This is too unreflexive to be an answer to the question: What is contemporary art? Rather, it substitutes passive acceptance for interrogation. Yet it does disguise a deep concern. Sometime in the late 1980s it began to occur to opinion makers in the art world that another overall style of the kind that seemed to shape art in the past was increasingly unlikely to appear.[3] Some began to fear—others delightedly anticipate—that, perhaps, contemporary art might always live in the aftermath of this "crisis," that it might be our "history" to be suspended in an incessant shifting, one that would prevent another paradigm locking into place. "Contemporary," therefore, could well come to mean periodlessness, being perpetually out of time, or at least not subject to historical unfolding. Will there ever be another predominant style in art, another period in social culture or epoch in human thought? Fredric Jameson has shown us that one of the key impulses of modernity was its high anxiety about defining historical periods, its incessant periodizing.[4] In contrast, the word "contemporary" comes, on this reading, to mean not "to be with time" but "to be out of time," to be suspended in a state after or beyond history, a condition of being always and only in a present that is without either past or future. Would this be horrific, debilitating or liberating?

Yet the "posthistorical" approach, I believe, means surrendering what art history, and historical materialist critique more generally, can offer to an understanding of the present. It is to take the institution of Contemporary

Art at its word. Looking carefully, and listening for the sounds behind the bluster, allows us to discern a deeper set of currents, unmistakably historical ones. The artists most thoroughly committed to making art in the conditions of contemporaneity know that they carry unresolved legacies from the history of art, especially those that shook art to its roots during the 1950s and 1960s. Many of these innovations were, at their core, extraordinary efforts to grasp the contemporaneity of things, others, images, and self. They resonate still. At the same time, artists have become more and more acutely aware that the powerful currents that drive broader visual cultures just as deeply inflect their fields of possibility, especially the visual languages open to them.

What are these unresolved legacies? My suggestion has been that artists these days cannot turn away from the fact that they make art within cultures that are predominantly visual, that are driven by image, spectacle, attraction, and celebrity on a scale far beyond that with which their predecessors had to deal. Additionally, they are embroiled willy-nilly in the fact that this image economy is shaped and reshaped by a constant warring between the visceral urgencies of *innervation* on the one hand and the debilitating drift towards *enervation* on the other. In their efforts to find figure within form, to win it from formlessness, artists cannot avoid using practices of surfacing and screening which, along with the rise and rise of the photogenic (the photographic, the cinematic, and the digital), and the conceptualist impulse to the provisionalization of art itself, are the great aesthetic and technical legacies of the nineteenth and twentieth centuries.[5]

The Trickster Effect

To many people, contemporary art remains such a specialist discourse that to discuss it in terms such as those used throughout this book seems implausible. It can seem the most baffling, hermetic, and crazy of all the arts, a sideshow of bad faith, and a self-serving, elitist enterprise that precipitates mistrust among broader publics. This feeling is concisely put by Peter Timms in his *What's Wrong With Contemporary Art?*

> Why is contemporary art so in thrall to spruikers [those who promote their own cause, e.g., a barker] and promoters, for example, and why do their lofty claims so rarely match the reality? Why does the market have such overwhelming power, even in areas, such as government funding and public broadcasting, previously thought to be its foil? If art has

become little more than a commodity in the global marketplace, if the primary concern of artists is the furtherance of their own careers, and if the success of any exhibition is measured by the amount of publicity it generates, what does this tell us about the role of the visual arts in our culture?[6]

These are not unreasonable questions. Timms is angry at the arrogance that, he believes, attends the "general reluctance of contemporary art professionals to engage with such fundamental questions" and their dismissal of doubters as conservative, ignorant, or unhelpful.[7] This leads straight to lack of public confidence in the arts, and their consequent marginalization: "Artists and curators, knowing that their careers depend on attracting attention to themselves at any cost, are increasingly turning to visual gags, titillation, public scandal or platitudinous commentaries on newsworthy social issues, under the pretence of 'challenging public perceptions.'"[8] On this view, contemporary art participates more and more willingly in a decline of standards, but does so hypocritically, in the name of a radical critique of the causes of this decline. It is a fraud perpetuated on the public by art world professionals, a condescending elite who then go on to defend their scam in the name of higher values which, in turn, they seek to impose on the public for its betterment. In return for this trickery, they seek rewards as the providers of public goods. In contrast, Timms advocates "art that seeks to play a part in arresting that process, not by means of any superficial appropriation, but through meaningful involvement in the legends, myths and stories that define cultures."[9]

In his *High Art Lite*, Julian Stallabrass acknowledges the same phenomenon, but from the opposite political position. Recognizing it as the art that late capitalist, spectacle society deserved, and perhaps had to have, an art that its producers could not but produce, he examines it for its traces of these connections, seeking deeper causes, not *ad hominem* targets at which to cast blame. Focusing on British art during the 1990s, a decade dominated by the yBas, he shows that these artists emerged in response to the deleterious, recession-generating impact of radical conservatism on British society—"society" was a concept that Margaret Thatcher scornfully dismissed as meaningless—only to transform their art into a simulacrum of the illusory class consensus promoted by New Labor. In its first phase, art created by the yBas was characterized by four traits: its "overtly contemporary flavor"; its international savvy in contrast to "the provincial air of much previous British work" (Warhol and Schnabel, he notes, were general models,

with the next generation led by Koons, Bickerton and Gober as more specific ones); "a new and distinct relation to the mass media," including frequent use of materials from mass culture; and the presentation of "conceptual work in visually accessible and spectacular form."[10] While these characteristics might seem quintessentially avant-garde, they were so only as appearance. Stallabrass's label "high art lite," trading as it does on an analogy to beer with low alcohol content, is aimed at "an art that looks like but is not quite art, that acts as a substitute for it."[11] His diagnosis of this essential ambivalence has turned out to be quite acute: "To court a wider audience, high art lite took on an accessible veneer, building in references and forms that people without specialist knowledge would understand—and even sometimes, in its use of mass culture, incorporating material that those with a specialist knowledge would generally not understand, having been too busy with their art historical monographs and too snobbish to have allowed themselves an interest in pop music or soap opera. In this way, the new art set out to appeal to the media and to enrage conservatives, generating the publicity on which it was coming to rely."[12]

This strategy has had predictable results. "As the art market revived and success beckoned, the new art became more evidently two-faced, looking still to the mass media and a broad audience but also to the particular concerns of the narrow world of art-buyers and dealers. To please both was not an easy task. Could the artists face both ways at once, and take both sets of viewers seriously? That split in attention . . . led to a wide public being successfully courted but not seriously addressed. It has left a large audience for high art lite intrigued but unsatisfied, puzzled at the work's meaning and wanting explanations that are never vouchsafed."[13] Thus the anger of influential writers during the 1980s, particularly art critics and reviewers such as Robert Hughes, Peter Fuller, and Dave Hickey, and of philosophers such as Jean Baudrillard, who accused the art world of conspiring in its own disappearance.[14]

However well founded when directed at specific targets such as the publicity machines of artists such as Koons and the now aging and establishment yBas, this anger falls short on two counts. It fails to recognize the real, if uneven, achievement of certain of these artists—Damien Hirst or Matthew Barney, for example. More importantly, it cannot be generalized to all contemporary art. To do the latter is to ignore the substantial accomplishment of those many artists who, during the same period and since, have, as I showed in the latter part of this book, made art on quite other premises, and to powerful or subtle effect.

Millions attend museums, and millions are attracted to contemporary art's aesthetic, fashionability, and buzz. Yet along with this quantitative growth, and this with-it-ness, there is, I believe, a deeper, qualitative shift going on. At the Documenta 11 exhibition in Kassel in mid-2002, I witnessed more people learning more about the current state of world affairs than was possible, at that time, to glean from official and commercial media. The interrogation of contemporaneity by artists and the new values emergent from this are slowly spreading. There are a variety of interactions—difficult and dangerous, to be sure—between critical practice and institutionalized contemporary art. In this Faustian exchange, both the conformist and the critical tendencies take advantage of the fact that contemporary art is uniquely plugged in to the image economy, the symbolic exchange between people, interest groups and cultures that takes predominantly visual forms. It is everywhere accepted that visuality is preeminent in news and entertainment, advertising, television, print media, fashion, commodity design, and urban architecture. Its force in shaping the self-images of most of us is less evident (albeit unconscious) but no less powerful. It is in recognition of the subtle power and the all-pervasiveness of this trafficking in images, that I call it "the iconomy."[15] The common visual language of the most conformist and the most critical elements of this visual economy is also that most widely used in contemporary art and design. This is tricky territory. We have seen it in play throughout this book.

Is Contemporary Art More of a Challenge to Interpretation than Before?

Why does contemporary art seem such a challenge to its committed interpreters? To curators, who wish to display its currents, its array; to critics, who want to grasp what is pertinent within it; to those few who would discern the outlines of its incipient history—what may be important within it, and also of course, why this may be so, now and in the future? And to artists, because they have, like it or not, inherited from the best of modernism the sense (even obligation) that to make art now is, in significant part, to put forward a proposition about what it is to make art now, or might be? All of which leads to another question, one that, it seems, begs to be asked in concert with the first. Is contemporary art more of a challenge to interpretation than before? What "before" means is, of course, a key part of the problem—but I will show its possible solution.

There have always been a host of obvious challenges to the ready interpretation of art as it happens, qualities that new art seems to share with everything that comes freshly into the world: nascence, precipitousness, immaturity, incompleteness, and provisionality. Then there are qualities related to its differences from other art: novelty, unfamiliarity, rarity, and so forth. More difficulties follow from just where it appears, how, and to whom: its legibility, its mode of address, accessibility, or availability. These are commonplace problems that interpretation must work to overcome—as it does, with varying and changeable degrees of success. Beyond them, however, there is nowadays a widespread sense that recent and current contemporary art has these qualities to an unusual degree, perhaps more so than at any time in the previous history of art. And that it has some further qualities that make its contemporaneity distinct from that of previous art.

Although this sense is widespread, a recent statement by Donald Kuspit, in an essay entitled "The Contemporary and the Historical," registers them all at once:

> There has always been more contemporary than historical art—or, to put it more broadly, there has always been more contemporaneity than historicity—but this fact only became emphatically explicit in modernity. Art history's attempt to control contemporaneity—and with that the temporal flow of art events—by stripping certain events of their idiosyncrasy and incidentalness in the name of some absolute system of value, was overwhelmed by the abundance of contemporary art evidence that proposed alternative and often radically contrary ideas of value.[16]

Let me break this lament down into a list of oft-heard claims, all of which—singly and together—challenge previous interpretative modes.

There seems to be more contemporary art than ever before. "Before" can mean any moment before this current decade, but the far horizon is usually the 1950s, and looming large before it (as we look back) are the 1960s, when modernism was at its most developed, so powerfully writing its current and future agenda, and its prehistory, all the while hovering on the cusp of eclipse. Each decade since has offered striking markers of significant change. Viewed from the present, the big story is the shift from modern to contemporary art. This has occurred against many backgrounds, not least a massive worldwide expansion of the cultural industries. The visual art–producing institutions (art schools, museums, galleries, auction houses, publishers, educators) have ramped up to industrial levels and are putting out more new

art, sooner and with less vetting, to booming crowds of consumers—along, of course, with vast recycling of past art, its contemporary relevance and interest highlighted. On top of this, there is a frenzy of interest among curators and young scholars in the recent past—in effect, in the early years of current, contemporary art.

It is more diverse than ever before in all its aspects: medium, content, location, affect, effect. This perception is, perhaps, an effect of the fact that, since late high modernism (pop, minimalism, conceptual art), there has been no period style. So distant is this kind of aesthetic power that the very idea of a contemporary period style seems not only odd and undesirable but to have all but faded from memory. No qualities of any kind, at any level, are shared by a sufficient number of works to make even their contemporaneousness self-evident. A paradoxical result is that not all contemporary art looks "contemporary," and much of it does not look like art at all.

It is being generated all over the world, not just at a limited set of centers. However persistent some generalities, impositions, influences, and the like may be, they are drowning in a rising tide of particularity. Local knowledge and often the native language are needed to begin to grasp the point of the work. This requirement has become too much for any one person to encompass. Even teams of local experts (curators, critics, writers, etc.) are struggling to present objective pictures of regional developments. A subset of this concern is the sense that *contemporary art is increasingly being disseminated locally, regionally, laterally, and cross-currently*, in ways that are beginning to bypass the vertically integrated market and publicity system for international art.

It is being made by younger artists and exhibited more quickly than before. This is abundantly evident in the phenomena of "art school art" in the biennales, of overstocked art fairs replacing museums, galleries, and auctions as the places to see and be seen, and of voracious collectors setting agendas across the entire art world, including the establishment of museums consisting of their own collections, from which they enthusiastically (advised by their curators, or off their own bat) mount shows of artists whom they consider interesting, present interpretive exhibitions on idiosyncratic themes or promote certain tendencies in contemporary art that they happen to have collected.

Canons, Plurality, and Particularity

A de facto strategy in the face of this long list of concerns is to acknowledge most, if not all, of them but insist that the work of certain artists and the

pursuit of certain practices constitute the core of contemporary art that is likely to last. Curators, critics, and historians, as well as art markets and institutions, just have to wait a little—resist the latest fashions yet leave out the lure—and some works of art will, in time, join the canon. From this perspective, another paradox arises: contemporary art is that art being made today that will eventually become of long-term art historical interest. But how, now, can you (fore)tell?

A variant of this view, held strongly in the Western art centers, is that the best art of today is consistent with earlier art of consequence that was produced within the modernist, avant-garde traditions of the twentieth century—taking these multiple, cosmopolitan modernities as richly conflicted at the great metropolitan centers, and as including art created at many of the connected peripheries, as well as in the artistic trafficking between them. New art can be assessed against this diverse and complex legacy. This is a difficult, but not impossible, task, and many historians and critics have tackled it from a spectrum of perspectives since the 1970s. The journal *October*, for example, was founded as an ongoing critique of narrow views of modernism, and has closely examined art that flows from modernist and postmodern premises, but rarely shows interest in art that has resulted from the postcolonial turn. *Art Since 1900* is a recent textbook that reflects this approach. By organizing entries according to the year of the occurrence of their content, it tracks above all the contemporaneity of modern art, rather than its history—at most, it implies a limited numbers of histories of modernist art: double modernism (formal and informal) for two of its authors (Rosalind Krauss and Yve-Alain Bois), or a continuing and heroic, but ultimately futile, struggle by certain neo-avant-garde artists against the seductions and the degradations of the Culture Industry (Benjamin Buchloh).[17] While a large portion of the entries are devoted to artists active since the 1960s, it leaves ambiguous the question of whether anything fundamental has changed. The implication is that it has not, or, if so, it has changed in ways that exceed the frameworks used in the book. One of the authors, Hal Foster, was frank about this. Asking "Are there plausible ways to narrate the now myriad practices of contemporary art over the past twenty years?" he describes the two "primary models" that they have used during this period—"on the one hand, the model of a medium-specific modernism challenged by an interdisciplinary postmodernism, and, on the other, the model of a historical avant-garde . . . and a neoavant-garde"—as having become "dysfunctional."[18] Another author, Benjamin Buchloh, admits that "the bourgeois public sphere" to which both previous avant-gardes were related, albeit critically, has "irretrievably

disappeared," to be replaced by "social and institutional formations for which we not only do not have any concepts and terms yet, but whose modus operandi remains profoundly opaque and incomprehensible to most of us."[19] These are honest admissions, by outstanding critics, of a bafflement that is shared by most of their colleagues.

Yet the canonical approach, however internally flexible, reaches its limits in many ways: it is inherently conservative and so will slip behind history unless historical forces themselves turn overwhelmingly conservative (as, evidently, many of them have these days); it is tied to the disposition of power in the cultural institutions and to their increasingly volatile fates within contemporaneity; the modernist version of canonicity relies on the paradox of avant-garde rupture and individual renovation, both of which are becoming increasingly difficult to maintain as innovative artists turn away from even antimodernism; finally, it is a European, Western story of inevitable recursion to the metropolitan centers, one that, after the postcolonial turn, has become increasing difficult to sell both at home and abroad.[20]

In contrast to canonicity, there are a variety of *pluralist* views, some of which shade into *relativism*, including radical relativism. It is a commonplace that the present cannot be grasped until it becomes, in some sense, a past. Hegel's metaphor of the owl of Minerva flying only at twilight is taken to mean that contemporary history is an oxymoron. The practical difficulties of seeing a pattern within the flux of current events are evident. On the other hand, there is genuine concern (and past evidence enough) that authoritative statements by curators, critics, and now collectors on tendencies could lead to their being followed by artists, to their becoming trends, thus distorting the practice of art and second-guessing art's "natural" historical evolution—which, on this view, should be left entirely to artists. (Given the position-taking and contestation that drives much contemporary art—as it has much of the art of at least the modern past—this is naïve.)

As we have seen, Donald Kuspit offers a version of the pluralist position that is precisely calibrated to the situation that he believes contemporary art has reached now, in the early twenty-first century. I cited his observations that contemporaneity has exceeded art history's efforts to establish value. He does not specify precisely when this change occurred, but his examples all imply that it was introduced during the 1960s, when "the turbulent pluralism of modern art . . . increased exponentially in the postmodern situation." He takes this to be the naturally, or at least historically, evolved state of contemporary art production, and so attacks artists, critics, curators and historians who would try to second guess art history by preferring

"the happy few or the One and Only truly and absolutely significant art-ist." The responsible role for criticism in this context is, he believes, to keep advancing a "pluralism of critical interpretations" of current, recent and past art in order to "keep it in contemporary play." For Kuspit, "the power of contemporary art comes from the insecurity of being ephemeral," so that nominating particular artworks, or works by select artists, as today's art for the future is to reduce them to "sterile homogeneity." In the current context, which he sees quite accurately as dominated on the one hand by a Malthusian overproduction of artists, and on the other by the exclusivist superficiality of extraordinary auction prices and media-sensationalist ce-lebrity, any form of interpretive generalization will be self-defeating at best, complicit at worst. When this is put alongside the incommensurate particu-larity and radical incompleteness that is natural to the contemporary, the only option for criticism is, he believes, to make "an interpretive case for a particular art's interestingness by tracking its environmental development in the context of the observer-interpreter's phenomenological articulation of his or her complex experience of it."[21] Criticism, then, not history. Or history as accreted criticism. Despite his use of the term "pluralism," this is a *particularist* position.

Kuspit is right about the dangers of generalization in a situation where the shots are being called by inimical institutional, media and market forces. But singularizing particularity, however shrouded in objections to the larger forces, is no solution. An engaged, implicated relativism is more difficult, but more responsible. But what are its consistent dimensions? How do they vary according to the situation in which they seek relevance?

A Distinction, Three Contentions,
and Some Proposed Lines of Inquiry

In the introduction I argued that the concept of the contemporary has al-ways served to acknowledge the quickly passing present, but that it also had a great but insufficiently tapped potential to grasp the multiplicity of relationships between being and time that were occurring now and that had occurred in the past. It would do so, of course, as it always has, alongside other terms that addressed other aspects of the nature of human being in time—notably the "modern," which has dominated historical thinking, and thinking about history, during the past two centuries at least. This began to change in the latter decades of the twentieth century, first under the ru-bric of the "postmodern." Now, as the limits of postmodernist explanation

have been reached, the world stands face to face with itself, in all of its rich contemporaneity.

Contemporaneity is, according to standard definitions, "a contemporaneous condition or state." In the expanded sense of the term "contemporary," this means a state defined above all by the play of multiple relationships between being and time. Obviously, this condition has been a vital part of human experience since the beginning of consciousness. Equally self-evident is the fact that other relationships—not least structures of religious belief, cultural universalism, systems of thought and political ideologies—have mediated these particular ones. In recent times, however, there has been a noticeable spread of the sense that the encompassing power of these structures has weakened considerably, not least because of the everywhere evident contestation between them. Nowadays, the frictions of multiplicitous difference shape all that is around us, and within us, everything near and far, every surface and depth. With the passing of modernity, the evaporation of the postmodern and the rise of fundamentalisms, with the eruptions of an overstressed planet and the diminution of imaginable futures, contemporaneity seems to be all that we have. It seems, too, that almost every kind of past has returned to haunt the present, making it even stranger to itself. Is this a new era, or have we passed beyond the cusp of the last period that could plausibly be identified as such? These considerations lead us to this contention. *Contemporaneity is the fundamental condition of our times*, manifest in the most distinctive qualities of contemporary life, from the interactions between humans and the geosphere, through the multeity of cultures and the ideoscape of global politics to the interiority of individual being. Against its grain, we must write its history, as it is happening, otherwise it will elude us—even, perhaps, destroy us.

From this it follows that the primary object of any history of contemporary art worthy of the name is not the Contemporary Art that subsists in public consciousness and mass media, or that which occurs as a general category in non-art discourses. These conceptions are worthy of note, but they are not the main game. Similarly, the self-conceptions that prevail in the intersecting sets of interest that constitutes the art world—including the territories of those committed to Contemporary Art—are indispensable to inquiry, but are in themselves mostly symptomatic. Since the 1950s, all over the world, an increasing number of artists have been highlighting as their essential subject matter *the ontology of the present* (to use a phrase of Fredric Jameson's)—that is to say, elements of what it is to be in time.[22] One after another, each of the relevant professional expositors—artists them-

selves, critics, reporters, curators, dealers, auctioneers, and collectors—has attempted to identify what is going on in art as it has been happening. Each has drawn attention to important factors, usually in line with their interests. Slowly, however, elements of a plausible picture have come into focus. Now, after a few false starts, it is the historian's turn to set out an overview. But of what? *For the history of contemporary art, the core object of inquiry is the art, the ideas, the cultural practices and the values that are created within the conditions of contemporaneity.* Showing what, how, and why these have recently taken, and are currently taking, the forms that they do is the core task of contemporary art history. The backstory is the shift—nascent during the 1950s, emergent in the 1960s, contested during the 1970s, but unmistakable since the 1980s—from modern to contemporary art.

Implied in these two contentions are many others of relevance to art history as a discipline. *Contemporaneity itself has many histories, and histories within the histories of art.* Mostly, art historians tend to notice contemporaneous elements in a work of art as distractions that, they believe, will recede in importance—indeed, disappear from sight—once a more measured historical gaze recognizes the true nature of the work's achievement. But a more subtle understanding of contemporaneity as constituting all the possible relationships between being and time identifies a shifting body of subject matter that has always been available to art. Different sets become relevant at particular times, in specific places. The art historical quest unleashed by this idea obliges us to ask some unexpected questions. To what extent, and how, was awareness of the disjunctions between being and time registered within the symbolic languages that adorned the caves of Africa, marked the deserts and the rocky plateaus of what became Australia, were painted in the caves of what became Europe, and were created on the plains and islands of what became Asia and the Pacific? And so on, everywhere, throughout time, up to the present.

From these contentions, a number of lines of historical inquiry follow quite directly.[23] If, during the past two centuries, the elements of contemporaneity have been subsidiary to the powerful forces constituting modernity, what has caused the recent ascendancy of the contemporary? How might these changes be traced within language use in general, and art discourse in particular? But this changeover has not been a simple transfer, or translation, from one state (modernity) to another, similar one (contemporaneity). The state of what it is to be a state, the conditions as to what counts as a condition, are changed. In historical terms, therefore, when it comes to considering the present and the future, periodization

may no longer be possible. In art historical terms, we are *not* talking about the arrival to succession of one, all-encompassing contemporary style. This does not mean the instant death of style as such. It does mean, however, that any styles that do persist will do so as anachronisms. Thus my positioning of what I have called retro-sensationalism, remodernism, and spectacle art.

Examining those occasions, within debates about art, when the concept of the "contemporary" has surfaced as the indicator of key values seen to be at stake would enable us to note some prefigurations, perhaps even sketch a prehistory, of contemporary within modern art. Exploring such situations in depth is an important task: it would be foundational to a well-grounded history of contemporary art. We have already noted some striking examples while discussing, in the first chapter, such precedents as the reaction against MoMA by the Institute of Contemporary Art in Boston in 1948. In British colonies throughout the 1930s, contemporary art societies were formed, mostly as artists' exhibiting organizations, in opposition to local academies. The charter of the Contemporary Art Society, founded in Melbourne in 1938, is typical: "By the expression 'contemporary art' is meant all contemporary painting, sculpture, drawing, and other visual art forms which is or are original and creative or which strive to give expression to contemporary thought and life as opposed to work which is reactionary and retrogressive including work which has no other aim than representation."[24] In every case there is an utterly specific conjunction of artistic tendencies, one of which takes the name "contemporary"—for that time, in that circumstance. Taken together, they hint at the richness, and the complexity, of the *prehistory of the contemporary within the modern.* They suggest, too, the interest that may lie—for the "alternative modernities" or "cosmopolitan modernisms" project—in tracking these largely forgotten pathways. As well as a further challenge: tracing the distinctive ways in which art in each of these regions shifted from modern to contemporary art.

While the term "contemporary" did not come to dominate institutional art discourse until the 1990s, artists working in a number of centers throughout the world began to pay different kinds of very close attention to the nature of contemporaneity some forty years earlier. What role did these concerns play in what is everywhere acknowledged as a time of major transformation in the history of art? Are these the first signs of what some now see as the shift from modern to contemporary art? Or did they signify transitions on a smaller scale (to, or within, "late modern" art and architecture, for example)?

In the long aftermath of World War II, a number of artists in different parts of the world felt compelled to experiment with the idea of making something that, in the first instance of its conception and apprehension, would be as if it were something that might have come into an uncreated existence. Lucio Fontana began to conceive of paintings in this way in 1949, as did Jiro Yoshihara and Shozo Shimamoto in 1950, along with other members of Gutai in 1954. Yves Klein soon after saw into the void, as did Guy Debord, in his anti-film *Hurlements en faveur de Sade* (June 1952). Robert Rauschenberg's surfaces, covered with black or white house paint during 1951 and 1952, were mere receivers of light, shadows and other occurrences. In the latter year, John Cage used them in his "concerted action" (later re-named *Theatre Piece No. 1*) at Black Mountain College, North Carolina. Andy Warhol's lasting significance is less his celebration of consumerist imagery than his registration, in his works of the early 1960s, of death in the present—the violent deaths of ordinary Americans as much as those of JFK, Marilyn Monroe, and others. These examples suggest that attempts to grasp, and to escape, contemporaneity were crucial drivers of the great changes in late modern art.

If artists took the lead in facing the demands of the contemporary in the 1950s and 1960s, can we say that critics were most prominent in both obstructing (the formalists) and facilitating (everyone else) openness to these values during the latter decade and the 1970s? Can we say that the market returned to reclaim the agenda during the 1980s, whereas curators dominated art world self-definition during the 1990s (staging a contest between internationalist but antiglobalization biennales and globalizing museums of modernist art)? Can we say that since the turn of the century, collectors, followed quickly by auction houses and art fairs, have led in highlighting what counts as current art? I believe that we can outline the recent history of art world discourse in this way, and that when we do we find that the increasingly complex variety within contemporaneity has become the main subject of this discourse.

Recent books on contemporary art are divided between pictorial compilations accompanied by minimal information text and brief artists' statements (the Taschen model); anthologies of interpretive essays by theorists, critics, and curators (the Blackwell model); or long lists of themes deemed to be of current concern.[25] A few textbooks have been attempted, with more sure to come. Meanwhile, art discourse finds itself in an oddly suspended state between an arrested art criticism and a nervous historicism (this state seems to have lasted longer than before—itself a sign of the debilitating

effects of our contemporaneity). We have remarked that *Art Since 1900*, for all of its outstanding qualities, was subject to this situation.

In contrast, the postcolonial turn has generated the need for narratives that work on global, regional, and local levels. These are essential to understanding art, not only as it is created within cultures but also as it enters into the exchanges between them. While its history is as old as human manufacture, this circulation has come to be the most obvious feature of contemporary art. Pluralist and particularist objections lead to passivity before the impacts of globalization, and an inability to trace in art and culture the unfolding of decolonization. They are blocking the postcolonial project. Recognizing this, many scholars, especially those on the South American continent, in Eastern and central Europe, in Africa and throughout Asia and Oceania, are developing more nuanced positions.[26] The work of scholars from the regions, and those in the centers pursuing the full implications of the postcolonial turn, raises the possibility of comparative studies of contemporary art as it happens, and the further possibility of tracing the shift from modern to contemporary art as it occurred in specific ways in different regions throughout the world. Telling these stories is the great challenge facing historians of contemporary art.[27]

In the Euro-American centers, a younger generation of art historians already has begun the task of writing a revisionist history of art made and shown in those centers. After all, contemporary art there, as elsewhere, is, by any timeline, at least forty years old. Revived interest in the 1960s and 1970s is not merely retro-fashion. It is a response to the thirst on the part of institutions to take stock of work by artists either long dead (Warhol by over twenty years) or nearing the natural end of long and productive careers. For the current younger generation, to see the 1960s and 1970s in ways distinct from the interpretations offered on all sides, and from above, by survivors from that moment, would be to arrive at an independent view of the great changes in art that occurred then, and to see them in ways useful to present practice and thinking.[28] Full-scale revisions of this art have been undertaken by a number of curators and historians—it is being repositioned both in relation to previous art and to the key thematics of contemporaneity: those of temporality, multiplicity, and dislocation.[29]

What Kind of Art Matters Now? Curators Stage the Debate

Ambitious big-picture interpretations, like all polemics worth their salt, aim to be acute descriptions of how particular (artistic) practices relate to

general (social) conditions. They are about desirable positionality. It seems to me that, in visual art discourse in the years around 2000, two big answers came to figure forth amidst the multitude of smaller ones. This was especially evident in the major world art distribution centers. From broader world perspectives, however, their prominence is misleading, and, perhaps, self-defeating. The multitudes may be on the cusp of having their day.

The fierce debate that divided the international art world after the Documenta 11 exhibition of 2002 exposed certain value antipathies that have been looming since around 1980, and had been at the baseline of art world discourse for at least a decade. Sometimes, when the grinding between them gets too hard, they appear in raw terms. In the first chapter I cited MoMA chief curator Kurt Varnedoe locating, in 2000, the historical significance of his museum's collections of recent art:

> There is an argument to be made that the revolutions that originally produced modern art, in the late nineteenth and early twentieth centuries, have not been concluded or superseded—and thus that contemporary art today can be understood as the ongoing extension and revision of those founding innovations and debates. The collection of the Museum of Modern Art is, in a very real sense, that argument. Contemporary art is collected and presented at this Museum as part of modern art—as belonging within, and responding to, and expanding upon the framework of initiatives and challenges established by the earlier history of progressive art since the dawn of the twentieth century.[30]

Compare this conception of what was most at stake in millennial art exhibitions to that of another curator, Okwui Enwezor, introducing the platforms that constituted Documenta 11, of which he was artistic director. After a series of discussions held in different cities throughout 2001 and introduced by such titles as "Democracy Unrealized" (Vienna and Berlin), "Experiments with Truth: Transitional Justice and the Processes of Truth and Reconciliation" (New Delhi), "Creolité and Creolization" (St. Lucia), and "Under Siege: Four African Cities, Freetown, Johannesburg, Kinshasa, Lagos" (Lagos), the exhibition opened at Kassel, Germany, in 2002. Enwezor describes his project in a language inconceivable to Varnedoe:

> The collected result in the form of a series of volumes and exhibitions is placed at the dialectical intersection of contemporary art and culture. Such an intersection equally marks the limits out of which the postcolo-

nial, post-Cold War [sic], post-ideological, transnational, deterritorial-
ized, diasporic, global world has been written. This dialectical enterprise
attempts to establish imaginative and concrete links within the various
projects of modernity. Their impact, as well as their material and sym-
bolic ordering, is woven though procedures of translation, interpreta-
tion, subversion, hybridization, Creolization, displacement, and reas-
semblage. What emerges in this transformation in different parts of the
world produces a critical ordering of intellectual and artistic networks
of the globalizing world. The exhibition as a diagnostic toolbox actively
seeks to stage the relationships, conjunctions, and disjunctions between
different realities: between artists, institutions, disciplines, genres, gen-
erations, processes, forms, media, activities; between identity and sub-
jectification. Linked together the exhibition counterposes the supposed
purity and autonomy of the art object against a rethinking of modernity
based on ideas of transculturality and extraterritoriality. Thus, the ex-
hibition project of the fifth Platform is less a receptacle of commodity-
objects than a container for a plurality of voices, a material reflection on
a series of disparate and interconnected actions and processes.[31]

Seeking a middle path between these two contending forces—one a tiring
juggernaut, the other a swarming of attack vehicles—has become a common
pursuit. The 2005 exhibition Formalismus at the Hamburger Kunstverein
was conceived, in the words of Berlin critic Diedrich Diederichsen, as "a
reexamination of the basic ideas of modernism in the light of the very con-
temporary cognizance that every detail of presentation and production is
already contaminated by specific histories."[32] Grounding one set of values
these days usually means doing so in relation to the other sets. Diederichsen
understands the relationship between the two sides in the debate this way:

> Theoretical ambitions notwithstanding, the exhibition offered a so-
> phisticated overview of art today. The work provided an alternative to
> certain regressive and particularistic tendencies: on the one hand, the
> return to the normality of painting and spectacular images in keeping
> with the logic of the art market; on the other, the recourse to an art that
> is satisfied with constructing global networks of semi-politicized creative
> subcultures.[33]

From where he stands, both of these big answers—remodernist and
postcolonial—are reductive options, and each is as empty as the other. This

view is widely held today. To Diederichsen, as for others, the only way forward is between them, via "dialectical synthesis." This is neither good Hegelianism nor brave theory. A more complex sense of dialectical fury was a key to Enwezor's conception of Documenta 11. Indeed, he has since gone on to claim that postcoloniality is not confined to those countries that were subject to and subsequently freed themselves from the colonial yoke. The entire world today is, in his view, a "postcolonial constellation."[34] In chapter 9, I argued that this perspective is pivotal to grasping the conditions in which contemporary art is being made everywhere in the world today.

The third term that one might expect from a classic dialectic—the synthesis—has yet to take a clear shape in art world discourse. A pointer is a set of ideas advanced since 1997 by the then curator at Palais de Tokyo, Paris, Nicolas Bourriaud, under key terms such as "relational aesthetics" and "postproduction art."

> The possibility of a relational art (an art taking as its theoretical horizon the realm of human interactions and its social context, rather than the assertion of an independent and private symbolic space), points to a radical upheaval of the aesthetic, cultural and political goals introduced by modern art. . . . Every artist whose work stems from relational aesthetics has a world of forms, a set of problems and a trajectory which are all his own. They are not connected together by any style, theme, or iconography. What they do share together is much more decisive, to wit, the fact of operating within one and the same practical and theoretical horizon: the sphere of inter-human relations. Their works involve methods of social exchanges, interactivity with the viewer within the aesthetic experience being offered him/her, and the various communication processes, in their tangible dimension as tools serving to link individual groups together. So they are all working within a relational sphere, which is to today's art what mass production was to Pop Art and Minimal Art.[35]

The irreconcilability of these constructions—more than the force that each of them might claim in and of itself—calls for the identification of another narrative about modernism, one that underlies my approach, and increasingly that of many others. We can now see that avant-garde practices and various kinds of institutional modernisms, in all of their recently recovered complexity, did drive modern art in Europe from the 1850s to the 1960s. Its achievements and example did spread throughout much of the world through the processes of colonization. It was adopted in varying degrees in

most of the colonies—and was adapted and transformed in many of them. These changes amounted to a circuitry of exchange—massively unequal, provincialist to be sure, but the precipitation of change was not entirely one-way traffic. The "provinces" generated their own modernities, and they did so in varying degrees of awareness of their contemporaneousness with art being generated at the centers. This cosmopolitan trafficking, as Bernard Smith, among others, has shown, became international modern art.[36] By the 1950s, however, in the aftermath of World War II, with the breaking apart of the colonial system and the division of the world into numbered spheres, the conditions for making modern art began to change, then shifted seismically.

Contemporary art has inherited all of these changes—indeed, I would argue, it *is* all of these changes as they continue to play out *as art*. This is not to impose the priorities of secondary disciplines on those of art practice. *Most works of contemporary art, if they aspire beyond conformity or anachronism, are de facto suggestions as to what a work of contemporary art might be in circumstances such as these.* But they are, these days, different kinds of proposition, put forward within conditions that are qualitatively different from those that shaped the art of their modernist and even postmodernist predecessors. Some scholars, such as Alexander Alberro, recognize that contemporary art is the outcome of a different kind of period.[37] Others, such as curator Nicolas Bourriaud, continue to allocate the same phenomena to a continuing, if much altered, modernity. In his 2009 *Altermodern Manifesto*, Bourriaud proposes that this difference amounts to an "altermodernity," driven above all by "planetary negotiations" between agents from different cultures. Responsive artists, he suggests, seek highly mobile practices that employ polyglot modes of translation, and journey in open-ended ways through space and time, including history. This captures much of what I have been suggesting--although to deploy, however ironically, the manifesto format (a classically modernist move), and to highlight one quality, however internally complex, as being of the essence, risks the reduction of this profound, proliferative--indeed, paradigmatic--change to another "ism" in art's history. Nevertheless, the laudable aim is to bring into focus the way at least some artists are imagining what Bourriaud characterizes as "the modernity to come, the modernity appropriate to the twenty-first century."[38] I have been arguing that this art to come is already with us, and has been taking shape alongside other currents that continue to play out the conflicted inheritances of modernity. Thus my hypothesis, proposed in the introduction, that the conditions of contemporaneity manifest themselves

in art today in three broad currents within which some smaller scale tendencies may be discerned.

World Currents

A history of contemporary art worthy of the name should draw on efforts to date, yet be built on a framework that is distinct from that which underlay Modern Art, the art of modernity. It would recognize the inheritances, both positive and problematic, from earlier art—modernist, premodern, early modern, other than modern. It would treat art that originates from all over the world, in its local setting and in its international circulation—acknowledging that it is, perhaps for the first time, *the world's art* (not, that is, a universal art with local instances, nor local arts organized by colonization or globalization, but particular arts generated by the world's diversity). It would scrutinize current and recent art for what it shows of the ontology of the present. If it addresses these qualities, contemporary art history might become worthy of its object: contemporary art—art in, and of, contemporaneity. I have been attempting to lay the groundwork for such a history throughout this book. It is my answer to Foster's question: "Are there plausible ways to narrate the now myriad practices of contemporary art over the past twenty years?" This answer is also a response to Buchloh's question about how we might understand current social and institutional formations, after their modern, bourgeois history has reached its completion, as globalization goes into slow motion, and eventual meltdown.

We return to the hypothetical description of the conditions of contemporaneity and of the currents of contemporary art that have emerged within them that I proposed, in schematic fashion, in the introduction. I hope that it is clear that this proposal grew out of the experiences described in the preceding chapters, as a way of understanding what I take to be the fundamental forces shaping contemporary art whatever its manifestations: as artworks, exhibition sites, markets, studios, networks, actions, conversations . . . I repeat it, for the sake of recollection, will add some final comments, and then point to works by just two of the many contemporary artists who also reflect on these same questions.

The first major current in contemporary art, I have argued, amounts to the aesthetic of globalization, serving it through both a relentless remodernizing and a sporadic contemporizing of art. It has two discernable aspects, each of which is perhaps a style in the traditional sense of being a marked change in the continuing practice of art in some significant place

that emerges, takes a shape that attracts others to work within its terms and to elaborate them, prevails for a time, and seems to be coming to an end. One aspect is the embrace of the rewards and downsides of neoliberal economics, globalizing capital, and neoconservative politics, pursued during the 1980s and since through repeats of earlier-twentieth-century avant-garde strategies, yet lacking their political utopianism and their theoretic radicalism, above all by the yBas but also by Schnabel, Koons, and many others in the United States, as well as by Takashi Murakami and his followers in Japan, for example. This tendency—which I have labeled "Retro-sensationalism"—has burgeoned alongside another: the constant efforts of the institutions of modern art (now usually designated "Contemporary Art") to reign in the impacts of contemporaneity on art, to revive earlier initiatives, to cleave new art to the old modernist impulses and imperatives, to renovate them. The works of Richard Serra, Gerhard Richter, and Jeff Wall most powerfully exemplify this tendency. Reluctantly, in abhorrence of the limits of labels, but bowing to the inevitable, one might designate it "Re-modernism." In the work of certain artists, such as Matthew Barney and Cai Guo-Qiang, both currents come together in a conspicuous consummation, generating an aesthetic of excess that might be tagged the "Art of the Spectacle," or "Spectacularism." In contemporary architecture, similar impulses shape the buildings, especially those for the culture industry, designed by Frank Gehry, Santiago Calatrava, and Daniel Libeskind, among others.

How does art of this kind appear when we pose to it the question: What is contemporary art? It comes across as a late modern art that, half-aware that it is too easily in tune with the times, continues to pursue the key drivers of modernist art: reflexivity and avant-garde experimentality. In this sense, it is the latest phase in the universal history of art as such. Its bet is that art emergent within the other currents I have identified will fade into oblivion, and that it will persist as the art remembered by the future. Yet these hopes are tempered by the realization that, today, such values are being held against the grain of the present, with little hope that the times will change favorably, or that art can do much to effect desirable change. This contrasts greatly to their early-twentieth-century predecessors, whose critiques of the abuses of capitalism or of the iron cage of modernity were based on what seemed then to be possible, even plausible, utopias. Nostalgia for this failed project is widespread, spurring recurrent interest in moments when it seemed still viable, including the latest ones, the transitions towards the contemporary: thus, for example, the heartfelt recycling of Warhol's critical imagery of the early 1960s in the work of many current artists, notably Christian Marclay.

The second current emerges from the processes of decolonization within what were the second, third, and fourth worlds, including its impacts in what was the first world. It has not coalesced into an overall art movement, or two or three broad ones. Rather, the postcolonial turn has generated a plethora of art shaped by local, national, anticolonial, independent values (diversity, identity, critique). It has enormous international currency through travelers, expatriates, new markets but especially biennales. Local and internationalist values are in constant dialog in this current—sometimes they are enabling, at others disabling, but they are ubiquitous. With this situation as their raw material, artists such as Cildo Meireles, Jean-Michel Bruyère, Shirin Neshat, Isaac Julien, Georges Adéagbo, William Kentridge, and many others are producing work that matches the strongest art of the first current. Postcolonial critique, along with a rejection of spectacle capitalism, also informs the work of a number of artists based in the cultural centers. Mark Lombardi, Allan Sekula, Zoe Leonard, and others have developed practices that critically trace and strikingly display the global movements of the new world disorder between the advanced economies and those connected in multiple ways with them. Other artists base their practice around exploring sustainable relationships with specific environments, both social and natural, within the framework of ecological values. Still others work with electronic communicative media, examining its conceptual, social, and material structures: in the context of struggles between free, constrained, and commercial access to this media and its massive colonization by the entertainment industry, artists' responses have developed from net.art towards immersive environments and explorations of avatar-viuser interactivity.

What kind of answer do we get when we pose the question of the contemporary to the art of this current? To artists participant in the first phases of decolonization, those being asked for an art that would help forge an independent culture, a necessary step was to revive local traditional imagery and seek to make it contemporary by representing it through formats and styles that were current in Western modern art. To artists seeking to break the binds of cultural provincialism or of centralist ideologies, however, to be contemporary means to be able to make an art as experimental as that being made in the metropolitan centers. Geopolitical changes in the years around 1989 opened out a degree of access between societies closed for one and sometimes two generations. The work of unknown contemporaries became visible, and the vanquished art of an earlier avant-garde became suddenly pertinent to current practice. Frenzied knowledge exchange ensued, and hybrids of all kinds appeared. As we saw in the case of Cuba, the desire

soon arose to create and disseminate a contemporary art that, toughened by the experiences of postcoloniality, would "remake Western culture," and thus would be valid throughout the entire world. The postcolonial turn during the 1990s and first decade of the twenty-first century has led to the art of the second current becoming predominant on international art circuits, including those at the modern metropolitan centers. It is a paradigm shift in slow motion that matches the changing world geopolitical and economic order. From this perspective, contemporary art today is the art of the global south.

The third current that I have discerned is different in kind yet again, being the outcome, largely, of a generational change and the sheer quantity of young people attracted to active participation in the image economy. As art, it takes the form of quite personal, small scale and modest offerings, in marked contrast to the generality of statement and monumentality of scale that has increasingly come to characterize remodernizing, retro-sensationalist, and spectacular art, and the conflicted witnessing that continues to be the goal of most art consequent on the postcolonial turn. Younger artists certainly draw on elements of the first two tendencies, but with less and less regard for their fading power structures and styles of struggle, with more concern for the interactive potentialities of various material media, virtual communicative networks and open-ended modes of tangible connectivity. Working collectively, in small groups, in loose associations, or individually, these artists seek to arrest the immediate, to grasp the changing nature of time, place, media and mood today. They make visible our sense that these fundamental, familiar constituents of being are becoming, each day, steadily stranger. They raise questions as to the nature of temporality these days, the possibilities of place-making vis-à-vis dislocation, about what it is to be immersed in mediated interactivity and about the fraught exchanges between affect and effect. Within the world's turnings, and life's frictions, they seek sustainable flows of survival, cooperation and growth.

It follows from the mindset and the modes of practice of this generation of artists that they share no single answer to the question of what is contemporary art. Indeed, their radar of operations—their politics, in a word—is, for the most part, lower and more lateral yet also more networked than the global perspectives that exercise postcolonial artists and indifferent to the generalizations about art itself that remain important for the remodernists. Most of them abhor the superficialities of the spectacle, however much they know that it has permeated all of our lives. They begin from their experiences of living in the present, so that the question for them becomes less a

matter of what *is* contemporary art, more one of which kinds of art might be made now, and how might they be made with others close to hand.

We have seen that each of the three currents disseminates itself (not entirely, but predominantly) through appropriate—indeed, matching—institutional formats. Remodernism, retro-sensationalist, and spectacularist art are usually found in major public or dedicated private museums, prominent commercial galleries, the auction rooms of the "great houses," and the new celebrity collections, largely in the centers of economic power that drove modernity. Biennales, along with traveling exhibitions promoting the art of a country or region, have been an ideal venue for postcolonial critique. These have led to the emergence of a string of new, area-specific markets. The widespread art of contemporaneity appears rarely in such venues—although some of it doubtless will, as the institutions adapt for survival and certain artists make their accommodations—preferring alternative spaces, public temporary displays, the net, zines and other do-it-yourself-with-friends networks. There is, of course, no exclusive matching of tendency and disseminative format. Just as crossovers between what I am discerning here as currents are frequent at the level of art practice, connections between the formats abound, and artists have come to use them as gateways, more or less according to their potential and convenience. The museum, many artists will say today, is just one event site among the many that are now possible. But this mobility is recent, and has been hard won. While convergence certainly occurs, temporary alliance—the confluence of differences—is more common.[39]

The form of this description, its identification of three contending currents, might suggest that the classic logic of the dialectic is in operation. From this perspective, institutionalizing remodernism and retro-sensationalism would be the thesis, postcolonial multiplicity the antithesis, and remix, relational survivalism the synthesis. A further implication would be that the last will soon turn into a thesis, then attract an as yet unimaginable antithesis, and so on . . . the process will continue to unfold, the structure remain in place, the history of art will go forward in essentially the same way. My contention, in contrast, is that while these processes do seem to be identifiable to a degree, the overall shift into the conditions of contemporaneity is leaving behind the world in which they had their purchase. The synthesis will not occur. It is, instead, just one supplement among a number of others, a number that is potentially infinite. The three narratives that now compete in art world discourse are indeed signs of deeper changes in the practice of art. But they are not merely symptoms of what it is to make art in

13.2. Josiah McElheny, *An End to Modernity*, 2005. Chrome-plated aluminum, electric lighting, hand-blown glass, steel cable, and rigging. Commissioned by the Wexner Center for the Arts of the Ohio State University. (Courtesy of Donald Young Gallery, Chicago, and Andrea Rosen gallery, New York. Photograph by Kevin Fitzsimmons.)

the conditions of contemporaneity. Rather, my contention is that the three currents that I have outlined are the *actual* kinds of art that these conditions have generated. The currents are tied to each other, uncomfortably but of necessity. They are changeable contraries that are only partially synthesizable into each other, contradictions that are highly generative but only as supplements of their mismatching. Like so much else in contemporary conditions, they are, at once, irreconcilable and indissociable.[40] Their friction in relation to each other is of their essence. They are, in a word, *antinomies*—like all other relationships characteristic of these times. This is how art today is answering the question of its contemporaneity.

American artist Josiah McElheny's *An End to Modernity* (2005) is a glass and metal hanging sculpture, 12 feet high and 16 feet in diameter, a virtuoso demonstration of the artist's highly developed skills as a glassblower.[41] Based on chandeliers at the Metropolitan Opera, New York (themselves with precedents in early-twentieth-century Austrian design—those of J. & L. Lobmeyr of Vienna), it pays homage to historical modern glass making. It enjoins

13.3. Josephine Meckseper, *The Complete History of Postcontemporary Art*, 2005. Mixed media. (© 2008 ARS, NY / VG Bild-Kunst, Bonn.)

13.4. Josephine Meckseper, "Untitled (Demonstration, Berlin)," 2001. Color photograph. (© 2008 ARS, NY / VG Bild-Kunst, Bonn.)

us to enjoy this old-fashioned modernism, and to do so in a very personal, indeed romantic, way: at its core is a disco-like mirror ball, in which each spectator can see a reflection of him or her self. Yet its specific forms are a direct illustration of the big bang theory of the origins of the universe, based on consultation with physicists. Thus it parodies its own title: visually, it makes the paradoxical, impossible claim that modernity was there at the beginning and will keep on expanding to the end. In a light-hearted yet quite spectacular way, McElheny's sculpture expresses the hope for the perpetuation of modern culture that still animates remodernizing contemporary art.

Working in both Berlin and New York, Josephine Meckseper showed her installation *The Complete History of Postcontemporary Art* (2005) at the 2006 Whitney Biennial; it is now in the Saatchi Collection, London.[42] This is a shop window display of easily recognizable, everyday objects—contemporary but ordinary commodities. Yet we are also invited to see them as if we are looking from the future, from a time after the triumph of capitalism, so that this display looks like those shops in East Germany, when they were suddenly exposed, after 1989, as instantly anachronistic. She symbolizes the confusion over the 2005 vote against the European Union constitution by including a rabbit that holds a flag with "Oui" and "Non" on either face, and which spins. Famous works of contemporary art are wittily referenced by each of the objects; her implication is that the reputations and the relevance of artists such as Joseph Beuys and Jeff Koons will fade just as quickly: even capitalist art is subject to entropy. Her larger argument is stronger even than this. Meckseper always shows her vitrines alongside sets of her photographs of antiglobalization demonstrations in Berlin, Washington, and elsewhere. She clearly favors this contestatory perspective, but recognizes that its imagery—and art that simply serves it—is also losing its power, its purchase on a critical contemporaneity. A different imagery is needed. It is just becoming visible to us.

Notes

INTRODUCTION

1. Hal Foster, quoted in Gillian Whiteley, and Peter Muir, "Surveying Art since 1900: Gillian Whiteley Talks to Yve-Alain Bois, Hal Foster and Rosalind Krauss," *The Art Book*, 12, no. 4 (November 2005): 18. The remark was made during an interview concerning the textbook that Foster coauthored with Rosalind Krauss, Yve-Alain Bois, and Benjamin H. D. Buchloh, *Art Since 1900: Modernism, Anti-Modernism, Postmodernism* (London: Thames & Hudson, 2005). He was speaking as a historian, and was contrasting recent, relatively successful studies of the "internationalism of modernism" to the challenges of doing the same for contemporary art. His career as a critic has been distinguished by his willingness to write essays that seek to position major currents in contemporary art as they unfold. See, for example, "The Artist as Ethnographer," in *The Return of the Real* (Cambridge, MA: MIT Press, 1996), 171–204; and "An Archival Impulse," *October* 110 (Fall 2004): 3–22.
2. Damien Hirst, *I Want to Spend the Rest of My Life Everywhere, with Everyone, One to One, Always, Forever, Now*, 2nd ed. (London: Booth-Clibborn; New York, Monacelli Press, 2006). This title is taken from a 1991 work by Hirst that—in its deployment of propped sheets of glass and a ping pong ball suspended in the air over a gas spigot—parodies both minimal sculpture and his predecessor Jeff Koons's 1985 *Equilibrium Tanks* series of works in which basketballs are suspended within distilled water inside Perspex boxes.
3. On this question, see W. J. T. Mitchell, *What Do Pictures Want? The Lives and Loves of Images* (Chicago: University of Chicago Press, 2005).
4. See Terry Smith, "Creating Value Between Cultures: Contemporary Aboriginal Art," in *Beyond Price: Values and Valuing in Art and Culture*, ed. Michael Hütter and David Throsby (Cambridge: Cambridge University Press, 2008), 23–40.
5. See, for example, Samuel P. Huntington, *The Clash of Civilizations and the Remaking of the World Order* (New York: Simon & Schuster, 1996); and Thomas Friedman, *The World is Flat: A Brief History of the Twenty-First Century* (New York: Farrar, Straus & Giroux, 2005).
6. This string of terms evokes the analyses advanced in, respectively, Arjun Appardurai, *Modernity at Large: Cultural Dimensions of Globalization* (Minneapolis: University of Min-

nesota Press, 1996); Guy Debord, *The Society of the Spectacle* (Detroit, MI: Black and Red, 1977); Terry Smith, introduction to *The Architecture of Aftermath* (Chicago: University of Chicago Press, 2006); and Jacques Rancière, *The Politics of Aesthetics* (London: Continuum, 2004).

7. For a broader treatment of these questions from a variety of viewpoints, see Terry Smith, Okwui Enwezor, and Nancy Condee, eds., *Antinomies of Art and Culture: Modernity, Postmodernity, Contemporaneity* (Durham, NC: Duke University Press, 2008).

8. In 2001, when I first posed this question in this way (see the preface), I was encouraged by the heuristic boldness exhibited, so characteristically, by George Steiner in his inaugural lecture "What is Comparative Literature?" at the University of Oxford on October 11, 1994 (Oxford: Clarendon Press, 1995). For my first formulations, see Terry Smith, *What is Contemporary Art? Contemporary Art, Contemporaneity and Art to Come* (Sydney: Artspace Critical Issues Series, 2001).

CHAPTER 1

1. See Terence Riley, *Yoshio Taniguchi: Nine Museums* (New York: MoMA, 2004); and Glenn D. Lowry, *The New Museum of Modern Art* (New York: MoMA, 2005).

2. Nicolai Ouroussoff, "Art Fuses With Urbanity in a Redesign of the Modern," *New York Times*, November 15, 2004. An equally nuanced response is Hal Foster, "It's Modern but Is It Contemporary?" *London Review of Books* 26, no. 24, December 16, 2004, 23–25.

3. This comparison evokes the recollection that the first museum of modern art in New York was the Gallery of Living Art, established by Albert Eugen Gallatin at New York University in December 1927, two years before MoMA. The name of the gallery clearly reflects the example of the Musée des Artistes Vivants, established in the Luxembourg Museum, Paris, in 1818. Gallatin's collection, which emphasized the Parisian avantgarde and included such key works as Picasso's *Three Musicians* (1921) and Fernand Léger's *The City* (1919), was shown in a reading room in a building on Washington Square with the expectation that the university would eventually create a gallery. Its failure to do so led Gallatin to donate the collection to Philadelphia.

4. See Julian Stallabrass, *High Art Lite: British Art in the 1990s*, 2nd ed. (London: Verso, 2001); and Stallabrass, *Art Incorporated: The Story of Contemporary Art* (Oxford: Oxford University Press, 2004).

5. Arthur C. Danto, *After the End of Art; Contemporary Art and the Pale of History* (Princeton, NJ: Princeton University Press, 1997), 10.

6. Kirk Varnedoe, *Modern Contemporary: Art at MoMA since 1980* (New York: MoMA, 2000), 12.

7. John Elderfield, *Modern Painting and Sculpture: 1880 to the Present* (New York: MoMA, 2004), 12.

8. John Elderfield, quoted in "New York Arts Report," Public Broadcasting Service, Channel 13, New York, November 27, 2003.

9. Michael Kimmelman, "Racing to Keep Up with the Newest," *New York Times*, November 19, 2004.

10. Quoted in John B. Hightower, foreword to *Four Americans in Paris, The Collections of Gertrude Stein and Her Family* (New York: MoMA, 1970), 8. Hightower's implication is that Stein made the remark to his predecessor, Alfred H. Barr Jr.

11. In Prague in 1796, the Society of Patriotic Friends of the Arts set up a Picture Gallery of living artists, open to the public. These Friends were Bohemian noblemen whose high cultural aspirations had been suddenly isolated by Emperor Joseph II's centralization of imperial administration in Vienna. While required to move their households to that city, they did not wish to give up support of local artists. See Nadezda Blazicková-Horová, ed., *19th-Century Art, Guide to the Collections of the National Gallery in Prague* (Prague: National Gallery, 2002), 7. These kinds of developments require further research.

12. The most thorough discussion of this topic to date, encompassing museums in Europe, the United States, and elsewhere, is J. Pedro Lorente, *Cathedrals of Urban Modernity, The First Museums of Contemporary Art, 1800–1930* (Aldershot, UK: Ashgate, 1998). More generally, see Tony Bennett, *The Birth of the Museum* (London: Routledge, 1995), especially chapter 6; as well as his important chapter "The Exhibitionary Complex," in *Thinking About Exhibitions*, ed. Reesa Greenberg, Bruce W. Ferguson and Sandy Nairne (London: Routledge, 1996), 81–112. A popular account of these changes is Robert Hughes in his *The Shock of the New: The Hundred-Year History of Modern Art Its Rise, Its Dazzling Achievement, It's Fall* (New York: Knopf, 1981), which drew extensively on Ian Dunlop, *The Shock of the New* (New York: American Heritage Press, 1972). The most relevant specific study is Mary Anne Staniszewski, *The Power of Display: A History of Exhibition Installations at the Museum of Modern Art* (Cambridge, MA: MIT Press, 1998).

13. Paper to Trustees, 1933, cited in Alfred H. Barr, *Painting and Sculpture in the Museum of Modern Art* (New York: MoMA, 1967), 623.

14. Alfred H. Barr Jr., "An Effort to Secure $3,250,000 for the Museum of Modern Art," official statement, April 1931 (MoMA library archives, New York) (original emphasis).

15. Angelica Zander Rudenstine, "The Institutionalization of the Modern—Some Historical Observations," in *Post-Modern or Contemporary?* Conference proceedings, International Committee of ICOM for Museums and Collections of Modern Art (Düsseldorf, June 25–30, 1981), 48.

16. It was during this period that the museum attracted trenchant criticism for reducing the experience of its audiences and its systemic antipathy to the art of the present. See, for example, Carol Duncan and Alan Wallach, "The Museum of Modern Art as Late Capitalist Ritual: An Iconographic Analysis," *Marxist Perspectives* 1 (1978): 28–51.

17. A wider range of the artist's work may be found in Raphaela Platow, *Dana Schutz: Paintings 2002–2005* (Waltham, MA: Rose Art Museum, 2006).

18. Perhaps more space will help the museum to think about these problems in fresh ways. Early in 2007 it sold the adjacent lot to Hines, an international real estate developer, for $125 million. It will gain forty thousand square feet of additional space in the seventy-five story residential tower being designed by French architect Jean Nouvel. While Nouvel's torqued steel frames may add to the Manhattan skyline a profile as striking as its famous predecessors, it is unclear how MoMA might rework the limitations of

Taniguchi's design by shifting its display functions sideways. See Nicolai Ouroussoff, "Next to MoMA, Reaching for the Stars," *New York Times*, November 15, 2007. This project was deferred late in 2008 due to the economic downturn.

19. Michael Kimmelman, "Power, Injustice, Death, Loss: At Sea in the Here and Now," *New York Times*, September 1, 2006.

20. Glenn D. Lowry, introduction to *MoMA Highlights since 1980* (New York: MoMA, 2007), 16.

21. Ibid., 15.

22. A rare reference to postmodernism may be found in the concluding chapter of Robert Storr, *Modern Art Despite Modernism* (New York: MoMA, 2002), a book and exhibition devoted to alternative and anti-modernist trends in twentieth-century art.

23. On the many kinds of postmodernist historicism, see Charles Jencks, *The Language of Post-Modern Architecture*, 6th ed. (New York: Rizzoli, 1991).

24. Lowry, introduction to *MoMA Highlights since 1980*, 19.

CHAPTER 2

1. Michael Kimmelman, "The Dia Generation," *New York Times Magazine*, April 6, 2003, 30–37, 58, 61, 72, 76–77.

2. See Calvin Tomkins, "The Mission: How the Dia Art Foundation Survived Feuds, Legal Crises, and Its Own Ambitions," *New Yorker*, May 19, 2003, 46–47. On earlier phases of the Dia Foundation, see Bob Colacello, "Remains of the Dia," *Vanity Fair*, September 1996, http://www.vanityfair.com/magazine/archive/1996/09/colace110110199609.

3. See Nicholas Baume, *From Christo & Jean-Claude to Jeff Koons: John Kaldor Art Projects and Collection* (Sydney: Museum of Contemporary Art, 1995); and Adam Free, *Journey to Now: John Kaldor Art Projects and Collection* (Adelaide: Art Gallery of South Australia, 2003).

4. See Nicholas Serota, *Interpretation or Experience: The Dilemma of Museums of Modern Art* (London: Thames & Hudson, 1996), 42–50.

5. For details of Dia's operations and costs, see Tomkins, "The Mission," 46–53, and Kimmelman, "Racing to Keep Up with the Newest."

6. Hal Foster, "At Dia:Beacon," *London Review of Books* 25, no. 11, June 5, 2003, 29, http://www.lrb.co.uk/v25/n11/fost01_.html.

7. Tomkins, "The Mission," 47.

8. Quoted in ibid., 46. Portentousness, however, can collapse into pretentiousness with alarming ease. In October 2003, Serra showed major new work at the Gagosian Gallery, New York. Massive steel sheets were cut with curves that not only evoked the bodies of ships, they seemed ready to slide out across the concrete floors. His 2006 exhibition at the same venue was more precisely calibrated to its spaces.

9. Wilhelm Heinrich Wackenroder and Ludwig Tieck, *Herzensergießungen eines kunstliebenden Klosterbruders*, cited in Detleff Hoffman, "The German Art Museum and the History of the Nation," in *Museum Culture: Histories, Discourses, Spectacles*, ed. Daniel J. Sherman and Irit Rogoff (Minneapolis: University of Minnesota Press, 1994), 6.

10. For a close study of the spiritualism at the core of the Dia project, and the spiritualisms that attended much art practice during the period, including that of many Minimal artists, see Anna C. Chave, "Revaluing Minimalism: Patronage, Aura, and Place," *Art Bulletin* XC, no. 3 (September 2008): 466–86.

11. "Sandy Nairne," in *Contemporary Cultures of Display,* ed. Emma Barker (New Haven, CT: Yale University Press; London: The Open University, 1999), 107. In its rush to banish memories of the state control of the arts in the name of the people during the Nazi period, documenta I, II, III also rejected—indeed, excluded—the possibility that art of any conceivable interest could be made in Communist East Germany.

12. Foster, "At Dia:Beacon,"29.

13. Peter Schjeldahl amusingly divides art museums into these categories: "encyclopedia," "house," "civic," "boutique," "pavilion," "laboratory," and "destination," citing contemporary examples of the last four. See his "Art Houses," *New Yorker,* January 13, 2003, 87–89.

14. Foster, "At Dia:Beacon,"29.

CHAPTER 3

1. See Rita Hatton and John A. Walker, *Supercollector: A Critique of Charles Saatchi* (London: Ellipsis, 2000), 122–28. For a more generous view of Saatchi's activity during this time, see Richard Cork, "The Saatchi Gallery Opens," *The Listener,* March 23, 1985, reprinted in Richard Cork, *New Spirit, New Sculpture, New Money: Art in the 1980s* (New Haven, CT, and London: Yale University Press, 2003), 316–18.

2. Charles Saatchi, "A Private View," cited in Sarah Kent and Cathy Runciman, eds., "The Saatchi Gallery," *Time Out London* (special supplement), September 2003, 8.

3. Sarah Kent, "Location, Sensation, Relocation," in "The Saatchi Gallery," *Time Out London* (special supplement), September 2003, 4.

4. Sarah Kent, "Damien Hirst," in "The Saatchi Gallery," *Time Out London* (special supplement), September 2003, 9.

5. Both remarks from Charles Saatchi, "Introduction," *100: The Work That Changed British Art* (London: Cape / The Saatchi Gallery, 2003), 11.

6. Mignon Nixon, Alex Potts, Briony Fer, Anthony Hudek, and Julian Stallabrass, "Round Table: Tate Modern," *October* 98 (Fall 2001): 25.

7. Rita Hatton's reaction—"Where am I, whose house is this, am I at Hampton Court, a museum, or a gallery?"—is not untypical of experienced art world observers. See her "Letter from London: What Has Charles Saatchi Got in His Satchel?" *Art Monthly Australia* 162 (August 2003): 10–11.

8. Alison M. Gingeras, ed., *"Where are we going?" Selections from the François Pinault Collection* (Milan: Skira, 2006). Skira describes the book as: "Published on the occasion of the inaugural exhibition at Palazzo Grassi, this spectacular catalogue demonstrates François Pinault's singular engagement with some of the most influential and challenging artists of our times."

1. Cited in Frances Spalding, *The Tate, A History* (London: Tate Gallery Publishing, 1998), 286.

2. The project was funded by £50 million through the Millennium Commission from lottery funds, £12 million from the national government's urban regeneration agency the English Partnership, and £6.2 million from the Arts Council. The planning and funding background to the Tate Gallery of Modern Art, as it was known right up until just before its opening, is outlined in Spalding, *The Tate, A History*. See also the Channel 4 television series on the unfolding project, and the related book by the same name, *Power Into Art* (London: Channel 4, 2000); and Emma Barker, "The Museum in the Community: The New Tates," in *Contemporary Cultures of Display*, ed. Emma Barker (New Haven, CT: Yale University Press; London, The Open University, 1999), 178–99. On the earlier history of the Tate, see Brandon Taylor, "From Penitentiary to 'Temple of Art': Early Metaphors of Improvement at the Millbank Tate," in *Art Apart: Art Institutions and Ideology Across England and North America*, ed. Marcia Pointon (Manchester: Manchester University Press, 1994), 1–32; and J. Pedro Lorente, *Cathedrals of Urban Modernity, The First Museums of Contemporary Art, 1800–1930* (Aldershot, UK: Ashgate, 1998), especially chapter 3.

3. Spalding, *The Tate, A History*, 266.

4. Richard Cork, "The Need for Change at the Tate," *The Listener*, December 17, 1987, reprinted in Richard Cork, *New Spirit, New Sculpture, New Money: Art in the 1980s* (New Haven, CT, and London: Yale University Press, 2003), 334. See also Spalding, *The Tate, A History*, 284–50.

5. Figures from, respectively, the Millennium Commission report on projects funded in 2000 (http://www.millennium.gov.uk), and Louise Jury, "Culture: Tate unveiled as the world's most popular gallery for modern art," *The Independent* (London), May 12, 2001. Jury cites comparative figures for the year 2000–1: visitors to the Musée National d'Art Moderne at the Pompidou Center, Paris numbered 1.7 million; at MoMA, New York, 1.2 million; at the Guggenheim, New York, and Guggenheim, Bilbao, 900,000 each.

6. On the journeys of curators such as Harald Szeeman and Rudi Fuchs from the conceptualist moment to the "ahistorical" present, see the brilliant discussion in Jean-Marc Poinsot, "Large Exhibitions: A Sketch of a Typology," in *Thinking About Exhibitions*, ed. Reesa Greenberg, Bruce W. Ferguson, and Sandy Nairne (London: Routledge, 1996), 39–66. Key exhibitions include Harald Szeemann, *Documenta VII* (Kassel, 1982), *Der Hang zum Gesamtkunstwerk: europäische Utopien seit 1800* (Kunsthaus, Zurich, then Düsseldorf, Vienna, and Berlin, 1983); Kaspar Koenig, *Westkunst: Zeitgenössische Kunst seit 1939* (Cologne, Rheinhallen, 1981); Christos Joacomides, Norman Rosenthal, and Nicholas Serota, *A New Spirit in Painting* (Royal Academy, London, 1981); Achille Bonito Oliva, *Avanguardia, transavanguardia* (Mura Aureliane, Rome, 1982); Christos Joachimides, *Zeitgeist: International Kunstaustellung* (Martin Gropius Bau, Berlin, 1982); and Norman Rosenthal, *German Art in the 20th Century* (Royal Academy, London, 1985). See also Debora J. Meijers, "The Museum and the 'Ahistorical' Exhibition: The Latest Gimmick by the Arbiters of Taste, or an Important Cultural Phenomenon?" in Greenberg,

Ferguson and Nairne, *Thinking About Exhibitions*, 7–20; and Hans-Joachim Müller, *Harald Szeemann: Exhibition Maker* (Ostfildern-Ruit: Hatje Cantz Verlag, 2006).

7. This topic is explored by Victoria Newhouse, *Art and the Power of Placement* (New York: Monacelli Press, 2005), especially the concluding sections.

8. Nicholas Serota, *Experience or Interpretation: The Dilemma of Museums of Modern Art* (London: Thames & Hudson, 1996), 55. Curators' decisions of course remain crucial to how these museums are experienced. As do those of collectors, such as Count Guiseppe Panza di Biumo, in the arrangement of his museum of conceptual and installation art at Varese, Italy, which places a premium on the patron realizing the artist's intentions with the artist's permission but not necessarily direct involvement, as well as the more common visit by the artist to create a site-specific work.

9. Serota, *Experience or Interpretation*, 39–42, 50–55.

10. Jean-Christophe Amann, "From the Perspective of My Mind's Eye: On the Occasion of the Opening of the Museum of Modern Art, Frankfort," in *Museum für Moderne Kunst und Sammlung Ströher*, ed. Jean-Christophe Amann and Christmut Präger (Frankfurt: Museum für Moderne Kunst, 1991), 49.

11. See Han Hollein, "To Exhibit, to Place, to Deposit: Thoughts on the Museum of Modern Art, Frankfort," in *New Museology*, ed. Andreas C. Papadakis (London: Academy Editions, 1991), 73–81.

12. A point made emphatically by Okwui Enwezor, "The Postcolonial Constellation," chapter 11 in *Antinomies of Art and Culture: Modernity, Postmodernity and Contemporaneity*, ed. Terry Smith, Okwui Enwezor, and Nancy Condee (Durham, NC: Duke University Press, 2008). Marlene Dumas was born in South Africa, and has been living and working in Holland since her student days. André Gide reports on his visit in *Voyage au Congo* (Paris: Librairie Gallimard, 1927).

13. A detailed critical examination, by a group of artists, critics and art historians, of the display logics and curatorial strategies of the opening exhibitions may be found in the "Round Table: Tate Modern," *October* 98 (Fall 2001): 3–25.

14. See Iwona Blaswick and Simon Wilson, eds., *Tate Modern: The Handbook*, rev. ed. (London: Tate Modern Publishing, 2001).

15. Titles and quotations are from Tate Modern publicity and online material. See http://www.tate.org.uk/modern/.

16. All figures and quotations in these paragraphs are from http://www.tate.org.uk/modern/transformingtm/.

CHAPTER 5

1. Quoted in Coosje van Bruggen, *Frank O. Gehry: Guggenheim Museum Bilbao* (New York: Solomon R. Guggenheim Foundation, 1997), 115. The issue of whether Gehry is an artist—indeed, our "Greatest Living Artist"—is a matter much disputed, most trenchantly by Hal Foster in his *Design and Crime (and Other Diatribes)* (London: Verso, 2002), 32–40. In the broader culture, there are few doubts. In 2005, Tiffany & Co. introduced the Frank Gehry Collection, a line of women's jewelry that employed some of his signa-

ture shapes as earrings, bracelets, brooches, and so forth. The slogan? Gehry's signature, followed by "BEAUTY WITHOUT RULES." In chapter 1 of *The Architecture of Aftermath* (Chicago: University of Chicago Press, 2006) I explore the role of this museum in the image economy (the "iconomy"), and in the actual economy of the region, as well as offer an assessment of it as architecture relative to other cultural structures.

2. Quoted in Van Bruggen, *Frank O. Gehry*, 119.

3. Rosalind Krauss, "The Cultural Logic of the Late Capitalist Museum," *October* 54 (Fall 1990): 3–17. Krauss acknowledges her debt—as do all of us who address these topics—to Fredric Jameson's epochal article "Postmodernism, or The Cultural Logic of Late Capitalism," *New Left Review* 146 (July–August 1984): 53–93.

4. Krauss, "The Cultural Logic of the Late Capitalist Museum," 4.

5. Ibid., 7.

6. Carl Andre, quoted in David Bourdon, "The Razed Sites of Carl Andre," *Artforum* 5, no. 2 (October 1966): 15.

7. Gehry was prominent among those architects who came together for the Deconstructivist Architecture exhibition curated by Phillip Johnson and Mark Wigley at the Museum of Modern Art in 1988. As Anthony Vidler has observed, the main impulse of these architects was to distinguish their work from then-fashionable postmodernist architecture, particularly its signature reliance on historical pastiche— See Anthony Vidler, "Deconstruction Boom," *Artforum* XLII, no. 4 (December 2003): 33. Robert Venturi and Charles Moore were perhaps the best exponents of what was regarded by the others as having become too quickly a superficial, historicist, developer-dominated style. For an exploration of the relationships between modern architecture and philosophical deconstruction, see Mark Wigley, *The Architecture of Deconstruction, Derrida's Haunt* (Cambridge, MA: MIT Press, 1993).

8. Quoted in Van Bruggen, *Frank O. Gehry*, 115.

9. These sketches are copiously illustrated throughout Van Bruggen, *Frank O. Gehry*.

10. Van Bruggen, *Frank O. Gehry*, 66.

11. Ibid.

12. Victoria Newhouse, *Towards a New Museum* (New York: Monacelli Press, 1998), 254–56. On Gehry's use of CATIA and related technologies, see Bruce Lindsay, *Digital Gehry: Material Resistance, Digital Construction* (Basel, Switzerland, and Boston: Birkhäuser, 2001).

13. Locals have recognized these shortfalls. Hard by this huge tower is a modest monument to a local poet, who is shown realistically, in life size, walking along the riverfront, cigarette in hand, declaiming—all of which is framed and linked to the towering Gehry-form by a flat iron slab cutout so the figure may be seen.

14. Philip Jodidio, ed., *Connaissance des Arts, Guggenheim Bilbao*, special issue (Paris: 2000): 34.

15. See, for example, Dinah Dysart, "Guggenheim Bilbao," *Art and Australia*, 36, no. 3 (1999): 342–43.

16. Newhouse, *Towards a New Museum*, 259.

17. Ian Ritchie, "An Architect's View of Recent Developments in European Museums," in

Towards the Museum of the Future, New European Perspectives, ed. Roger Miles and Lauro Zavala (London: Routledge, 1994), 7–30.

18. It is worth noting, for the record, that whereas Gehry, as we have seen, has worked assiduously to meld sculptural inventiveness into his architectural form-thinking, Serra insists that these arts are irreducibly separate. A remarkable instance was Serra's assertion, on the television show "Charlie Rose," that "I draw better in my sculptures than Frank does in his architecture." (Public Broadcasting Service, December 14, 2001, http://www.charlierose.com/view/interview/2777) The tendency of my argument is that, in making these remarks, Serra was insisting on a distinction that, while it reflects his recursive attitudes as to the basic differences between the arts, is denied in the spectacularization of his own art.

19. Quoted in Newhouse, *Towards A New Museum*, 254.

20. Wouter Davidts, "Art Factories: Museums of Contemporary Art and the Promise of Artistic Production, from Centre Pompidou to Tate Modern," *Fabrications* 16, no. 1 (June 2006): 30. Davidts's book, *Bouwen voor de Kunst? Museumarchitectuur van Centre Pompidou tot Tate Modern* (Ghent: A&S/books, 2006), is a brilliant treatment of these tendencies.

21. See Carmen Giménez, Hal Foster, and Richard Serra, *Richard Serra: The Matter of Time* (Göttingen: Steidl, 2005), and Hal Foster, "On 'The Matter of Time,' Interview with Sculptor Richard Serra," *Artforum* XLIV, no. 1 (September 2005): 270–75.

22. Quoted in Margaret King, "Theme Park Thesis," *Museum News* (September/October 1990): 60–62.

23. Quoted in Patricia Leigh Brown, "Art and History Clash on City's Sacred Ground," *New York Times*, March 30, 2008. Schwartzman was commenting on plans by Gap clothing retailer Don Fisher to house his contemporary art collection in a Richard Gluckman–designed building in the Presidio district of San Francisco.

24. See the chapter by Lynne Cooke, "Deliberating on the Role of the Foundation as Art Institution in North America: Dinosaur or Desideratum?" in *Foundations of Philanthropy: Private Support for Contemporary Art*, ed. Terry Smith (Sydney: University of New South Wales Press for the Sherman Foundation, 2007), 47–55. Chapters by David Elliott (36–45), Rupert Meyer (56–71), and Gene Sherman (72–83) explore other examples. Collector Dasha Zhukova, girlfriend of billionaire Roman Abramovich, is funding the establishment and programming of the Center for Contemporary Art Moscow in a 1927 bus depot designed by Constructivist architect Konstantin Melnikov. It opened in September 2008 with a large-scale survey retrospective of the installations of Ilya Kabakov, who returned after a twenty-year exile. The dangers inherent in this model are apparent in the changing financial priorities of the Ullens Center for Contemporary Art. Six months after its early 2008 launch, Belgian philanthropist Guy Ullens brought forward the break-even date for the $6 million per annum operation from 2013 to 2010. See Chris Gill, "What Is Going on at the Ullens Center in Beijing?" *The Art Newspaper* 192 (June 2008): 12.

25. See http://www.schaulager.org/en/index.php?pfad=schaulager/konzept.

26. See Edward Wyatt, "To Have and Give Not," *New York Times*, February 10, 2008; Martin

Filler, "Broad-Minded Museum," *New York Review of Books*, March 20, 2008; and Stephanie Strom, "To Keep or Donate: Foundations Wrestle With the Question," *New York Times*, March 12, 2008, http://www.nytimes.com/2008/03/12/arts/artsspecial/12donors.html.

27. Frank Gehry, cited in Anna Carver, "Guggenheim sells Bilbao effect to Abu Dhabi," *The Art Newspaper* 178 (March 2007): 32.

28. Nicolai Ouroussoff, "City on the Gulf: Koolhaas Lays Out a Grand Urban Experiment in Dubai," *New York Times*, March 2, 2008, http://www.nytimes.com/2008/03/03/arts/design/03kool.html. See also C.J. Hughes, "Is the Dubai Bubble Starting to Burst?" *Architectural Record*, November 20, 2008, http://archrecord.construction.com/news/daily/archives/081120dubai.asp.

29. See, for example, Hans Haacke, "Museums, Managers of Consciousness," in *Art Museums and Big Business*, ed. Ian North (Sydney: Art Museums of Australia, 1984); Fred Wilson, *Mining the Museum: An Installation*, ed. Lisa G. Corrin (Baltimore: Norton, 1994) and Andrea Fraser, *Museum Highlights: The Writings of Andrea Fraser*, ed. Alexander Alberro (Cambridge, MA: MIT Press, 2005).

30. See Andrea Fraser, *Little Frank and His Carp*, 6 min. DVD NTSC, Friedrich Petzel Gallery, New York, 2001. Her 2003 text, "Isn't This a Wonderful Place? (A Tour of a Tour of the Guggenheim Museum, Bilbao)," is reprinted in Fraser, *Museum Highlights*, 233–60, and in Ivan Karp, Corrine A. Kratz, Lynn Szwaja, and Tomás Ybarra-Frausto, *Museum Frictions: Public Culture/Global Transformations* (Durham, NC: Duke University Press, 2006).

31. Nicolas Bourriaud, *Postproduction* (New York: Lukas & Sternberg, 2002), 65.

32. For an amusingly self-deprecating presentation of a similar perspective see Paul Werner, *Museum Inc.: Inside the Global Art World* (Chicago: Prickly Paradigm Press, 2005).

CHAPTER 6

1. Michael Kimmelman, "Free to Play and Be Gooey," *New York Times*, February 21, 2003. This updates the critic's earlier estimate of Barney as "the most important American artist of his generation." (A comment that itself echoes a famous *Time* magazine headline about Jackson Pollock: "Is This the Greatest Living American Artist?"—a sentence that US art critics dream of being able to write, again. As we have seen, Kimmelman gave himself that license when he visited Dia:Beacon: "The Dia Generation," *New York Times Magazine*, April 6, 2003, 30–37, 58, 61, 72, 76–77). Now, Kimmelman sees Barney as the "most compelling, richly imaginative artist to emerge in years," as embodying the hope for art globally. And as competing with Frank Gehry for the title of the Greatest Living Contemporary Artist.

2. Tim Griffin, "Matthew Barney: The *Cremaster* Cycle," *Artforum* (May 2003): 162. On November 2003, the museum announced that it was purchasing Barney's *Chrysler Imperial*, the major sculptural work in the exhibition, splitting the estimated $1 million cost with an anonymous European collector who is a member of its International Council. (See Carol Vogel, "Acquiring Art Inventively," *New York Times*, November 21, 2003).

3. As they indeed were, metaphorically, when in 2000–1, the museum presented its over-promoted and undercurated Giorgio Armani exhibition, coincidentally with a $15 million donation from the designer himself. See Eleanor Hartney, "The Guggenheim's New Clothes," *Art in America*, February 2001, 61–63. See also Roberta Smith, "Memo to Art Museums: Don't Give Up on Art," *New York Times*, December 3, 2000. Menswear retailer Hugo Boss and Delta Air Lines sponsored the *Cremaster* cycle exhibition. The estimated cost of Barney projects and exhibitions to date is $80 million.

4. Kimmelman on the response to the *Cremaster* exhibitions of 2002 in Cologne and Paris, "Free to Play and Be Gooey," *New York Times*, February 21, 2003. Roberta Smith reacts to this reaction in her comment: "But perhaps Barney has redefined the visual artist as movie director/rock star/stuntman/set designer and become a middlebrow emblem of artistic difficulty, seriousness and ego whose popularity renders critical opinion mostly moot" ("Matthew Barney: The *Cremaster* Cycle," *Artforum*, May 2003, 193). On McQueen, see former *Artforum* editor Ingrid Sichy, "Alexander the Great," *New York Times Magazine*, February 23, 2003, 64, in which she gushes: "McQueen is a show-man, and he has very high expectations for fashion. He knows how to cut a dress, a jacket, and a pair of pants with the best of them, but that's not enough for him. He also wants fashion to have weight and content and depth, so he puts on presentations—spectacles, really—of his collections that aim to have the punch of art and that are sometimes political, sociological, shocking, and scary. Some of this content carries over into the clothes themselves, either literally or in their aura. But in general their distinguishing features are beauty; a sense of craft; a strong, confident silhouette; and the marriage of tradition with the avant-garde." The language here is reversible, like an art-fashion jacket.

5. McQueen used Mullins when he art directed a special issue of the magazine *Dazed and Confused* devoted to disability in September 1998 (see Claire Wilcox, ed., *Radical Fashion* [London: V&A Publications, 2001], 50–51, 97). Mullins is a central character in *The Order*, where she plays herself in various forms, and has other major roles in *Cremaster 3* and throughout the cycle.

6. It is not that the architecture banishes the art, as Rosalind Krauss feared—thus her use of "emptied" instead of "empty" in her description of the spectator's experience of Minimalist work in the "late capitalist museum" ("The Cultural Logic of the Late Capitalist Museum," *October* 54 [Fall 1990]: 3–17.) Absence—as the inevitable other of presence—was structured into such work, into its character as encounter, all along.

7. Nancy Spector, "Only the Perverse Fantasy Can Still Save Us," *Matthew Barney, The Cremaster Cycle* (New York: Guggenheim Museum, 2002), 2.

8. Daniel Birnbaum, "Master of Ceremony," *Artforum* (September 2002): 185 (original emphasis). The Wagner analogy is, at least on the level of form, a fair one, as Barney is obviously setting out to create a *Gesammtkunstwerk*, a "total work of art," one that uses all available mediums to effect all the senses at once, that Wagner pioneered at Bayreuth. This effect is also sought in the Guggenheim display.

9. An exception was *New Yorker* art critic Peter Schjeldahl, who appended a brief para-

graph to the end of his review of shows by Douglas Gordon and Franz West, in which he pounced on:

> the reign, at the Guggenheim Museum, of America's top artist-showman these days, Matthew Barney. Barney's five gorgeous and hermetic 'Cremaster' films and related sculpture, drawings, photographs and ornamentation make a cornucopia of Frank Lloyd Wright's spiral. The sheer spectacle is thrilling. But a searching visit to the show was a bummer. Barney's gnomic symbology—all those mythic critters and grisly initiation rites, the blimps, the motorcycles, Richard Serra, Budapest, and the Chrysler Building—is humorless and numbing. It isn't pretentious, exactly, because pretense presupposes a desire to impress. Barney's art is a solipsistic, closed loop, in which the viewer is superfluous. But the Guggenheim show should not be missed, as evidence of good old American individualism gone rancid. (*New Yorker*, March 24, 2003, 87.)

For one of the most prominent defenders of the beauty effect in contemporary art, this is surprising. Perhaps, for him, as for Dave Hickey, contrarianism loses its charms when it is taken into the portals of power.

10. Friedrich Nietzsche, *The Birth of Tragedy and The Case of Wagner*, trans. Walter Kaufmann (New York: Vintage Books, 1967), 166 (original emphasis). Nietzsche had celebrated Wagner in his first book, *The Birth of Tragedy* (1872); the two then shared great enthusiasm for each other for some years until irreconcilable differences drove them apart. In 1888, before succumbing to madness, Nietzsche wrote twice on Wagner: the essay just cited, and the longer *Nietzsche contra Wagner*, his last book. For a similarly subtle and critical take on Wagner, see Thomas Mann, *Pro and Contra Wagner*, trans. Allan Blunden (1933; Chicago: University of Chicago Press, 1985). Art world insiders will note that Birnbaum's use of this passage is an allusion to the use of it as an epigram by Benjamin H. D. Buchloh in his "Beuys: The Twilight of the Idol, Preliminary Notes for a Critique," *Artforum* (January 1980): 35–43, reprinted in Buchloh, *Neo-Avantgarde and Culture industry, Essays on European and American Art from 1955 to 1975* (Cambridge, MA: MIT Press, 2000), 41–64. Birnbaum's celebration of Barney is the reverse of Buchloh's objection to the over-rating of the German artist.

11. Jerry Salz, "Swept Away," *Village Voice*, February 24, 2003, http://www.villagevoice.com/2003-02-25/art/swept-away/.

12. Nancy Spector, "Only the Perverse Fantasy Can Still Save Us," 2.

13. A full account is given by Nancy Spector in part 2 of her catalog essay, "Only the Perverse Fantasy Can Still Save Us," 30–73.

14. Birnbaum, "The Master of Ceremony," 182.

15. From an interview with Sebastian Smee, "Breaking Boundaries with Ambition," *Australian Art Review* 1 (March–June 2003): 29. Barney used almost identical words in his interview with Linda Yablonsky, "A Portrait of the Artist as a Gun Man," *Time Out New York*, October 14–21, 1999, 200. On this point see Spector, "Only the Perverse Fantasy Can Still Save Us," part 3, 76–89.

16. Spector, "Only the Perverse Fantasy Can Still Save Us," 55.

17. Gilles Deleuze and Felix Guattari, *Anti-Oedipus: Capitalism and Schizophrenia* (Minneapolis: University of Minnesota Press, 1983), esp. part 1.

18. Daniel Barenboim and Edward W. Said, *Parallels and Paradoxes: Explorations in Music and Society* (London: Bloomsbury, 2002), 39.

19. Slavoj Žižek, "The Specter of Ideology," *Mapping Ideology*, ed. Slavoj Žižek (London: Verso, 1994), 25–26.

20. See Roger D. Hodge's satire, "Onan the Magnificent: The Triumph of the Testicle in Contemporary Art," *Harper's Magazine*, March 2000, http://www.harpers.org/OnanTheMagnificent.html.

21. Spector, "Only the Perverse Fantasy Can Still Save Us," 5–6.

22. Jean Baudrillard made the same leap in his book *The Mirror of Production*, an instant classic of postmodernist theory (trans. Mark Poster; St Louis: Telos Press, 1983). I comment on this question, and on the implications for art since Courbet of the double at the heart of the concept of production (material transformation and theatrical presentation) in my essay "Production," in *Critical Terms for Art History*, ed. Robert S. Nelson and Richard Shiff, 2nd ed. (Chicago: University of Chicago Press, 2002), 361–81.

23. Serra was alert to all these implications. He comments: "I decided to just do what I do, giving my all every time. How can you possibly go wrong that way?" (cited in Barney, *Matthew Barney*, 499). Serra recalls that when Jean-Luc Godard, for *One Plus One*, induced the Rolling Stones to allow him to film their recording session for the song "Sympathy for the Devil," but set it in a car wrecking yard with the intention of showing the egregious commercialization of pop music, lead singer Mick Jagger outsmarted the director by singing the song differently each time, but with equal passion and conviction, eventually producing an effect that, to many, has outlasted the rest of the film.

24. Nancy Spector, quoted in Barney, *Matthew Barney*, 88. Cremaster films sold for up to $387,500 each at auction in 2003. Barney distributes a DVD, *The Order: From Cremaster 3*, for $25. See Greg Allen, "When Fans of Pricey Video Art Can Get It Free," *New York Times*, August 17, 2003.

25. This argument is developed in detail by Stephen Tumino, "Barneyworld: Absolutely American" (unpublished paper, Contemporary Visual Cultures seminar, University of Pittsburgh, Spring 2003).

26. Smith, "Matthew Barney," May 2003, 161.

27. Quoted in Bennett Simpson, "100 Words: Matthew Barney talks about de Lama Lamina, 2004," *Artforum* XLLI, no. 9 (May 2004), 190.

28. See http://unit.bjork.com/specials/dr9/.

CHAPTER 7

1. See Sean O'Hagan, "Damien of the Dead," *The Observer* (London), February 19, 2006, http://www.guardian.co.uk/artanddesign/2006/feb/19/art. Hirst rates lower in net worth estimates, being estimated by *The Sunday Times* as £200 million ($388) in 2008, but by others at twice that sum (see "How Much Is Damien Hirst Worth?" *The Art*

Newspaper 192 [June 2008]: 61). I am particularly grateful to economist Neil de Marchi of Duke University for his comments on this and the following chapter.

2. The process of manufacture is chronicled in Damien Hirst, *For the Love of God: The Making of the Diamond Skull*, ed. Jason Beard (London: Other Criteria and White Cube, 2007).

3. Koons's *Hanging Heart (Magenta and Gold)*, from a 1994–2006 series, went for $23.6 million and his *Diamond (Blue)*, from a 1994–2005 series, for $11.8 million, both to dealer Larry Gagosian. In the same sale, Damien Hirst bought a 1969 Francis Bacon self-portrait for $33 million. Koons's *Hanging Heart* series is the product of the artist working with a consortium of dealers. Dealer and collector Adam Lindemann consigned *Hanging Heart (Magenta and Gold)* to auction straight from the warehouse.

4. On the first two of these phases, see Laura de Coppet and Alan Jones, *The Art Dealers*, rev. ed. (New York: Cooper Square Press, 2002) and Diane Crane, *The Transformation of the Avant-Garde: The New York Art World 1940–1985* (Chicago: University of Chicago Press, 1987).

5. Olav Velthuis, *Talking Prices: Symbolic Meanings of Prices on the Market for Contemporary Art* (Princeton, NJ: Princeton University Press, 2005). Adam Lindemann, *Collecting Contemporary Art* (Cologne: Taschen, 2006) is an unrepentant insider's viewpoint, which collects accounts of their beliefs and practices by a number of dealers, collectors and auctioneers. Sarah Thornton, *Seven Days in the Artworld* (New York and London: W. W. Norton, 2008) is another engaging insider report. Despite its title, Don Thompson, *The $12 Million Stuffed Shark: The Curious Economics of Contemporary Art* (New York: Palgrave Macmillan, 2008) is a measured profile by a professional economist.

6. See Daniel Crowley, "The Contemporary-Traditional Market in Africa," *African Arts* 1, no. 4 (Autumn 1970): 43–49, 80.

7. Roger Bevan, "Contemporary Art Smashes the $100 Million Barrier," *The Art Newspaper* 48 (June 2004): 41.

8. Carol Vogel, "Momentum in Art Auctions Continues to the End," *New York Times*, November 12, 2004.

9. See http://www.artfact.net/.

10. In Australia, this then-extraordinary sum precipitated a storm of controversy. Since the money was paid from public funds, the purchase featured in criticism of the Labor government's economic management, a key factor in its dismissal in 1975. See Lindsay Barrett, *The Prime Minister's Christmas Card: Blue Poles and the Cultural Politics of the Whitlam Era* (Sydney: Power Publications, 2001). See also Terry Smith, "Putting Painting at Stake: Jackson Pollock's *Blue Poles*," in Anthony White, *Jackson Pollock's Blue Poles* (Canberra: National Gallery of Australia, 2002), 55–68.

11. Peter Watson, *From Manet to Manhattan: The Rise of the Modern Art Market* (New York: Random House, 1992), 417.

12. Watson, *From Manet to Manhattan*, 416–17 describes the Scull sale. See also J. E. Patterson, "Facts, Figures, and Questions about the Scull Sale," *Artnews* (December 1973), 80, and B. D. Kirschenblum and J. Schott, "America's Pop Collector, Robert C. Scull," *Art Journal* 39, no. 1 (Fall 1979): 50–54. On Rosenquist's history in

the salerooms see Richard Polsky, "Art Market Guide 2000," http://www.artnet
.com/magazine/features/polsky/polsky12-20-00.asp.

13. See Thomas E. Norton, *100 Years of Collecting in America: The Story of Sotheby Parke-
Bernet* (New York: Abrams, 1984). Kline died in 1962, Nicholson twenty years later.
Some closely contemporary works were sold even before the formal naming of sales
as "contemporary." An instance is the sale of David Smith's 1957 sculpture *Raven IV* in
a modern art sale in November 1964. Smith died in 1965 (ibid, 180.)

14. Watson, *From Manet to Manhattan*, 417–18. At boom times, more auction houses seek
action in the contemporary market. For example, in response to the recovery of 1997–
98, Phillips, which had specialized in earlier modern art and furniture, entered the
contemporary art specialist market in 1999, soon after its acquisition by de Pury and
Luxembourg. In 2000 its New York office began a series of sales devoted to contempo-
rary photography.

15. Emmanuel Saez and Thomas Piketty, "Income Inequality in the United States, 1913–
1998," *Quarterly Journal of Economics* 118, no. 1 (2003): 1–39. See the updated version at
figure 1 in Emmanuel Saez, "Striking it Richer: The Evolution of Top Incomes in the
United States (Update Using 2006 Preliminary Estimates)," http://emlab.berkeley
.edu/users/saez.

16. Watson, *From Manet to Manhattan*, 421.

17. Press release, Christie's New York, November 16, 2006. See Carol Vogel, "Records Tum-
ble at Auction of Postwar Art," *New York Times*, November 17, 2006. The Warhol market
is driven by many factors, one being the activity of collector Jose Magrabio. See Kelly
Crow, "The Man with 800 Warhols," *Wall Street Journal*, January 4, 2008.

18. *Art Market Trends 2007* (Saint-Romain-au-Mont-d'Or: 2008), 24–26, http://www
.artprice.com.

19. This collector activity is reinforced by key studies of the market undertaken during
this period. See, for example, Robin Duthy, *The Successful Investor: A Guide to Art, Gold,
Wine, Antiques, and Other Growth Markets* (London: Collins, 1986); William Baumol,
"Unnatural Value: Or Art Investment as a Floating Crap Game," *American Economic
Review* 76 (1986), 10–14; and Bruno Frey and Werner Pommerehne, *Muses and Markets,
Explorations in the Economics of the Arts* (Oxford: Blackwell, 1989). These studies are re-
viewed by Watson, *From Manet to Manhattan*, chap. 38, 422–32.

20. See Roger Bevan, "The Changed Contemporary Art Market: Have Auction Houses Tried
to Become Dealers either by Buying Them or Behaving Like Them?" *The Art Newspaper*
no. 121, January 1, 2002: 34, http://TheArtNewspaper.com/news/articleasp?idart+8573;
and Rita Hatton and John A. Walker, *Supercollector: A Critique of Charles Saatchi* (London:
Ellipsis, 2000).

21. Olav Velthius, "Accounting for Taste," *Artforum* XLVI, no. 8 (April 2008): 307.

22. *The Art Newspaper*, no. 170 (June 2006): 52.

23. Artprice, *Art Market Trends 2007*, 16–19, at http://www.artprice.com. Fine art auction
sales turnover is as follows: United States, 41 percent; United Kingdom, 29.7 percent;
China, 7.3 percent; France, 6.4 percent. Comparative figures for 2006 are: United States,
46 percent; United Kingdom, 27 percent; China, 5 percent; France, 6 percent. Within

this, for contemporary art, China and the United Kingdom (each with 20 percent) follow the United States.

24. Quoted in Peter Timms, "Artnotes: Superbreed," *Art Monthly Australia* 192 (August 2006): 49. Meanwhile, Hirst had persuaded Steven Cohen, who had purchased his 1991 *The Physical Impossibility of Death in the Mind of Someone Living*, to finance the conservation of the work (essentially, get a new shark, and inject it properly this time). Simultaneously, Hirst unabashedly sold for $4 million a smaller shark in formaldehyde piece—this time entitled (what else?) *The Wrath of God* (2005)—to the Samsung Museum in Seoul. In 2007, Cohen placed the remixed, "original" shark in the Metropolitan Museum, New York, on a short-term loan while he contemplated the shape of a museum for his own collection. The Metropolitan gave it pride of place in its (admittedly very thin) contemporary art rooms, put up related works by Winslow Homer and Francis Bacon, and, in its wall text, invited viewers to contemplate the meaning of the sublime today.

CHAPTER 8

1. Quoted in Debra Jopson, "Whitefella Dreaming," *Sydney Morning Herald,* November 15–16, 2003.

2. On the Australian market, including Aboriginal art, in its global context, see Annette Van den Bosch, *The Australian Art World: Aesthetics in a Global Market* (Sydney: Allen & Unwin, 2005); and Benjamin Genocchio, *Dollar Dreaming: Inside the Aboriginal Art World* (Melbourne: Hardie Grant Books, 2008).

3. On Aboriginal art in general, including recent developments, see Fred R. Myers, *Painting Culture: The Making of an Aboriginal High Art* (Durham, NC: Duke University Press, 2002), a study that pays close attention throughout to the matter of value formation and clashes of values. Among the many introductory texts to the movement as a whole, see Robert Edwards, *Australian Aboriginal Art* (1974; Canberra, Australian Institute of Aboriginal Studies, 1979); Peter Sutton, ed., *Dreamings: The Art of Aboriginal Australia* (New York and Melbourne: Viking, 1988); Jennifer Isaacs, *Arts of the Dreaming: Australia's Living Heritage* (Lansdowne: Sydney, 1984); Jennifer Isaacs, *Australian Aboriginal Painting* (Sydney: Craftsman House, 1989); Terry Smith, "From the Desert," in Bernard Smith, Terry Smith, and Christopher Heathcote, *Australian Painting 1788–2000* (Melbourne: Oxford University Press, 2001), chap. 15; Wally Caruana, *Aboriginal Art* (London: Thames & Hudson, 1993); and Howard Morphy, *Aboriginal Art* (London: Phaidon, 1998). Statistics covering both indigenous and nonindigenous art production, circulation, and patronage may be found in H. H. Guldberg, *The Arts Economy, 1968–1998: Three Decades of Growth in Australia* (Sydney: Australia Council, 2000); and Senate Standing Committee on Environment, Communications, Information Technology, and the Arts, *Indigenous Art—Securing the Future, Australia's Indigenous Arts and Crafts Sector* (Canberra: Senate Printing Unit, Parliament House, 2007). "Indigenous" includes both Aboriginal and Torres Strait Islanders; a total of 410,003 persons in the 2001 census (http://abs.gov.au/AUSSTATS/abs@nsf/MF/3238.0).

4. Michael Reid, "Aboriginal Art at Auction: A Record Sale at Sotheby's," *Art and Australia* 41, no. 2 (summer 2003): 283. Dollar amounts are Australian, which was then equivalent to 75 percent of U.S. dollars. In 2007, the average rate had risen to 82 percent; in 2008, close to parity.

5. Sue Neales, "Art Direction," *Australian Financial Review,* July 2004, 14–20. The story features planeloads of Sydney-based collectors being flown into remote settlements— Balgo, for example—to buy paintings at specially staged release days. The estimate of the total market is that of Professor John Altman, Director of the Centre for Aboriginal Economic Policy Research at the Australian National University, Canberra. Information on 2005 auctions is from Geoffrey Maslen, "Curb in Aboriginal Art sales," *Sydney Morning Herald,* July 22, 2005.

6. See Robert Leonard, ed., *Richard Bell: Positivity* (Brisbane: Institute of Modern Art, 2007).

7. In my essay "Kngwarreye Woman Abstract Painter," (in *Emily Kngwarreye Paintings,* ed. Jennifer Isaacs, [Sydney, Craftsman House, 1998], 24–42), I demonstrate this and trace the emergence in Kngwarreye's work of an original and significant visual structure—that of reaching out, digging in, and back toward the body—contrasting it to those of Western abstract artists with whom her work is often compared. Some of the essays in Margo Neale, *Emily Kame Kngwarreye, Alhalkere, Paintings from Utopia* (Brisbane, Queensland Art Gallery, 1998) attempt parallel readings.

8. This is the beginning of an argument against the presumptions candidly set out in James Elkins, "Writing About Modernist Painting Outside Western Europe and North America," in *Compression vs. Expression: Containing and Explaining the World's Art,* ed. John Onians (Williamstown, MA: Sterling and Francine Clark Institute, 2006), 188–214. This debate is long running and highly developed in Australia. See, for example, Ian Burn, *National Life and Landscapes: Australian Painting 1900-1940* (Sydney: Bay Books, 1990); and Ian McLean, *White Aborigines: Identity Politics in Australian Art* (New York: Cambridge University Press, 1998). It continues unabated today; see, for example, Ian McLean, "How Art Can Change the World: Art, Life and Modernity in Western Arnhem Land," *Art Monthly Australia* 188 (April 2006): 29–32.

9. See Terry Smith, "Aboriginality and Post-Modernity: Parallel Lives," in *Transformations in Australian Art,* vol. 2, *The Twentieth Century—Modernism and Aboriginality* (Sydney: Craftsman House, 2002), 144–67.

10. The catalog for the exhibition, a three-volume boxed set with inserts profiling the major offerings, includes an essay by Michael Bracewell that celebrates Hirst as a protean creative force equivalent to art itself, and an interview in which the artist responds frankly to questions about his risk-taking willingness to go "straight to market. Bang!" Sotheby's London, *Damien Hirst: Beautiful Inside My Head Forever* (London: Sotheby's, 2008), 8–12, 16–25.

11. Roger Bevan, "Contemporary Art: Have We Reached the Cusp of the Boom?" *The Art Newspaper* 170 (June 2006): 49.

12. Richard Feigen, "It's Definitely a Bubble, but When It will Burst Is Anybody's Guess," *The Art Newspaper* 182 (July-August 2007): 28.

13. Facts and quotations in this paragraph from Milton Esterow, "The Top 10," *ART-news*, 105, no. 7 (Summer 2006), at http://www.artnewsonline.com/issues/article .asp?art_id=2086.

14. Robert J. Shiller, *Irrational Exuberance* (Princeton, NJ: Princeton University Press, 2000), 6, esp. fig. 1.1. An important chart showing the relationship between the Real S&P Stock Price Index and present value subsequent real dividends is fig. 9.1 on page 186; it shows the same kind of gap.

15. Artprice, *Art Market Trends 2007* (Saint-Romain-au-Mont-d'Or: Artprice.com S.A. 2008), 6. For whatever his opinion is worth, Damien Hirst remains irrepressibly optimistic. Asked whether his expectations as to his 2008 sale might be excessive, he replied: "I mean, I think the market is much bigger than anybody realizes. I think potentially it's much, much wider, and everybody's got panicked into thinking you've got to be careful. I don't think you have to be careful. I think the market can take a lot of art, especially if it is good art." Quoted in *Damien Hirst—Beautiful Inside My Head Forever* (London: Sotheby's, 2008), 17. On the Hirst sale, see Roberta Smith, "After the Roar of the Crowd, an Auction Post-Mortem," *New York Times*, September 20, 2008.

16. See Melanie Gerlis, "Auction Houses Embark on Damage Limitation Exercise as Market Slumps," *The Art Newspaper* 196 (November 2008): 1; and Roger Bevan, "Auctions Make Nearly Half Low Estimates," *The Art Newspaper* 197 (December 2008): 55.

17. On Kunstmarkt 67, the first European art fair of the kind now prominent, see Christine Mehring, "Emerging Market," *Artforum* XLVI, no. 8 (April 2008): 322–29.

18. For detailed reports, see issues of *The Art Newspaper*: October 2005 (on Frieze), January 2006 (on Art Basel/Miami Beach), and July–August 2006 (on Art Basel).

19. Reports in *The Art Newspaper* 174 (November 2006): 49 and 58.

20. Peter Schjeldahl, "The Art World: Temptations of the Fair," *New Yorker*, December 26 and January 1, 2007, 148. Ruprecht cited by Carol Vogel, "Hard Times Hit Houses Where Art Meets Cash," *New York Times*, January 31, 2009.

21. Asked about this comment during a panel convened by the U.S. branch of the International Association of Art Critics during the 2007 meeting of the College Art Association, in New York in February 2007, Mr. Rubell responded, first, that this was true of life in general, but later explained that he did not mean that one had a very short time to discover the work of a "new artist"; rather, that the work of an artist of whom one had heard (via a dealer or another artist, even a critic) and had targeted to collect, would most likely be quickly snapped up.

22. Marc Spiegler, "The Trouble with Art Fairs," *The Art Newspaper* 175 (December 2006): 36–37.

23. Koons's bottomless vacuity in this regard is adroitly profiled in Calvin Tomkins, "The Turnaround Artist: Jeff Koons, Up from Banality," *New Yorker*, April 23, 2007, 59–67. Murakami's embrace of capital is celebrated in a 2005 Microsoft advertisement entitled "Murakami Is Passionate about the Intersection of Art and Commerce." See, for example, *New Yorker*, June 6–13, 2005, 41–43; and the title of his 2008 exhibition at the Brooklyn Museum of Art: "© Murakami."

24. Cited in Mike Sperlinger, "Future into Futures: An Interview with Diego Cortez," in Martin Braathen et al., *The Price of Everything . . . Perspectives on the Art Market* (New York: Whitney Museum of American Art, 2007), 34. This book includes works by artists who are critical of market effects, cynical about them and playfully mocking of them.

25. I develop this argument in detail in "Creating Value Between Cultures: Contemporary Australian Aboriginal Art," in *Beyond Price: In Search of Cultural Value*, ed. Michael Hütter and David Throsby (Cambridge: Cambridge University Press, 2007), 23–40. In the same volume, Neil de Marchi contributes a chapter that also touches on this topic; see his "Confluences of Value: Three Historical Moments," in *Beyond Price*, 200–19. For pertinent general comments on the phenomena discussed in these two chapters see Thomas Crow, "Historical Return," *Artforum* XLVI, no. 8 (April 2008): 286–91, and for an frank insider account see Judith Ben Hamou-Huet, *The Worth of Art (2)* (New York: Assouline, 2008).

CHAPTER 9

1. Okwui Enwezor, ed., *Documenta 11_Platform 5: Exhibition* (Ostfildern-Ruit: Hatje Cantz, 2002), "Democracy Unrealized" (Vienna and Berlin), "Experiments with Truth: Transitional Justice and the Processes of Truth and Reconciliation" (New Delhi), "Creolité and Creolization" (St. Lucia), and "Under Siege: Four African Cities, Freetown, Johannesburg, Kinshasa, Lagos" (Lagos). Since then, Enwezor has developed his thinking into a more general conception: see his "The Postcolonial Constellation," chapter 11 in *Antinomies of Art and Culture: Modernity, Postmodernity, Contemporaneity*, ed. Terry Smith, Okwui Enwezor, and Nancy Condee (Durham, NC: Duke University Press, 2008).

2. Stuart Hall and Michael Hardt, "Changing States: In the Shadow of Empire," in *Changing States: Contemporary Art and Ideas in an Era of Globalisation*, ed. Gilane Tawadros (London: iniVA, 2004), 135. *Documenta 11* attracted much comment, most of it pro or con partisan. More useful are questions, such as those raised by Sylvester Okwunodu Ogbechie, "Ordering the Universe: *Documenta 11* and the Apotheosis of the Occidental Gaze," *Art Journal* 64, no. 1 (Spring 2005): 80–89.

3. República de Cuba, Ministerio de Cultura, *Principales Leyes y disposiciones relacionadas con la cultural as artes y la enseñanza artística*, Tomo II. (Havana: Gaceta Oficial de Cuba, 1984), 121. This passage was translated by Miguel Rojas-Sotelo.

4. No official history of the Havana Biennale has yet appeared, but its inspirations and achievements are evident in the catalogs produced for each event and in the published records of the accompanying conferences. These often include retrospective analyses of previous biennales. To date, the closest thing to an independent history is Rachel Weiss, "Visions, Valves, and Vestiges: The Curdled Victories of the Bienal de La Habana," *Art Journal* 66, no. 1 (Spring 2007): 10–26. A history drawing on insider accounts is under preparation by Miguel Rojas-Sotelo, "Cultural Maps, Networks and Flows: The Bienal de La Habana 1983–2008," (unpublished dissertation, Department of the History of Art and Architecture, University of Pittsburgh). I am indebted to both.

5. See Rosa Artigas, *Bienal 50 Anos* (São Paulo: Fundação Bienal de São Paulo, 2001). The Bienal de São Paulo has done much more than insert Brazilian artists into the international art circuit. Its exhibitions have, over the years, been crucial barometers of the capacity of the Brazilian art world to critically analyze itself and its history. For example, the 1999 biennale, curated by Paulo Herkenhoff, was devoted to the theme of *anthropophagia* (on which, see Edward Liffingwell, "Cannibals All—24th São Paulo Bienal," *Art in America* [May 1999], 48–55).

6. Néstor García Canclini, "Modernity after Postmodernity," in *Beyond the Fantastic: Contemporary Art Criticism from Latin America*, ed. Geraldo Mosquera (Cambridge, MA: MIT Press, 1996), 28. More generally on these issues, see Néstor García Canclini, *Hybrid Cultures: Strategies for Entering and Leaving Modernity*, 2nd ed. (Minneapolis: University of Minnesota Press, 2005). See also Walter Mignolo, *Local Histories/Global Designs: Coloniality, Subaltern Knowledges, and Border Thinking* (Princeton, NJ: Princeton University Press, 2000).

7. Canclini, "Modernity after Postmodernity," 27 (original text in italics). With regard to internationalism, it is worth noting that both Brazil and Cuba had strong first and second world affiliations. European cultural currents remain strong in Brazil, which sees itself as a country in South but not Latin America. During the cold war years, Cuba saw itself as leader of the "nonaligned" nations, but it became increasingly economically dependent on the USSR during the 1970s, such that the abrupt withdrawal of Soviet support after 1990 had devastating, and still continuing, consequences.

8. Gerald Mosquera, "El Tercer Mundo hará la cultura occidental," [The Third World Makes Western Culture] *Revolución y Cultura* (July–September, 1986): 39–47. A special number in association with the 2nd Bienal de La Habana 1986.

9. See Luiz Camnitzer, *New Art of Cuba*, rev. ed. (Austin: University of Texas Press, 2003). On earlier art in Cuba, including that of Wifredo Lam, see Juan A. Martínez, *Cuban Art and National Identity 1927–1950* (Gainesville: University Press of Florida, 1994).

10. Jean-Hubert Martin, *Magiciens de la terre: Centre Georges Pompidou, Musée national d'art moderne, La Villette, la Grande Halle* (Paris: Editions du Centre Pompidou, 1989). In an interview, the curator commented, "I want to play the role of someone who uses artistic intuition alone to select objects which come from totally different cultures . . . I intend to select these objects from various cultures according to my own history and my own sensibility. But obviously, I also want to incorporate into that process the critical thinking which contemporary anthropology provides on the problem of ethnocentrism, the relativity of culture, and intercultural relations." Quoted in Benjamin H. D. Buchloh and Jean-Hubert Martin, "The Whole Earth Show," *Art in America* 77, no. 5 (May 1989): 153.

11. A mild instance is Peter Schjeldahl's condemnation by faint praise in his review "The Global Salon: European Extravaganza," *New Yorker*, July 1, 2002: "*Documenta* 11 brings to robust maturity a style of exhibition—I call it festivalism—that has long been developing on the planetary circuit of more than fifty biennials and triennials, including the recent Whitney Biennial. Mixing entertainment and soft-core politics, festivalism makes an aesthetic of crowd control. It favors works that don't demand contempla-

tion but invite, in passing, consumption of interesting—just not too interesting—spectacles" (94). More considered responses to this exhibition in the context of similar surveys since *Magiciens de la Terre* may be found in a thematic section of the *Art Journal* 64, no. 1 (Spring 2005), edited by Norman L. Kleebatt.

12. Francesco Bonami, *Dreams and Conflicts: The Dictatorship of the Viewer: 50th International Art Exhibition* (Venice: Marsilio, Biennale di Venezia, 2003.) Among critical reactions, see, for example, Marcia Vetrocq, "Venice Biennale: 'Every Idea But One'—In Its 50th Edition, the Biggest Ever, This Venerable Institution May Have Lost Its Way," *Art in America* 91, no. 9 (2003): 76–87, 136–37, and the perspectives offered by Scott Rothkopf, Linda Nochlin, and Tim Griffin, "Pictures of an Exhibition: The 50th Venice Biennale," *Artforum* XLII, no. 1 (September 2003): 174–81, 246, 251, 254, 261.

13. Prince Claus Fund for Culture and Development, The Hague, press release, August 23, 2003. See also *The 2003 Annual Report of the Prince Claus Fund* (The Hague: Prince Claus Fund, 2003), 4.

14. Bienal de Havana, *El Arte con la Vida* (Havana: Wifredo Lam Contemporary Art Center, 2003), 387.

15. "Premises and Principles," press release of the Wifredo Lam Contemporary Art Center, July 2003. http://universes-in-universe.de/car/habana/bien8/press/e-concept.html.

16. Luis Camnitzer, "Art and Life?" in Bienal de Habana, *El Arte con la Vida* (Havana: Wifredo Lam Contemporary Art Center, 2003), 395.

17. This work was shown in *States of Exchange: Artists from Cuba*, at the Institute of International Visual Arts, London, January–March 2008.

18. Cuban-born Ana Mendieta moved to the United States as a young woman. She became an outstanding performance artist during the 1970s, creating a series of earth works based on the silhouette of her body. She died in New York in 1985, aged thirty-seven, under ambiguous circumstances. See Jane Blocker, *Where Is Ana Mendieta? Identity, Performativity, and Exile* (Durham, NC: Duke University Press, 1999).

19. These developments have been traced in a number of excellent studies. See, for example, Olu Oguibe and Okwui Enwezor eds., *Reading the Contemporary: African Art from Theory to the Marketplace* (London: Institute of International Visual Arts, 1999; Cambridge, MA: MIT Press, 1999); Sidney Littlefield Kasfir, *Contemporary African Art* (London: Thames & Hudson, 1999); Shannon Fitzgerald and Tumelo Mosaka, *A Fiction of Authenticity: Contemporary Africa Abroad* (St Louis: Contemporary Art Museum of St Louis, 2003), Gilane Tawadros, *Fault Lines: Contemporary African Art and Shifting Landscapes* (London: iniVA and the Forum for African Art and the Prince Claus Fund, 2003), and Simon Najami, *Africa Remix: Contemporary Art of a Continent* (Ostfildern: Hatje Cantz; and London: Hayward Gallery, 2005).

20. Marina Gržinić, *Situated Contemporary Art Practices, Art, Theory and Activism from (the East of) Europe* (Frankfurt: ZRC SAZU, Ljubljana and Revolver, 2004). For a magisterial survey of these changes see Tony Judt, *Postwar: A History of Europe since 1945* (New York: Penguin, 2005).

21. István Rév, *Retroactive Justice; Prehistory of Post-Communism* (Stanford, CA; Stanford University Press, 2005).

22. Paolo Colombo and Elizabeth Johns, *Jane & Louise Wilson: Stasi City* (Hanover: Hanover Kunstverein, 1997).

23. Irwin, ed., *East Art Map: Contemporary Art and Eastern Europe* (London: Afterall, 2006), and http://www.nskstate.com/irwin/works-projects/eastartmap.php. A useful update and critique of this enterprise is Marina Gržinić, Günter Heeg, and Veronika Darian, *Mind the Map! History Is Not Given* (Frankfurt: Revolver, 2006).

24. For example, in 1992, members of Group Irwin invented an imaginary state, NSK, or Neue Slowenische Kunst, which offers passports stating "The NSK State holds the status of a virtual state without physical territory, and does not exist in the real, three-dimensional space. Its sole territory is *time*." It continues to seek official recognition from actual states in parodies of their procedures. See http://www.nskstate.com.

25. Forgács is also director of the Private Film and Photo Archive at the Open Society Archive, Central European University, Budapest, of which Rév is director.

26. Vivan Sundaram, *Re-Take of "Amrita": Digital Photomontage* (New Delhi: Tulika Books, 2001).

27. For comments on these developments and on these and related artworks, see Li Xianting, "Major Trends in the Development of Contemporary Chinese Art," in *Chinese New Art, Post-1989*, ed. Chang Tsong-Tzung (Hong Kong: Hanart T Z Gallery, 1993); John Clark, *Modern Asian Art* (Sydney: Craftsman House; and Honolulu: University of Hawaii Press, 1998); and Jonathan Hay, "Double Modernity, Para-Modernity," Gao Minglu, "'Particular Time, Specific Space, My Truth': Total Modernity in Chinese Contemporary Art," and Wu Hung, "A Case of Being 'Contemporary': Conditions, Spheres, and Narratives of Contemporary Chinese Art," chapters 7, 8, and 14 in Smith, Enwezor, and Condee, eds., *Antinomies of Art and Culture*.

28. See, for example, Museo Nacional Centro de Arte Reine Sofia, *Torres-Garcia* (Madrid: Ministerio de Cultura, 1991).

29. See Mary Jane Jacobs and Nancy Princenthal, *Alfredo Jaar, The Fire This Time, Public Interventions 1979–2005* (Milan: Charta, 2005).

CHAPTER 10

1. Dirk Braeckman, *Heaven of Delight: Jan Fabre* (Brussels: Koninklijk Paleis, Fonds Mercator, 2002).

2. Jean Michel Bruyère, born 1959, lives and works in Dakar as filmmaker, director, writer, sculptor, photographer, and graphic artist. He is the founding and artistic director of *"la fabrics"* (*Groupe d'Intervention Artistique Internationale*), and director of the art school Ecole d'art Man-Keneen-Ki in Dakar. He is also the founder and director of LFK 1314, Electronic Theater of Marseille. On the *Enfants de Nuit* project, see http://www.theatre-contemporain.net/spectacles/enfants_de_nuit/.

3. "Viuser" is a concept coined by Keir Smith, "Rewarding the Viuser: A Human-Tele-visual Data Interface Application," paper presented at VSMM 2003, *Virtual Reality Multimedia*, Montreal, Canada, 2003. http://keirdotnet.net/Papers/KSmith.rewarding_viuser.pdf. A closely related concept, "vuser (viewer/user)" was coined by Bill Sea-

man in 1998; see his "Recombinant Poetics" (2000) at http://digitalmedia.risd.edu/
billseaman/textsRecomb.php.

4. Cited in Jean-Michel Bruyère/LFK, "Outline," trans. by Sarah Clift, at http://www.zkm
.de/futurecinema/bruyere_werktext_e.html, which includes the 1999 manifesto by the
artists of LFK.

5. "Nunc tibi me posito visam velamine narres, Si poteris narrare, licet." Ovid, *Metamor-
phosis*, 3.192–193.

6. Bruyère/LFK, "Outline."

7. This is a major thematic in contemporary art in Africa. See, for example, Okwui En-
wezor, *Snap Judgments: New Positions in Contemporary African Photography* (New York:
International Center for Photography; Steidl Verlag, 2006), and Colin Richards, "Af-
termath: Value and Violence in Contemporary South African Art," chapter 13 in *An-
tinomies of Art and Culture: Modernity, Postmodernity, Contemporaneity*, ed. Terry Smith,
Okwui Enwezor, and Nancy Condee (Durham, NC: Duke University Press, 2008). The
most suggestive theorization of these issues may be found in Achille Mbembe, *On the
Postcolony* (Berkeley: University of California Press, 2001).

8. Achille Mbembe, "Flow: What Does Africa Name?" catalogue excerpt in *Studio, The
Studio Museum in Harlem Magazine*, Spring 2008, 9.

9. Gerald Mosquera, "El Tercer Mundo hará la cultura occidental," [The Third World
Makes Western Culture] *Revolución y Cultura* (July–September, 1986): 39–47.

10. Elizabeth Farrelly, "Why These Half-Baked Figurines Leave Us Lost for Words," *Sydney
Morning Herald*, July 12, 2006.

11. Cited in Sunanda Creagh, "Making 180,000 Figures Is One Big Deal," *Sydney Morning
Herald*, June 7, 2006.

12. See Caroline Turner ed., *Art and Social Change: Contemporary Art in Asia and the Pacific*
(Canberra: Pandanus Books, Australian National University, 2005), 210–11, cover image.

13. Sime's work was included in Christine Y. Kim, ed., *Flow* (New York: The Studio Museum
in Harlem, 2008).

14. Farrelly, "Why These Half-Baked Figurines Leave Us Lost for Words," 13.

15. Lisa Corrin, ed., *Shirin Neshat* (London: Serpentine Gallery; and Vienna: Wein Kun-
sthalle, 2000); and Giorgio Verzotti, ed., *Shirin Neshat* (Milan: Charta and Castello di
Rivoli Museo d'Arte, 2002). The complexities of Neshat's situatedness are explored in
Wendy Meryem K. Shaw, "Ambiguity and Audiences in the Films of Shirin Neshat,"
Third Text 57 (Winter 2001-2): 43–52.

16. See Ghazel, *All About Me* (Tokyo: Musashino Art University AlphaM Project, 2005).

17. Marjane Satrapi, *Persepolis: Story of a Childhood* (New York: Pantheon, 2003); Marjane
Satrapi, *Persepolis 2: Story of a Return* (New York: Pantheon, 2004); Marjane Satrapi,
Embroideries (New York: Pantheon, 2005).

18. Juan Davila with Guy Brett and Roger Benjamin, *Juan Davila* (Melbourne: Melbourne
University Press, 2006).

19. Tracey Moffatt and Gael Newton, *Tracey Moffatt: Fever Pitch* (Sydney: Piper Press, 1996);
Lynne Cooke, *Tracey Moffatt: Free-Falling* (New York: Dia Foundation, 1997); Filippo
Maggia, ed., *Tracey Moffatt: Between Dreams and Reality* (Milan: Skira, 2006).

20. The murderous implications of these practices are examined in Arjun Appadurai, *Fear of Small Numbers, An Essay on the Geography of Anger* (Durham, NC: Duke University Press, 2006).

21. See Isaac Julien, Martina Attille, Reese Auguiste, Peter Gidal, "Aesthetics and Politics: Working on Two Fronts," *Undercut* 17 (London: Film-Maker's Co-Op, 1988), 36.

22. See Kobena Mercer, "Avid Iconographies," in *Isaac Julien* (London: Ellipsis, 2001), 7–21.

23. Marc Augé, *Non-Places: Introduction to an Anthropology of Supermodernity* (London: Verso, 1995).

CHAPTER 11

1. "When What was Darkness Becomes Light: A Conversation between James Turrell and Tadao Ando in Minamidera," *Naoshima News* 2, no. 1 (June 1999), quoted in Philip Jodidio, *Tadao Ando at Naoshima: Art, Architecture, Nature* (New York: Rizzoli, 2006), 23–24.

2. Installation art has been theorized in this way by Boris Groys in *Art Power* (Cambridge, MA: MIT Press, 2007) and in Boris Groys, "The Topology of Contemporary Art," chapter 4 in *Antinomies of Art and Culture: Modernity, Postmodernity and Contemporaneity*, ed. Terry Smith, Okwui Enwezor, and Nancy Condee (Durham, NC: Duke University Press, 2008). For more historical perspectives, see Julie Reiss, *From Margins to the Center: The Spaces of Installation Art* (Cambridge, MA: MIT Press, 1999); and Miwon Kwon, *One Place After Another: Site-Specific Art and Locational Identity* (Cambridge, MA: MIT Press, 2002).

3. Fernand Braudel, *Civilization and Capitalism: The Fifteenth to the Eighteenth Century.* Vol. 3, *The Perspective of the World* (New York: Harper and Row, 1984), 19–20.

4. See, for example, Brian Holmes with the 16 Beaver group, the "Continental Drift" seminar, at http://16beavergroup.org/drift.

5. Quoted in Uta Grosenick and Burkhardt Riemschneider, eds., *Art Now* (Cologne: Taschen, 2005), 18.

6. These works, and their specific settings, are illustrated in Jodidio, *Tadao Ando at Naoshima*, and are discussed, along with the ambitions of Soichiro Fukutake, in Jodidio's essay "Paradise Regained: Architecture, Art and Nature on the Island of Naoshima," 11–43.

7. See Chris Townsend, ed., *The Art of Bill Viola* (London: Thames & Hudson, 2004).

8. The most useful introduction remains Howard Morphy, *Aboriginal Art* (London: Phaidon, 1989). My views may be found in Terry Smith, "Aboriginality and Postmodernity: Parallel Lives," in *Transformations in Australian Art.* Vol. 2, *Modernism and Aboriginality* (Sydney: Craftsman House, 2002), 144–67. On aboriginal conceptions of time, see Tony Swain, *A Place for Strangers: Towards a History of Australian Aboriginal Being* (Sydney: Cambridge University Press, 1993).

9. Quoted in Scott Rothkopf, "Embedded in the Culture: The Art of Paul Chan," *Artforum* XVIV, no. 10 (Summer 2006): 304–12. For the artist's comments on this series see

http://www.art-diary.net/PAUL-CHAN-Lights-Drawings. An essay by him, along with an interview conducted by Hans Ulrich Obrist and further essays by prominent critics, may be found in Paul Chan, *Paul Chan, The 7 Lights* (London: Serpentine Gallery; and Cologne: Buchhandlung Walter König, 2007).

10. See Keith Schneider, "Look at Me, World! Self-Portraits Morph Into Internet Movies," *New York Times*, March 18, 2007.

11. On the pervasive uneasiness with questions of time in 1960s art, see Pamela M. Lee, *Chronophobia, On Time in the Art of the 1960s* (Cambridge, MA: MIT Press, 2004). Some interesting observations on time in 1980s art may be found in Carolyn Bailey Gill, ed., *Time and the Image* (Manchester: Manchester University Press, 2000), especially the introduction, by Mark Cousins (1–8), and the chapter by Mieke Bal, "Sticky Images: The Foreshortening of Time in an Art of Duration" (79–99). A recent survey is Shamim M. Momin, "Time Change," in Henriette Huldisch and Shamin M. Momim, *Whitney Biennale 2008* (New York: Whitney Museum of American Art, 2008), 50–78.

12. These observations follow a viewing of *Andy Warhol: A Documentary Film*, by Ric Burns, screened by the Public Broadcasting System, September 2006, especially comments by Stephen Koch and Wayne Kostenbaum. See also Staff of the Andy Warhol Museum, *Andy Warhol 365 Takes: The Andy Warhol Museum Collection* (New York: Abrams; Pittsburgh: Andy Warhol Museum, 2004).

13. To view Bors's film, go to http://www.chrisbors.com/Psycho.mov.

14. Eve Sullivan, "Andy Warhol's *Time Capsules* in Melbourne," *Art Monthly Australia* 183 (September 2005): 18–23.

15. See Fraser Ward, "Alien Durations: Tehching Hsieh 1978–89," *Art Journal* 65, no. 3 (Fall 2006): 6–19.

16. See János Strucz, *L'Assunzione della Techné/Tackling Techné, Hungarian Pavilion, La Biennale di Venezia, 1999* (Budapest: Mester Nyomda, 1999).

17. Jean-Christope Royoux, Marina Warner, and Germaine Greer, *Tacita Dean* (London: Phaidon, 2006); and Tacita Dean, *Tacita Dean: Analogue* (Göttingen: Steidl Verlag and the Schaulager, 2006).

18. See Peter Hill, "Australia and New Zealand go to Venice," *Art Monthly Australia* 183 (September 2005): 12–15.

19. Exhibited in Norman Rosenthal, et al., *Apocalypse: Beauty and Horror in Contemporary Art* (London: Royal Academy of Arts, 2000).

20. Quoted in Uta Grosenick, ed., *Art Now*, vol. 2 (Cologne: Taschen, 2005), 114.

21. Benjamin Buchloh, "The Curse of Empire," *Artforum* XLVI, no. 1 (September 2005): 254–58.

22. Lu Jie, *The Long March: A Walking Visual Display*, http://www.longmarchfoundation.org.

23. See Wu Hung and Christopher Phillips, *Between Past and Future: New Photography and Video from China* (Chicago: University of Chicago Press, 2004).

24. Jeremy Millar, *Fischl and Weiss, The Way Things Go* (London: Afterall Books, 2007), 20.

25. Quoted in Dean Kuipers, "Are Friends Electric?" http://www.adobe.com/uk/motion/spotlights/aitken/index.html.

26. Roberta Smith, "The Museum as Outdoor Movie Screen, Featuring Five Lives Lived After Dark," *New York Times*, January 18, 2007.

27. See Bill Horrigan and Kutlug Ataman, *Küba* (New York and London: Lehman Maupin Gallery/Artangel, 2005).

28. Statement sent by the artist, June 6, 2008. See also Homi Bhabha, "Another Country," in *Without Boundary: Seventeen Ways of Looking*, ed. Fereshteh Daftari (New York: Museum of Modern Art, February–May 2006), 33.

CHAPTER 12

The first epigraph in this chapter is from "Create Dangerously," a lecture given at the University of Uppsala, December 1957, quoted in Albert Camus, *Resistance, Rebellion and Death* (New York: Alfred A Knopf, 1960), 191. Camus' relationships to the political struggles in Algeria, and his role in debates in France on the question, were complex and unorthodox, and, in his last years, tended towards what appeared to most at the time as a reactionary conservatism. For his own statements on these matters, see *Resistance, Rebellion and Death*, 81–110. This does not, in my view, lessen the relevance of his war time work and his postwar existentialism to present concerns. The second epigraph is from Scott Rothkopf, "Embedded in the Culture: The Art of Paul Chan," *Artforum* XVIV, no. 10 (Summer 2006): 304–12.

1. See Christine Morrow, *Emily Floyd: The Outsider* (Perth: John Curtin Art Gallery, Curtin University of Technology, Western Australia, 2005).

2. Harold Pinter, "Art, Truth, and Politics," *The Guardian Weekly*, December 8, 2005, http:// www.nobelprize.org/nobel_prizes/literature/laureates/2005/pinter-lecture-e.pdf.

3. "Becoming an artist was a political choice. This does not mean that I make 'political art,' or even 'political graphic art.' My choice was to refuse to make political art. I make art politically." (Thomas Hirschhorn, interview with Okwui Enwezor, in *Thomas Hirschhorn: Jumbo Spoons and Big Cake, The Art Institute of Chicago; World Airport, The Renaissance Society at the University of Chicago* [Chicago: Lowitz + Sons, 2000], 13–14). Hirschhorn echoes the slogan adopted by Jean-Luc Godard and Jean-Pierre Gorin when they founded *le groupe Dziga Vertov* in 1968: "The problem is not to make *political* films but to make films *politically*." See Colin McCabe, *Godard: Image, Sound, Politics* (London: Macmillan, 1980), 19.

4. Retort (Iain Boal, T. J. Clark, Joseph Matthews, and Michael Watts), *Afflicted Powers, Capital and Spectacle in a New Age of War*, 2nd ed. (London: Verso, 2006), 198–99. See comments by Julian Stallabrass, "Spectacle and Terror," *New Left Review* 37 (Jan/Feb, 2006): 87–106.

5. Guy Debord, *The Society of the Spectacle* (1967; New York: Zone, 1994).

6. Retort, *Afflicted Powers*, 210 (original emphasis).

7. President George W. Bush, "Transcript: 'We Strive to Be a Compassionate, Decent, Hopeful Society," *New York Times*, February 1, 2006.

8. Giorgio Agamben, *State of Exception* (Chicago: University of Chicago Press, 2005), 87.

9. Ibid.

10. Ibid., 88.

11. Pinter, "Art, Truth, and Politics."

12. "As the heir of a corrupt history that blends blighted revolutions, misguided techniques, dead gods, and worn-out ideologies, in which second-rate powers can destroy everything today, but are unable to win anyone over, in which intelligence has stooped to becoming a servant of hatred oppression, that generation, starting from nothing but its own negations, has had to re-establish both within and without itself a little of what constitutes the dignity of life and death" (Albert Camus, "Speech of Acceptance Upon the Award of the Nobel Prize for Literature," *Resistance, Rebellion and Death* [New York: Alfred A Knopf, 1960], 197).

13. Robert Hobbs, Mark Lombardi, and Judith Richards, *Mark Lombardi: Global Networks* (New York: Independent Curators International, 2003).

14. The trajectory of Sekula's work is traced in Sabine Breitwieser, ed., *Performance Under Working Conditions* (Vienna: Generali Foundation; Ostfildern-Ruit: Hatje Cantz, 2003).

15. This work is illustrated and introduced by Helen Molesworth in chapter 10 of *Antinomies of Art and Culture: Modernity, Postmodernity and Contemporaneity*, ed. Terry Smith, Okwui Enwezor, and Nancy Condee (Durham, NC: Duke University Press, 2008).

16. See Jill Bennett, *Dennis Del Favero, Fantasmi: 1994–2004* (Sydney: College of Fine Arts, Ivan Dougherty Gallery, 2004).

17. See Thomas Hirschhorn et al., *Thomas Hirschhorn* (London: Phaidon, 2004). Discussed in Benjamin H. D. Buchloh, "An Interview with Thomas Hirschhorn," *October* 113 (Summer 2005): 77–100.

18. Quoted in Charles Merewether, ed., *2006 Biennale of Sydney; Zones of Contact* (Sydney: Biennale of Sydney, 2006), 182–83.

19. Laura Hoptman, "Unmonumental: Going to Pieces in the 21st Century," in New Museum of Contemporary Art, New York, *Unmonumental: The Object in the 21st Century* (London: Phaidon, 2007), 128. The comment makes sense if one confines "art" to that which is like-sculpture, or like-painting, or whatever historical medium, and "discourse" to renovations of modernist concerns being debated in the major centers, especially the relatively newer ones such as Berlin and Los Angeles—although clearly artists such as Mike Kelley and Jason Rhoades are as much tutelary geniuses of this tendency in the United States as Isa Genzken in Europe.

20. Henriette Huldisch, "Lessness: Samuel Beckett in Echo Park, or An Art of Smaller, Slower, and Less," in Henriette Huldisch and Shamin M. Momin, *Whitney Biennial 2008* (New York: Whitney Museum of American Art, 2008), 38.

21. "Unbuilding" is discussed in William Langewiesche, *American Ground: Unbuilding the World Trade Center* (New York: North Point Press/Farrar, Straus & Giroux, 2002); and in Terry Smith, *The Architecture of Aftermath* (Chicago: University of Chicago Press, 2006), chapter 6.

22. The best survey of this turning in "new media" art is Jeffrey Shaw and Peter Weibel, *Future Cinema* (Karlsruhe: ZKM; and Cambridge, MA: MIT Press, 2003). My views are presented in "Interaktion in dem Zeitgenössischen Kunst" [Interaction in Contem-

porary Art], in *Vom Funken zum Pixel: Kunst = Neue Medien*, ed. Richard Castelli et al., 23–31 (Berlin: Nicolaische Verlagsbuchhandlung und Martin-Gropius-Bau, Berliner Festspiele, 2007).

23. See http://www.theyesmen.org, and Andy Bichlbaum, Mike Bonamo, and Bob Spunkmeyer, *The Yes Men: The True Story of the End of the World Trade Organization* (New York: The Disinformation Co., 2004).

24. Pia Lindman, "The New York Times, Monuments, Art, and Affect: Re-Enactments in Grey-Scale," in Graham Coulter-Smith and Maurice Owen, *Art in the Age of Terrorism* (London: Paul Holberton, 2005).

25. Markus Mai and Arthur Remke, *Urban Calligraphy and Beyond* (Berlin: Die Gestalten Verlag, 2003).

26. Jake Smallman and Carl Nyman, *Stencil Graffiti Capital: Melbourne* (New York: Mark Batty, 2005).

27. See http://www.banksy.co.uk. In September 2006, Banksy staged a show of his prints and sculptures at a warehouse in downtown Los Angeles. The invitation read: "1.7 billion people have no access to clean drinking water. 20 billion live below the poverty line. Every day hundreds of people are made to feel physically sick by morons at art shows telling them how bad the world is but never actually doing something about it. Anybody want a free glass of wine?" Cited in Edward Wyatt, "In the Land of Beautiful People, An Artist Without a Face," *New York Times*, September 16, 2006.

28. See Colin Moynihan, "As Street Art Goes Commercial, a Resistance Raises a Real Stink," *New York Times*, June 28, 2007.

29. Quoted in Uta Grosenick, ed., *Art Now*, vol. 2 (Cologne: Taschen, 2005), 478. See Adam Szymezyk et al., *Gregor Schneider. Totes Haus ur / Dead house ur / Martwy Dom ur 1985–1997* (Frankfurt: Portikus; Warsaw: Galerie Foksal; Mönchengladbach: Städtisches Museum Abteiberg; Paris: ARC–Musée d' art moderne de la Ville de Paris, 1997), http://www .gregorschneider.de.

30. See Grosenick, *Art Now*, 16–19.

31. A range of relevant examples may be found in Tacita Dean and Jeremy Millar, *Place* (London: Thames & Hudson, 2005), including works by Gillick. On the long modern history of the fecund relationships between art and architecture see Germano Celant, ed., *Architecture & Arts 1900/2004, A Century of Creative Projects in Building, Design, Cinema, Painting, Sculpture* (Milan: Skira, 2004).

32. Adrian Searle, "You Are Here," *The Guardian*, September 16, 2003, http://arts.guardian. co.uk/culture/2003/sep/16/1.

33. See Lawrence Weschler, *Mr. Wilson's Cabinet of Wonders* (New York: Vintage, 1999).

34. Patricia Piccinini, *Nature's Little Helpers* (New York: Robert Miller Gallery, 2005).

35. I explore a number of these initiatives in "Currents of Contemporaneity: Architecture in the Aftermath," *Architecture Theory Review* 11, no. 2 (2006): 43–53.

36. Teddy Cruz, "Border Postcards: Chronicles from the Edge," James Stirling Memorial Lectures on the City, Canadian Centre for Architecture, Montréal, and London School of Economics, Cities Program in collaboration with the Van Alen Institute, 2005. http:// cca.qc.ca/pages/Niveau3.asp?page=StirlingLectures&lang=eng. The group Torolab

has conceived a number of similar projects, for example, *The Region of the Transbor-der Trousers* (2004–5), clothing designed for easy passage across contested zones, and *InShop(Shop)* (2007), a rubbish collection unit for useful recycling. See http://www.torolab.co.nr.

37. Krzysztof Wodiczko, *Critical Vehicles: Writings, Projects, Interviews* (Cambridge, MA: MIT Press, 1999).

38. Francis Alÿs, "A Thousand Words: Francis Alÿs talks about When Faith Moves Mountains," *Artforum* XL, no. 10 (Summer, 2002): 146–47.

39. See *Walter Benjamin: Selected Writings.* Vol. 1, *1913–1926*, ed. Marcus Bullock and Michael W. Jennings (Cambridge, MA, and London: The Belknap Press of Harvard University Press, 1996), 236–53. On Martinez, see Gilbert Vicario, *The Fully Enlightened Earth Radiates Disaster Triumphant Daniel Joseph Martinez United States Pavilion 10th International Cairo Biennale 2006* (Houston: Museum of Fine Arts, 2006); and Hakim Bey, "Divining Violence," Rachel Leah Baum, "Immanent Wars," Harper Montgomery, "Evangelist Cynic," and Eric G. Wilson, "The Sacred Technology of Daniel Joseph Martinez," *inter-Review* 2, no. 8 (2008): 32–37, 38–41, 42–45, 46–50 respectively.

40. Even mainstream art journals such as *Art in America* have come to acknowledge this changed situation: see the "Art & Politics" issue (no. 6, June/July, 2008).

41. Simon Njami, "Chaos and Metamorphosis," in *Africa Remix: Contemporary Art of a Continent* (London: Hayward Gallery, 2005), 18.

42. Claire Bishop, "The Social Turn: Collaboration and its Discontents," *Artforum* XLV, no. 6 (February 2006): 178–83.

43. On questions of affect as they relate to the widespread treatment of trauma in contemporary art, see Jill Bennett, *Emphatic Vision: Affect, Trauma, and Contemporary Art* (Stanford, CA: Stanford University Press, 2005).

44. Jacques Rancière, *The Politics of Aesthetics* (London: Continuum, 2004); Pinter, "Art, Truth, and Politics." Rancière elaborates his theory with direct reference to works by a number of contemporary artists in an fascinating interview, "Art of the Possible," conducted by Fulvia Carnevale and John Kelsey in *Artforum* 45, no. 7 (March 2007): 256–67.

CHAPTER 13

1. This observation is based on two sample surveys. The first was undertaken during 2001–2 using particularly the resources of the Getty Research Institute, Los Angles; the second during 2002–3, at the University of Pittsburgh. In both cases, initial searches through WorldCat were supplemented by searches through a range of worldwide specialist catalogs, guides, and bibliographies, followed by those made available by the major U.S. art research institutions, and then by searches through the catalogs of significant U.S. and European libraries. Searches were made into the holdings of selected South American and Australian libraries and institutions. The search was for the occurrence of the terms "modern" and "contemporary" or their cognates in the European languages in the titles of books and articles, exhibition catalogs, pamphlets,

or other publications, in the naming of visual arts museums, galleries, exhibiting spaces, or departments of museums and auction houses since the 1870s. Two searches were made through a number of editions of dictionaries of art and glossaries of art terms, noting the incidence of definitions of the words "modern" and "contemporary" and their cognate terms, and the content of the entries for modern and contemporary art institutions, movements, associations, etc. While the survey does not claim to be complete, the patterns and repetitions in the data suggest a clear general picture. I intend to explore the historical trajectory of the interplay between the modern and the contemporary in world art discourses in a forthcoming book provisionally entitled *Becoming Contemporary.*

2. Francis Fukuyama, *The End of History and the Last Man* (New York: Free Press, 1992).

3. Arthur Danto was among the first to articulate, and attempt to theorize, this recognition in a set of essays published from 1984 to the later 1990s. While acknowledging these pioneering efforts, my reservation is that they were confined to an inadequate conception of contemporary art as "posthistorical." Danto soon abandoned this hypothesis, as he did the question itself. Its strongest statement may be found in the introduction to *After the End of Art: Contemporary Art and the Pale of History* (Princeton, NJ: Princeton University Press, 1997).

4. Fredric Jameson, *A Singular Modernity: Essay on the Ontology of the Present* (London: Verso, 2002), 23–30.

5. These thoughts are pursued in the introduction and in various essays in Terry Smith, ed., *Impossible Presence: Surface and Screen in the Photogenic Era* (Sydney: Power Publications; and Chicago: University of Chicago Press, 2001).

6. Peter Timms, *What's Wrong With Contemporary Art?* (Sydney: University of New South Wales Press, 2004), 10.

7. Ibid., 11.

8. Ibid., 13.

9. Ibid. Timms's examples include the reworking of Shakespearian comedy in films such as *Love Actually* (he might be persuaded to add the HBO television series "Deadwood" [2005] and "Rome" [2006], among many others), English composer James Macmillan's efforts to "express Christian religious ecstasy in a modern musical language" (p. 13), and Emily Kame Kngwarreye's preservation and revivification of ancient Australian Aboriginal stories in her Yam Dreaming paintings. These are all constructive alternatives. Timms's critique is not as blanket a whine as that of those mentioned above, and of others such as Julian Spalding. See the latter's *The Eclipse of Art: Tackling the Crisis in Art Today* (Munich: Prestel, 2003).

10. Julian Stallabrass, *High Art Lite* (London: Verso, 1999), 4.

11. Ibid., 2.

12. Ibid., 9.

13. Ibid., 11. He returns to this point on page 282: "That high art lite looks both ways—to the mass market and the elite art market—has produced a depth of ambiguity, manifested in its refusal to take a stand, its general lack of depth, and the levity with which it treats its wider audience." Stallabrass updated his argument as an even stronger po-

lemic in his *Contemporary Art: A Very Short Introduction* (Oxford: Oxford University Press, 2004).

14. There are important distinctions to be made between the reflexive and subtle, yet brusquely combative style of Robert Hughes, "The Decline of the City of Mahagonny," the introduction to his *Nothing if not Critical* (New York: Knopf, 1990), 1–28; the crude contrarianism of Peter Fuller's "Fine Art After Modernism," in his *Beyond the Crisis in Art*, 44–67 (London: Writers and Readers Publishing Cooperative, 1982); and the reactionary opportunism of Dave Hickey's "Enter the Dragon: On the Vernacular of Beauty," the introduction to his *The Invisible Dragon: Four Essays on Beauty* (Los Angeles: Art Issues Press, 1994), 21–22. Populist newspaper writers throughout the world have not helped promote insightful understanding: a random sample might include Jed Pearl in *The New Republic*, Christopher Knight in the *Los Angeles Times*, and John McDonald in the *Sydney Morning Herald*. Peter Plagens offers an informative lament on the demise of opinionated art criticism in a U.S. mass media environment increasingly devoted to quick-scan, broad-scale consumption demographics in "Contemporary Art, Uncovered," *Art in America* 2 (February 2007): 45–51. Baudrillard launched an early attack in a 1987 lecture at the Whitney Museum, New York ("Toward the Vanishing Point of Art"), returned to the theme in his *Le Complot de l'Art* (Paris: Sens & Tonka, 1997), and repeated it in his 2003 Venice Biennale lecture "Art Contemporary . . . to Itself." These texts may be found in Jean Baudrillard, *The Conspiracy of Art: Manifestos, Interviews, Essays* (New York: Semiotext(e), 2005). A more measured sociological perspective is offered by Nathalie Heinich, *Le Triple Jeu de l'art contemporain* (Paris: Éditions de Minuit, 1998), and, building on Heinich, by Mario Perniola, *Art and Its Shadow* (New York: Continuum, 2004).

15. This concept is advanced in the introduction to Terry Smith, *The Architecture of Aftermath* (Chicago: University of Chicago Press, 2006).

16. Donald Kuspit, "The Contemporary and the Historical," *Artnet* (April 2005), http://www.artnet.com/magazine/features/kuspit/kuspit4-14-05.asp. These views are given fuller treatment in Kuspit's book *The End of Art* (New York: Cambridge University Press, 2004).

17. Hal Foster, Rosalind Krauss, Yve-Alain Bois, and Benjamin Buchloh, *Art Since 1900: Modernism, Anti-Modernism, Postmodernism* (London: Thames & Hudson, 2005). Foster's interest in psychoanalysis does not lead to a distinct history of modernism, although it certainly does issue in distinctive accounts of the works that he, the author of the majority of the entries, treats. Among a number of astute reviews of the book see Charles Harrison, "After the Fall," *Art Journal* 65, no. 1 (Spring 2006): 116–19; and Nancy J. Troy, Geoffrey Batchen, Amelia Jones, Pamela M. Lee, Romy Golan, Robert Storr, Jodi Hauptman, and Dario Gamboni in "Interventions Reviews," *Art Bulletin* LXXXVIII, no. 2 (June 2006): 373–89.

18. Foster et al., *Art Since 1900*, 679.

19. Ibid.

20. I expand on these points in my chapter "Canons and Contemporaneity," in *Partisan Canons*, ed. Anna Brynzki (Durham, NC: Duke University Press, 2006). An interesting

discussion of the postcolonial implications of this question by Niru Ratnam, Irit Rogoff, Richard Dyer, Kobena Mercer, and Alia Syed may be found in "Critical Difference: Art Criticism and Art History," in *Changing States: Contemporary Art and Ideas in an Era of Globalisation*, ed. Gilane Tawadros (London: iniVA, 2004), 254–60. A quite other perspective is to see that contemporary art that continues to depend on its medium as canonical and that which does not as "noncanonical," to see these two streams as coexistent, as just different from each other, with no necessary claim on the other, yet with the possibility that a pathway between them might be found by some artists. This is a view advanced by photographer (or, as he would prefer, picture-maker) Jeff Wall in, for example, Peter Osborne, "Interview Jeff Wall: Art after Photography, after Conceptual Art," *Radical Philosophy* 150 (July/August, 2008): 36–51.

21. Kuspit, "The Contemporary and the Historical."

22. See Jameson, *A Singular Modernity*, 211–15.

23. For a more detailed outline of the proposals in this section, see Terry Smith, "Pour une histoire de l'art contemporain (Prolégomènes tardifs et conjecturaux)," *20:21 Siècles 5–6* (Automne 2007): 191–215.

24. Cited in Bernard Smith with Terry Smith and Christopher Heathcote, *Australian Painting 1788-2000* (Melbourne: Oxford University Press, 2001), 218.

25. Examples of the thematic approach include Edward Lucie-Smith, *Art Tomorrow* (Paris: Editions Pierre Terrail, 2002), which pursues eight; and Eleanor Heartney, *Art and Today* (London: Phaidon, 2008), in which sixteen are tracked.

26. Major elaborations and revisions of the history of avant-gardism in South America are offered in such recent studies as Mari Carmen Ramirez and Hector Oléa, *Inverted Utopias* (Houston: Museum of Fine Arts; and New Haven, CT: Yale University Press, 2005); and Carlos Basualdo, ed., *Tropicália: A Revolution in Brazilian Culture 1967–1972* (Sao Pãulo: Cosac Naify, 2005). I have noted a number of similar initiatives in notes to previous chapters, especially 9, 10, and 11.

27. An outline is offered in Terry Smith, *Contemporary Art: World Currents* (London: Laurence King; and Upper Saddle River, NJ: Prentice-Hall, forthcoming).

28. As argued for by James Meyer, "The Return of the Sixties in Contemporary Art and Criticism," chapter 16 in *Antinomies of Art and Culture: Modernity, Postmodernity and Contemporaneity*, ed. Terry Smith, Okwui Enwezor, and Nancy Condee (Durham, NC: Duke University Press, 2008).

29. Among new perspective exhibitions see, for example, Ann Goldstein, ed., *Reconstructing the Object of Art: 1965-1975* (Los Angeles: Los Angeles County Museum of Art, 1995); Paul Schimmel and Russell Ferguson, eds., *Out of Actions: Between Performance Art and the Object: 1949-79* (Los Angeles: Museum of Contemporary Art, 1998); Richard Flood and Francis Morris, eds., *Zero to Infinity: Arte Povera 1962-1972* (London: Tate Gallery, 2002); Ann Goldstein, ed., *A Minimal Future? Art as Object 1958-1968* (Los Angeles: Los Angles Museum of Art, 2004); Helen Molesworth, *Work Ethic* (Baltimore: Baltimore Museum of Art, 2003). Excellent recent scholarship on the protohistory of contemporary art in Euroamerica includes Pamela M. Lee, *Chronophobia: On Time in the Art of the 1960s* (Cambridge, MA: MIT Press, 2004); Martha Buskirk, *The Contingent Object*

of Contemporary Art (Cambridge, MA: MIT Press, 2003); Anne Reynolds, *Robert Smithson: Learning from New Jersey and Elsewhere* (Cambridge, MA: MIT Press, 2003); and Alexander Alberro, *Conceptual Art and the Politics of Publicity* (Cambridge, MA: MIT Press, 2003).

30. Kirk Varnedoe, *Modern Contemporary: Art at MOMA since 1980* (New York, MoMA, 2000), 12. For a critique of MoMA's millennial exhibitions, particularly *Modernstarts: People. Places.Things,* see Franco Moretti, "MoMA2000: The Capitulation," *New Left Review,* second series, 4 (July–August 2000): 98–102.

31. Okwui Enwezor, "The Black Box," *Introduction to Documenta 11_Platform 5: Exhibition* (Ostfildern-Ruit: Hatje Cantz, 2002), 55.

32. Diedrich Diederichsen, "Formalismus," *Artforum* XLIII, no. 3 (March 2005): 231.

33. Ibid.

34. Okwui Enwezor, "The Postcolonial Constellation," chapter 11 in Smith, Enwezor, and Condee, *Antinomies of Art and Culture.*

35. Nicolas Bourriaud, *Relational Aesthetics* (Dijon: Les Presses du Réel, 2002), 14, 43. See also Bourriaud, *Post-Production* (New York: Lucas and Sternberg, 2002). Both were reviewed in Claire Bishop, "Antagonism and Relational Aesthetics," *October* 110 (Fall 2004): 51–79.

36. Bernard Smith, *Modernism's History: A Study in Twentieth-Century Art and Ideas* (Sydney: UNSW Press, 1998). An excellent survey of the issues can be found in the introduction to Kobena Mercer, ed., *Cosmopolitan Modernisms* (London: iniVA; and Cambridge, MA: MIT Press, 2005).

37. Alexander Alberro, "Periodizing Contemporary Art," in Jaynie Anderson ed., *Crossing Cultures: Conflict, Migration, Convergence; Proceedings of the 32nd Congress of the International Committee of the History of Art* (Melbourne: Melbourne University Publishing, 2009).

38. Nicolas Bourriaud, "Altermodern Manifesto," posted as part of the exhibition, Altermodern: Tate Triennial 2009, Tate Modern, London, February–April 2009. Text and interview at http://blog.tate.org.uk/turnerprize2008/?p=74.

39. For an assessment of how these currents manifested themselves in the curatorial programs of the 52nd Venice Biennale, Documenta 12, and the 4th Munster Sculpture Project, see Terry Smith, "The World, from Europe: The Mega-exhibitions of Mid-2007," *X-Tra Contemporary Art Quarterly* 10, no. 3 (Spring 2008): 4–19.

40. Jacques Derrida drew attention to this kind of troubled coupling in much that is pressing at present, describing, for example, the "pure" concept of justice as essential to the actual operations of the law but as "irreducible" to it, as is the concept of forgiveness to the various processes of social reconciliation currently being undertaken. See, among many other texts, his "On Forgiveness," in Jacques Derrida, *Cosmopolitanism and Forgiveness* (London: Routledge, 2001), 51.

41. See Josiah McElheny, *Notes for a Scupture and a Film,* ed. Helen Molesworth (Columbus, OH: Wexner Center for the Arts, 2006).

42. See Marion Ackerman, ed., *Josephine Meckseper* (Ostfildern-Ruit: Hatje Cantz for the Kunstmuseum, Stuttgart, 2007).

Index

antinomies, 269
Antonioni, Michelangelo, 102
apolitical art, 224
Apolítico (Prieto), 163, 166
Apollo Pavilion, Peterlee New Town, 230
Appardurai, Arjun, 273n6, 296n20
Architecture of Aftermath, young British
 artists (Smith), 273n6, 279n1
architecture of museums, 265; CATIA
 modeling in, 77, 79; Centre Pompidou
 (Paris), 84, 86; for cultural tourism,
 89–90; Guggenheim Museum (Bilbao),
 71–87, 242; industrial settings of,
 81–82, 84–85; Massachusetts MoCA
 (Williamstown), 76–77; Museum of
 Contemporary Art (Los Angeles),
 84–85; spectacle in, 7, 9, 15, 74, 86–87;
 traditional rectangular galleries of,
 60–61, 76, 83–84, 90; Weisman Art
 Museum (Minneapolis), 78–79. *See also*
 building-as-sculpture
ARCO (Feria Internacional de Arte Con-
 temporaneo), 143
*Arena (Where I would have got had I been
 intelligent)* (Beuys), 41–42
Arias, Fernando, 159
Armani, Georgio, 283n3
Armelder, John, 224–25
"Art, Truth, and Politics" (Pinter), 217–18
Art and Culture (Greenberg), 23
Art Basel, 143–44, 145
Art Basel/Miami, 143–44, 145
ArtFacts.Net, 121
art fairs, 143–45, 251, 258, 290n21
art history. *See* historical analysis
artist collectives, 230–31, 267
artist-in-residence programs, 88
*Art Must Be Beautiful, Artist Must Be Beauti-
 ful* (Abramović), 32
Artpace, San Antonio, 88
Art Power (Groys), 296n2
art practice, 267–68
art school art, 251

Art Since 1900 (Foster, Krauss, Bois, and
 Buchloh), 252, 259, 273n1, 303n17
Ash Wednesday (Neuenschwander and
 Guimarães), 66
Asian Field (Gormley), 182–85
Asian jewel beetles, 172–73, 186
assemblages, 225
Assume Vivid Astro Focus, 224–25
Ataman, Kutlug, 122, 213–14
Atlas Group, 122
Attendant, The (Julien), 189
auction houses, 120–26, 128, 258, 287n14;
 banking functions of, 130; competition
 among, 139–40; competition from art
 fairs with, 143–45; conventional focus
 of, 145–46; global reach of, 130–31;
 monopoly charges against, 143. *See also*
 markets for contemporary art
audience. *See* markets for contemporary
 art; viewers of contemporary art
Australian Aboriginal art, 10, 121, 133–43;
 authenticity questions in, 137–38;
 canonical works of, 138, 289n7; cotem-
 poral coexistence in, 138–39, 289n8;
 distributors of, 134–36; Dreamings nar-
 ratives of, 203, 296n8, 302n9; exclusion
 from art fairs of, 143; exhibitions of,
 138; humanoid ancestor figures of, 183;
 impact of globalization on, 139, 142;
 popularity of, 133–36, 289n5; prices
 of, 136–37, 140–41, 289nn4–5; spiritual
 communication role of, 134
Autobiografía (Bruguera), 164–65
Autumn Rhythm (Pollock), 123
avant-garde, 30, 252–53, 262–63, 304n26
Ave Maria (Cattelan), 65

BaadAsssss Cinema (Julien), 188
Backside of the Moon (Turrell), 193–95
Bacon, Francis, 286n3, 288n24
Bal, Mieke, 297n11
Ballad of Trotsky, The (Catelan), 121
Bankside Power House, 56

Banksy, 228, 300n27

Barenboim, Daniel, 106

Barnes Foundation, 19

Barney, Matthew, 9, 91–113, 181, 248; athletic performances of, 100–1; critical response to, 96–97, 159, 283n4, 283n9; photos of, 105, 108; post-*Cremaster* work of, 113; props and structures by, 102–3, 282n2; spectacularism of, 7, 265; three-part system of, 107–8, 285n22. See also *Cremaster* cycle (Barney)

Barr, Alfred H. Jr., 28, 30, 36, 123

Barros, Fabiana de, 158

Basquiat, Jean-Michel, 188, 228

Bather (Cézanne), 18

Baudelaire, Charles-Pierre, 78

Baudrillard, Jean, 248, 285n22, 303n14

beautiful otherness, 172–90; in allegories of globalization, 181–85; in anachronistic tension, 185–87; in animality of *Si Poteris Narrare, Licet*, 173–81, 295n7; in Julien's constructions of interracial coupling, 187–90; work of forgetting in, 172–73

Beckett, Samuel, 225

Bedia, José, 155

Beethoven, Ludwig van, 105

Bell, Richard, 133–34, 137–38

Belper, Jonathan, 102

Benczúr, Emese, 207–8

Benesse Foundation. *See* Naoshima Island, Japan

Benesse House, Naoshima Island, 199

Benjamin, Walter, 235

Bennett, Tony, 275n12

bestiality. *See* beautiful otherness

Beuys, Joseph, 22, 271; anti-institutionalism of, 60; at Dia, 41–42; "Kapital=Kunst" slogan, 57; prominence rating of, 121; at the Tate Modern, 57, 63

Bevan, Roger, 121, 140–41

Beyond Price: In Search of Cultural Value (ed. Hütter and Throsby), 291n25

Bhopal, India, 226

Bickerton, Ashley, 52, 248

Bienal de La Habana, 152–66, 266–67; curatorial methodology of, 154–56; histories of, 291n4; marginalized voices at, 155–58; origins of, 152–54; representations of Cuba in, 162–65; sponsors of, 157; 7th exhibition (2003) of, 10, 157–68; 8th exhibition (2006) of, 165–66; "Tradition and Contemporaneity" exhibit of, 155–56; use of multiple venues for, 157–59

Bienal de São Paulo, 154, 292n5

biennales, 7–8, 9, 251, 268

Bilbao Museum. *See* Guggenheim Museum, Bilbao

Billboad Utilizing Graffitists Against Unhealthy Promotions. *See* B.U.G.A.U.P.

Bingo (Matta-Clark), 24

Birken, Alexandra, 225

Birnbaum, Daniel, 96–97, 99, 283n8, 284n10

Birth of the Museum, The (Bennett), 275n12

Birth of Tragedy, The (Nietzsche), 284n10

Bishop, Clare, 237

Björk, 95, 113

Black Skin White Mask (Fanon), 188

blaxploitation films, 188

Bloodline: The Big Family No. 3 (Zhang), 131

Blue Poles (Pollock), 123

Boccioni, Umberto, 64

Bock, John, 225

Bodo, 65

Boetti, Alighiero, 33

Bois, Yve-Alain, 252, 273n1, 303n17

Bonami, Francesco, 156

Bond, Allan, 130

Bonnard, Pierre, 21

Boss, Hugo, 283n3

Bourgeois, Louise, 43, 63, 91

Bourriaud, Nicolas, 90–91, 262, 263

boutique museums, 47. *See also* collector museums

Geffen Contemporary, 84–85

Gehry, Frank, 7, 265; critical acclaim for, 282n1; design process of, 75–76; Guggenheim (Abu Dhabi) of, 89; Guggenheim Museum (Bilbao) of, 9, 15, 71–87, 242, 279n1; L.A.'s Temporary Contemporary of, 84–85; Tiffany jewelry collection, 279n1; use of CATIA by, 77, 79; Weisman Art Museum of, 78–79

Genzken, Isa, 225, 226

Getty Museum, L.A., 91, 130

GFP Bunny project (Kac), 230

Ghazel, 186–87

Gide, André, 62, 279n12

Gilbert & George, 56–57

Gill, Carolyn Bailey, 297n11

Gillick, Liam, 225, 229–30, 300n31

Gilmore, Garry, 97, 101–2

Gladstone, Barbara, 223

Glass, Phillip, 185

globalization, 2, 5–7, 259, 264–65; allegories of, 181–85; antiglobalization discourses, 7, 169, 221–24, 258, 271; in Guggenheim's concept of the museum, 93–95; institutionalization of Contemporary Art in, 241–44; of markets for contemporary art, 54–55, 117–32, 139–47, 287n13; multiple temporalities of, 212; in Saatchi's modus operandi, 54–55; value of the present in, 132, 139–40; varied temporalities within, 197–98. *See also* postcolonial discourses

Global Studio, 231

Gluckman, Richard, 40

Gober, Robert, 25, 35, 248

Godard, Jean-Luc, 285n23, 298n3

Godfather cycle, 111

Goldblatt, David, 25

Golden Calf, The (Hirst), 140

Goldsworthy, Andy, 230

González, Julio, 81

Gonzalez-Torres, Felix, 33

Gordon, Douglas, 206, 225

Gorin, Jean-Pierre, 298n3

Gorky, Arshile, 23

Gormley, Anthony, 181–85

graffiti, 228, 300n27

Graham, Dan, 39

Greenberg, Clement, 23

Green Car Crash (Green Burning Car I) (Warhol), 129

Greenwich mean time, 197

Group Irwin, 167–68, 294n24

Groys, Boris, 296n2

Gržinić, Marina, 167

Guattari, Felix, 103

Guggenheim Foundation, 93–95, 282–83nn2–3

Guggenheim Museum, Abu Dhabi, 89

Guggenheim Museum, Bilbao, 9, 15, 37, 71–87, 242; atrium of, 17, 71–75, 81, 244; east tower ("High Reader") of, 81–83, 280n13; emptied spaces of, 111–12; fish gallery of, 85; inclusive remodernism of, 79–81; meeting of sculptural and functional in, 74–85, 95–96, 280n7; modernist art of, 75; photos of, 72, 73, 80, 82; populist message of, 74–75, 86, 91; Serra's works at, 84, 85–86; temple-like qualities of, 200; traditional rectangular galleries of, 60, 76, 83–84

Guggenheim Museum, New York, 75, 83–84, 91; Barney's works in, 93–113, 282n2; photos of, 94; Rotunda of, 93–95; spiral ramps of, 95, 283n3, 283n9. See also *Cremaster* cycle (Barney)

Guimarães, Cao, 66

Gulf Art Fair, 143

Gurksy, Andreas, 26

Guston, Philip, 34

Gutai group, 258

Haacke, Hans, 90

Haburger Kunstverein, 261

Hadid, Zaha, 89, 162

Hall, Stuart, 151

Maggi, Marco, 160–62

Magiciens de la Terre exhibit, 155–56, 292n10

Maiastra (Brancusi), 66

Mailer, Norman, 97

Malevich, Kazimir Severinovich, 20

Maman (Bourgeois), 63, 91

Manet, Edouard, 188

Manifesta, 156

Mann, Thomas, 284n10

Manzoni, Piero, 22

Mao (Warhol), 128

Mapping the Studio I (Fat Chance John Cage) (Nauman), 43

Mapplethorpe, Robert, 188

maps, 169–70

Marclay, Christian, 265

Marden, Brice, 33

Mariño, Armando, 162

markets for contemporary art, 9–10, 117–32, 246–47, 251, 291n24; at art fairs, 143–45, 258, 290n21; artist prominence ratings in, 121; at auction houses, 120–26, 130–31, 139–40, 143–46, 258, 287n14; for Australian Aboriginal art, 133–43; bubble economy of, 141–43, 290n15; collector museums in, 47, 87–89, 251, 281nn23–24; conventional focus of, 145–46; for Cuban art, 156; dominance of, 120–21; emergence of, 123–27; globalized context of, 54–55, 119–32, 139–47, 287n13; for Hirst's works, 117–19; investor/collectors in, 123–24, 127–32, 141, 144–45, 258, 287n19; for local and regional artists, 130–31; monetarization of collecting in, 120, 130–32; prices in, 121–25, 128–30, 254; resale royalties in, 124–25; sales figures for, 140–43; secondary markets in, 124–32; Warhol's transitional role in, 126, 128–29

Martí, José, 162

Martin, Agnes, 33

Martin, Jean-Hubert, 155–56, 292n10

Martinez, Daniel Joseph, 235–36

Massachusetts Museum of Contemporary Art, Williamstown, 76–77

mass media, 225–28

Matisse, Henri, 18–20, 61, 63

Matta-Clark, Gordon, 24

Matter of Time, A (Serra), 85–86

Mbembe, Achille, 180–81

McCarthy, Paul, 32–33

McCracken, John, 23

McDonald, John, 303n14

McElheny, Josiah, 269–70

McQueen, Alexander, 95, 283nn4–5

McQueen, Steve, 61, 65, 236

McShine, Kynaston, 31

Meantime (Almond), 197

mechanisms of desire, 103–5

Meckseper, Josephine, 54, 270–71

media mobility, 225–28, 299n22

media specificity, 224

mediation, 145, 157, 196, 224

Mei Moses Annual All Art Index, 125–27

Me in 2000, 2001, 2002 (Ghazel), 186

Meireles, Cildo, 266

Melnikov, Konstantin, 281n24

Mendieta, Ana, 163–64, 293n18

Mercator projection, 169–71

Metropolis (Lang), 79, 111, 172

Metropolitan Museum, New York, 123, 288n24

Meuck, Ron, 52, 53, 91

Meyer, Rupert, 281n24

Migration (Lawrence), 21

Miho Museum, Japan, 200

Millar, Jeremy, 212, 300n31

Millennium Commission, 56

Miller, Dorothy, 31

Miller, George, 99

Milošević, Slobodan, 210

Minamidera, Naoshima Island, 87, 193–95, 198

Minibayea, Almagul, 224

minimalism, 23, 245; in Dia projects, 39–47; emptiness of, 95–96, 283n6; industrial settings of, 84, 225; materialist outlooks of, 201; at MoMA, 22; in sculptural architecture, 76; at the Tate Modern, 61–62, 66; use of *Untitled* as title in, 28

Mirror of Production, The (Baudrillard), 285n22

Miyajima, Tatsuo, 198–99

modern art, 6, 242, 246, 250; contemporaneous assessments of, 252–53; Nietzsche's insights on, 96–97; prehistory of contemporary art in, 6, 257; quest for transcendence of time in, 197–98; transition into contemporary art from, 126, 128, 247, 256–59

Modern Art Despite Modernism (Storr), 276n22

Modern Contemporary: Art at MoMA since 1980 (MoMA), 27–28

Modernity at Large (Appardurai), 273n6

modernity/modernism, 1–2, 4, 254, 262–64; Baudelaire on, 78; Bourriaud's altermodernity, 263–64; colonial forces of, 6, 197, 262–63; historicizing impulses of, 245

Modern Painting and Sculpture: 1880 to the Present (Elderfield), 28

Moffatt, Tracey, 187

MoMA. *See* Museum of Modern Art

Moment is the Moment, The (Aitken), 198

Monderna Museet, Stockholm, 91

Mondrian, Piet, 21

Monet, Claude: at MoMA, 17; at Naoshima Island, 200; at the Tate Modern, 61, 63, 66

monetarization of collecting, 130–32

Monroe, Marilyn, 128, 258

Monsoon (Aitken), 212–13

Montana, Linda, 207–8

"*Monuments*" *for V. Tatlin* (Flavin), 41

Monument to Balzac (Rodin), 15

Monument to Georges Bataille (Hirschhorn), 223

Monument to Martyrs of the Revolution, 2006, 166

Monument to the Third International of 1920 (Tatlin), 68

Moor, Ayanah, 226–27

Moore, Charles, 280n7

Morphy, Howard, 296n8

Morris, Robert, 44, 76

Mosquera, Geraldo, 155, 181

Mueck, Ron, 129

Mullins, Aimee, 95, 283n5

Murakami, Takashi, 7, 265; market for, 128, 147, 290n23; at Palazzo Grassi, 55

Murray, Elizabeth, 25

Musée d'Art Moderne de la Ville de Paris, 76

Musée d'Elysée, Lausanne, 205

Musée des Artistes Vivants, Paris, 29–30, 274n3

Musée d'Orsay, Paris, 19

musées de passage, 29–30, 31, 85

Museo Nacional de Bellas Artes, Havana, 156–57

Museum für Moderne Kunst, Frankfurt, 60

Museum Kunst Palast, Düsseldorf, 91

Museum of Contemporary Art, Los Angeles, 42, 84–85

Museum of Jurassic Technology, Los Angeles, 230

Museum of Modern Art, New York (MoMA), 9, 13–37, 200; Aitken's *Sleepwalkers* at, 213; atrium of, 16–17; attendance at, 66; contemporary art exhibits of, 17, 32–36; critical reactions to, 257; curatorial territorialism of, 17–18; Deconstructivist Architecture exhibit at, 280n7; defensive remodernism of, 26, 27–36, 260, 275n16, 276n22; Eliasson's Take Your Time exhibit at,

198; founding goals of, 28, 30–31, 36; modern art exhibits of, 17–23; Nouvel tower display space, 275n18; NYC as artwork in, 25; Out of Time exhibit at, 34–35; photos of, 14, 16, 19, 20, 21, 23, 26; Sculpture Garden of, 14, 15; Stella retrospective at, 123; Taniguchi's expansion of, 13–18, 35–36, 83; temporary exhibition galleries of, 17

Museum of Modern Art, Oxford, 58

museums, 7–10, 241–44, 265; as archive, 62–63; artists' attitudes towards, 122; branding of, 91–92; collector museums, 47, 87–89, 251, 281nn23–24; crowd management in, 195; cultural tourism at, 89–90; deaccessioning of works by, 119; demographics of visitors to, 59; experience museums, 71, 87, 90–92, 195; globalized conceptions of, 93–95, 282–83nn2–3; institutional redefinitions of, 9–10, 29–30, 36–37, 111–13; *musée de passage* approach, 29–31, 85, 275nn11–12; populist tendencies of, 74–75, 86, 91; private management of, 87; site specificity of, 94–95; spectacle in architecture of, 7, 9, 15, 74, 86–87; temple-like evocations by, 200–201. *See also architecture of museums; names of specific museums, e.g. Saatchi Gallery*

My Bed (Emin), 50

Myra (Harvey), 50

Nadal-Ginard, Bernardo, 129

Nana (Saint-Phalle), 91

Naoshima Island, Japan, 47; Benesse House collection of, 199; Chichu Art Museum of, 199–200; Fukutake's spiritual goals for, 200–201; Honmura village installations of, 198–99; Minamidera of, 87, 193–95, 198

National Gallery of Australia, 123, 286n10

Nature's Little Helpers (Piccinini), 230

Nauman, Bruce, 22; at Dia, 43; at MoMA, 25, 33; at Naoshima Island, 200; prominence rating of, 121

Ndiaye, Ousmane, 159

neoconservativism, 7, 265

neoliberal economics, 7, 120, 265

Neshat, Shirin, 185–87, 266

net.art, 8, 27, 266

Neto, Ernesto, 157

Neuenschwander, Rivane, 66, 232–33

Never.Ignorant.Gettin'.Goals.Accomplished (Moor), 226–27

New Cuban Art, 155–56

new disorder, 5, 8, 78, 273n5

Newhouse, Victoria, 79, 83

Newman, Barnett, 16, 20, 22, 64

new media, 225, 299n22

New Museum of Contemporary Art, 34

News from the Coyote (Beuys), 41–42

New York Earth Room (de Maria), 39

Nicholson, Ben, 125, 287n13

Nietzsche, Friedrich, 96–97, 284n10

1965/1-∞ (Opałka), 208

Ninth Hour, The (Catelan), 121

Njami, Simon, 235–36

Nkanga, Otobong, 159

Nobel Prizes for Literature, 217–18, 220–21, 299n12

Noland, Cady, 34

Norrie, Susan, 212

North, East, South, West (Heizer), 42

Nouvel, Jean, 89, 275n18

Number 1A, 1948 (Pollock), 21

Obrist, Hans Ulrich, 296n9

Observance (Viola), 201

October journal, 252

Ofili, Christopher, 50

Oiticica, Hélio, 22, 23

Oldenburg, Claes, 74

Olivia, Achille Bonito, 278n6

Olympia (Manet), 188

Onassis, Jacqueline Kennedy, 128

One and Three Chairs (Kosuth), 23

Real, 106
Red Slate Circle (Long), 61, 63
Red Studio, The (Matisse), 19
Reinhardt, Ad, 31
relational aesthetics, 262, 268–69
relativism, 253–54
remodernism, 7, 245, 257, 265, 268; of
 Barney's *Cremaster* cycle, 96–97; of
 Gehry's Bilbao museum, 79, 96; indus-
 trial contexts of, 225; markets for, 10;
 at MoMA, 26–36, 275n16, 276n22; post-
 colonial responses to, 169–71; quest for
 transcendence of time in, 197
Renoir, Pierre-Auguste, 18
Resistance, Rebellion and Death (Camus),
 298
Retort, 218–19
retro-sensationalism, 7, 91, 245, 257, 265,
 268; of Barney's *Cremaster* cycle, 96–97;
 of Gehry's Bilbao museum, 96; instant
 impact of, 194–95, 197, 225; markets
 for, 10; postcolonial responses to,
 169–71
Rév, István, 167
Reverón, Armando, 22–23
Rhein II (Gurksy), 26
Rhoades, Jason, 299n19
Rice, Condoleezza, 226–27
Richter, Gerhard, 138–39, 265; at MoMA,
 24, 25, 35; prominence rating of, 121
Riedweg, Walter, 159
Right You Are If You Think You Are (Leirner),
 169
Ritchie, Ian, 83
Rivera, Diego, 21
Rocky Horror Picture Show, 107
Rodchenko, Aleksander, 20, 81
Roden Crater (Turrell), 39
Rodin, Auguste, 15
Rodríguez, Robaldo, 155
Rojas-Sotelo, Miguel, 291n4
Rolling Stones, 285n23
Roppongi Hills Tower, Tokyo, 63

Rorschach blot skeleton (Warhol), 25
Rosenquist, James, 123
Rosenthal, Norman, 278n6
Roth, Dieter, 32
Rothko, Mark, 33, 66
Rothko Chapel, Houston, 16
Rothschild, Nat, 117
Rubell, Don and Ira, 87, 144, 145, 290n21
Rubin, William, 19
Rudenstine, Angelica, 30
Ruprecht, William F., 145
Ruscha, Ed, 210
Russian Ark (Sokurov), 244
Ryder, Albert, 30
Ryman, Robert, 33, 41

Saadiyat Island (Abu Dhabi), 89–90
Saatchi, Charles, 49–50, 53–55, 58, 127,
 129, 140
Saatchi Gallery, London, 9, 37, 49–55,
 87, 129, 271; absence of Australian
 Aboriginal art at, 138; curatorial logic
 of, 50–52; museum-like ambiance of,
 53–54, 277n7; New American Art from,
 54; photos of, 51, 52; yBas exhibits at,
 49–51, 58–59
Saez, Emmanuel, 127
Said, Edward, 105
Saint-Phalle, Nikki de, 91
Salcedo, Doris, 26
sales of contemporary art. *See* markets for
 contemporary art
Salz, Jerry, 97
Samba, Chéri, 33, 65
Samsung Museum, Seoul, 288n24
Sanaa, 34
Sandback, Fred, 22, 39, 43–44
Sant'Elia, Antonio, 81
Sastre, Martin, 159–60, 225
Satrapi, Marjane, 187
Schaulager Museum, Basel, 88
Schjeldahl, Peter, 47, 144, 277n13, 283n9,
 292n11

Sotheby's: Aboriginal art at, 136–37; competition of, 139–40; contemporary art sales by, 121, 123–25, 129, 131–32, 140; one-artist exhibit by Hirst at, 140, 142, 289n10; 2008 sales at, 142–43

Soto, Jesús Rafael, 22

Sots Art, 127

Source of Life, The (Frédéric), 173

South London Gallery, 58

spectacle art and architecture, 6, 7, 15, 219, 257, 265, 268; in building-as-sculpture, 9, 74, 86–87; for cultural tourism, 89–90; by deconstructivist architects, 77, 280n7; in experience museums, 71, 87, 90–92, 195; populist leanings in, 74–75, 86, 91. See also architecture of museums

SPECTACULAR, 90–91

spectacularism, 7, 257, 265, 268

Spector, Nancy, 96, 97, 100–101

Spero, Nancy, 34

Spider (Bourgeois), 43

Spiral Jetty (Smithson), 39

spiritual discourses, 200–201

splashers, 228

Stalker, 231

Stallabrass, Julian, 53, 247–48, 302n3

Staniszewski, Mary Anne, 275n12

Starry Night, The (Van Gogh), 18

Starved Letters (Neuenschwander), 232–33

Stasi City (Wilson and Wilson), 167

Stedelijk Museum, 30

Stein, Gertrude: on musées de passage, 85; on museums of modern art, 29, 35, 90, 275n10

Steiner, George, 273n8

Stella, Frank, 123

stock market, 141–43

Storr, Robert, 276n22

Straightening Spears (Tjupurrula), 203, 296n8

Stranger, The (Camus), 216–17

Struth, Thomas, 24

Studio Pei-Zhu, 89

subjectification of viewers, 47, 277n13

sublime, 46–47, 288n24

Sudbrack, Eli, 224–25

Sugimoto, Hiroshi, 53, 129, 199

Sundaram, Vivan, 168

Super (M)art (Rawanchaikul), 243–44

surrealism, 43–44, 62, 63

Sussman, Eve, 26, 209

Sustained Suture (Nkanga), 159

Suvero, Mark di, 77

Swain, Tony, 296n8

Swallow, Ricky, 209

Sydney Biennale of 2006, 182–85, 224

"Sympathy for the Devil," 285n23

Szeeman, Harald, 278n6

Take Your Time (Eliasson), 198

Taking of Christ, The (Caravaggio), 202

Talking Prices (Velthuis), 120

Taniguchi, Yoshio, 13–18, 35–36, 83

Tarantino, Quentin, 99

Tate Gallery, 56, 57–59

Tate Modern, 9, 24, 30, 37, 56–68; architecture of, 56–57; attendance at, 59, 66; Beuys collection of, 63; colonialist reflex of, 62–64, 279n12; conceptualism at, 59–60, 64; contemporized displays of, 59–60; engagement with diversity at, 67; expansion plans for, 66–68; funding of, 57, 59, 278n2; indigenous art at, 62–64; local artifacts at, 62; minimalism at, 61–62, 66; opening of, 49–50; patronage of, 49, 56–57; photos of, 57, 61, 62, 67; pop art at, 65; rehang of 2005–6 at, 64–66; surrealism at, 62, 63; temporary exhibits at, 63; The Wrong Gallery exhibit at, 66; yBas collection at, 53; "zone" model of, 60–64, 278n6, 279n8

Tatlin, Vladimir, 68

Temporary Contemporary, 84–85

tercomundismo, 154–55

Contents

In memory of my father, Allan George Eldridge Smith